DE

1

The Aesthetic Experience

The Aesthetic Experience

An Anthropologist Looks
at the Visual Arts

Jerome Pierre

JACQUES MAQUET

Yale University Press

NEW HAVEN AND LONDON

1197114I
DLC

4-19-86 JH

Designed by James J. Johnson
and set in Palatino Roman type.
Printed in the United States of America by
Murray Printing Company, Westford, Massachusetts.

Library of Congress Cataloging in Publication Data

Maquet, Jacques Jérôme Pierre, 1919–
 The aesthetic experience.

 Bibliography: p.
 Includes index.
 1. Aesthetics. I. Title.
BH39.M39 1986 701′.1′7 85–8232
ISBN 0–300–03342–7 (alk. paper)

*The paper in this book meets the guidelines for
permanence and durability of the Committee on
Production Guidelines for Book Longevity of
the Council on Library Resources.*

10 9 8 7 6 5 4 3 2 1

Contents

Illustrations

Preface

This book presents, in outline, a system of interpretation of the visual arts in an anthropologist's perspective. It does not offer a survey of what has been written on the visual experience of art. Discussions are limited to the sources of this system and to what is of immediate relevance to it. Consequently several important contributions by anthropologists to the study of art and the related subjects of symbols and metaphors are not mentioned. More anthropologists than the ones here discussed have indeed described artifacts, analyzed styles, elaborated concepts, proposed classifications, and constructed theories on the functions and significations of symbolic thinking. At this initial point, situating my system in relation to other perspectives of interpretation is not necessary. It would even be somewhat presumptuous.

The idea of this book slowly matured in seminars held over two decades, first in Paris, at the Ecole des Hautes Etudes en Sciences sociales and the Musée de l'Homme, and later in Los Angeles, at the University of California, in the Department of Anthropology. Many stimulating discussions were generated by colleagues and students who attended these seminars.

A Wenner-Gren Foundation grant aided me in starting my art slides collection. Several grants from the UCLA Academic Senate provided me with research assistance.

Dawn Chatty, Barbara Mathieu, Marjorie Dickenson, and Martin Cohen participated with sagacity and alacrity in the early stages of the manuscript preparation. David Blundell cheerfully and generously put his talent and expertise at my disposal in the selection and production of photographs. Nancy Daniels performed with discrimination and endurance the exacting task of meticulously editing the final version of the entire manuscript and diligently assisted me in the carrying out of the author's responsibilities during the publishing process.

Ellen Graham, editor at Yale University Press, thanks to her enthusiasm and rigor, efficiently fulfilled her difficult role of encouraging and prodding the author.

My wife Gisèle patiently shared with me the inevitable yet unpredictable vicissitudes of book making. As beneficial as her forbearance was her active collaboration, from discussing incipient thoughts and tentative concepts to advising on practical matters.

Finally, I wish to thank the artists and their copyright holders, museums, art galleries, private collectors, photographers, and photographic agencies for their cooperation with the illustrations.

The Aesthetic Experience

The Reality Anthropologists Build

IN THIS BOOK, AN ANTHROPOLOGIST LOOKS AT THE VISUAL ARTS. THIS IS NOT A STRIKING first line. Yet I cannot find a better description of the approach that is developed here.

An *anthropologist's* views are not anthropology. The inclusion of one anthropologist's contribution to that body of knowledge we call anthropology depends on the consensus of other anthropologists. The process of inclusion is unpredictable, nonformalized, and takes some time. Thus I do not claim that what is attempted here is, or will be, recognized as a portion of mainstream anthropology.

Also, like my fellow anthropologists, I am not *only* an anthropologist. Most of us have been seriously involved in other intellectual disciplines. For me, these have been law, philosophy, and sociology, particularly the sociology of knowledge.[1] All of us have been exposed to, and have responded to, some of the great intellectual stimulations of this century such as Marxism and Freudianism, existentialism and phenomenology, surrealism and structuralism, counterculture and consciousness movements. And, of course, all of us have been molded by some affective encounters or spiritual commitments. When researching or writing, however, we sometimes try to act as if we were only anthropologists. In this book, I have not attempted to do so: not only my anthropological *persona* has written the pages that follow. The person I have become by having lived through the excitements and disappointments of the intellectual and emotional turbulences of the twentieth century has also written them. I see no virtue in refusing to take experiential resources into account because they do not fit in the traditional framework of one's discipline. Anything that is relevant should be taken into account.

Of course, such things should be dealt with in a manner appropriate to a work of knowledge. Observations should be validly made, and conclusions should be supported by the kind of evidence and the type of argumentation used in scholarly discourse. This is what I have attempted to do. As I will make clear in several discussions, an epistemological concern has been constantly present during the preparation of this study.

1

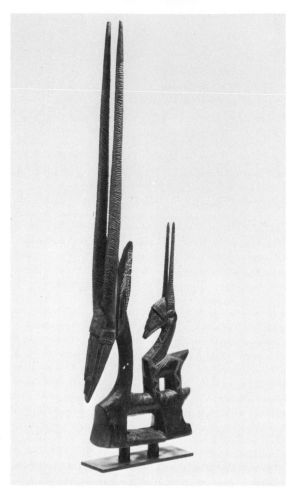

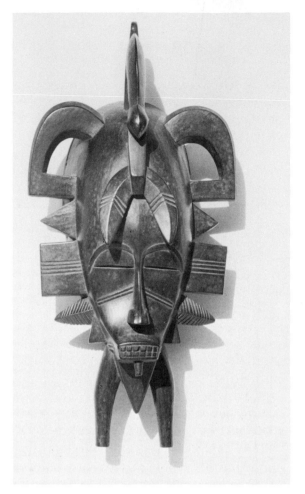

Ritual headdress *(bamana chi wara)*. Bambara, West Africa. Museum of Cultural History, University of California, Los Angeles. Photo by Richard Todd.

Mask. Senufo, Ivory Coast. Private collection, Los Angeles. Photo by Jacques Maquet.

Aesthetic anthropology may not be mainstream anthropology, but my idea of it originated, years ago, from research on a typically anthropological matter: the visual arts of traditional Black Africa. The questions I had in mind were typically anthropological too. What were the functions of the stunning Baga headdresses, the elegant Baule figurines, or the impressive Dogon statues in the societies in which they had been carved? Were they only perceived as ceremonial objects by the members of these societies, or were they also considered art objects by the users? Why were the Bambara and Senufo styles of sculpture different when Bambara and Senufo, both millet farmers, lived in similar environments and in the same region? I approached African artifacts as cultural phenomena, and it proved to be a fruitful perspective.[2]

It seemed warranted to extend the scope of the inquiry and to keep the same perspective. I became interested in anthropology of art, art and culture, cross-cultural aesthetics, and related matters treated under such headings in university courses and scholarly books. These titles connoted an anthropological approach to art.

Art has been mainly "built" by art historians as a fairly autonomous domain in which chronology and the sequence of schools and styles are the main issues. For some philosophers, art is a contingent manifestation of a transcendental beauty. For art critics, the visual objects express the intentions and skills of an individual artist. For experimen-

tal psychologists, art is a stimulus generating responses whose variations may be measured. Psychiatrists see in art a sublimation of repressed impulses, and art dealers see a source of market commodities. What can anthropologists add to this series of—here oversimplified—"constructions" of art by different groups of specialists?

The reality anthropologists build is not fragmented. It is a whole in which man's activities and creations are not considered each apart from the others. Our studies still validate Tylor's more than century-old definition of culture as "that complex whole which includes knowledge, belief, art, law, morals, custom, and any other capabilities and habits acquired by man as a member of society."[3] Walter Goldschmidt reaffirms the centrality of the concept of culture as an integrated whole in anthropology. "Man does not live leisure on Saturday, religion on Sunday, and economics the other five days of the week; what he believes, what he does, and how he feels are all of a piece."[4] His detailed ethnography of the Sebei, an African people, is a convincing demonstration that a culture is a whole, "not merely in the sense of interconnection, but on a much deeper level."[5]

In an anthropological perspective, art is not reduced to an ideational configuration of forms; it is situated among other systems such as philosophies, religious beliefs, and political doctrines. It is not separated from the societal organizations that support it (academies, art schools, museum and commercial galleries), nor from the institutionalized networks of the total society (government, castes and classes, economic agencies, and private corporations). It is related to the system of production which constitutes the material basis of the society. A first contribution of anthropology is the construction of art within an encompassing reality.

A second is a cross-cultural scope. Anthropology began as an ethnology of nonliterate societies, and it has been comparative ever since its origin. Many other social sciences are comparative, but none has such a wide range of comparison, from the small-scale societies of hunters and gatherers to the enormous contemporary industrial states. Difference in size would invalidate any comparison if the fundamental unity of humankind were not recognized as a basic element of our reality. Because the human organism, particularly the nervous system, is practically identical among all living populations, we may assume that its main functions, such as acting, thinking, contemplating, being affected by feelings and emotions, are not limited to some human populations. As creation and appreciation of art are mental processes, it is not unwarranted to look for their manifestations in the whole gamut of cultures. We do not know if art phenomena are universal, and we do not a priori claim that they should be. We just say that they could be.

Probing into these "anthropology of art" questions, I was soon treading ground not mapped by mainstream anthropology. I had to consider problems new for anthropologists. How are art objects distinguished from other man-made things? Is there a specific perception of the artistic quality? Is there a contemplative mode of consciousness to be distinguished from cognition and affectivity? Since anthropology did not provide me with the conceptual tools needed for approaching these questions, I looked for them in other disciplines of knowledge. The first results of this query were published in my *Introduction to Aesthetic Anthropology*.[6]

The *Introduction*, limited by the constraints of the series in which it was first published, touched many points too briefly; in the present book they receive the more extended treatment they deserve. Also, the exploration of the aesthetic experience was

left unfinished in the *Introduction*. I did not consider its symbolic dimension and the implications of symbolism. Yet it is only through the symbolic character of art that we can clarify some fundamental questions: the basis for preferences in art, the assessment of the aesthetic quality, and the relevance of communication and emotion to the analysis of art. These matters, which were beyond the scope of the *Introduction*, are discussed here.

When I wrote the *Introduction*, I shared with phenomenologists the assumption that art is not an independent entity, either in the world out there or in the realm of essences and ideas, but a mental construction agreed upon by a group of people. This was for me an important philosophical position, but without significant consequences for empirical research. Now, I better appreciate the methodological implications of this theoretical standpoint.

I suggested above that art history, psychology, anthropology, and other disciplines of knowledge "build" art, whereas it is more usual to say that they "observe" art. Social sciences, as well as the humanities, use the common language of a society (except for a few so-called technical terms), and the common language indeed implies that there is a world of things out there (rocks, tables, paintings, sculptures, etc.) as well as a world of nonmaterial entities (love, prestige, beauty, the past, etc.). It further implies that these material or ideal things have an existence of their own, and that they can be observed and known. For example, the prestige of the current president may be measured and compared to the prestige of past presidents. To know things is to say in words what they are. If what is said about a thing—or, more precisely, an *object*—corresponds to what it is, this bit of knowledge is true; if not, it is false. The language we use in everyday life, as well as in the social sciences, constantly reiterates the implicit belief in an external world of observable objects. It also reiterates the notion that truth is conformity of what is stated about an object with what the object is.

If we, social scientists, live in the world implied by the language we speak, then we approach art as an external entity. This suggests to us certain questions such as, How can we define art with objectivity? and, Is there true art in this or that society? If, on the contrary, we consider art as a collective construction, we are led to ask other questions such as, Has this particular society built in *its* reality something similar to what is called art in *our* reality? and, What is implied in what they say and do when they look at this carving? In this perspective, we do not compare a collective view with its object but with another collective reality, constructed either by a community of scholars or by our own society. In this approach, one does not claim that a particular view, even the observer's critical view, is a closer approximation to a part of an external world than another view; one does not compare two representations of the same object, to the object; one compares two realities.

Why use the term *reality*? Does it not denote what is usually called *world view*, *Weltanschauung*, *image du monde*: ideational configurations in which a society expresses its outlook on the total environment in which its members live? Indeed, reality refers to such an ideational system, but it makes clear that these systems are not images of a reality but the reality itself. When I see a painting as artistic, a ceremony as religious, an act as political, a transaction as economic, I perceive these qualities as "real" in the sense that they exist independently from my views of them. To me, they are neither imaginary nor arbitrary. When I attend a Catholic mass, I do not feel free to call it an economic

transaction; it is a religious ritual, whatever I may think of it, because it is considered that way by the members of my society. The term *reality* connotes this independence from the subject's mind. This is why we prefer it. It reminds us of the firmness and solidity of the collective constructions.

We prefer it for a second reason. World *views* and similar terms again suggest a reference to external objects. They imply that they are *views* of the world, *images, reflections* of something which is beyond them. The word reality implies no further reference to an external object; it excludes being an image of something else, thus being either true or false. The real simply is.

A reality, independent from an individual subject as well as from an object beyond itself, is the mental construction of a group. It is a "socially constructed reality," to use the terminology of Berger and Luckmann.[7] Its validity is based on the consensus of the total society or of one of its specialized groups. The French men and women of the thirteenth century agreed on, and lived in, a reality that included an earth-centered universe, a humankind damned by an original sin and redeemed by a divine savior, and a social order dominated by a king and a nobility. The French people of the twentieth century have constructed, and are living in, a completely different reality. The reality built by the physicists of today bears no resemblance to the reality of the physicists of one century ago. Each of these realities was, or is, validated by the consensus of the contemporaries, be they the common men and women of a society or the specialists in a certain field.

We should not forget that this book deals with socially constructed realities and not with a world of external entities, material or nonmaterial. This phenomenological position should imbue every step of our study. It makes indeed a difference even at the level of the concrete development of a research.

It is hoped that this study will be a modest contribution to knowledge. In the phenomenological perspective, previously outlined, how can one contribute to knowledge? By extending or modifying the reality built by precedent anthropologists and other social scientists. Scholarly realities are in constant process: each new book or article changes them a little or, sometimes, very much. In order to be included in a disciplinary reality, a contribution must fit in the preexisting construction. As with material buildings designed by architects, it is a matter of continuity in materials (a stone wall should not be extended with bricks), in techniques (a standard mass-produced door should not be put next to a handcrafted one), and in styles (a Gothic steeple should not surmount a neoclassic church). Similarly, the kind of data, the methods of research, and the type of discourse usual in a branch of knowledge should also be found in any new contribution. Some revolutionary changes in the paradigms of a science might also happen, as we have been made aware by Kuhn, but continuity is more frequent.[8]

In the Western tradition of critical knowledge, there is only one model for acceptable cognition. The starting point is a *theory*, a carefully worked out reality, usually expressed in a well-defined system. For instance, the cultural materialist theory, which states that in a culture the source of dynamism is primarily located in the productive process. The visual forms of artifacts are thus expected to be influenced by this process and to reflect the differences in the systems of production.

From the theory, *hypotheses* are generated. For instance, one may deduce from

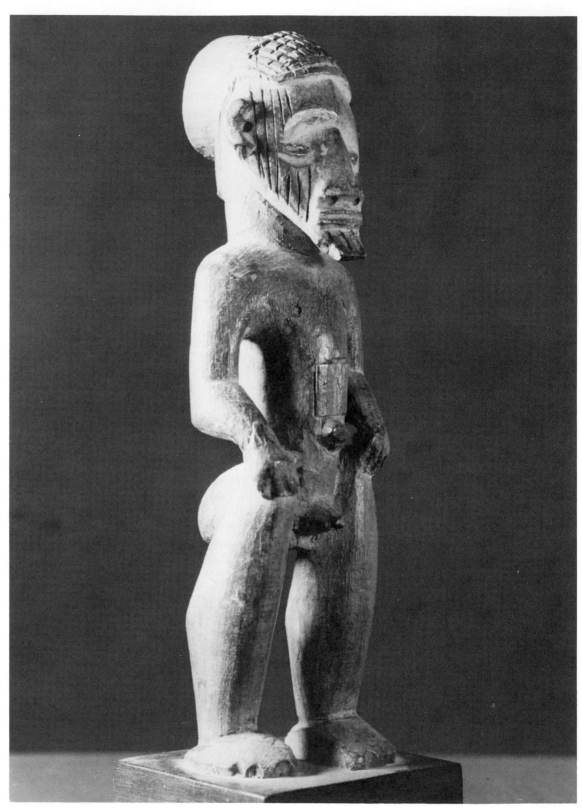

Ritual figurine. Teke, Congo. Private collection,
Los Angeles. Photo by Jacques Maquet.

cultural materialism that the forms of artifacts made in the African equatorial forest societies will display folk-style characteristics because on the subsistence level of production there is no division of labor and no specialization of craftsmen. The savanna kingdoms, which produce a surplus, on the other hand, will develop court, or elite, art forms in their artifacts. The difference between a theory and a hypothesis is that the theory cannot be directly confronted with facts whereas a hypothesis can be tested.

This testing, under the form of *empirical observation*, is the third step of our paradigm of critical knowledge. In our example, it is possible to observe the artifacts made in forest societies and in savanna kingdoms and see if there is a folk/elite difference in their forms.

Because the three steps of the paradigm—theory, hypothesis, and observation—are emphasized differently in the physical sciences, the social sciences, and the humanities, the complete model may not be apparent in some research, and an analysis may be needed to reveal it. Later we shall come back to this matter. I mention this well-known paradigm of critical knowledge here because it does not seem to fit in a phenomenological perspective. It appears to imply that theory and hypothesis are mental representations of something external, and that observation is a comparison between that something external and its image.

Certainly, this is usually how it is understood. Yet it need not be so. What we observe is also a built reality. In our example, the two pairs of variables, *subsistence production/surplus production* and *folk style/court style*, are concepts defined by the observers. For instance, subsistence and surplus may be defined with reference to individual families or to the whole societal unit. A society may have no surplus to export although its individual

Cup. Kuba, Zaire. Royal Museum of Central Africa, Section of Ethnography, Tervuren, Belgium.

farmers produce more than their families need. The other pair of variables is also defined by the observers. They may decide that abundant ornamentation, glossy finish, and professional-like expertise are the criteria of an elite style; or they may choose other features. It is the observer who selects the criteria and who defines each of them. In other terms, the facts are not out there, they are made-up.

We have been trained to regard *facts* as external touchstones of our knowledge. "A hypothesis is proved if supported by facts" because, it is usually understood, the intellectually anticipated relationship can be observed in the world out there. "Confirmation by facts" can be better described as the fit of a newly constructed extension of reality (the hypothesis) into a previously built system (the facts). Ironically, the word *fact*, which connotes independent entities for most of us, comes from the Latin *factum*, which means *made*.

In the present study, when using the paradigm of valid knowledge—theory, hypothesis, observation—we remain aware that the facts we observe are themselves parts of a socially constructed reality. This does not deprive them of their confirming value, but it does qualify it.

Art is a part of a socially constructed reality. Our first task is to apprehend that part of reality and to describe it.

There are as many realities as there are long-lived and stable groups of interacting people engaged in related activities. Each of them creates its reality. In a plural society (which includes several ethnic or religious groups, or a stratification of classes or castes) and in any large and complex society (which comprises specialized occupations), there are several realities. Cattle owners and land tillers in Rwanda, Brahmin and Sudra in India, upper-class New Yorkers and Lower East Side dwellers, nuclear scientists and monks, bankers and janitors live in different "worlds," as it is often stated. Yet each of these pairs lives in the same encompassing society during the same period. When members of the two groups within the pair meet, they interact and talk with each other. Their common ground is what phenomenologists call the "everyday reality."

All members of plural and complex societies, in fact, spend a large part of their lives in everyday reality. The philosopher's proverbial man in the street is every one of us, most of the time. It is only when we explicitly act as members of a group or a profession that we switch to a specialized reality. For the physicist in the laboratory, matter is constituted of electrically charged subatomic particles in motion, but outside the laboratory, bricks and timber are as solid, massive, and inert for physicists as for the man in the street. In the classroom, the teacher explains that colors are not properties of things, but characteristics of reflected light: they are electromagnetic radiations which have a certain wavelength range; but when the class is over, teacher and students continue to speak of red apples and yellow grapefruit. The yogi, who while sitting in meditation has experienced a state of egolessness, still uses the ordinary pronouns *I* and *me* in conversation. The reality constructed from everyday living is an unavoidable one for us all, most of the time.

For this reason, it seems to me that a good research procedure is first to consider art in terms of the everyday reality, rather than in those of the more specialized realities of philosophers, critics, and even artists.

Another reason is that the reality common to all the members of a society is more similar to another common societal reality than the particular realities of specialized

groups. All over the world, everyday realities reflect some universal human experiences: using the environment for collective survival, coping with the unfolding of the life cycle, and communicating for the sake of cooperation. The principal values sought for in the mainstream social life seem to be the same everywhere: power and prestige, affluence and pleasure. These quasi-universal experiences generate similarities in everyday realities.

The ordinary language spoken by all the members of a society creates a set of assumptions shared by its users. For instance, the grammatical organization of the English language makes its users speak in sentences consisting of at least a subject and a predicate. "This tree is beautiful" and "Carol is tall." There is no practical way to speak English without attributing predicates to subjects. The implied assumption is that we live among substantial beings, like Carol and the tree, which keep their identities as long as they exist, and to which we attribute qualities, like tallness and beauty. This grammatical structure "builds" qualities as separate from the subject: tallness does not belong to the core identity of Carol, neither does beauty belong to the tree. Indeed if I say "Carol is beautiful" and "This tree is tall" I do not imply that Carol and the tree are substantially affected by the new predicates; the same subjects simply support other qualities. The subject-predicate structure, though, is not limited to English: it exists in most languages, as do certain other linguistic features. This is another reason for anticipating convergences in the everyday realities of many societies.

Anthropologists are, and have always been, concerned with intercultural comparisons. Comparing requires some similarities between the things to be compared. Art objects and experiences should be first considered within everyday realities because this is where similarities may be expected.

Art should exist as an explicit category in the common language of the ordinary people of the society we wish to consider first. The word *art*, or its correspondent in the language spoken by the whole society, should be understood and occasionally used by everybody. It should make sense to all who hear it in conversation or on the radio and who read it in a newspaper. The ability to understand words and to use them meaningfully is, of course, different from the capability to define them. Everyday language, an instrument for living, does not include many verbal definitions. I cannot define electronics, but I can competently use my pocket electronic calculator. And, when I buy one, I can clearly indicate to the salesperson the features I want it to have. When a man says "I love you" to a woman, this statement makes sense to them, and to somebody who happens to overhear it; it is meaningful and does not require a discussion of the concept of love. Defining words and concepts in common use is the specialized task of those who compile dictionaries; it is not a skill necessary for everyday communication and interaction.

The presence or absence of the word *art* in everyday vocabulary is a matter I raise here because anthropologists have found out that a corresponding word does not exist in most of the languages of the nonliterate societies they used to study exclusively. This may appear surprising, since anthropologists have written articles and books on the arts of these societies, and in chapter 7 I shall discuss at length the implications of the paradox. A brief comment can be made here. It is the American and European observers of nonliterate cultures who have designated some objects made in these societies as *primitive*

art. Carvings representing men, women, or animals, colorful ornaments, decorated panels, and similar objects were said to be "art." They were analogous to some of the objects Western artists had produced for centuries: figurative sculptures and paintings, adornments and embellishments of surfaces, and decorative patterns.

Lest this observation seem too simplistic, I wish to add here that this process of assimilating into the art category objects imported from faraway and dominated countries is ancient and recurrent in history. Often the makers of the objects called "artistic" did not have the word *art* in their vocabulary. The conquerors attributed this quality to these objects. Victorious armies incorporated into the artistic reality of their homeland the looted pieces brought back from the defeated countries.

In terms of scholarly strategy, it would not be advisable to start our study in a culture which does not possess in its language a word that could translate the English term *art*. Of course, at a later stage, we shall consider what conclusions we may draw for aesthetic anthropology from the fact that some societies do not have a word for art in their common language.

Contemporary industrial societies explicitly include art as a word in their common languages and as a part of their everyday realities. As I happen to live in Los Angeles, I refer to its metropolitan culture as the everyday reality in which to start the investigation of art. Yet, as the focus of our study is not what is specific to the Los Angeles cultural scene, we could begin our inquiry in any large urban area of the contemporary world, make similar observations, and draw similar conclusions. Paraphrasing the ancient philosophers' dictum "In any man, the same nature," we can say "In any city of our age, the same everyday."

It could be objected that by beginning anthropology at home we are guilty of ethnocentrism, one of the anthropologist's capital sins. The sin is to take one's collective reality for an external and independent world, which then becomes the absolute criterion of correctness for other cultural views. If we were to consider that art, as implied and expressed in the Los Angeles language and practice, is what art is 'in itself', and what it should be, we would be ethnocentric. Here, we are aware that our "home definition" of art is simply *our* reality and not a standard for others.

Another objection is that there is the difficulty of maintaining an objective stance when concerned with one's own society. It is assumed that the observers' biases, interests, and emotional involvements are almost insuperable when observers are immersed, as members, in the societies they study.

One should realize, however, that observers are *also* involved when they study societies foreign to them. On the surface, involvement may be less apparent and less directly identifiable. But, at a deeper level, involvement is strong: when one decides to share the life of an alien society for one year and often for a longer period, the stakes are high for the ego. If involvement is deemed an obstacle to objectivity, it is not limited to "home anthropology."

But is this an obstacle? In the conventional paradigm of the validity of knowledge, as conformity to an external object, certainly involvement is an obstacle. In our phenomenological perspective, however, involvement may be turned into an asset, particularly at the descriptive stage of our inquiry. At this point, what we need is an understanding of *art in everyday reality* in the culture of a contemporary urban area of the industrialized world. Having an insider's access to that reality will be an aid to understanding it.

Art in Human Experience

CHAPTER TWO

Art in Everyday Reality

TO THE WORD ART, THERE CORRESPOND SEVERAL CONCEPTS, MEANINGS, OR INTELLECTUAL representations. We would like to know what art means for the men and women of today who live and work in a large city. To ask them, or a representative sample of them, the direct question, What does art mean? would provide idiosyncratic answers and many instances of "I don't know." The culture of everyday life includes very few definitions of concepts, and certainly no definition of art. Yet a concept of art may be inferred from our daily behaviors and categories. Though working in our own society, we have to use the same approaches as an anthropologist in an unfamiliar culture. One of these approaches, the one we choose here, is to start from the *insiders'* categories.

From the insiders' point of view, the word *art* does not primarily point to a notion, but to a category of material objects. In its daily use, it serves for designating a class of things, for distinguishing them from other things. When anthropologist Mesquitela Lima was among the Cokwe of Angola, he noticed that the word *hamba* referred to an important concept in the Cokwe system of beliefs concerning spirits, and that a variety of things—such as small carved figurines, stones, and plain pieces of wood—were designated by the same term, *hamba*. He began his research by delimiting the class of objects called *hamba*.[1] Let us begin by exploring the sets of objects subsumed under the category of art for the people living in Los Angeles.

A good survey of what is put into this category in our culture may be found in the classified telephone directory of Los Angeles. The alphabetical entries, from "Art Galleries, Dealers & Consultants" to "Art Schools," cover most of the institutions, occupations, and societal networks recognized as being associated with art objects. We are informed on where to go if we want to buy paintings, graphics, sculpture, drawings, prints, weavings, and silk screens. Or if we want to rent them or sell them, to have them cleaned, restored, appraised, packed, and shipped. Some galleries are specialized in ancient and primitive art, others in French Impressionists and Fauves, and others in etchings from Chagall, Picasso, and Miró. Folk art collections are offered by other dealers.

Information is also provided on making art objects, with schools for learning painting, drawing, sculpturing, industrial design, photography, and ceramics, and shops where the necessary art supplies can be purchased. The area's art museums, where art objects are on exhibition, are also mentioned.

The focus of all these directory entries is the *art object*. On the basis of the knowledge held in common by all members of our society (or, at least made available to them in the general dictionaries of our language), we may infer that art objects are these items made by the classical techniques of painting, drawing, and sculpturing, plus a few related techniques like photography, weaving, and pottery. Art, as used in the directory, does not include all the fine arts recognized in the nineteenth-century academic classification: what is related to architecture, literature, drama, music, and dance is not cross-referred.

Classified directories are meant for consumers; they are exclusively business-oriented. The art entries tell us that, among all the commodities on the market, there is a commercially recognized category of art objects. Unlike concepts, market categories do not overlap; they are exclusive in the sense that items of the same type are not sold under more than one category. Market categories have a high degree of stability, for they reflect the specialization of commercial enterprises. This absence of ambiguity is very fortunate—and unusual—as it makes it possible for the observer to identify the extension of a class of phenomena from the point of view of the society that is studied. What an anthropologist wants to study—for example, religious phenomena—often does not correspond to an inside category embodied in a class of material objects. In such a case, the anthropologist is left wondering if, for instance, a given ceremony is religious, magic, or political.

The art object category is not only commercially based. It is also recognized as a focal category in some educational institutions: art museums and art schools. A large number of specialized persons (curators, teachers, administrators, librarians, technicians, guides, and museum attendants), an imposing architectural complex of buildings (exhibition

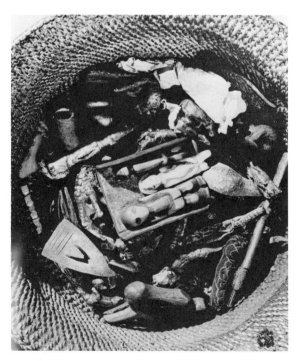

Hamba in a basket. Cokwe, Zaire. Instituto de Investigação Cientifica Angola, Luanda. Photo from Lima 1971.

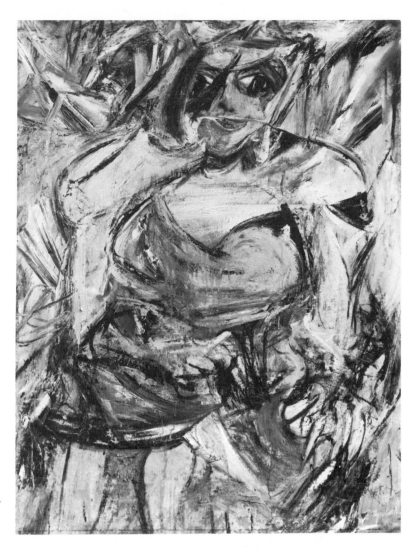

WILLEM DE KOONING. *Woman, II*. 1952. Collection, The Museum of Modern Art, New York. Gift of Mrs. John D. Rockefeller 3rd.

halls, maintenance workshops, storage rooms, lecture halls, classrooms, studios, rest-aurants, and kitchens), a multiple organization of services (audiovisual production, research, conservation, teaching, public relations, fund raising, and security) supported by public and private funds are related to and have developed around these movable items called art objects.

All this is common knowledge in our society. According to the usual expression, "everybody knows" that among the material things around us, there is a distinct class of things known as art objects, and "everybody knows" where to find them: in museums and galleries. This is a part of the everyday reality in which we live, not only in Los Angeles, but in any large city of the contemporary industrialized world.

Our daily reality provides us with a first, and unambiguous, indicator for identifying art objects: objects exhibited in museums and sold in galleries are art objects.

In addition to social categories used for practical classification, the everyday reality is expressed by what people say in informal conversations. Talking with the man in the street, remembering some comments we heard or made ourselves (the man in the street, after all, is our everyday self), we become aware that some art objects in galleries and museums are considered by some people as not "really" art. At the Museum of Modern Art in New York, I overheard angry visitors saying "This is not art," when they were

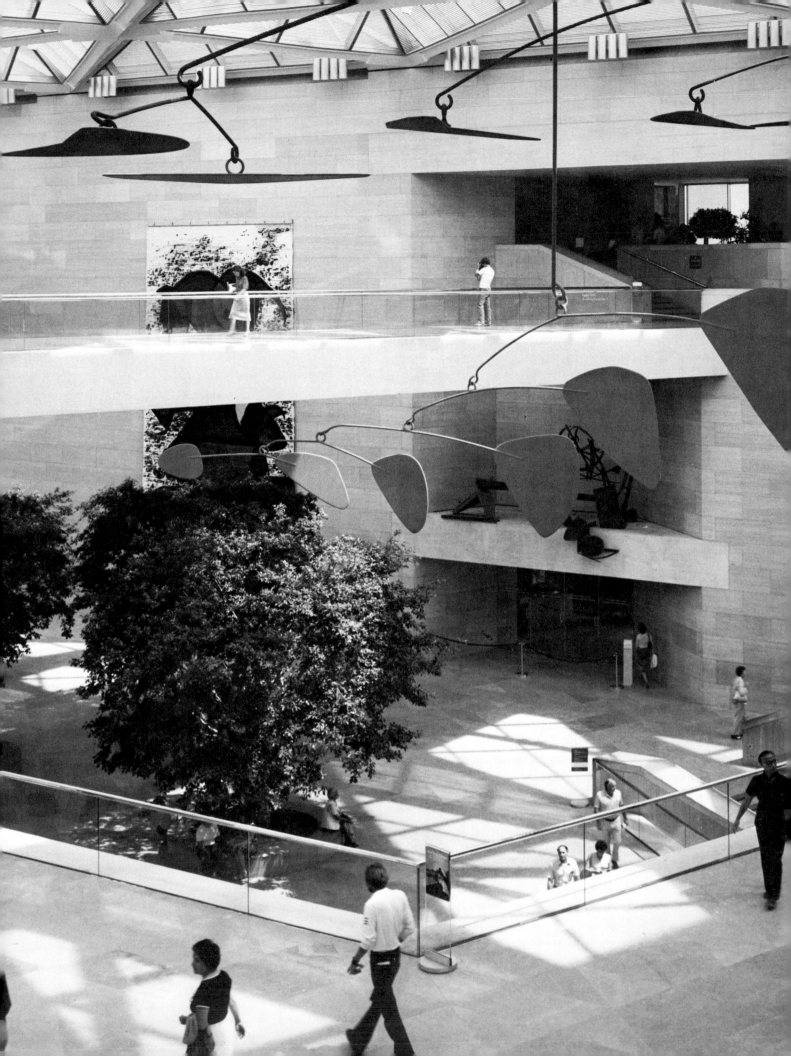

looking at a painting of the *Woman* series by Willem de Kooning or at an Andy Warhol *Campbell's Soup* picture.

In daily speech, art also connotes a positive value. "A bad painting is not art, and should not be hung on the walls of a museum" is a summary of many comments. A piece, to be really art, should have a certain "artistic" value. The everyday reality seems thus to offer two criteria for identifying art objects: location in a museum or gallery and something called artistic value.

The two criteria are complementary rather than contradictory. The "artistic value" is the reason an object should be exhibited in a museum or offered for sale in a gallery. Museum and gallery objects are presumed to have an artistic value, and when it is lacking we feel deceived in our expectations. When our response to an object is "This is not art," we express disappointment.

At this point in our study, the criterion of artistic value cannot replace the criterion of location as an indicator. We do not yet know how to recognize the artistic value of an object, whereas it is fairly easy to identify art objects by their belonging to the museum-gallery network. We shall thus continue to use it, but we note that in the common reality of our culture the still mysterious artistic value is a positive attribute that should characterize exhibited objects.

Let us now proceed to museums and galleries, and observe the behavior of the people around us, as well as our own. Behaviors indirectly reveal, too, what reality a society has built, and is still building—for reality construction is an ongoing process.

Museum visitors walk slowly from one painting to another, from a statue to a vase, from an eighteenth-century armchair to a showcase with a few pieces of china. They stop in front of the objects and look at them; they read the short notices on the labels and look back at the objects. In front of a painting, they move back and forth until they have found a spot at the right distance and angle from where they feel it best seen. Sometimes a docent gives an explanation, or a visitor makes a comment for the benefit of another; what is said refers to what they are looking at. It is appropriate to speak softly so as not to disturb other viewers. One should refrain from touching anything and from sitting on the exhibited chairs. One may sit on benches set up in relation to the things to be seen, and not in a manner favoring conversation as in a living room or a hotel lobby.

Such is the museum behavior generally expected. It is different from the behavioral patterns appropriate in a church, in an airport waiting hall, or at a cocktail party. Museum behavior clearly expresses that visitors are there for looking at the objects on display.

Similar patterns of conduct are in order wherever items recognized as art objects are presented: in galleries, in sculpture gardens, in the homes of art collectors, or in the halls or on the grounds of private corporations and public buildings. In the latter places, which have other functions than to house art objects, one pays attention to them only occasionally; when one does, it is by silently looking at them.

From these socially expected behaviors, we immediately may infer another facet of the social reality of art objects: to be beheld is their proper and only use. Paintings are hung on walls, sculptures are erected in gardens, murals are applied on plastered surfaces just to be looked at. This is an immediate inference: it does not have to be proved by reasoning. It carries its own evidence in everyday knowledge. What else could be done with a painting, a drawing, a mural, a statue, a photograph but to look at them? They were made for that purpose: they are visual objects by destination.

East Building interior courtyard. National Gallery
of Art, Washington, D.C.

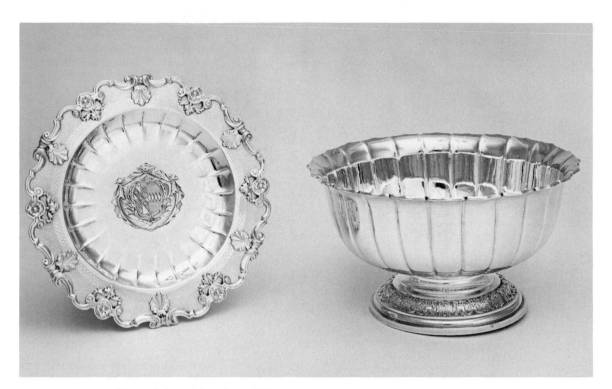

PAUL DE LAMERIE. Silver dish and bowl. c. 1725.
Los Angeles County Museum of Art.
The Mr. and Mrs. Arthur Gilbert Collection.

But what about the eighteenth-century armchairs, the silverware, the tables and desks that are exhibited in our fine arts museums? They were made to be used for sitting, eating, serving a cup of tea, or writing upon, and in fact they were used that way. And what about the industrially made objects on display at the Museum of Modern Art, such as a Thonet rocking chair, a Braun coffee grinder, an Olivetti typewriter? And what about the furniture on display at the Musée du Louvre during the 1972 temporary exhibition devoted to Knoll International? These objects were designed for specific uses and are still performing their intended functions in many kitchens and living rooms, offices and conference rooms. They were not destined to be visual objects.

Yet in museum settings they were metamorphosed into art objects to be looked at. As mentioned in my *Introduction*, the distinction between "art by destination" and "art by metamorphosis" is useful.[2] Originally made by André Malraux in his *Museum Without Walls*, it brings a welcome clarity to the reason for such a variety of objects in fine art museums.[3]

When visiting a museum, one can assign each art object to either one of the two categories. Belonging to the category of art by destination are landscapes and still lifes, narrative and genre pictures, nudes and mythological characters, abstractions and nonfigurations. Such two- or three-dimensional objects certainly were drawn or painted, carved or cast in order to be art objects. On the contrary, classified as art by metamorphosis are those objects, hand crafted or industrially produced, which originally belonged to

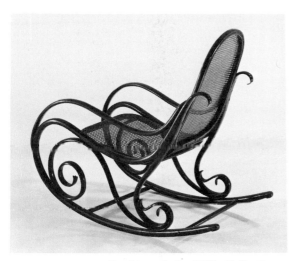

THONET BROTHERS. Rocking chair. 1860. Collection, The Museum of Modern Art, New York. Gift of Café Nicholson.

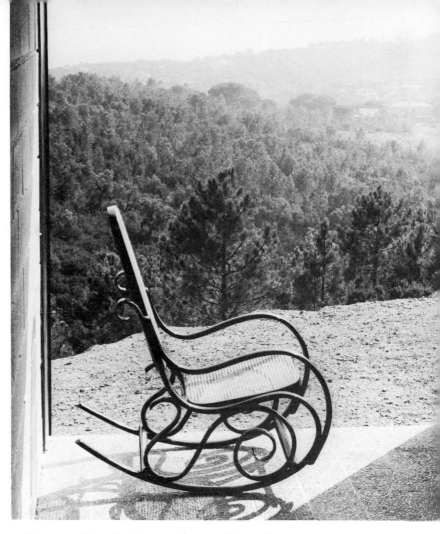

A Thonet rocking chair in a private residence. Les Issambres, Var, France. Photo by Jacques Maquet.

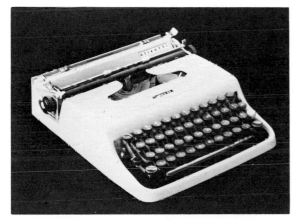

MARCELLO NIZZOLI. Olivetti typewriter. 1949. Collection, The Museum of Modern Art, New York. Gift of the Olivetti Corporation of America.

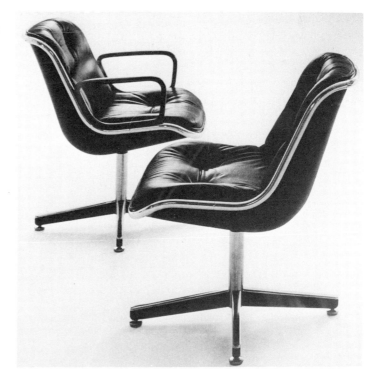

CHARLES POLLOCK. Knoll armchair and side chair. 1965. Photo by Herbert Matter (Knoll 1971).

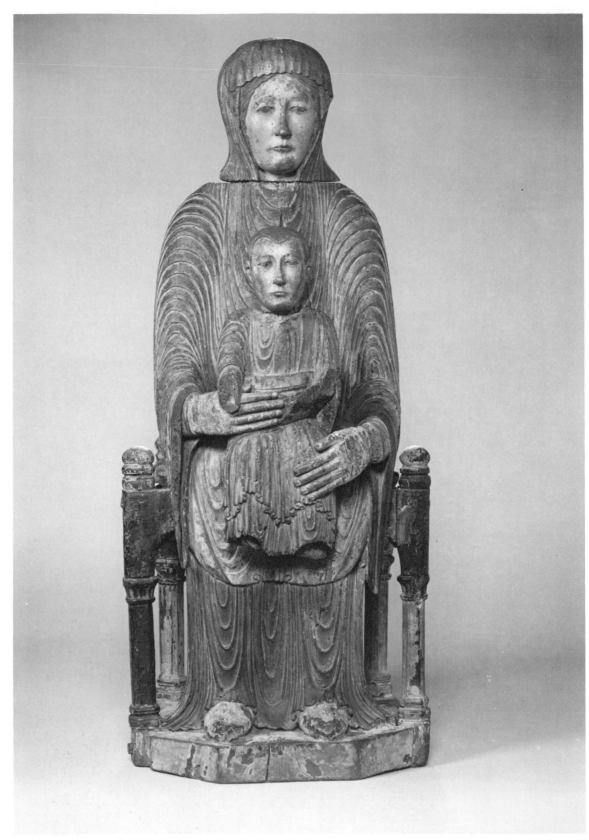

Virgin and Child. Auvergne, France. 12th century.
The Metropolitan Museum of Art, New York. Gift
of J. Pierpont Morgan, 1916 (16.32.194).

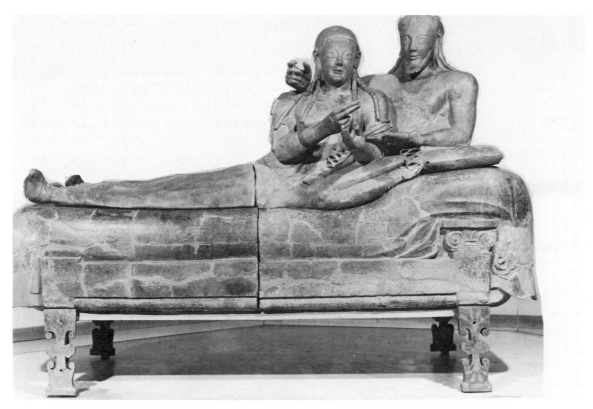

Reclining couple on sarcophagus. c. 520 B.C.
Museo Nazionale di Villa Giulia, Rome.
Photo by Brogi.

NANA KRAUS. *Portrait of Erwin Broner, Architect.*
1984. Artist's collection, Los Angeles. Photo by
Jacques Maquet.

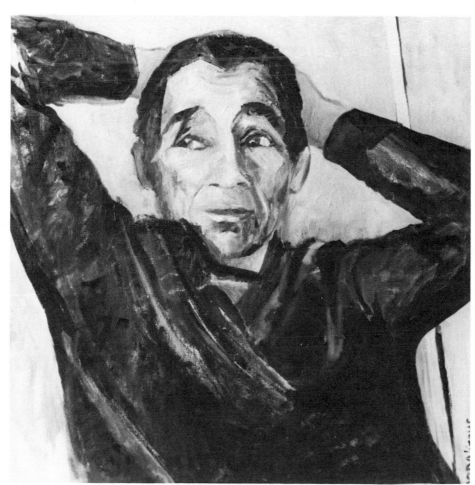

contexts other than art, but later on were included in the network of galleries and museums.

A "context other than art" is not restricted to the world of utilitarian objects, the only ones we have mentioned so far. It also includes objects made for use in religious ritual, government ceremonial, and family memorial. A statue of the Virgin and Child carved from wood during the twelfth century to be placed in a church in Auvergne became a work of art eight centuries later when displayed in a New York museum, The Cloisters.

An Etruscan terracotta representing a reclining couple is a stunning piece that may be seen at the Museo Nazionale di Villa Giulia, in Rome. This sculpture was made twenty-five centuries ago as the lid of a sarcophagus, in the context of cult homage to the family forebears. It became "art" when it was excavated.

Among the statues sheltered in our museums, some originally were erected on public squares to glorify national heroes, and among the paintings, there are many portraits which were intended to be memorials of personalities important to their country, their city, or just their family. Now, heroes and personalities have been forgotten. For the museum visitor, the portraits are identified as "a Greco," "a Frans Hals," and "a Picasso"—not as Brother Paravicino, Pieter van den Broecke, and Kahnweiler, who were the persons represented. In the museum context, the images of these individuals were metamorphosed into art.

"Primitive art" covers another large group of artifacts that were metamorphosed into art objects. In the societies where they were created, the masks of traditional Black Africa were worn by dancers in order to provide spirits with embodiments through which they could express emotions and feelings and communicate requests and demands. In European and American museums, masks were separated from dances and from the rest of the costumes. They were put in a showcase, and they became motionless carvings.[4]

In their traditional setting, the ancestral statues carved in the societies of the equatorial forest of Africa evoked the continuity of the kinship group and the solidarity of all the descendants of a common ancestor, the lineage founder. Offerings were brought to them in the family compound where they were kept.

In the kingdoms of West Africa, as well as in those of the savanna south of the equatorial forest, royal headdresses, ornated scepters, and ceremonial stools represented the glory and the power of kings and paramount chiefs, and they were revered as signs of authority. When separated from their cultures of origin and physically removed to very different societies, such objects can no longer operate as they used to do in their primary contexts. In the new environments, there are no spirits in search of a body who could dwell in these particular masks, no lineage reaffirming its unity, and no ruler requiring his subjects' homage in the forms which were prescribed in faraway kingdoms.

A metamorphosis is unavoidable: a new reality has to be constructed for these objects so that they make sense for the people living in the society into which they have been introduced. The metamorphosis is not always into an art object. It may be into a curiosity, something strange which reveals how "different from us" are those who made these objects, or into an artifact of material culture in the collection of an ethnographic museum, or even into a "fetish," an "idol," a false god—all demonstrating the superiority of our own gods.

The visitor to an art museum who pays attention to the distinction between the two categories of art object—by destination and by metamorphosis—will discover how numerous are the items that were not made for display only. In fact, few art objects by destination were ever made in pre-Renaissance Europe or in nonliterate societies.

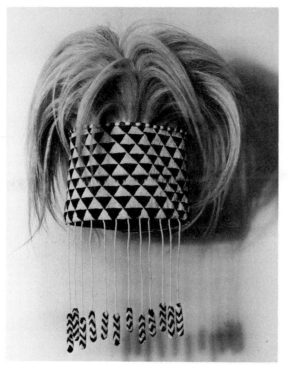

Royal headdress. Rwanda. Royal Museum of Central Africa, Section of Ethnography, Tervuren, Belgium.

Royal headdress worn by King Rudahigwa in a public ceremony. Nyanza, Rwanda. 1955. Photo by Jacques Maquet.

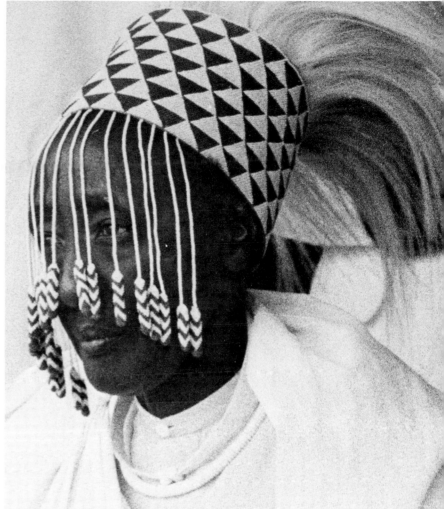

In our everyday reality, art is first approached as an action-oriented or practical category. Everyday knowledge is more concerned with where to find art and how to deal with it than with what it is. The everyday category of art first includes those man-made objects which are exhibited in museums and transacted about in galleries. The objects thus identified as art objects are at the center of a specialized network of educational institutions, professional associations, and commercial enterprises. This approach to the art phenomenon evokes the famous "definition" of a Jew as somebody regarded as a Jew by self and others. The statement is not a definition, it does not tell what Jewishness is but merely provides an indicator of identification. It is only a first step.

The everyday reality further provides us with a behavioral model for our encounters with art objects: we are expected to look at them. Their only use is visual, even when their acquisition was motivated solely by the buyer's search for social prestige. Observing art objects, we notice that some of them were made only to be looked at (there are no other possible uses that we can discover), whereas many had other functions outside the art context (such as utilitarian, religious, or political). This distinction is not explicitly stated

in the everyday culture; it is an observer's interpretation founded on general historical knowledge.

Finally, the everyday reality of art includes the notion of artistic value. Museum and gallery objects are expected to show evidence of an undefined quality (that we simply call artistic for lack of any more precision at this point). It is perceived as essential: objects wanting in it should not be displayed, in fact should not even be called "art."

The Aesthetic Vision

ART OBJECTS—SOCIALLY IDENTIFIED AS SUCH—ARE ON DISPLAY IN MUSEUMS AND HOMES, IN gardens and palaces only to be looked at. This is strange. We spend almost all our waking hours with open eyes, looking at things and people. The urban environment is almost entirely man-made, and we have to be visually aware of it all the time. Why should more objects be made only to be looked at?

The adverb *only* suggests that we may look at things not just for looking at them, but for ulterior reasons. When I look at a traffic light, it is not only to receive a visual impression of red, green, or yellow, but to conform my driving to the directions given by the lights. When walking on the street, I look around me in order not to get lost, not to bump into somebody, and to recognize a friend if, perchance, one comes by. In a library, I do not just look at a book, but I read the text in order to understand what the author wrote.

These are different ways to look at something: the quick and precise glance at the traffic light distinguished among all the lights of a downtown business street, the scanning and panoramic look when moving in a crowd, and the focusing of the reader's eyes on the words of the book. Is there another way of looking when in the presence of art objects?

There is a way of looking at art objects which is different from the ways just illustrated. This visual relationship between a viewer and an art object is a specific mental phenomenon.

Social scientists do not feel comfortable when they have to describe and analyze inner processes. They believe that they should not trust their own introspection, as it is subjective; that they should not accept informants' introspections if they do not have behavioral correlates; and that observations of mental states cannot be independently repeated by several observers. These methodological doubts and objections rest on a certain conception of objectivity that has evolved from the scientific study of physical phenomena. The criteria applied in that field cannot simply be transferred to the study of mental phenomena. A field of investigation should not be closed on the grounds that the research methods of another are not applicable. In each area of phenomena, such as

ROBERT GRAHAM. *Dance Column I*, detail. 1978. Franklin D. Murphy Sculpture Garden, University of California, Los Angeles. Photo by Jacques Maquet.

physical, biological, social, and mental, there are strategies which permit attainment of critical knowledge. Called "science" in the physical and biological areas, and "scholarship" in the humanities, critical knowledge is systematically built with a primary concern for cognitive validity.

Critical knowledge can be opposed to ordinary knowledge where such a concern is not of overriding importance. But critical knowledge is rooted in the commonsense methods of everyday knowledge. In ordinary life we have to take into account the mental states of others and thus try to understand them. We use, quite reasonably, different approaches.

The first approach is to refer the mental experience of somebody else to an analogous experience we have had. You tell me that you have a strange guilt feeling since your father passed away last month, though you know you have no responsibility in his death due to cancer, and in fact you loved him very much. I can understand what you feel. Twenty years ago, I heard on the news that the flight to London on which my brother was booked had ended in a crash. To my surprise, I was overwhelmed with guilt more than grief.

Because we can refer to an accumulation of experiences kept in memory, we can understand analogous feelings, emotions, and processes occurring in others' minds. In fact, even in scientific studies, we refer to our accumulated experience more than we like

SOREL ETROG. *Mother and Child.* 1964. Franklin D. Murphy Sculpture Garden, University of California, Los Angeles. Photo by Jacques Maquet.

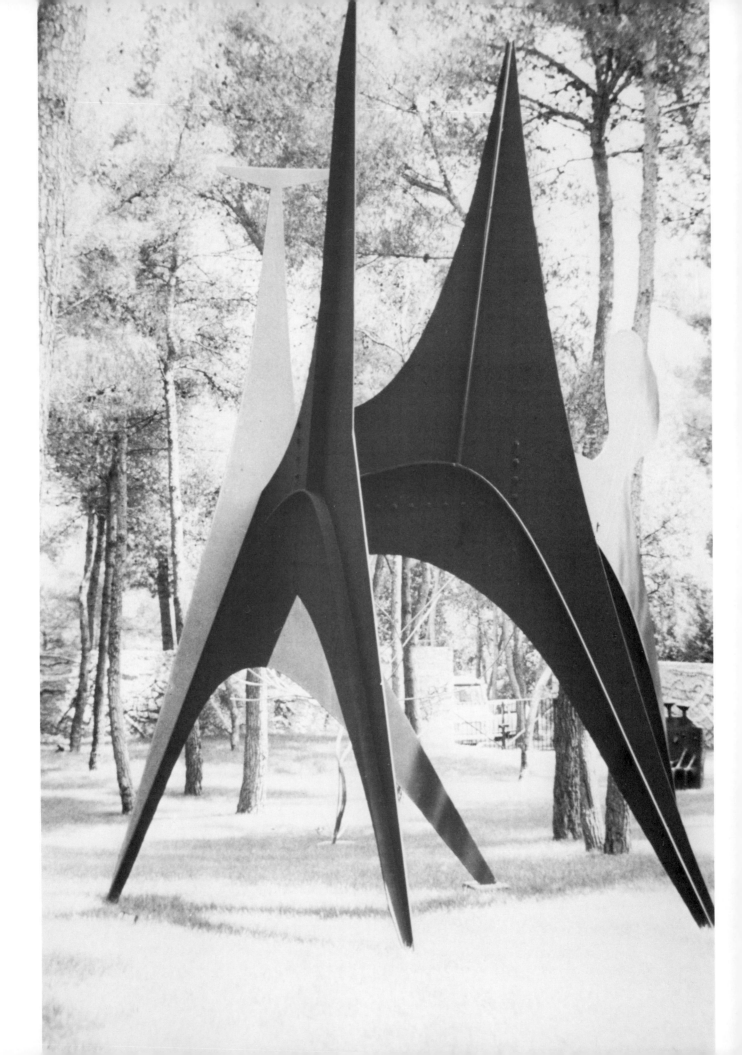

to admit. Commenting on a theory of perception, the philosopher Frits Staal notes that "our personal knowledge of perception is vast and is taken for granted. When we study reports on perception or theories of perception, we make constant use of this repository." He concludes that "without the vast experience of perception which we all have accumulated from early childhood," the scientific literature on perception could not have been written, nor would it be intelligible.[1]

Let us call this first approach to inner phenomena *experiential reference.* In order to understand what "looking at an art object" is, let us remember what we experienced when looking at a work of art, or let us go to a museum and look at one.

I very vividly remember my encounter with the large Calder stabile in the garden of the Museum of the Maeght Foundation in Saint-Paul-de-Vence a few years ago. Wandering through the outdoor museum with two friends, I first saw the stabile from a distance. It is erected among trees with a light-colored foliage—silver birches, I believe. There stood huge, nonfigurative forms in black steel plates, very much in contrast to the green and sunny environment. Their presence imposed on my attention. Moving closer, I stopped where I could best see the stabile and I looked at it for some time, not being aware if the time was short or long. Later, I did not remember if I was standing or sitting: I was just looking. The image of the stabile is very clear in my mind; I still see the general shape as well as some details of the metal surface. Though I was looking with intensity, I did not try to analyze the different shapes of the plates, nor to figure out the height or the weight of the stabile. In fact, I did not think at all while I was looking, nor did I pay any attention to my companions. I did enjoy the experience, but I became aware of the enjoyment only later, after the actual encounter was over. During the experience, I was not in an introspective mood, and I did not even notice my affective state: pleasure or absence of pleasure. In fact, "I," my usual self, was not in the foreground of my awareness; the visual experience of that sculpture was filling all my consciousness.

Later, when discussing with my companions what we had seen at the museum, I had little to say about the stabile. I told them that my visual experience had been intense, that for a time it somehow had put me outside of my usual stream of thoughts, worries, and feelings. When asked what Calder meant by the sculpture, all I could say, after some reflection, was that the stabile meant for me a powerful, but latent and contained, energy. It was a force that was not threatening, but friendly and even reassuring; it was ready to flow in harmony with the trees around, it was not going to explode and destroy.* I had no comments to offer on the place of that piece in the evolution of Calder's artistic career, nor on its possible importance in the trends of contemporary sculpture.

This is the kind of experience we can refer to when, as anthropologists, we want to analyze the particular way one looks at art objects. A comparative reflection, remaining very close to experience, reveals differences in our ways of looking at things. I look at a map of sixteenth-century London in order to discover how the city space was organized. I analyze the distribution of the different areas: the King's palace, the nobility's residences, the merchants' establishments, the markets, the port. I am thinking and reasoning all the time; I jot down some notes and make rapid sketches in order to better grasp the essential characteristics of that space. It is an analytical observation aimed at intellectual understanding, very different from the way I looked at the Calder stabile.

*Years later, when preparing this book, I discovered that the name of this stabile was *Les Renforts*, "the reinforcements" (Fondation Maeght 1967: plate 48).

ALEXANDER CALDER. *Les Renforts* (The Reinforcements). 1963. Fondation Maeght, Saint-Paul, Alpes Maritimes, France. Photo by Jacques Maquet. © ADAGP, Paris / VAGA, New York, 1985.

An old postcard with a view of the Taos pueblo is on my desk; recently I found it with other souvenirs in a closet. I look at it and I remember the lovely trip made years ago in the American Southwest, and the friend who was traveling with me; I wonder where she is now. My look at the postcard is a rapid glance that triggers an affective state of nostalgia, pleasant and sad at the same time. In fact, it is for enjoying the bittersweet taste of personal remembrances that I look at old pictures.

In front of me is the city map of Los Angeles. I look at it to find the place where I will have to be later today and the best way to get there. I am not concerned now with the organization of space in Los Angeles, nor with the street names that might conjure nostalgic memories. And I do not look at the grid of the map as if it were a kind of geometrical graphic. I look only for useful indications that will help me get to my appointment.

By referring to one's personal repository of art experiences, one may capture the specificity of looking at art objects, and by a phenomenological analysis, one may express in everyday language some characteristics of the visual relationship to art. The object is seen as a whole, in its totality; its different parts may be perceived as distinct, but are not analyzed separately. The looking is "only looking"; there is no further aim. One does not look at the stabile to find out what welding techniques were used, or as a starting point for daydreaming. It is a visual presentation with nothing behind or beyond it. The art object appears to "dominate" the viewer, in the sense that the latter's importance is not as strongly felt as in ordinary life: it is the object that matters. In other terms, the distinction subject-object becomes less sharp. The awareness of the object has priority over the self-awareness of the subject. As in our preceding analyses, the explicit elucidation of these characteristics—object perceived as a whole, vision not a means to another goal, predominance of the object—is based on direct inferences and remains very close to the beholder's experience.

Experiential reference, the first approach to the inner response to an art object, may be supported by a second approach: the common language and what it implies. Do we find the reality constructed by and revealed through the ordinary language to be congruent with the personal experiences just described?

In the English language which we use everyday, and which everybody understands, there are several simple words that denote, in a rudimentary but clear manner, purely visual responses to things or persons: *beautiful, nice, pretty, handsome,* and their antonyms *ugly, unattractive, inelegant, ungainly.* Certainly these words have other connotations than 'good to look at' (or the opposite), but they have only a visual meaning in many cases. Within the context of a sentence (and when we speak or write, words are always understood to be in sentences), there is no ambiguity: "This tree is beautiful" refers to the tree's visual aspect whereas "Peter is a beautiful person" refers to his moral qualities.

That the meaning 'good to look at' is familiar even to children is illustrated by a study made in 1970 by the psychologist Grace F. Brody. She wanted to assess the preferences among abstract visual forms of over five hundred children ages three to seven. The figures used were the circle, the rectangle, the diamond, and the horizontally and vertically bisected square. The children were shown a perfectly regular rendering and a slightly distorted one of the same figure, and were asked to point to the drawing that looked "nicest."[2]

A significant majority of the children found the regular renderings "nicer" than the distorted ones. These results are not directly relevant to the question we discuss here: what matters is that the children understood the question and that one austere nonrepresentational geometrical form could appear "nicer" to them than another one. They could consider the visual quality as such, and look at the figures in the way characteristic of a pure vision (the experiment had been designed in such a way as to make it impossible to look at the figures as images or as conventional signs). These children had already internalized what is meant by "nice." Certainly they had already often heard comments such as "This coat is very nice, but is not warm" which indicate that the visual aspect of something can be separated from the others and can have a different value. The visual aspect may be positive, and the others, negative.

It may seem strange that these ordinary words repeated by each of us so often every day are associated with the much less frequent visual experience of a work of art. Certainly an engrossing experience of art and the fleeting look at so many things we term "nice" and "pretty" are different experiences, yet they are on a continuum. The word *beautiful* summarizes a positive visual response to an art object: it is indicative of a state of mind rather than descriptive of the object.

When I say "Calder's stabile is beautiful," I mean that when I looked at it, my visual experience was fine. This trite and commonplace statement is, in fact, most appropriate. The experience of "only looking" is not analytical; in retrospect, a description and an analysis of the experience may be attempted if needed for some specific purpose such as giving a lecture about it. But in the normal course of life, it is sufficient simply to take note of the experience, and the hackneyed sentence "This Calder is beautiful" does just that: it indicates that this stabile triggered an appreciative response in the beholder. When applied to a dress, a hairstyle, or a pair of shoes, *nice, pretty,* and *beautiful* are also indicators of a viewer's positive response. But the depth of the experience, though expressed by the same word, is commensurate with the object (a monumental Henry Moore reclining figure, or a necktie) and the circumstances (a coffee grinder in the skillfully lit glass case of a quiet museum gallery, or on the cluttered shelf of a noisy and crowded hardware store).

Some very ordinary words of our everyday language point out the variable quality of visual experiences. This assessment is part of our common reality that "everybody knows." This second approach to mental states through what the common language implies confirms our personal inner experience that we referred to in the first approach.

A third approach is to take cognizance of what the experts say. I understand my friend's guilt regarding his father's death by remembering an analogous experience of mine when I thought that my brother had perished in an airliner accident. But I cannot explain why my friend and I felt guilty about misfortunes for which we were not at all responsible. Reading some psychoanalytic literature, I learn that unconscious hostility and repressed hatred are frequent in a son toward his father, and among rival siblings; that often hostility generates an unconscious wish that father or sibling were dead; and that when father or sibling happens to die, one feels responsibility and remorse for the event. This opinion of the experts provides me with an explanation for mental processes my friend and I experienced.

What are the views of the experts on the visual relationship between beholder and

art object? By experts I mean those who specialize in art history or art criticism, in philosophy or psychology of art, and the connoisseurs and curators who have reflected upon their visual familiarity with art.

Specialists use the term *aesthetic* for denoting the specific quality of the perception and experience of art objects as such. The eighteenth-century German philosopher Alexander Baumgarten is credited with being the first to select the Greek term *aisthetikos*, which originally meant 'pertaining to sense perception', and give it its modern meaning. During the nineteenth and twentieth centuries, the term was widely adopted by specialists and even by ordinary users of the language. The invention, and the widespread adoption, of a new word to designate the response to art indicates that in our reality, there is a specific way to look at works of art.

There is also a consensus of experts on some of the essential characteristics of the aesthetic experience. As a lineage of British thinkers—from Archibald Alison to Clive Bell, Roger Fry, Herbert Read, Edward Bullough, and Harold Osborne—have situated the aesthetic experience at the center of their studies, they have developed a detailed and complex knowledge of it. In *The Art of Appreciation*, Osborne discusses the features that have been regarded as characteristic of the aesthetic attitude.[3] He describes eight such features; his ten-page account is so illuminating that I will summarize it here.

A first feature of the aesthetic perception is that it separates, "frames apart," the object from its visual environment in order to favor the concentration of attention. Second, the context of the object—historical, sociological, and stylistic—so important for the historian, is irrelevant for the aesthetic beholder. "The intellectual interest in knowing all that can be known *about* a work of art may be ancillary to, but is not identical with, the aesthetic interest. The two interests are related but distinct."[4] Third, a complex object is perceived as complex, but it is not analyzed into an assemblage of "parts standing in such and such relations to each other."[5]

Fourth, aesthetic experience is "here and now." Our practical concerns that make the future and the past implicit in all our everyday life are put into abeyance; consequently "the characteristic emotional color" of the aesthetic experience is made of serenity and detachment.[6] Fifth, "those meditative musings and plays of the imagination in which poetic sensibility delights to indulge are also foreign to an aesthetic engrossment," because they interfere with concentration on the visual object.[7]

Sixth, aesthetic perception is concerned with the object as seen, thus with its appearance, not with its existence. Kant associated indifference to the existence of the object with the disinterested approach to it he deemed necessary for the aesthetic perception. What matters is the object as visible, not its existence which makes ownership of it possible. Seventh, when aesthetic absorption is achieved, there is a loss of the sense of time, place, and bodily consciousness. The beholder becomes identified with the object, though a residual awareness of self as distinct is retained. Eighth, aesthetic attention may be directed to anything, but it cannot be maintained beyond what the object can sustain.

This description of what several specialists consider characteristic of aesthetic perceptions certainly confirms that our mental responses to works of art are not idiosyncratic or exceptional.

Our inner experiences concur with the experts' analyses on the specificity of our visual relationship to art objects. Beholding art requires attention. One is, and needs to

be, fully aware of the object; one's concentrated attention may reach the level of absorption when one becomes so engrossed in the object as to be only dimly aware of self. Beholding art requires silencing discursive activities; it is not compatible with an analytical attitude. The object is seen as a totality, and if there is an attempt at analysis, the specific perception recedes in a mental background or disappears. Beholding art requires disinterestedness. A desire to own the object in order to enjoy its exclusive possession, or a vicarious sensual satisfaction generated by the view of the object, is experienced as, and recognized as, an obstacle to the vision of works of art.

These three specific traits of the "only looking" attitude—attention, nondiscursiveness, and disinterestedness—are not explicit in the common language. Yet they are congruent with the ordinary words conveying the meaning of 'good to look at ', such as *nice* and *beautiful*. And, as they exclude the consideration of practical concerns ("This coat is beautiful, but expensive and made of delicate fabric"), these words suggest an absence of material interests, which is a part of being disinterested.

From the particular way we look at art objects, a new concept, *aesthetic object*, is suggested. It is defined as an object stimulating and sustaining in the beholder an attentive, nondiscursive, and disinterested vision. With the introduction of this new concept, we can clarify some questions left unanswered at the end of the preceding chapter.

From observing an urban society in its everyday life, we discovered that the reality referred to by the term *art* included a category of commodities that are found in a specialized segment of the market and that have a specific use. Further, we observed that the same term *art* also expressed a positive quality ("Really, this painting is art"), and that the denotations of the two meanings were not coextensive: all the art objects were not art, and all the objects with an "art quality" were not art objects. Now we can say that the mysterious "art quality" is the aesthetic quality.

The two concepts can be clearly defined and distinguished. *Art objects* are man-made items designed (art by destination) or selected (art by metamorphosis) for display. *Aesthetic objects*, man-made or natural, stimulate a total disinterested vision.

The two classes of objects are related. In an ideal world—where what is intended is realized—art objects would be a subclass of the class of aesthetic objects. In fact, they are two classes which partly overlap.

The distinction between *art* and *aesthetic*, as presented here, does not belong to the reality of the everyday language. Yet it makes explicit what everybody says about a painting that is "not art."

IVAN ALBRIGHT. *Into the World Came a Soul Called
Ida*. 1929–30. Courtesy of The Art Institute of
Chicago.

CHAPTER FOUR

The Significance of Form

WE HAVE SAID THAT AESTHETIC OBJECTS STIMULATE AND SUSTAIN THE BEHOLDER'S UN-divided, whole, and disinterested visual attention. But we have to go further in our analysis and delve more precisely into what aspect, or aspects, of the object is, or are, aesthetically significant.

It is not the question of the aesthetic evaluation of an object that we want to raise here, nor the question of artistic preferences. We want to find out in what area, as it were, the aesthetic relevance is located. Is it in the representational dimension of the aesthetic object, as in an image depicting beautiful persons, lovely flowers, and dramatic sunsets? Or is it in the craftsmanship dimension, as in a work effectively executed? Or is it in the basic material from which the object has been molded or carved?

In these last decades of the twentieth century, few would pause over these questions. However, less than a century ago, the answers would have been different for the majority of the public. These old attitudes still bear influence today, at a subliminal level. Let us briefly review them here.

If anthropologists are asked whether the society they study produces visual art, chances are that they will add to their answers a reference to images: "yes, they do carve or engrave, paint or draw humans and animals"; or, "no, they do not make pictures." We still tend to equate visual art with representations. There are good reasons for this continuing association.

Since the Renaissance, three of the four visual fine arts—painting, drawing, sculpture, and architecture—have been representational and have remained so until the first nonfigurative paintings, such as those composed by Kandinsky around 1910. During these centuries of figurative art, nonrepresentation was confined to decorative patterns and other ornamentations considered as minor and auxiliary works. Even if the absolute dominance of nonfigurative painting during the 1950s and 1960s is over, the painting of those decades established that representation by itself has no aesthetic relevance.

When paintings, drawings, and sculptures represent recognizable entities of our

GUSTAVE COURBET. *La Rencontre* (The Encounter).
1854. Musée Fabre, Montpellier. Photo by Claude
O'Sughrue.

experience or imagination, do the persons and things depicted matter? In our museums
are represented many attractive young women and handsome young men, elegantly
attired or in the nude; middle-aged men are kings and courtiers, warriors and aristocrats,
displayed with the noble bearing befitting their elevated status; older men are vigorous
and wise, at the peak of a life of intellectual or spiritual achievements. Landscapes are
sunny and inviting, mountains and lakes appear in their pristine freshness, and storms at
sea are more grandiose than frightening. In these images, persons and things are
endowed with more attractive qualities than are people and environments in our daily
lives. Is this "improvement" aesthetically necessary?

A noble and beautiful subject matter was indeed considered essential to art during
the centuries such paintings were made, mostly from the Renaissance to the nineteenth
century. In 1855, when Gustave Courbet proclaimed that artists should set their easels
where peasants live and work rather than in studios, he was regarded as a revolutionary
and called "leader of the School of the Ugly."

Yet even before Courbet's time there were works of art that did not represent
beautiful people and pleasant landscapes. Velázquez's dwarfs and mental defectives and
Goya's beggars and war victims were, and are, regarded as masterpieces. Again,
twentieth-century art makes it clear: subjects as deteriorated as Ivan Albright's middle-
aged and middle-class men and women, as depressed as Edward Hopper's characters,
and as uninviting as Yves Tanguy's landscapes hang on the walls of our museums.
Museum collections implicitly tell us what art theorists and critics explicitly say and

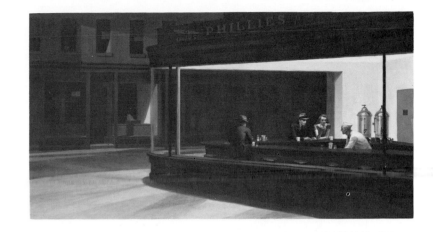

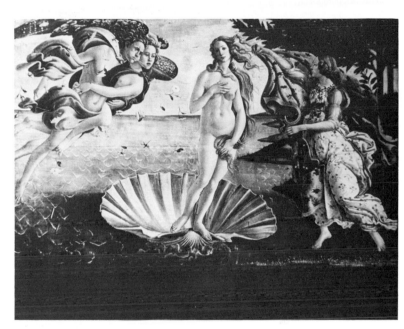

EDWARD HOPPER. *Nighthawks*. 1942. Courtesy of The Art Institute of Chicago.

SANDRO BOTTICELLI. *Birth of Venus* c 1482. Uffizi Gallery, Florence.

repeat: that the aesthetic quality of a work of art does not depend upon the attractiveness of what is represented. If Botticelli's *Birth of Venus* is a masterpiece, it is not because there is in the center a lovely young woman.

The painter as a virtuoso imitator of nature has always been fascinating. From the famous story of Zeuxis's grapes, so lifelike that birds were trying to peck them, to the illusionistic perspectives on Baroque ceilings to the contemporary more-than-photo-like images of the hyperrealists, perfect verisimilitude has always been admired as a feat of extraordinary skill. The earliest experience of art appreciation that I remember occurred during a sightseeing tour of Ghent with my mother. We were shown the *Adoration of the Lamb* retable by Hubert and Jan van Eyck. It is a masterpiece, we were informed by the guide, because each blade of grass had been separately painted in order to give the impression that it is a real meadow. Today, we still overhear "Look at the cat, it is so well painted that I could stroke it!" But our contemporaries agree that an illusionistic rendering, though certainly difficult, is not relevant to the aesthetic value of the piece.

Neither is superior craftsmanship, which is attested by a perfect execution of the

Ceremonial mask *(kanaga)*. Dogon, Mali. Museum of Cultural History, University of California, Los Angeles.

object: straight lines are really straight, curves are regular, colors are uniformly applied, surfaces are polished and shiny, and right angles have exactly ninety degrees. From the impressive Dogon carvings, recognized as masterpieces by the Western public and critics, to George Segal's plaster figures and to Rauschenberg's mixed-media assemblages, many of our museum pieces do not reveal superior craftsmanship or a concern for it.

The material from which the object is made is likewise irrelevant to the aesthetic value of a piece. Certainly there are noble materials—such as gold, ivory, precious stones, and rare timber—which, in the past, were regarded as the only appropriate ones for certain objects used in Christian ritual or at the king's court. We have since metamorphosed them into art, but certainly not because they were made in rare and expensive materials.

We do not say that the areas we have reviewed—representation, subject matter, mastery in resemblance and perspective, skillful execution, and material—are not noticed in the aesthetic perception. We only say that these are not the crucial areas that stimulate and support the aesthetic experience. It is not because it represents Aphrodite and is carved by a skillful sculptor from a block of rare marble that a statue will trigger and sustain the beholder's aesthetic interest.

After this process of elimination, the same question remains: what area of the object does carry aesthetic significance?

Vajrasattva in union with his Śakti. Rough brass figurine. Tibet. 20th century. Private collection, Los Angeles. Photo by Jacques Maquet.

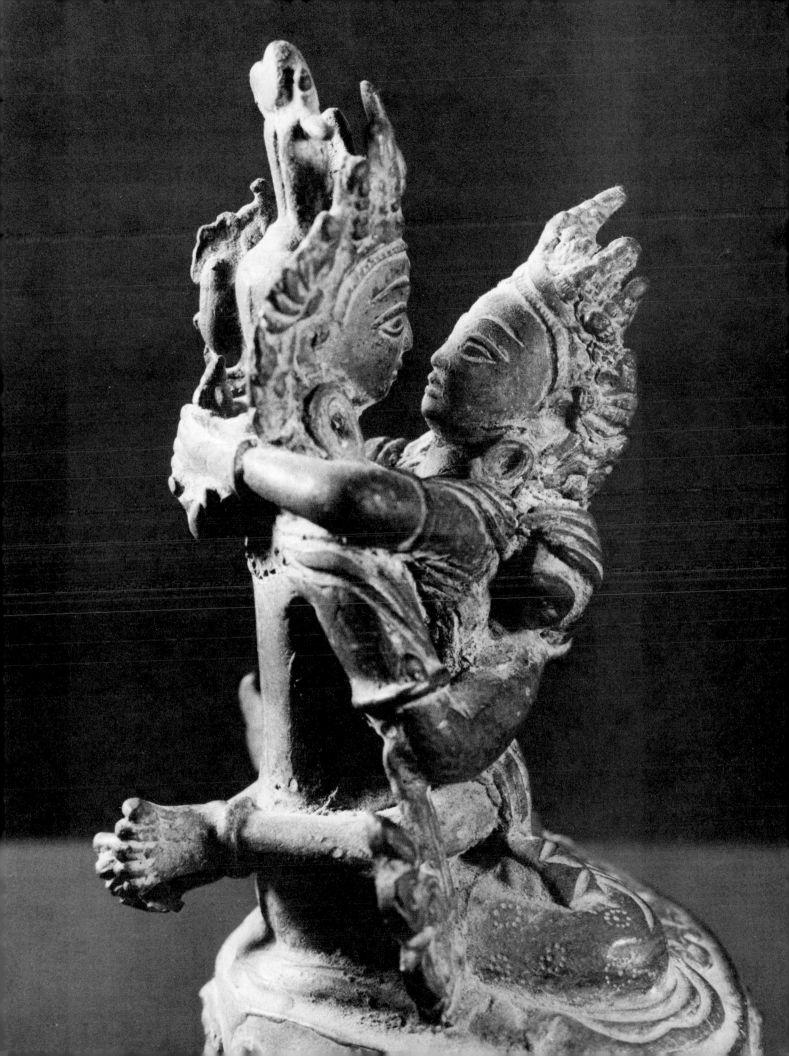

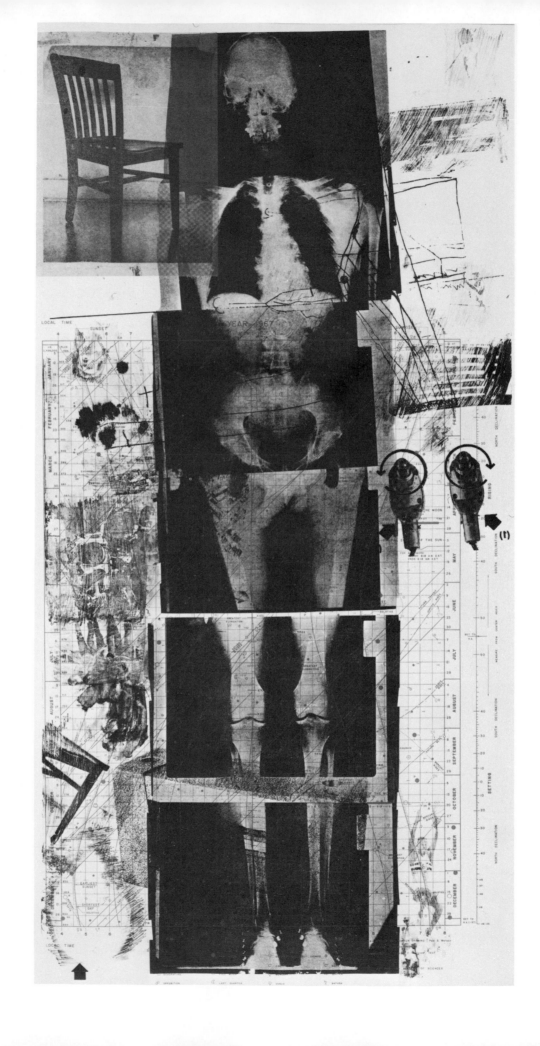

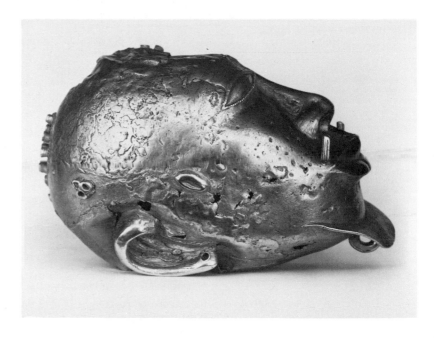

Gold mask. Asante, Ghana. Wallace Collection,
London.

The answer is, in fact, implied in what we said about the way we look at something in an aesthetic mode. When we just look at the object as a whole, without analyzing it, and without associating with it memories and projects, thoughts and feelings, gossip and erudition, we, as beholders, pay attention to the visual appearance of the object: what is visible and only what is visible. As the painter Maurice Denis expressed it in an often-quoted sentence written in a manifesto published in 1890: "A picture, before being a war horse, a nude woman, or some anecdote, is essentially a flat surface covered by colors arranged in a certain order."[1] It is that flat surface covered by colors arranged in a certain order which is the area of aesthetic significance.

What is first visible is the outline, the border line that separates the object from the surrounding space. For a painting, a drawing, a photograph, the frame marks the outline and is usually a rectangle or a square. For a three-dimensional object, the outline is the visual contour of the sculpture which makes it distinct from the environment: air, space, background, and foreground.

Then, within the border line of a painting, there are the "colors arranged in a certain order": the areas established by different colors, the shapes formed by closed lines or by contrasts of light and dark. In sculpture, there are the three-dimensional volumes revealed by reflected light, and the areas delimited by differences in texture, smooth and rough, which absorb and reflect light in varied manners. Without touching, we "see" that the feel of the surfaces is different.

All these visual elements—outline and lines, shapes and colors, light and texture—constitute the *form* of the object. It is this area of the form that is aesthetically significant; it is in this aspect of the object that we have to look for what stimulates and sustains the holistic and disinterested attention of a beholder.

To realize that the aesthetic significance of an object is on the side of its form is an important step, but not the last one. Every man-made thing (as well as every natural thing, of course) has a visual form, but not necessarily one that can support an aesthetic vision. Some configurations of visual elements appear to be better than others in stimulat-

ROBERT RAUSCHENBERG. *Booster*. 1967. Los Angeles
County Museum of Art. Gift of The Times Mirror
Company.

ing a perception in the aesthetic mode. This raises the question of what makes the form of some objects aesthetic. This question shall be addressed later; at this point we should further discuss the implications of the conclusion just reached: the aesthetic relevance of visible things lies in the area of their form.

Since Kant, *content* is usually opposed to form in the sense that what is said is opposed to the way it is said. If we transpose content to the visual field, it can denote what is represented, but this denotation (or this meaning) is not applicable to nonfigurative artworks, neither to metamorphosed utilitarian objects, nor to the other nonformal elements we have just reviewed—verisimilitude, superior execution, and the matter from which the object is made. To keep clear of these difficulties, I have suggested *substance* as the term to be opposed to form in the visual field.[2] Without forcing its meaning, substance has a broad denotation that can accommodate all the nonformal elements, from what it represents (if applicable) to the stuff of which it is made.

The boundary visually separating the formal area—the flat surface of the painting or drawing, the combined volumes of the sculpture—from its surroundings is of particular importance. It is often emphasized by a frame which clearly bestows another quality to the surface or the space that it encloses. Even perception is influenced by the frame.

In the late afternoon of a summer day, a friend is sitting in a garden, under a tree; she is reading. Her dress is light blue; she wears a wide-brimmed straw hat. She is partly under the shade of the tree and partly in the sunshine. However, I see the dress as uniformly blue, and her lovely tan as even, on her forehead under the brim of the hat and on her chin which is in the sun. I take a photograph of her. In the print, I see that the dress is greenish in the shade, and flat white in the sunlight, without gradations and modeling. The upper part of her face is in a bluish shadow which strongly contrasts with the highlighted lower part.

I saw the local color of the dress, light blue, as uniform in sunlight and shade because I knew it was its "true" color, and I did not make the perceptual effort to pay attention to the differently lit areas of the dress. This is a usual and well-known phenomenon. The camera recorded the optical colors, the colors as they appear in specific light conditions, as it was designed to do. But why did I not also "see" the local colors on the photographic print? When I looked at the photograph I knew as well as I did in the garden that the whole dress was blue. What made the difference is the frame: it separates the picture from its environment and makes me see it as a surface covered with different colors. Looking at the picture as an area of forms, I perceive the colors "as they are," as optical colors. This change of perspective occurs without any decision, effort, or even consciousness on my part; it is imposed on me, as it were, by the frame. I still perceive the configuration of colors and shapes as representing my friend, but I have become aware of the colors as forms.

An analogous experience may be made with music. Suppose you listen to a concert performed outdoors, on a summer night. There are the sounds of the musical instruments; and also, there are low-level noises: muffled coughing, the drone of traffic on a distant freeway, the rising and falling hum of a car passing on a nearby road and of an aircraft flying over the area, the barking of a dog. You are dimly aware of these noises, and actually they do not bother you much as they are outside the auditive frame of the musical performance. If you pay attention to the music, they are framed out.

If, immediately after the concert, you listen to a tape recording made during the performance, those same noises become a part of what you listen to, and you cannot avoid hearing them. They are now included within the auditive frame of the tape. The only noises you can frame out during the playback are the low-level interferences coming from other sources than the tape deck. You perceive the sounds on the tape "as they are" on it, and "as they were" during the performance.

The unexpected effect of the frame on our sensory perceptions, as revealed in the cases of the photographic print and the tape recording, stresses the significance of the aesthetic object as offering a visual or auditive area separated from the everyday continuum of sensory stimulants for the eye and the ear. But are we attuned to the perception of forms as forms, that is, do we see shapes, colors, and lights as shapes, colors, and light? Do we in fact see the visible?

We do. But if we want to be fully alert to the aesthetic forms whenever they are present in our field of vision, we have to prepare ourselves, to train ourselves. There is nothing unusual in this. All our potentialities—to memorize, to reason, to apply our attention to action—are actualized by precept and practice. Instruction and exercise began early in our life and were an important part of the long process of education, even though we may have been unaware of this.

But we were not trained to look systematically at what we saw. On the contrary, we were conditioned to give priority to other uses of vision, particularly to develop the rapid and precise glance which *recognized* a danger to be avoided or an opportunity to be grasped. From the dark clouds perceived as omen of a coming storm, to the smile on a stranger's face which promised a friendly disposition, to the blinking light indicating that a car was about to change lanes, we were trained to promptly identify visual cues for an immediate response.

Sometimes the conditioning is so strong that it operates when we visit a museum. Because we have so often seen postcards and other reproductions of *Mona Lisa*, a quick look is sufficient for us to recognize the original painting at the Louvre Museum, and we move on to the next room. How often are we unable to tell the color of the suit or the dress of a person we have spent the whole day with at work?

Stress on conceptual knowledge, another feature of our education, leads us to give more weight to what we know than to what we see. We know that the carpet was made in a uniform beige, and we "see" it uniformly beige near the windows, under the table, and in the corner of the room where an electric lamp is lit. If we put what we know between brackets, we see that the carpet is not uniform in color: it is lighter near the window, darker under the table, and yellowish near the lamp.

The very language we speak operates as a screen: we "see" the world through it. The Bureau of Standards has a system of designating colors that permits us to name 267 colors; and some art schools use a system starting with six primary colors (blue, green, red, yellow, magenta, and cyan) that can be combined by addition and subtraction to divide the circular spectrum into twelve, twenty-four, or more separated segments.[3] In ordinary language, we use perhaps a dozen names for distinguishing colors; the parts of the spectrum that are not separately designated by names are not "seen"; more exactly, they are lumped with the adjacent parts that have a name.

Training ourselves to see consists in a deconditioning. Forms are not simply convenient pointers indicating threats and opportunities. And forms are not to be hidden, as it

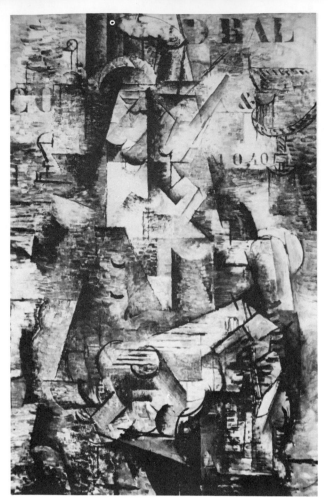

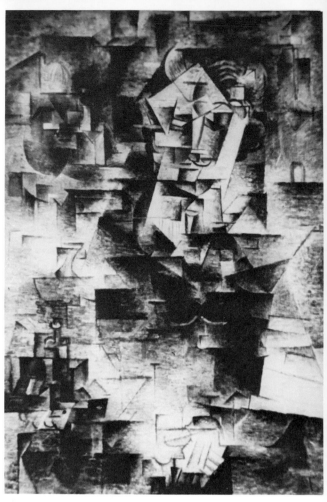

GEORGES BRAQUE. *Le Portugais* (The Portuguese). 1911. Oeffentliche Kunstsammlung, Kunstmuseum, Basel. © ADAGP, Paris / VAGA, New York, 1985.

PABLO PICASSO. *Portrait of Daniel-Henry Kahnweiler*. 1910. Courtesy of The Art Institute of Chicago.

were, behind a screen of useful conceptual simplifications. Our preparation consists in setting aside and temporarily removing the functions of indication and conceptual simplification which obscure the visual encounter with the forms. We need to turn our attention away from distracting concerns.

Elimination of competing concerns accounts for the recognized importance of nondiscursiveness and disinterestedness in the aesthetic experience.

Visiting the Kunstmuseum in Basel, I look at Braque's Cubist painting *The Portuguese*. I remember having seen a similar one, *Kahnweiler* by Picasso. I wonder who has influenced the other; the date of *The Portuguese* is on the museum label, 1911. I do not remember the date of the Picasso portrait, but it must be about the same time, certainly after *Les demoiselles d'Avignon*, which is not as analytically cubist as *Kahnweiler*, and the year of *Les demoiselles* is 1907, for sure. I have to check the date of *Kahnweiler*. In the museum bookstore, they certainly have books on Picasso, and I can quickly check the date when leaving the museum. But, after all, does it matter which painting came first? Around 1910, Picasso and Braque were close friends, and together they were experimenting with Cubist techniques . . .

These speculations, relevant to art history, had completely removed my attention

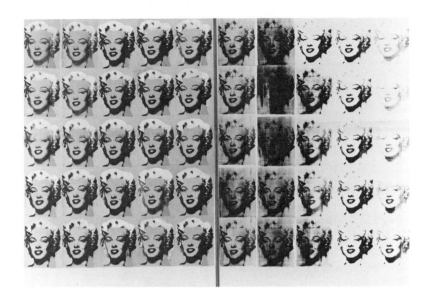

ANDY WARHOL. *Marilyn Diptych*. 1962. The Tate Gallery, London.

from *The Portuguese*. Though I continued to look at it while thinking, this stream of thought has obstructed the development of an aesthetic vision. My mind was not open to it; my attention was occupied with information about the painting and could not be focused on the painting itself.

The famous *Marilyn Diptych* silkscreen painting by Andy Warhol, made of an enlarged photograph of Marilyn Monroe's head repeated twenty-five times on the canvas, was exhibited in a New York gallery in the early sixties. I saw it there a few months after her suicide. I remembered her last film, *The Misfits*, and how convincingly she played her part. Did she see herself as a misfit in life despite her successful career and her immense popularity? May this have had more to do with her suicide than the solitude mentioned in magazine articles? . . . And so went my thoughts; they were about the person represented. I barely looked at "the flat surface covered by colors arranged in a certain order." It may well be that the forms on the canvas were not that arresting; in any case, my stream of thoughts distracted me from them.

To take an art object as a stimulant for imagination has been "one of the most popular trends of art criticism from the earliest times until the present day," wrote Osborne.[4] Yet imagining what are the emotions and thoughts of the persons depicted, or commenting upon the moral message of the artist one "reads" in the work, or letting the stream of associations run, stands in the way of looking at the forms as forms.

In this section discursive thinking has been understood in its broadest sense. It includes not only the logical reasoning proceeding from premises to conclusions, but any activity of the mind moving, even by association, from one idea to the other. This is true to the word's etymology: the Latin *discursus* comes from *currere* 'to run', and *dis-* 'in different directions'. This evokes the image of a very active mind going back and forth from one mental content to another and, by doing so, establishing relationships between ideas.

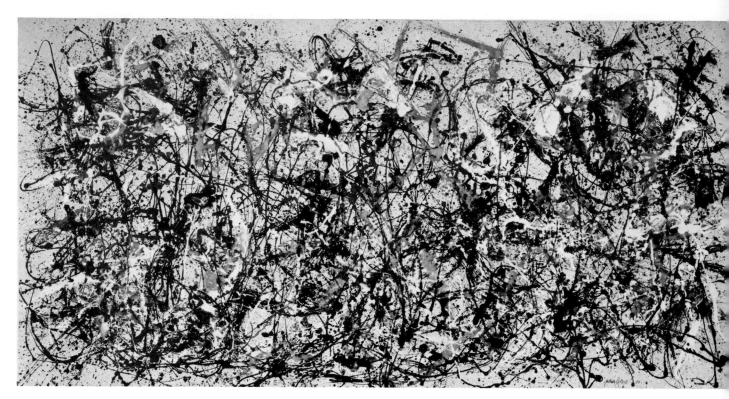

JACKSON POLLOCK. *Autumn Rhythm.* 1950. The
Metropolitan Museum of Art, New York.
George A. Hearn Fund.

To be disinterested seems to have a moral connotation unexpected in the field of art appreciation. In fact, it is a prerequisite here not as a moral virtue, but as a condition of total attention to the object as a configuration of forms.

Our common language, embodied in general dictionaries, distinguishes *uninterested* from *disinterested*. To be uninterested in something is to have no interest in it, to be indifferent to it. I am not interested in sailboats; I am indifferent to them; I am uninterested in buying one, possessing one, and sailing on one. Uninterested conveys the meaning of a lack of interest in something. Disinterested concerns the self: it is to be free of self-interest and ego-involvement. To be self-interested is to be centered on the pursuit of personal advantages: pleasure and affluence, power and status, prestige and recognition. To be ego-involved is to be absorbed in oneself and one's own advancement.

Looking at Jackson Pollock's *Autumn Rhythm*, an action painting which captures the vitality of the New York School of abstract expressionism in the years immediately following World War II, I am reminded of New York at that time and how exhilarating my discovery of it was. Pollock was a part of that discovery. The painting I am looking at is the pretext for, and the trigger of, a flow of personal reminiscences: what I was doing and thinking and expecting during that period, the projects I realized, and those I gave up. Self-interest dominates my consciousness; I still look at the painting, but I do not pay any attention to it.

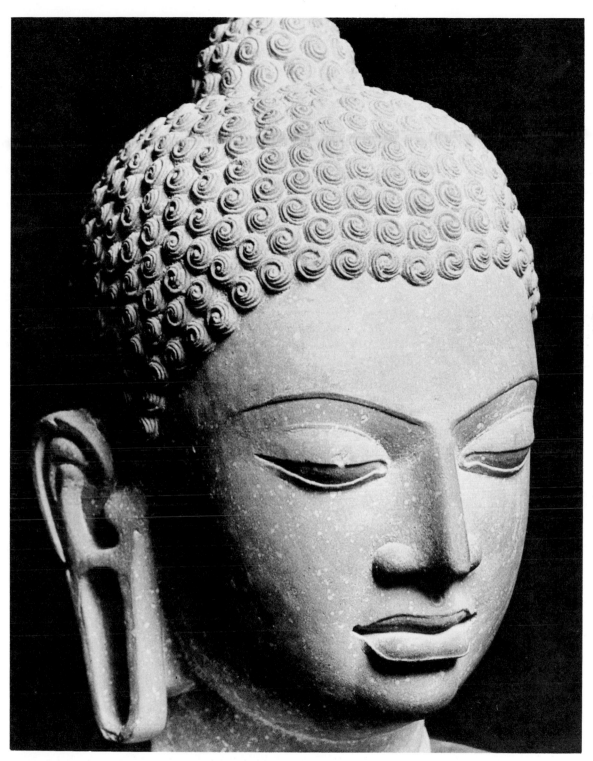

Head of the Buddha. Mathurā, India. 5th century.
Archaeological Museum, Mathurā. Photo from
Snellgrove 1978, by kind permission of Kodansha
International, Tokyo.

At a dealer's in ancient art, I see the head of a Buddha image in stone. It is a fifth-century Indian statue. The modeling is soft, the eyes closed, and the smile barely perceptible. My full attention is focused on the head; time stops. The dealer tells me the price, and I am back in time and place. I want to own that head, to bring it home, and to enjoy myself in looking at it whenever I want. But I cannot possibly afford it. The dealer has stepped aside, and I keep on looking at it, yet I cannot recapture the aesthetic stance: the desire of possession is too strong. My passionate interest in the statue is, in fact, a passionate self-interest. I shall miss the joy, the pride, and the prestige of ownership; this is what upsets me and distracts my attention from the Buddha's head.

Self-disinterest may be expressed, when the picture is representational, in terms of distance between the beholder and what is depicted. I look at a *nishiki-e*, a polychrome print by Utamaro, a delightful image of a lovemaking scene. I am aware of the harmony of colors, the visual balance of the two bodies, the grace of the curving lines, the unity of the composition focused on three points on an invisible ascending line from lower left to upper right: the penetration, the man nibbling at the nipple of the woman, and the half-open mouth of the woman. I aesthetically perceive the picture as long as my attention is kept on the image, within the frame of the picture, at a distance from the same scene imagined as actual. If mental images of the pleasures of "unframed" intercourse move to the foreground of my awareness, my attention to the forms disappears. The aesthetic experience yields to an erotic reverie. Self-disinterest is replaced by self-indulgence.

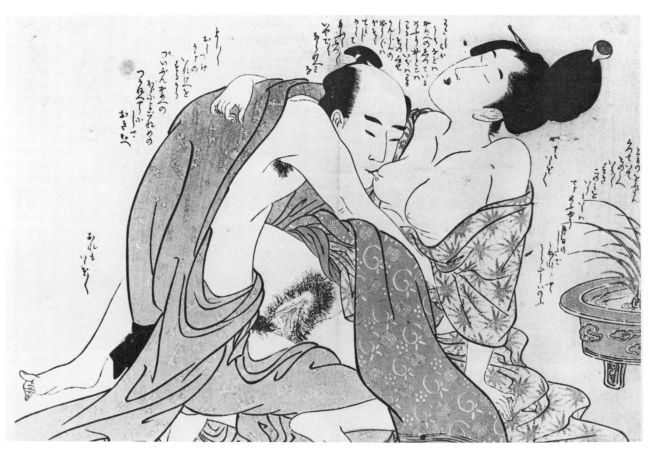

UTAMARO KITAGAWA. Polychrome print (*nishiki-e*) of a lovemaking scene. c. 1800.

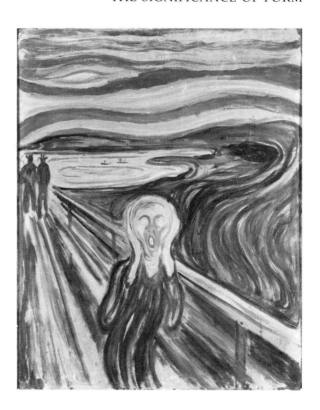

EDVARD MUNCH. *The Scream*. 1894. Munch Museum, Oslo.

The connection between self-indulgence and eroticism is obvious, but the beholder's ego may be equally involved in other emotions and feelings. *The Scream* by Edvard Munch is an impressive composition. The oblique straight lines indicate a descending direction—though they represent a horizontal bridge—and unstable curves dominate the upper part of the picture. The screaming person is terrified by something which is behind and slightly to the left of the beholder, and which seems to threaten the beholder as much as the screamer. It is death and suffering, inseparable from the human condition. At this point, the beholder's attention may be diverted from the flat surface of the picture and replaced by personal anxiety or even self-pity.

Adolph Gottlieb's *Blast, I* is a powerful nonfigurative painting. The title suggests a nuclear explosion, and the confused shape in the lower part of the painting may refer to the earth after an atomic war. The floating disk above, the sun, remains unaffected by mankind's destruction of its own habitat. Again, the beholders' attention may be deflected from the vision of the painting to fear for themselves and anger at the governments' irresponsibility.

Emotions always have a self-interested aspect, even if they seem purely altruistic. In the Museum of Modern Art, in New York, *Echo of a Scream* by Siqueiros has such an emotional impact that it is difficult to confine one's attention to the forms assembled on the canvas. In the ugly backyard of industrial civilization, which threatens to cover the whole world, a child is loudly screaming, and the echo of his scream fills the world, as indicated by an enlarged duplicate of his head which fills the upper part of the picture and dominates the pictorial space. The beholder who becomes emotionally involved will probably identify with the child, who represents the victims of the profit incentive on which our economic system is based.

ADOLPH GOTTLIEB. *Blast, I.* 1957. Collection, The Museum of Modern Art, New York. Philip Johnson Fund.

DAVID ALFARO SIQUEIROS. *Echo of a Scream.* 1937. Collection, The Museum of Modern Art, New York. Gift of Edward M. M. Warburg.

The aesthetic experience results from an encounter between a subject, the beholder, and an object whose forms are aesthetically significant. We have established that the necessary disposition of the beholder is an attitude of nonanalytical and disinterested attention, and we have identified the configuration of visible forms as the area of the object on which the beholder's attention is focused.

Still, we are at the threshold of the aesthetic encounter. On the side of the beholder, concentrated attention, nonanalysis, and no self-interest are only preliminary conditions. On the side of the object, the visible forms simply delimit the area.

We must now consider further the beholder's mental apprehension of aesthetic forms.

Aesthetic Vision as Contemplative

THE BEHOLDER'S MENTAL PREPARATION FOR AN AESTHETIC ENCOUNTER, AS JUST DESCRIBED, appears to be similar, in fact almost identical, to the preparation recommended to meditators in some classical Eastern traditions. Is it a superficial resemblance mainly due to the limited vocabulary available for the description of mental phenomena, or is there a deep convergence of the two experiences?

This matter deserves to be carefully considered. If there is a significant parallelism at the experiential level, the aesthetic vision, so far studied in isolation, would be placed within a broader framework, and the specificity of the aesthetic vision could be better explained.

What is called in the West "the Eastern traditions" refers to several bodies of doctrines and practices so immense as to defy any attempt to use them as manageable terms of comparison. We will restrict our comparison to two major literary sources, Patañjali's *Yoga Sūtra* (Aphorisms) and Buddhaghosa's *Visuddhimagga* (The Path of Purification).[1] We take them as important works respectively representing the Hindu system of Yoga (Sk. *yoga darśana*)* and the Theravāda Buddhist system of meditation.

These texts, written by two Indian scholars, probably during the fifth century A.D., were at that time epitomes of long traditions: the Buddhist was about one thousand years old, and the Yoga still more ancient. They also were starting points of new phases of these traditions, and they still are used for meditational practice. The *Yoga Sūtra*, a collection of 195 short aphorisms to be memorized, requires commentaries (a sūtra is a thread on which to string the beads of commentaries), and commentaries were written by Vyāsa (between the 7th and the 9th centuries), by Vāchaspatimiśra (9th century), by King Bhoja (11th century), and by Vijnānabhikshu (16th century).[2] Recent authors continue to offer new translations and new commentaries of Patañjali's *Yoga Sūtra*.[3] The *Visuddhimagga*, a long treatise of more than seven hundred pages in the Pali Text Society

*In this passage "Sk." indicates a Sanskrit word, and "P." indicates a Pāli word.

edition, is considered the basic work of reference by many contemporary meditation teachers in Theravāda countries (mainly Sri Lanka, Burma, and Thailand). *Yoga Sūtra* and *Visuddhimagga*, far from being little-known marginal sources, are alive and important texts on meditation.

Concentrating one's attention on the visible object is the first condition for an aesthetic perception. The first of the *Yoga Sūtra*'s four books is devoted to concentration (Sk. *samādhi*). In the second aphorism, yoga, as a mental discipline, is defined as the elimination of the distractions that prevent concentration. In Wood's translation, it is the "suppression of mental fluctuations."[4]

In the third chapter of the *Visuddhimagga*, also devoted to concentration (P. *samādhi*), it is stated that concentration is the "centering of consciousness . . . on a single object," with "non-distraction as its characteristic." The object on which one concentrates may be water in a bowl, colors perceived in flowers spread on a tray, an artifact such as a disk made of clay, a bodily activity such as breathing, a mental image such as a decaying corpse, or a virtue such as compassion. The frame, as a device for isolating the object and facilitating visual concentration on it, was recommended to Buddhist meditators. He who chooses to concentrate on a fire "should make a hole, a span and four fingers wide, in a rush mat, a piece of leather, or a cloth, and, after hanging it in front of the fire . . . should sit down" and look at the fire so framed.[5]

The aesthetic attention should be nondiscursive. Patañjali, in the concise style of his aphorisms, mentions several kinds of intellectual fluctuations of a discursive nature that the yogi must suppress: cognitions, whether true or false, imaginations, and memories.[6]

The Path of Purification considers the case of some mental objects that may be approached either through discursive reflection or through nondiscursive meditation. The former approach is found to be unwise as it may generate distracting thoughts and emotions. For instance, reflecting about death, "if (one) exercises one's attention unwisely in recollecting the death of an agreeable person, sorrow arises, as in a mother on recollecting the death of her beloved child she bore; and gladness arises in recollecting the death of a disagreeable person, as (an) enemy." On the other hand, one can meditate on death in a nondiscursive manner by mentally repeating "Death will take place," or even more simply "Death, death."[7]

It is widely recognized that the aesthetic vision is disinterested, characterized by detachment, as Harold Osborne reminded us.[8] The term *detachment* is also used by teachers of meditation: affective fluctuations of emotions, feelings, and desires make concentration impossible if they are left uncontrolled. Patañjali's yogi control their affective fluctuations by dispassion, (Sk.) *vairāgya*, which is translated by Woods as nonattachment, "the consciousness of mastery of desires."[9]

The Buddhist meditator has to overcome "greed, craving, and clinging." This effort is called virtue (P. *sīla*), and the first two chapters of *The Path of Purification* are devoted to virtue. Virtue, described as nonattachment, is considered by masters of meditation and aestheticians alike from the same standpoint: not as an achievement to be attained primarily for the sake of social morality, but as a requirement for mental concentration.

When the usual mental stream of thoughts and feelings, regrets and anxieties, fears and hopes, futilities and incongruities has slowed down or stopped, attention is stabilized on the visible object. This state is described by metaphors. One is *absorption* of the subject into the object, as if the subject's consciousness, having penetrated into the object, finally

disappears in it. Another metaphor, antithetical to the absorption image, is the *invasion* of the field of consciousness by the object, as if the vision made by the object penetrates and fills the viewer's mind. A third metaphor is that of *nonduality*, suggesting that object and subject become one.

Harold Osborne and other aestheticians observe that when the aesthetic encounter is successful, "we are no longer fully conscious of ourselves as persons sitting in a concert hall or standing before a canvas in a picture gallery . . . we become identified with the aesthetic object by which our attention is gripped and held."[10]

Meditators also are said to achieve states of absorption (Sk. *dhyāna*; P. *jhāna*). In fact, this part of the theory of meditation is considerably developed in the Theravāda tradition. *The Path of Purification* distinguishes eight levels of absorption. The first level is not unlike the absorption described by aestheticians: the usual flow of thoughts and feelings is broken, the mind is undistracted, steadily fixed on the object of meditation as on one point. This is called "one-pointedness of mind" (P. *citta ekaggatā*).[11] There may be a deepening of the aesthetic absorption that could be described in terms of the other levels of meditative absorption, at least to the fourth level. We do not know, because aesthetic experiences have not been described and analyzed with the careful observation and the sophisticated conceptualization characteristic of the texts found in the Eastern meditational traditions. At any rate, there could be no parallelism between the higher levels of meditation—namely, the fifth to the eighth—and mental states characteristic of the aesthetic vision. Indeed, these levels are no longer associated with any sensory perceptions, which are essential in the apprehension of the visible.

In both traditions, the term *samādhi*, concentration, denotes a state of deep and quiet meditation where the subject experiences oneness with the object. Mental absorption is favorable to a nonverbal understanding of the object. Absorption, in fact, is usually sought for the insights it provides rather than for its own sake. Insights, intuitions, illuminations—all immediate apprehensions of the object—give access to the object "as it is." This expression *the object as it is*, so frequent in writings on meditation, may be misleading. It does not mean the object *as it is in itself*, independent from any subject (something logically contradictory as there is no object without a subject), but the object *as it is nonverbally*, freed from the conceptual conditioning that acts as a screen between an experience and the consciousness of it. The insights (Sk. *vipaśyanā*; P. *vipassanā*) of the meditator in the Theravāda tradition correspond to the beholder's intuition.

These Sanskrit and Pāli texts deal with mental states which are not part of the usual repository of experiences of twentieth-century Western men and women. However, experiential references are available to Westerners, and accessible to anthropologists. During four trips in South and Southeast Asia, I practiced meditation in the Buddhist Theravāda tradition as a resident trainee in four monasteries in Sri Lanka, Thailand, and Burma for about four months altogether.*

In one exercise I was to focus my attention on abdominal breathing. I was to be aware of each upward movement of inhalation and of each downward movement of exhalation,

*The monasteries were the Vipassanā Bhāvanā Centre in Kanduboda, Sri Lanka; the Samnak Vipassanā Vivek Asom in Chonburi, Thailand; the Thathana Yeiktha in Rangoon, Burma; and the Tapovanaya in Angoda, Sri Lanka. My meditation teachers were respectively the late Ven. Seevali Thero, Ven. Acharn Thawee Bhalathammo, Ven. Sayadaw U Javana, and Ven. D. Chandrasiri Maha Thera, to whom I am deeply grateful.

and mentally—not verbally—take notice of them. Trying to do so, one rapidly becomes aware of the tremendous force of the stream of mental phenomena, and of its resistance to the meditator's attempts at controlling its fluctuations. These fluctuations are perceived as obstacles to the exercise of concentrated attention.

Memories, images, daydreams, and expectations are immediately recognizable, but discursive thinking is tricky for the apprentice meditator to discern. For instance, I was ruminating and comparing the ups and downs of breathing to the waves of the sea, wondering if there was a kind of rhythmic pattern common to the physical world and myself, if this could be considered a pantheistic view, and so on. In this manner, my attention moved away from the object on which I wanted to concentrate, abdominal breathing. It took me some time and the guidance of my teacher to be able to distinguish discursive thinking from insight.

Another day, I was reflecting on the monotony of our secluded life in the monastery, and how few were the items it provided for remembering; from there, I began to build a hypothesis on the relationship between unique events and memory. On another occasion, I was trying to express a clear conceptual distinction between detachment and indifference. These analyses were taking me away from the meditative state of consciousness.

The training was intensive: about eight hours of sitting meditation and four hours of walking meditation a day, complete silence except for the daily private interview with the teacher, no reading, and writing kept to a few notes in the field diary. It was effective. Slowly, the flow of fluctuations decreased; concentration could be maintained for longer periods of time and became deeper; and some insights on life's limitation, impermanence, and insubstantiality flashed through my mind.[12]

This experiential reference to meditation—as limited as it was—confirms the analogy of meditation with aesthetic absorption. What can be read in Patañjali's *Aphorisms* and in Buddhaghosa's *Path of Purification* remained opaque to me until I had had a beginner's experience of meditation. But should an individual's mental experience be taken into account in the scholarly search for critical knowledge? Earlier we used the experiential reference approach to clarify what is meant by "looking at an art object." In that case we could refer to an experience common to many, if not all, of our contemporaries living in the industrial world; at present we refer to the meditative experience, which is not a part of the cultural stock of every Western person.

The reporting of inner phenomena by an individual observer should meet the standards of validity and reliability considered acceptable for fieldwork observations. This matter is discussed in the Appendix. Suffice it to say here that the reliability of my observations can be checked; other observers may go to the monasteries where I have been, and the conceptual framework I have used is presented in this book. Just as hundreds of Sinhalese, Thai, and Burmese and a few Westerners have done and still do, other observers may undertake intensive meditational training and compare their observations with mine.

Their validity may be assessed too. Social scientists rightly are suspicious of the validity of what an informant may say about his mental experiences if there is no way to check the informant's perceptivity and veracity. Fortunately, in traditions where certain mental skills are taught, and have been taught for centuries, there is an indirect control: the teacher knows how these skills should be acquired—as there is a mapped progression—and what the indicators of the progression are. A teacher is not easily

fooled by a trainee's illusion or deception. A disciple's assertion accepted by a discerning teacher is as valid as a good informant's statement reported by a perceptive anthropologist.

Two main Eastern traditions, represented by two of their fundamental texts, and interpreted in their experiential context, attest that there is a parallelism between aesthetic vision and meditative absorption. From the analogy of the two processes, it may be inferred that aesthetic perception and meditation reveal the same mode of consciousness, a mode different from cognition and emotion, which we may call the mode of contemplation.

In order to grasp what the contemplative mode is in relation to the others, let us consider the Western construction of the human psyche from a phenomenological perspective. The distinction between what I refer to as 'me' and as 'the world' around me is basic to this construction. If somebody were to deny, in everyday life, the soundness of this distinction, he could not use the common language, he could not take part in social interactions, and he soon would be committed to psychiatric care. Certainly, in other realities than the everyday one, for instance in the reality built by philosophers, the distinction between the empirical 'ego' and 'the world' can be questioned without social disapproval; but in the transactions of the practical life and the communications of the common language, the duality 'I' and 'the world' is a basic assumption.

The world is everything that is outside of my body: the natural and man-made environment, the other sentient beings, and particularly the other human beings. The *I* is my body, or more precisely the consciousness of my body. I perceive it differently from the way I perceive other bodies, from inside, as it were. My body may be deprived of consciousness for a certain time; for instance, after a severe shock, I may lie unconscious, and then regain consciousness. The opposite, a consciousness deprived of body, is not a part of the Western reality in the twentieth century. *Mind*, a synonym of consciousness, does not primarily suggest awareness; it evokes the continuous functions of the brain, such as thought, will, and perception, and includes the unconscious processes of the brain.

Consciousness may be described as the totality of the mental processes of which I am aware at a certain time. In addition to this meaning of consciousness as awareness, consciousness is also, in our common language, an accumulation of records of these mental contents of which I have been aware during the life of my body; it is a bank in which memories are kept. What is in my mind at any time may come either directly from the world (after having been processed by my sensory organs) or from my store of records.

As consciousness, I am constantly in transaction with the world. Because I have different intentions regarding the world, I approach it in different ways. We have an everyday experience of three of these fundamental approaches: acting, knowing, and feeling. We approach the world in an active mode when we seek to change it by modifying the environment, by obtaining something from somebody by persuasion, pressure, or exchange, or by planning ahead toward a sequence of acts that eventually will produce some results. *Knowing* is the cognitive mode of consciousness. Here we want to observe something without changing it, just to understand how it works. It may be something trivial and speculative (such as, Why has this candidate lost the election?),

or something studied by rigorous scholarly methods (such as a historical reconstruction of the diffusion of Bantu languages in sub-Saharan Africa). *Feeling* here indicates the affective mode of consciousness. The subject's mind is dominated by an emotional state (such as anger, love, hatred, or admiration) usually accompanied by pleasantness or unpleasantness.

Aesthetic vision and meditative attention do not fit into any of these three modes of consciousness. They are not active, as they are not oriented toward changing the world; they are not cognitive, as they are characterized by nondiscursiveness, nonverbality, and holism; and they are not affective, as they exclude self-interest. They are contemplative.

Though not as noticeable as the other modes of consciousness, contemplative moments are many in everyday life. Each time we become aware of the visual quality of a dress or a tree, a billboard or a way to walk, the sky at sundown or the lights of the city, there is an aesthetic repose of a few seconds or a few minutes. During these fleeting encounters with things perceived as good to look at, the contemplative mode dominates our consciousness.

In the countries where everybody knows that "meditation is *the* essential practice of exemplary Buddhists," meditation in its full extent is practiced only by a small minority, a spiritual elite.[13] But short periods of time spent in a meditative mood are fairly popular. In Sri Lanka, children are encouraged to begin the day by sitting for a few minutes in the meditation posture and wishing all sentient beings to be free from suffering and to attain enlightenment; they are to repeat the words mentally in the quiet mood of lovingkindness (P. *mettā*). Some Sinhalese keep that practice all their lives. Laymen and laywomen are invited to meditate in the temple during the full-moon day of each month and during other celebrations, and many do. In the West, it is likely that some repetitive prayers and chanting weaken the flow of mental fluctuations and generate a contemplative attention.

Before making decisions in the course of ordinary life, we often do not have the time or the inclination to proceed with a discursive analysis of the situation, and we rely upon a total and immediate apprehension of a problem or a personality: an intuition. Usually it is by intuition that we perceive a person as trustworthy or not, and an undertaking as dangerous or not.

Intuition is not restricted to what occurs in everyday life. It has eminent apologists in philosophy and science. For Descartes, Locke, and Leibniz, fundamental truths were reached by intuition, and rational processes were later used for proof and explanation. Poincaré and Einstein, we are often reminded, stressed the importance of intuition in their scientific discoveries.

Intuitions, flowers that blossom in the silent and one-pointed mind, cannot be forced. But mental concentration stimulates their appearance or, more probably, permits the undistracted subject to become aware of their presence. Because of that, and because of their immediacy and totality, intuitions belong to the contemplative mode of consciousness.

As ideas and images, feelings and sensations arise and disappear in the mental field, so do modes of consciousness. These modes of consciousness after all are only conceptual categories into which we class mental fluctuations having some attributes in common. For instance, anger and love, being emotions of the subject, are classed under "affective mode."

Looking at the striking shape of a sports car, I find it beautiful; for a few seconds, visually overwhelmed, I am fully in the contemplative mode. Then I become aware of how that vision affects me: in fact, I am envious of the owner of the car, and envy belongs to the affective mode. A few seconds later, I wonder why this form is so arresting, and I begin to analyze it in the cognitive mode. Finally, the idea that perhaps I could afford such a car flashes into my mind; in the active mode, I begin to make some practical plans to find out first what is the price of the car, and what would be the trade-in value of my present car. This is a sequence of modes of consciousness following one another very rapidly, but at each moment, one mode is dominant.

In the common reality of our society, the contemplative mode is largely ignored; at the least, it is not as clearly recognized as the others. Its importance is less evident, and sometimes it appears mysterious. Why is this so?

From the standpoint of the individual, the other modes are, for most of us, more rewarding because they accord well with the mainstream values of our society.[14] Action offers the usual access to power, affluence, security, and prestige. Cognition, as such, may bring some prestige and some affluence but is most often a preparation for action. Affectivity is closely associated with pleasure; positive emotions, such as love, gratitude, and admiration, are pleasant to experience; and negative emotions, such as pity, anger, and contempt, may enhance self-esteem through others' recognition of one's generosity, self-satisfaction regarding one's virtues, and the self-righteousness of one's indignation. These are strong inducements to relate to the world through these approaches. Contemplation, on the other hand, is low-keyed, requires the effort of mental preparation—even for the aesthetic vision—and has little utility in the enhancement of self-interest.

At the collective level, contemplation has been of secondary importance in the evolutionary process. In order to survive, and to progress in the domination of the environment, action and cognition have been the most effective ways to deal with the world. It should not surprise us, then, that the Western tradition, the tradition most clearly committed to the domination of nature, did not develop methods for cultivating contemplative skills. However, in the present predicament of the highly industrialized societies—overpopulated, overpolluted, and depleting the earth's resources—the contemplative approach may become more attractive: it may become the most effective way of relating to the world to survive and progress.

Beginning in the 1960s, important new developments took place in the neurological study of the two hemispheres of the brain. On the basis of research on the lateralization of the brain conducted by R. W. Sperry and his associates M. S. Gazzaniga and J. E. Bogen, and from a survey of other research dating back to 1864, Joseph Bogen has proposed to localize in the left hemisphere the *propositional* capacity of the brain, and in the right what he calls its *appositional* capacity. Propositional refers to the use of words in forming propositions, and appositional refers to apposing or comparing, for example, perceptions and schemas. Appositional is admittedly vague because of the "difficulty in characterizing the ability of the right hemisphere [which] arises largely from our ignorance."[15]

According to Bogen's report on the dichotomies suggested by researchers who preceded him, the left-right lateralization of the brain has been associated with at least fourteen dualities since the 1860s. Here are five of these pairs (in which the first term is

always localized in the left hemisphere): (1) linguistic versus visual or kinesthetic; (2) symbolic or propositional versus visual or imaginative; (3) verbal versus perceptual or nonverbal; (4) verbal versus visuospatial; and (5) logical or analytic versus synthetic perceptual.[*]

Bogen states that "the original and hardly arguable fact [is that] the left hemisphere is better than the right for language, . . . 'verbal activity' or 'linguistic thought'; [and that] in contrast . . . the right hemisphere excells in 'non-language' or 'non-verbal' function."[16] With a typical Western bias, the left hemisphere is called the *dominant* hemisphere.

The characteristics of what we have called here the contemplative mode—nonanalytical, visual, receptive, perceiving totalities, and nonverbal—certainly belong to the right hemisphere. That the contemplative mode of consciousness is, according to these neuropsychological works, located in a certain area of the brain, is of little consequence for our own studies, except in one important connection. Separate organic rootings for cognition and contemplation provide a strong confirmation that they are distinct and irreducible mental functions.

At the beginning of this chapter, the aesthetic vision, so far considered in isolation, seemed to be a particular and somewhat narrow visual approach to tangible objects. I have attempted to put it in its broadest framework. As meditation, aesthetic vision apprehends its object in a contemplative mode of consciousness, which is one of the primary ways through which the subject relates to the world.

In moving from art as an everyday category to the aesthetic vision as a contemplative approach, I have tried to develop a conceptual framework that will enable us to make meaningful cross-cultural comparisons. That a fundamental mode of human consciousness is manifested in the aesthetic vision suggests that the aesthetic quality and its appreciation are likely to be found in many, if not all, cultural traditions.

[*]Bogen 1973:111. In the second dichotomy, the term *symbolic* has not the same acceptation as in this book (see chapter 10), where symbolic processes are seen as nondiscursive, nonanalytical, and nonverbal. They are associated with the functions of the right hemisphere.

CHAPTER SIX

Aesthetic Experience in Other Cultures

IF AESTHETIC VISION IS A MANIFESTATION OF CONTEMPLATION, AND IF CONTEMPLATION IS A basic mode of consciousness, we may conclude that the aesthetic perception is, at least potentially, universal. Any society may develop an aesthetic approach to natural and man-made things. But do many societies outside the urban centers of the contemporary industrial world recognize and actualize this human potentiality?

This question cannot be answered a priori. And, as we are dealing with an inner experience, direct observation of behaviors will not produce conclusive results. We will have to proceed in an indirect manner, and try to find indicators, as we did for our own culture—with the added difficulty that we are at a distance from other cultures.

Language provides us with precious indicators. Does the everyday language of the society we consider include words which denote a positive response to a purely visual stimulus? Does it possess words having the simple meaning of 'good to look at', as do the English terms *beautiful, handsome,* and *pretty*?

Words conveying such meanings were reported in some nonwritten languages of Africa by Leiris and Delange. Summarizing studies made on a dozen West and Central African languages, these French Africanists concluded that the distinction between 'good' and 'beautiful' was made in most of them. They particularly mentioned the languages of the Wolof of Senegal, the Bambara of Mali, the Susu of Guinea, the Daza of Central Sahara, the Bulu of southern Cameroon, and the Cokwe of Angola.[1] The words denoting 'nice to look at' in these African languages have slightly different connotations—as do *beautiful, handsome,* and *pretty*—but their core meaning is the same. As any anthropologist who has carried out research in Africa knows, the meaning 'nice to look at' is easily expressed in the language of the observed group. And, as any tourist having bargained in an African market knows, a message such as "I prefer this because it looks nicer than that" can easily be conveyed with a minimal linguistic competence of the two parties.

In the written language of the great traditions of Asia, the vocabulary pertaining to the different responses of a beholder is rich and subtle. And, as Thomas Munro makes

clear in his survey of Oriental aesthetics, there is an abundant literature in the classical languages of India, China, and Japan which is devoted to analysis, explanation, and theory of the aesthetic experience.[2] *Rasa*, the central concept of Sanskrit aesthetics, finds its origin in the *Nāṭyaśāstra*, a collection of texts probably written during the fourth or fifth century A.D., and its highest development in the work of the tenth-century philosopher Abhinavagupta, according to contemporary Indian specialists in aesthetics such as S. K. De, K. C. Pandey, and Y. S. Walimbe.[3]

The presence, in a language, of ordinary words referring to visual quality, and of intellectual reflections on the aesthetic experience, indicates that the aesthetic potentiality has indeed been developed in many societies, literate and nonliterate, simple and complex, ancient and modern.

There are silent cultures, those of societies which, linguistically, are dead: no speaker of their language remains, and there are no extant written archives. We only have a collection of their artifacts. Is it possible to find in the objects left some clues to the mental attitudes of their makers regarding the vision of forms?

Many artifacts are utilitarian. They are tools—knives and spears, pots and jugs, axes and hammers—worked by hand, used to perform simple tasks. They are instruments whose utilization is obvious. They do not require any explanation beyond themselves. Their purpose lies in directly or indirectly maintaining bodily survival. It is their evident and primary context.

These artifacts have formal characteristics of shape, color, and texture required for their proper operation in their usual context. These aspects constitute the instrumental form of the object. The knife's blade and its handle are shaped in a form that insures the most effective utilization of the knife for cutting meat or carving wood; the form is fully instrumental. The form may additionally have a visual quality which stimulates in us an aesthetic perception of it. Even if the contemporary observer has such a visual response, one cannot assume that the aesthetic form was a concern of the craftsman who made the knife or of the members of that group. But, if contemporary observers detect in the knife some formal aspects which were not needed for its efficacy as a cutting or carving tool, may we not assume that these noninstrumental forms reveal an aesthetic concern? Perfect regularity or smoothness of the handle, ornamental engravings, or application of a colored coating go beyond what is necessary for the proper use of the knife. These noninstrumental forms indicate an aesthetic interest within that society.

Elsewhere, I have posited the case of a wooden bowl discovered with other artifacts from an extinct culture.[4] Its context was everyday life; it was used to serve food. Its shape is circular, its rim rounded, its bottom flat. These formal characteristics are instrumental: circular shape and rounded edge made cleansing easier, and flat bottom prevented the vessel from being overturned. We also notice that the rim of the bowl is a perfect circle, which is not easy to achieve for a carver working with only adz and knife, and that some engraved patterns are repeated with regularity and symmetry. These latter formal characteristics are not instrumental: they do not enhance the utility of the bowl as a container for food. This constructed example was given substance by E. Adamson Hoebel who, quoting it, published a picture of a carved Trobriand Islands wooden bowl illustrating it.*

*Hoebel 1972:624. Discussing the same case, Richard L. Anderson notes that "roundness is highly desirable because it maximizes the strength and capacity of a vessel while minimizing its weight" (Anderson 1979:13n).

The criterion of noninstrumentality is applicable in our contemporary cultures as well as in distant and little-known societies. A sporting gun is made to fire on a certain type of game; silver engravings on the butt do not enhance its killing effectiveness. In the Canadian winter, a fur coat is a garment primarily made to keep its wearer warm; this goal is attained whether or not the pelts are perfectly matched in size and color. These formal aspects, not necessary for the proper use of the object in its context, have been added for their visual appeal.

Formal instrumentality is not confined to utilitarian contexts. For objects used in a religious context, there is also a ritual instrumentality. Let us assume that the chalice used in the rite of the Eucharist should be marked by a cross if the rite is to be efficacious. Thus the cross engraved in the metal is not decorative but instrumental. In the same way, some marks engraved on a wooden bowl used for food offerings to the ancestors may be

Carved wooden bowl. Trobriand Islands. Private collection. Photo by Don Breneman (Hoebel 1972).

Ardagh chalice. Ireland. 8th century. National Museum, Dublin.

magical signs that keep the evil spirits away, and not ornamental patterns. This, however, does not exclude noninstrumental forms; the way the cross and the magical signs are engraved may disclose a concern for balanced lines and shapes, for contrasting colors, or for the visual enhancement given by precious and semiprecious stones. These features are not necessary for the ritual effectiveness of the religious or magical rites.

At this point a question may be raised. In the case of a silent culture, known only by a set of artifacts, is it possible for the contemporary scholar to determine if a feature is instrumental or not? For instance, how do we determine if the artifact had its primary meaning in a ritual context? Certainly the criterion of noninstrumentality requires an interpretation based on a general knowledge of similar cultures of the same area, of objects of the same kind that we know more about, and about the ritual context. Such general knowledge is currently available for practically any set of artifacts. What if, as could happen, a new set were discovered in isolation, and could not be related to anything we know? In this case, an interpretation would be impossible, and only risky speculations could be presented. But such discoveries become increasingly unlikely. In the usual ethnographic or archaeological situation, comparisons are possible, and the noninstrumentality of forms may be ascertained.

Another objection should be discussed. Is it legitimate to infer a concern for aesthetic vision from an interpretation of some forms as noninstrumental? This inference is based on the fact that, indeed, an aesthetic intention is the only explanation for producing forms not necessary to the tool's fulfillment of its function. Why would craftsmen ornament the surface of an object with a decorative pattern if making it nice to look at had no meaning for themselves and other members of the society? Why would a carver take the trouble of making a perfectly circular bowl when an imperfect shape would not impair the use of the bowl? This interpretation of artifacts from silent cultures—those with no written texts and no members alive—is confirmed by the expressions of verbal cultures, which speak orally or textually: it is the concern for visual quality that prompts the creators of objects to go beyond the forms required by the instrumentality of the object.

The aesthetic intention in the makers of artifacts and the aesthetic appreciation in the users are not limited to the utilitarian and ritual instruments.

Another context in which objects have a conspicuous aesthetic dimension is the political. Scepters of chiefs, seats of kings, insignia of authority carried by attendants when the ruler appears before his subjects, and ornate vestments worn by the courtiers were, and still are, instruments of power. They expressed and strengthened the domination of the rulers over the subjects. In some cases these objects *were* power: the material possession of the crown or the throne gave legitimacy to the king. Among the contenders for the supreme power of the Asante, the one who could control the golden stool was recognized as the Asantehene. Such instruments of power most often are endowed to a high degree with aesthetic ornamentation.[5]

Social hierarchy is another context for objects with a strong aesthetic component. The large groups—castes or classes—into which a stratified society is divided express differences and ranks in status through objects used as distinctive marks. Insignia characteristic of aristocracies and upper classes, high initiation grades and prestigious professions, nobilities and other privileged minorities are illustrated by the gold-plated fly whisks of the Baule notables, the ivory figurines of the high initiates among the Lega, or the rank sculptures of New Hebrides.[6]

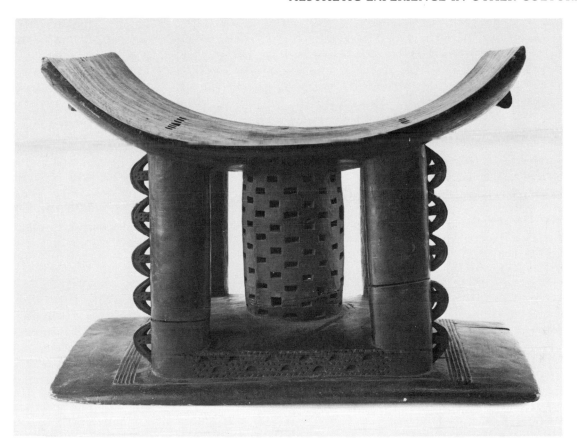

Asante chief's carved wooden stool. Ghana. Museum of Cultural History, University of California, Los Angeles.

The instrumentality of artifacts associated with government and hierarchy is to make evident the structures of societal relationships and thereby to reinforce them. The objects should express that there is a difference between rulers and subjects, superiors and inferiors, and that rulers and superiors should be admired, respected, and feared "because they are better" and thus deserve their privileges. The political and hierarchical function of these objects is more limited and, at the same time, more general than the utilitarian or ritual functions of the objects discussed above. The instrumentality of a knife (that it cuts or carves certain materials) provides the craftsman with more constraints in terms of size and shape of blade and handle, for instance, than the instrumentality of a scepter (through which the power and legitimacy of the king is manifested), which allows for a wide variety of sizes, shapes, and materials. The maker of a scepter has more opportunities to incorporate noninstrumental forms in the artifact than the maker of a knife. It is in this sense that hierarchical and political contexts are more favorable to aesthetic forms than are ritual contexts (limited by a particular ceremonial or myth) or utilitarian contexts (limited by the specific use of the tool).

The contexts we discussed—life-maintenance and ritual, government and stratification—are not the only ones in which artifacts display noninstrumental forms. Family is another: from the forebears' emblems to the parents-and-children pictures, there are

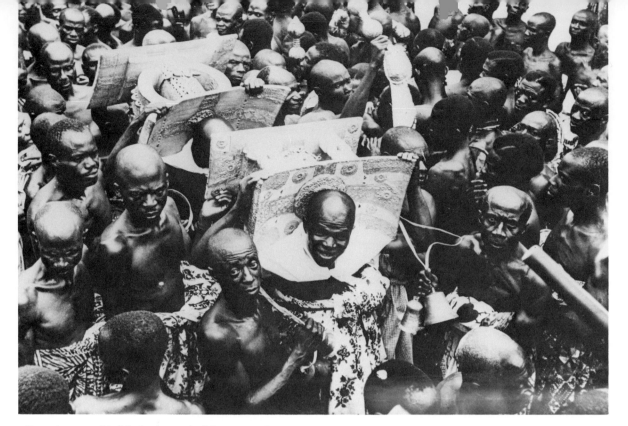

Two Asante chiefs' stools carried in procession.
Kumasi, Ghana. Photo: Ghana Information
Services.

numerous memorabilia whose instrumentality is to keep alive the memory of those with whom the living generations of the family may identify. This fosters solidarity among them and encourages them to cooperate with one another. Again, these artifacts make it possible for sculptors and painters to develop noninstrumental forms to a rather high degree.

The present discussion may give the impression that the beauty of an object, its aesthetic quality, is something *added* to the instrumentality of the object, as an accretion upon the surface of the artifact, as it were, if there is room for it. This is not what is meant. The aesthetic quality is not conceived as an ornament added to the object. But in our search for objective clues of aesthetic concern in other cultures, what clearly is an embellishment to the object is an unambiguous indicator of aesthetic intention. It is nothing more. The beauty of the knife is likely to be in its instrumental form, as the beauty of an aircraft propeller, and not in some decorative pattern on the handle. Yet, at this point, we cannot assume that the maker had an aesthetic intention when he shaped the blade; neither can we assume that the engineer who designed the propeller had such an intention. On the contrary, aesthetic intention may be inferred from noninstrumental adornments on the handle, even if they do not at all contribute to the "beauty" of the knife.

By distinguishing the aesthetic concern for a society from its aesthetic achievements, we can positively answer the question raised at the outset of this chapter. Yes, many societies—all the known societies, I dare say—recognize and actualize the human potentiality for aesthetic perception and appreciation. This answer is based on modest but indisputable indications provided by languages and artifacts. It is not dependent upon the aesthetic judgment of the observer.

CHAPTER SEVEN

Art in Other Cultures

AMONG THE DIFFERENT CONTEXTS IN WHICH WE HAVE DISCOVERED OBJECTS REVEALING AN aesthetic intention, a special context, the art context—in which the only function of the object is to be looked at—has so far not been mentioned; yet we may expect to find a large number of aesthetic objects in this context if it were as important in other cultures as it is in contemporary industrial societies. We discovered this context at the beginning of our exploration of the categories under which the visual forms are subsumed in the collective reality of our society. Is there such a context in other cultures? Do their carvers, painters, and craftsmen make objects only to be looked at? Do their beholders select such objects? In other words, do they produce and recognize art?

It seems the answer should be yes. Those in charge of the focal art institutions of our society—museums and galleries, art magazines and books—collect, exhibit, write about, report on, and sell artifacts produced in other societies that are labeled "art" of pre-Columbian America, of Oceania, of Africa, and more succinctly "primitive art." Clearly, these works meet the criteria developed in our second chapter: "displayed only to be looked at." They are works of art.

They are art *for us*. If we briefly examine them, we notice that practically all of them were produced and used in their societies of origin as weapons, kitchen utensils, regalia, insignia of rank, magical instruments, sacred objects, and ceremonial garments. They had particular instrumental uses in specific contexts; their primary function was not exclusively visual. They were not meant to be art objects by destination.

Neither were they, in their cultures of origin, metamorphosed into art objects after being no longer used in their primary contexts. In our culture we do this regularly, when we exhibit in an art museum a religious statue carved in the thirteenth century to be placed on a church's altar, a portrait of a young Spanish prince painted by Velázquez in the seventeenth century to be hung on a wall in his parents' castle, or a silver sauceboat produced by Thomas Shields in the eighteenth century to be placed on the dinner table of wealthy Philadelphians. Traditional masks and statues of Africa were discarded after their ceremonial use was over and simply left to decay; this was a rapid process for wood and other organic materials in hot, humid climates.[1]

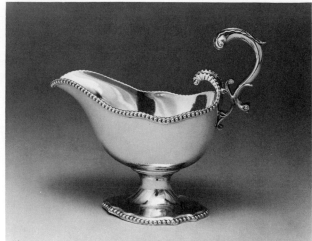

THOMAS SHIELDS. Silver sauceboat. c. 1780. Los Angeles County Museum of Art. Purchased with funds provided by the Decorative Arts Council.

DIEGO VELÁZQUEZ. *Prince Philip Prosper of Spain.* c. 1660. Kunsthistorisches Museum, Vienna.

Objects we have labeled "primitive art" were not art for those who made them. Did they make other objects with no other use than visual enjoyment? Yes, but they were few and of minor importance. Such were the small brass figurines forged by the Mossi and Dahomean smiths, the miniature baskets woven by the Tutsi women of Rwanda, the wooden cups elaborately carved in the shape of human heads by the Kuba craftsmen for the nobility, and the golden pendants hammered by Asante and other Akan artisans for the affluent.[2] Leiris and Delange call them trinkets and are understandably reluctant to recognize on the basis of these "worthless trifles" an African category of art.[3]

In the reality constructed by the men and women of the nonliterate world, art was neither a linguistic category nor a social practice.

The absence of art is not restricted to the societies without writing. In the civilization of the European Middle Ages, which belongs to the ancestry of the contemporary urban societies of the Western world, very few objects were made exclusively to be contemplated. Open an art history book devoted to the Middle Ages, and look at the photographs. Most of the pictures are of objects which were instrumental either in the Christian ritual, in the royal government, in the feudal hierarchy, or in the everyday life in castles and walled towns. Some artifacts certainly had solely visual relevance—tapestry wall hangings representing hunting scenes, for example—but they were few. No historian would think of restricting a study of the art of the Middle Ages to these objects.

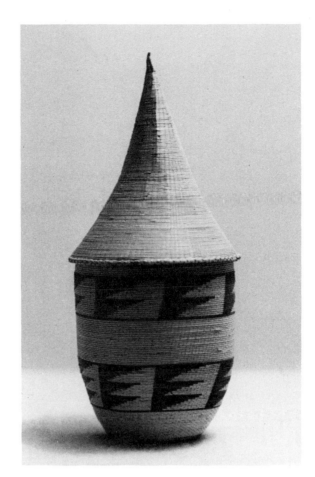

Rwanda traditional basket. Photo by Jacques Maquet.

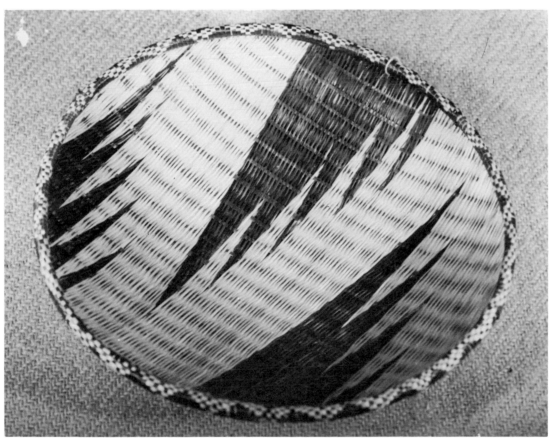

Rwanda traditional tray. Photo by Jacques Maquet.

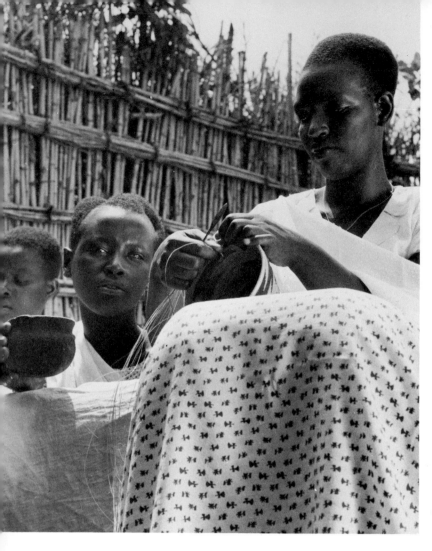

Tutsi woman weaving a basket. Nyanza, Rwanda.
1955. Photo by Jacques Maquet.

Classical antiquity, which covers another set of cultures antecedent to our own in the Western tradition, did not produce many exclusively visual artifacts either. The same approximate but significant test of the illustrated art history book certainly would provide us with a higher ratio of purely visual objects than would a book on the Middle Ages, from the small and elegant Tanagra figurines in clay and the bronze statuettes, small-scale replicas of large public statues for home display on what might be considered the second-century B.C. equivalents of the Victorian mantelpiece, to the mosaic coverings and the frescoes of the opulent Roman *villae*. Yet an art historian of the antiquity taking into account only these and similar art objects would miss what are considered to be the most significant aesthetic creations of Greece and Rome: the statues of the gods, temples and public buildings, and ornamented vessels for ceremonial or home uses.

If I may venture a generalization on the great Asian traditions—Indic and Chinese, Buddhist and Islamic—their aesthetic concern seems to have been expressed and satisfied more by the aesthetic quality of their temples and palaces, of their religious sculptures and paintings, and of their gardens and cities than by the art objects they produced. Buildings and artifacts were instrumental, but their forms went beyond the requirements of their use. Despite its broad scope, this generalization is, I think, cautious enough to be acceptable.

From a cross-cultural point of view, art objects probably have been made in all literate and complex societies, and in many nonliterate ones. They appear to have been somewhat marginal to aesthetic creativity and appreciation except in the case of post-Renaissance European societies and of industrially oriented societies. There the aesthetic concern has been localized in art objects. They are seen to be the main, if not the exclusive, support of the aesthetic experience. This experience is elsewhere sought in the visual forms of objects that are neither made for, nor used in, an artistic context.

At this point it may be useful to introduce an analytical tool, the concept of *aesthetic locus*.[4] Many artifacts, in fact most of them, have some noninstrumental formal features. After all, most of our mass-produced objects are "designed," and the purpose of industrial design is to make utilitarian objects aesthetically satisfying.[5] Consequently, practically everything we see around us embodies some aesthetic intention and has some aspects that are aesthetically relevant. This is not a phenomenon restricted to the industrially produced items. The handicrafted objects of the past also displayed noninstrumental forms. The aesthetic intentions were and are diffused in countless objects. In addition to that, they are also concentrated in certain categories of objects.

These categories of objects in which aesthetic expectations and performances are concentrated constitute what we call the aesthetic locus of a culture. In thirteenth-century Western Europe, the Christian ritual defined the aesthetic locus of the society. The aesthetic awareness of the society converged on the material items associated with the ritual, from cathedral architecture to church furniture, liturgical garments, statues, and paintings. In sixteenth-century Japan, the tea ceremony certainly was the center of an aesthetic locus which comprised landscape gardening, the tea-house and its interior

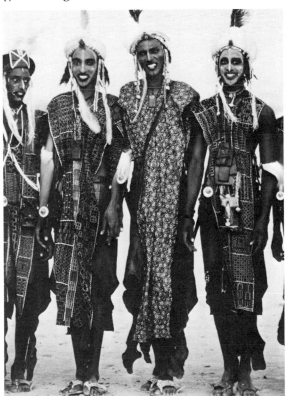

Four male Wodaabe dancers. West Africa.
Photo © Carol Beckwith, from Van Offelen and Beckwith 1983.

decoration, ceramic and lacquerware utensils, and textile motifs and materials for the appropriate vestments.

Ancestors' effigies and masks belonged to the aesthetic locus of many traditional societies of West and Central Africa. According to Jacqueline Delange, the aesthetic drive of the Bororo-Fulani (West African nomadic herdsmen also known as Wodaabe) is principally expressed in the elaborate attire and facial makeup of the young men during an annual celebration, which also is a beauty contest, and in the intricate and regular pattern of ties and knots they use to attach their belongings to the backs of carrier oxen.[6] Ceremonial adornments and utilitarian transportation fixtures are the aesthetic locus of the nomadic bands of these African pastoralists.

Since the eighteenth century the four disciplines of the fine arts in Europe have constituted the aesthetic locus of the Western societies. Except for one of them, architecture, the objects they produce—drawings, paintings, and sculptures—are art objects by destination. For approximately three centuries, the aesthetic locus of the Western tradition has been practically limited to art. In fact, we seem to be at the end of the dominance of art on the aesthetic locus of the industrially advanced societies. As I have argued elsewhere, art works are physically disappearing or are getting lost in our industrial environment. It is the time of the fading out of art.[7]

Whatever the prospects of art in our world, art objects were peripheral to the aesthetic locus of most societies. It is only in the West, and relatively recently—for three or four centuries—that creative and appreciative aesthetic efforts have converged on art.

When artifacts are uprooted from their culture of origin and are assimilated in another, several phenomena of culture change are triggered. Usually there is a shift from one aesthetic locus to another, and a metamorphosis of an object from instrument to art. The story of the transmutation of things made in traditional Africa into Western collector's items illustrates the interplay of many societal and cultural forces.

During European exploration and expansion overseas, which culminated in the colonial period of the nineteenth and twentieth centuries, many strange artifacts were brought to Europe from faraway countries by soldiers, traders, and missionaries. Not all of them, by far, were recognized as art objects. And for those that were, the process of acceptance was long. Descriptions of the ways European societies responded to the imported exotic artifacts may be found in the excellent studies written by Robert Goldwater and Jean Laude.[8]

The first man-made objects that reached Europe from sub-Saharan Africa arrived from the kingdom of Kongo at the end of the fifteenth century. They were few and were seen by few Europeans. Princes and rich merchants added them to the unique stones, unknown plants, ostrich feathers, and other natural rarities collected in their *cabinets de curiosités*. Lands abroad were believed to be very different from the familiar countries of Europe. There, flora and fauna were expected to be strange, even marvelous; and it was not evident that the people were human. Laude notes that it was only in 1537 that Pope Paul III officially made it known that the inhabitants of the newly discovered regions were truly human, thus worthy of becoming Catholics.[9]

In Lisbon and Rome, ancestral and other human representations were considered to be African idols worshipped under the influence of the devil and fetishes endowed with witchcraft power. Many were publicly burnt in the equatorial territories under Portuguese

authority, and those brought to Europe were at best somewhat frightening in their alien strangeness, and at worst marked by some satanic stigma. It should be noted that, despite the gross distortions of the religious significance of the African images, fifteenth- and sixteenth-century Europeans did not divest them of meanings pertaining to ritual and magical domains.

This is the basic reason these human icons were not apprehended only as visual forms during the first encounter between Black Africa and Western Europe. It was the time of the emergence of the notion of art. It had been prompted by the discovery of Greek and Roman statuary. Zeus and Athena, Apollo and Aphrodite were also foreign and pagan gods and goddesses, but as religious forces, they were dead, having been vanquished by victorious Christianity more than one thousand years before. Their statues, having lost all religious meaning, could only be assimilated in the culture of Renaissance Italy as beautiful visual forms. There was no other context for them: thus art became an essential category. African statues could not have become art because the gods they represented were still living forces, hostile to Christ and resisting his conquest. They could only be included in the religious segment of the Western reality as negative entities in the devil's camp. They were idols and fetishes, not statues.

A more superficial reason African images were not perceived as art is that their conceptual style of representation conflicted with the dominant idealized naturalism of the time. To admirers of the standards of beauty of the classical antiquity and the Renaissance, African images of man and woman could not fail to appear ugly or grotesque.

These characteristics of the first encounter of Black Africa with Western Europe more or less persisted until the colonial period. Political colonization, one of the consequences of the industrialization of Europe, established another relationship between Africa and the world. It lasted for about seventy-five years if we take two significant dates to mark its beginning and its end. In 1885 the European governments interested in expanding their sovereignty in Africa met at the Conference of Berlin and divided the interior of the continent into zones of influence. In 1960, at the peak of the movement for political independence, sixteen new states were formed from former colonial territories.[10]

During the period of European political domination of Black Africa, the number of artifacts imported into Europe increased tremendously. And they were seen by a great number of people. "Colonial" expositions and museums were organized as part of a public-relations effort to promote the colonial expansion. In Great Britain, France, Germany, and Belgium, only some business, military, and missionary groups were convinced that their countries should occupy and administer African territories; the general public and the elected assemblies were rather reluctant to see their governments engaged in what were called "colonial adventures." For these special-interest groups, to exhibit African objects was a means of propagating the colonial idea. Between 1850 and 1875, collections were begun for the museums of Berlin, London, Rome, Leipzig, Dresden, and Paris.[11] These were ethnological museums, not art museums.

Their exhibits were soon to be interpreted in terms of the evolutionary theory that became the dominant intellectual framework in the last decades of the nineteenth century. In his *Ancient Society*, published in 1877, Lewis H. Morgan applied to social and cultural phenomena some of the paradigms of biological evolution, such as the sequences from simple to complex and from inferior to superior. For Morgan, the first stage in cultural evolution is *savagery*, the period before pottery, subdivided into lower, middle,

and upper steps; the second stage is *barbarism*, the ceramic age, also with three steps; and the third stage, *civilization*, begins with writing.[12] Each contemporary society was understood to be on the evolutionary track, and its stage of development was assessed with reference to the general outline. The artifacts from "savage" and "barbarian" societies in the nineteenth-century collections were perceived as inferior to the ones produced in "civilized" societies, particularly those of Western Europe and North America, regions enjoying the highest level of "civilization."

The evolutionary theory provided an ideology making meaningful and acceptable the colonial enterprise. The bearers of cultures on a low rung of the evolutionary ladder did not have the right to stop the ascent of others and themselves to higher rungs. Those at the top of the ladder, the "civilized," had the right and the duty to develop mineral, vegetal, and human potentialities left unexploited in "inferior" societies. The latter were to be helped to progress toward "civilization" through a system of work and commerce, order and Christianity organized by the "civilized nations" for the benefit of humankind.

Colonial expansion and cultural evolutionism, so perfectly convergent, have to be taken into account if we wish to appreciate the nineteenth-century European understanding of African icons. It was taken for granted that in the fine arts, as in the other fields of culture, the nineteenth-century mainstream was the acme of a unilinear evolution—unilinear in the sense that all the cultural forms have to go through the same sequence

Three stages in the stylization of a bird and croco-
dile representation. Massim district, New Guinea.
Photo from Haddon 1895.

"Cubist" mask. Grebo, Ivory Coast. Collection, Musée de l'Homme, Paris.

and reach the same summit. And for the academic art tradition, any icon was aimed at reproducing the visual impression the beholder would have if looking at the object depicted. Anything deviating from a naturalistic representation was perceived as an unintended failure, the result of either incapacity or deterioration. Alfred C. Haddon, a biologist who led the Cambridge Expedition to the Torres Strait in the late nineteenth century, held the view that in the process of stylization and geometrization of animal forms (zoomorphs), there was a degeneration from the more realistic images, in which everybody can recognize, say, a crocodile, to the most simplified, in which verisimilitude is subordinated to regularity, symmetry, and economy.[13]

If one applies the criteria of academic realism to the African masks and figurines exhibited in European ethnographic museums, they are not acceptable as representations of men and women. They are more akin to children's drawings than to artists' works. This is how they were perceived at the turn of the century.

At that time, some artists in France and Germany did not share the optimism and complacency of the mainstream. They would later be called the "early moderns." They experimented with new forms and "new" emotions. In France, during the first decade of this century, Vlaminck, Derain, Braque, Picasso, and Matisse were concerned with translating the visual appearances of objects into structures made of cubes and other

regular volumes such as cones, cylinders, and spheres. These Cubists were surprised to discover that some analogous endeavors had been successfully completed in African statuary; traditional carvers of Africa, liberated from the imitation of visual impressions, had composed masks and statues with boldly assembled volumes that were not to be seen in the features of the human beings represented by the icons. In so doing, they expressed their conceptions of the nature of human beings and spirits, and they created works that had an existence of their own, and not merely as imitations.[14]

In Germany, also during the first decade of this century, Kirchner, Schmidt-Rottluff, Nolde, and Pechstein, united in Dresden's Die Brücke, attempted to develop a revolutionary art freely expressing deep and "primitive" emotions in simple linear forms and flat areas of plain colors. As art historian Werner Haftmann wrote, "they invoked the right to deform nature for the sake of expression."[15] When visiting the Dresden ethnographic museum, Kirchner was impressed by Melanesian and African forms, as Derain and Vlaminck were when they discovered African masks and statues in junk shops around Paris. The painters of Die Brücke found in icons from the world-without-writing (as well as in Gothic woodcuts) the expressive strength of simple forms and liberation from imitating nature.

These French and German painters were the first to recognize the aesthetic value of the images carved in nonliterate societies. Art critics followed the painters' lead. Carl Einstein, in an article published in 1915 and still read, analyzed African sculptures as visual forms only.[16] He concluded that the African tradition was the only one which had really solved the problem of the representation in three dimensions, the European sculpture remaining "painterly" to a large extent. In 1920, Roger Fry wrote that some African carvings were greater sculpture than anything produced in the Middle Ages because they had the special qualities of sculpture in a higher degree; their forms were really conceived in three dimensions.[17]

Books were written on "primitive art" from an exclusively aesthetic point of view, some even stating that ethnographical information was irrelevant.[18] Ancestral statues, ritual figurines, and ceremonial masks were metamorphosed into Western art objects. As most of them belonged to the aesthetic locus of their cultures of origin, and as art is our aesthetic locus, they shifted from the one to the other.

Anthropologists did not initiate the metamorphosis, but they accepted it. Curators of ethnographic museums and dealers in exotica followed avant-garde artists and critics: they organized temporary exhibits and sales of primitive art—which at last may appear without quotes since it now refers to a category of our Western reality. According to Goldwater's chronology, the first gallery exhibit of primitive art took place in New York as early as 1909, and the first museum exhibit opened in Paris in 1923.[19] Museums devoted exclusively to primitive art were founded: in 1957, the Museum of Primitive Art, in New York; and in 1960, the Musée des Arts d'Outremer, in Paris. The ultimate institutional recognition of the aesthetic achievements of the peoples-without-writing was given in the late seventies by the Metropolitan Museum of Art. The Michael C. Rockefeller wing was built expressly for "the art of Africa, the Pacific Islands, and the Americas."

The story of the assimilation of African objects into the art compartment of contemporary Western cultures sheds some light on the ways cultures change.

In the whole process of transmutation from African instrumentality to Western art,

human images were more important than other artifacts. From sixteenth-century missionaries to twentieth-century art critics, more attention was focused on human representations than on any other object. This is certainly due in part to our figurative bias. Our culture has accorded privilege to representations of tangible objects of our experience over nonfigurations which, for centuries, have been relegated to minor functions of ornamentation. It is also due—and more importantly, I think—to the strong significations imparted to the human figure. The way man and woman are represented encapsulates cultural values and gives some access to the imaginary world in which the members of a culture live: how they imagine gods and spirits, how they feel their impact, how they wish to be related to them.

These human icons, pregnant with the dreams and the ethos of a culture, have to make sense in the terms of the receiving culture if they are to find a place in it. The first human images that came to Europe were imported from the kingdoms of the Zaire river basin, particularly from the kingdom of Kongo. Some were charged with magical substances stuffed in a cavity in the abdomen, some were covered with nails in order to increase their power. These strange additions and the threatening features of faces and attitudes suggested the intention of harming. In the European imaginary world of the time, these human images made sense as evil beings.

Images from other cultures do not come in a political and economic vacuum. The way they are integrated in the receiving culture reflects the relationships between the two societies. The Portuguese who, in 1482, reached the mouth of the Zaire river were few and far from Portugal; the kingdom of Kongo in which they entered was a well-organized and rich state. In the following years, Kongo and Portugal were two sovereign states, nominally equal and allied. In fact, Portugal, a world power in the sixteenth century, put pressure on Kongo to obtain slaves for the plantations in America and, simultaneously, to convert the Kongo nobility to Catholicism. Resistance to this program created tensions and conflicts. The human representations of "the false gods of the pagans" were received as such in Catholic Europe.

During the colonization stage, relationships between Europe and Black Africa were different. Africa was militarily occupied and economically exploited. Neither Africans nor their gods were to be feared any longer. Images, together with spears and arrows, pots and baskets, hoes and adzes, were integrated in the Western cultures as documentary evidence of the differences and the inferiority of those who were to be dominated by us. Ethnographic exhibits and museums expressed these crude views in the objective terminology of the scientific theory of evolution, which could not be offensive to anybody except the ignorant.

Later, the chance encounter of the aesthetic research of a few artists, who later would become leading painters of the twentieth century, and of the formal solutions embodied in many African carvings, called the attention of the art establishment to the aesthetic quality of these carvings.

This suggests that there are only two options for integrating instrumental objects which have lost their original function because they are no longer in their original context: to adopt them as documents, or as art. The loss of the original function does not only result from transfer from one culture to another: it frequently occurs from obsolescence within one culture. What are we to do at present in North America with an oxen yoke, an aircraft propeller, or a calumet? Place them in an ethnographic or folklore circuit

(curiosities stores and exhibitions, interior decoration supplies, specialized or local museums). Or place them in an art circuit (art galleries and museums, critics and collectors) if their aesthetic quality is deemed to be significant enough.

Noting the considerable number of art objects by metamorphosis on the art circuit, it is tempting to see one of the origins of the Western category of art in these items which lost their primary function by conquest or obsolescence, processes particularly frequent in Western history since the Renaissance. Rapid obsolescence of an increasing number of instruments is a result of the accelerating pace of technical change. Domination and exploitation have characterized the interaction of Europe with many distant countries since the age of the European exploration of the seas and continents of the earth. In the large quantity of objects having lost their original instrumentality, some displayed aesthetic forms. By perceiving and contemplating these forms, beholders gave a new meaning to these objects and made of them art works.

The Aesthetic Object as Symbolic

PIET MONDRIAN. *Broadway Boogie Woogie.* 1942–43.
Collection, The Museum of Modern Art,
New York.

Meanings in Aesthetic Objects

IN AESTHETIC ENCOUNTERS, BEHOLDERS' MINDS ARE ABSORBED IN CONTEMPLATING THE visual forms of objects. Content and material, anecdote and depicted subject, war horse and nude woman fade away and leave the beholder's attention concentrated on the "flat surface covered by colors arranged in a certain order."

These ideas, put forward in the first part of this book, seem to epitomize what has been called *formalism* and *aestheticism*. For those who use these terms in a derogatory sense, granting aesthetic significance only to visual forms amounts to divesting aesthetic objects of any meaning. It is their conviction that an object reduced to its visible forms may at the most offer some delight to the eyes of the effete and decadent but would offer no meaning worth the attention of the serious person. Bottles and apples, breasts and legs are deprived of sense when perceived as Cézanne's famous cylinders, spheres, and cones. If there is no subject matter, then there is no meaning.

In the aesthetic experience, do forms have meanings apart from what they represent?

Some time ago, I was looking at Mondrian's *Broadway Boogie Woogie* exhibited in the Museum of Modern Art in New York City. It is a typical Mondrian geometrical composition of vertical and horizontal bands that traverse the whole surface. In this painting, the bands are adorned with small colored squares, and in some of the rectangles delimited by the strips there are other squares and rectangles. Whereas Mondrian's style has shown a persistent trend toward simplification and reduction, *Broadway*, which was painted in 1942–43, at the end of Mondrian's life, indicates a sort of reverse movement. Although every shape is still rigorously at right angle or parallel to the fundamental grid structure of the painting, it is more filled in and varied than some of his earlier compositions.

Knowing this piece of information concerning Mondrian's evolution, I mentally compared *Broadway* with the older, "purer" Mondrians I had seen and that I remembered. These mental images of other paintings were soon replaced by an attempt at reading the picture as a map of city blocks—suggested by "Broadway" in the title. The bright colored

squares, irregularly spaced, were interpreted as cars in the streets, seen from above. But the oblique of Broadway north of 42nd Street was not to be found in the picture. Before long, the second part of the title, "Boogie Woogie," evoked sounds and rhythms of jazz and the bright colored squares became joyful musical notations. I reminisced about a period of my life when I simultaneously discovered jazz and Manhattan. I was still seeing the picture, but I was not looking at it.

I directed my attention to the canvas. Thoughts and comments, associations and remembrances, the sadness and pleasantness of nostalgia receded into the background and subsided. There was a shift to a nonverbal contemplation: a quiet but intense vision of the painting. It was perceived as if seen for the first time, as if seen "as it is." Everything inside the frame was vividly present; beyond the frame, the wall and the world had a weakened existence. I was not aware of the passing time. After a few seconds, or a few minutes, or perhaps even many minutes, Mondrian's grid appeared as an intended order, a firm underlying scheme for life, on which the bright points of particular actions and emotions are arranged and located, classified and controlled. This thought was not the result of reasoning; it did not arise as a possible interpretation of a nonfigurative painting, which should be compared to other possible interpretations so that the best one would be retained. It appeared as an insight about life, an intuition about a certain manner of ordering one's life. This idea was made visible in the Mondrian painting.

What is described here in retrospect is verbalized and analytical. When I was contemplating the painting there was no verbal analysis, no distinction between *order* as a concept and as visually expressed by the painting. Order had the evidence and the presence of an experience in which one is involved. Yet order did not appear as restricted to the painting; as beholder I was aware that the Mondrian canvas was not life, but I perceived life and the canvas as sharing the same quality of order. Order in life was better understood because of the Mondrian, and order on the painted surface was better apprehended because it corresponded to a part of the life experience of the beholder. At the time of the visual commerce with the painting, I did not make any of these distinctions. Order was not a word but an experience. It was what the aesthetic object meant to the beholder.

This meaning was not provided by what the painting represented nor by its title. It was not an image of entities that we, or even Mondrian's contemporaries, could have recognized. It was not a part of the map of Manhattan, it was not a picture of the lights of Times Square, and it was not a representation of a group playing jazz. The meaning was provided by visual forms that were not figurative. This meaning of order was directly perceived in the forms.

From Mondrian's *Broadway*, I walked to another painting on exhibition at the Museum of Modern Art, Jackson Pollock's *Number 1* (1948). It was impossible to miss: its size is about nine by seventeen feet. What I knew about Pollock irrupted in my mind. Pollock had been discovered by Peggy Guggenheim and had had a short and brilliant career as the leading figure of the Abstract Expressionist movement. He had been the inventor of *action painting*, a technique of dripping liquid paint on a canvas stretched on the floor. *Number 1* was, in fact, a good example of the result achieved by that technique.

After remembering these bits of information, I succeeded in visually concentrating my attention on the thick impasto. The painting became an overwhelming presence. At the top layer, the eye followed one of the many white lines formed by the drippings. Not for long, however, as these lines were short and unconnected, resulting from brisk

JACKSON POLLOCK. *Number 1, 1948*. 1948.
Collection, The Museum of Modern Art,
New York.

movements of the hand apparently liberated from any rational control (the painter, in a trancelike state, worked rapidly). My attention then shifted to the texture under the drippings, a field of blots and irregular small marks. After a period of purely visual concentration—during which time none of the above description was verbalized—the meaning of the painting imposed itself on the contemplative awareness of the beholder: undirected energy, random movements of a matter in the process of becoming.

Another Abstract Expressionist painting, *Edge of August* (1953), by Mark Tobey, hung nearby. He painted it in his particular "white writing" style, covering the ground with small marks looking like the characters of an Oriental script. The little white strokes constituted an intricate network which appeared to stand, as a white cloud, a few inches away from the canvas. A triangle in another texture in the bottom left corner, and a narrow area to the right side, part golden yellow like a wheat field and part dark blue like a night sky, contributed to the three-dimensional impression suggested by this nonfigurative painting. The visual attention of the beholder was effortlessly kept on the canvas. Once again, my state of self-awareness receded and was replaced in the foreground of the mind by a visual absorption in the painting.

During this contemplative commerce with the object, I intuitively perceived it as the visual equivalent of quiet illumination. It was not experienced as an outburst of light, but as a soft clarity which totally permeates what is to be understood. Illumination, as meaning of the painting, imposed itself on the beholder. It did not appear as the best interpretation that could be argued for, but as an evidence. *Edge of August* meant illumination because it suggested an experience of it.

In the three aesthetic encounters just described, the meanings of the paintings were conveyed by their formal features: lines and colors, shapes and textures, contrasts of light and darkness. These three works were not figurative: they were not images of people or things that could be recognized because they existed in the outside world. Certainly, some lines evoked streets as drawn on a map, some colored squares could be read as markers for cars, some areas suggested by their hues earth or sky, day or night. But none of these configurations was a visual representation of a street, a car, or a country landscape. The three pictures were content-free, uncontaminated by represented items; the meanings we read in them could not be derived from outside subject matter as none was to be found.

Clearly, forms have meanings.

When paintings are images, forms represent warriors or peasants, forests or seashores, apples or water lilies. Obviously, these items contain meanings for those who observe them in the outside world. When represented on a canvas and aesthetically perceived, are their meanings derived from the forms on the canvas, or from the subject matter, the object as it is in the outside world? After all, Cézanne's apples are apples and Monet's water lilies are water lilies. The external object as conveyer of meaning seems to be more evident in pop art, where the imagery from advertising, packaging, comic strips, and fast-food items is so eye-catching—as it is an unusual imagery in the Western repertory of artistic motifs. Meanings seem to be generated by the outside objects rather than by the forms on the painted surface.

I concentrate my attention on Roy Lichtenstein's *Blonde Waiting* (1964). It is not easy because only a book reproduction is available to me, whereas the original oil painting is a

MARK TOBEY. *Edge of August*. 1953. Collection, The Museum of Modern Art, New York.

ROY LICHTENSTEIN. *Blonde Waiting*. 1964. Private collection, Los Angeles. © Lichtenstein / VAGA, New York, 1985.

four-by-four-foot canvas. Nevertheless the picture is strong enough to sustain a visual contemplation even when reduced to a four-by-four-inch photograph. Intense attention is given to the flat colors and the thick black lines delimiting the shapes. What the picture conveys to me appears with sudden evidence, *instability* and *anxiety*.

Is this meaning in the formal features of the picture or on the face of the young woman represented on the canvas? I look again at the photograph, this time in an analytical mode. The central area of the picture is strongly framed. First, it is in the middle of the square surface of the canvas. Second, the brighter center is framed again by the vertical yellow and black straight lines on the left side, by two horizontal straight black lines below, and by an array of darker flowing and curved lines above and to the right of the smaller "square."

In fact, this central area is unbalanced. The darker organic lines at the top visually have more weight than the two straight lines at the bottom. When there is more visual weight above than below, it is perceived as a lack of stability. In order to check this interpretation, I turn the book around and look at the picture upside down. It is immediately stabilized as the parts with more weight are at the bottom, offering a firm basis for the heavy vertical lines at the sides.

Returning the picture to its normal position, I look at the center. There the dominant lines are oblique, from upper left to lower right, an orientation visually perceived as "descending." The forms, when analyzed as forms, are in disequilibrium, and those located at the visually most important position, the center, are moving downward.

This analysis, made in retrospect, seems sufficient to explain why the contemplated forms gave the beholder the intuitive meaning of instability and anxiety. Imbalance and slipping down are, indeed, destabilizing and do create anxiety.

In the case of *Blonde Waiting*, shapes and colors on the painted surface are also representational. We may look at this Lichtenstein as if it were a window—or a keyhole through which we peek at a scene in an actual room, and analyze it in terms of the depicted subject matter: a young woman lying on a bed, her head resting on her shoulder and crossed forearms. She looks at an alarm clock on a table, near the brass headboard of her bed. Behind her, a Venetian blind is shut. Her face is very close to the beholder. The frown of her eyebrows, the tension of her mouth express annoyance and irritation. The whole scene suggests distress. The woman seems to expect somebody who is late; she is worried by the lateness which is ominous. The picture's caption, "blonde waiting," confirms this interpretation.

It is tempting to say that the Lichtenstein painting as a configuration of forms and as the representation of an anecdote, conveys similar meanings: instability and anxiety, worry and impending danger. First, there was an aesthetic apprehension of the painting, made in a contemplative mode of consciousness, during which the meanings of instability and anxiety were intuitively perceived. Then, in a cognitive mode of consciousness, I proceeded to two analyses. A formal analysis related the intuitive meanings to some features of the painted canvas, and a representational analysis revealed meanings convergent with the ones discovered in the forms.

If we admit the duality of form and subject matter, we can add that when form and subject matter compete for the attention of the beholder, what is represented is often the winner. The compelling presence of the outside world—here, the woman in the room—must be overcome if we want to concentrate our vision on the forms as such. But is the

form – representation distinction a useful one for clarifying the relation between aesthetic objects and the meanings they convey? Let us further consider the validity of this distinction in the light of a few more examples.

The human body in the nude is a perennial motif in the Western fine arts. For art historian Kenneth Clark, this "art form invented by the Greeks in the fifth century" is the only one of "those inheritances of Greece . . . revived at the Renaissance" which has survived in our century. "It may have suffered some curious transformations, but it remains our chief link with the classic disciplines."[1]

Innumerable images in two or three dimensions have the same subject matter, the female figure in the nude. Yet their meanings are quite different. The famous picture *The Source* (1856) by Ingres represents a girl standing with a water jug on her shoulder. A complete description of what is represented includes other features: she is standing on the edge of a pool of still water; behind her is a wall-like rock; and she is holding the jug so that water is gently flowing from its neck. But her body, in full frontal view, is obviously the dominant subject matter of the painting.

To this beholder, Ingres's *Source* conveys the meaning of poise, a blend of openness and reserve, which results in gravity and naturalness. This intuitive meaning is supported by subsequent formal analysis. The vertical lines of the left body contour and of the water flowing from the jug, the right angle of the elbow, and the short horizontal line of the forearm above the head give a straightforward linear composition and accentuate the frontality. The formal statement has directness but no rigidity: the curves on the right side of the body balance the straight lines on the left side.

These meanings conveyed by the forms are analogous to those we can read in the picture as representation. The eyes and traits of the woman's face express calm and serenity. She presents her body in full view without affectation and embarrassment, but by closing the knees, she makes herself sexually inaccessible. As Rudolf Arnheim wrote about this painting, "In the center of the silent plane lies the closed sanctuary of sex."[2]

From the point of view of formal and representational meanings, it is of interest to compare *The Source* by Ingres with its pop "interpretation," *Ode to Ang* (1972) by the Californian painter Mel Ramos. Stating that "art grows from art," Ramos has used famous pictures by Velázquez, Giorgione, David, Modigliani, de Kooning, and others as "sources" in the same way other pop artists—and Ramos himself—have taken comic strips as sources for their own paintings.[3] Ramos faithfully reproduces *The Source*'s composition in his *Ode to Ang* ("Ang" is another pop interpretation, this time of the name Ingres) but the style of representation is totally different. It is the pseudophotographic naturalism of commercial art in advertising and magazine illustration. This naturalism pretends to provide a representation as accurate as a photograph; and indeed sharpness of lines and distinctness in the rendering of details may duplicate a perfectly focused photograph. But lusciousness of shapes, smoothness of texture, and the glowing flesh reveal an idealization of the body that goes beyond the possibilities of a camera.

Difference in painting techniques—the slick sharpness of Ramos as opposed to the soft brushwork of Ingres—contributes to conferring completely different meanings to pictures otherwise so similar. Instead of poise with the connotations of gravity and sincerity, the Ramos painting conveys the meaning of fun. Certainly, the precise and glossy rendering is significant in the metamorphosis of an innocent nineteenth-century

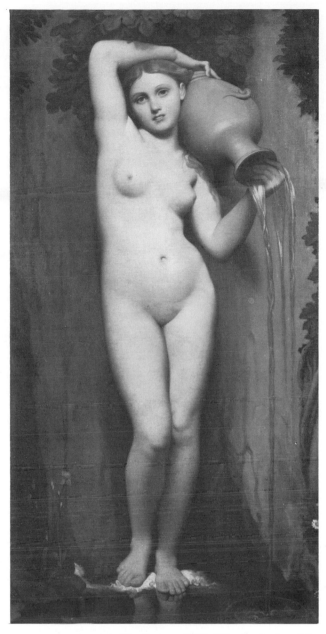

JEAN INGRES. *The Source.* 1856. Musée du Louvre, Paris. Photo: Musées Nationaux.

MEL RAMOS. *Ode to Ang.* 1972. Wilp Collection, Düsseldorf.

youth into an inviting twentieth-century California girl. But, in addition, representational features concur in conveying the light and pleasant meanings summarized by the word *fun*. There is the representation of nakedness rather than nudity: the absence of clothes is felt as a lack because the selective suntan reminds the beholder that the woman usually wears a two-piece suit on the beach. There is the unexpected weasel and the suggestion of playfulness in water and sun. There is the light-hearted irreverence of the parodic interpretation of a classic masterpiece.

In a stable rectangle, in which the longer side is horizontally oriented, Modigliani painted the *Reclining Female Nude* (1917). Within this frame, the dominant direction is a

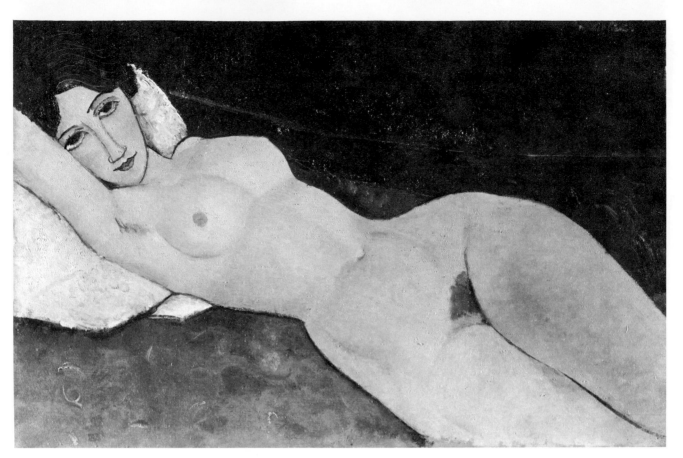

AMEDEO MODIGLIANI. *Reclining Female Nude*. 1917.
Staatsgalerie, Stuttgart. © ADAGP, Paris / VAGA,
New York, 1985.

descending oblique, from the upper left corner to the lower right one. This direction is
restated by a thin white line above the oblique. On the dark ground, the body contour
encloses a brighter area which extends, across the painting, along the axis of the domi-
nant oblique. Visually, this lighter surface is pulled down from the lower right corner by
the weight of the larger brighter surface in this corner. When we pay attention to the
person represented, we notice that this visually heavy area corresponds to her hips and
thighs—which are frontally seen whereas the body from waist to shoulders is presented
laterally. The eyes, open but dreamy, and the body lying in a sleep position suggest a
vegetative rest. All these traits contribute to the meaning of earthiness that can be
apprehended in this Modigliani painting.

This painting was a source for another interpretation by Mel Ramos. Despite the
aggressively pop title, *You Get More Salami with Modigliani No. 14* (1978), his painting is
serious. The general composition is similar to the Modigliani. The bright area of the body
is obliquely set up on the darker ground, but it is not weighted in the same way: the hip
region is thinner than in the Modigliani, and it is visually balanced by the large bright area
of the pillow. A strong projected light produces sharp shadows instead of the diffused
light in Modigliani's painting. Ramos's photographic style makes the woman repre-
sented more present. She does not daydream but establishes eye contact with the
beholder. For this beholder, the picture states that communion of thought and intimacy
of senses makes a woman-and-man relation whole.

In *The Blue Sofa* (1967) by Paul Delvaux, depth is obtained by an ostensible application
of the Renaissance principles of central perspective. From the plane of the canvas, the
planks of the floor and the girders of the glass roof converge to a vanishing point; the

MEL RAMOS. *You Get More Salami with Modigliani
No. 14.* 1978. Collection Dewain Valentine, Venice,
California.

glass wall, with repeated right angles, and the sofa are frontally placed as on a theater
stage. The structure of the space is made as visible as in the outside world. In fact, it is
more visible. The external world here is the trivial environment of a European suburb
with a cobblestone street, a railway bridge, and a distant cyclist. It is night, and the
almost-empty streets are lighted by a few public lamps.

Yet this commonplace scene is very strange. A strongly bluish light pervades the
whole picture and colors everything in cool blue. One nude young woman is sleeping on
the sofa while another one, standing, holds a candle. It can be said that the form (the
stressed elements of perspective, the blue tonality) and content (the incongruous nude
figures) contribute to the strangeness and eeriness of the depicted scene. Looking at the
central figure of the painting, the woman on the sofa, the beholder is made aware of the
actuality and consistency of her oneiric world. She is dreaming. What we see is what she
dreams, and at the same time it is the solid outside world of everyday life. The line cannot
be drawn between the inner world of dreams and the outer world of cobblestones and
street lamps. This is what the Delvaux picture means to this beholder.

Tom Wesselmann's series *The Great American Nude* was begun in 1962. Closer to the
Western fine arts tradition than are most of the other pop artists, Wesselmann has used
two classic art forms, the nude and the still life, and has duplicated some of Matisse's
color techniques. His *Great American Nude No. 92* (1967) is a composition radiating from a
central triangle from which centrifugal motion lines originate; they are kept in balance as
they compensate one another. The central triangle is also an image of the pubis of the
woman lying on a piece of material spotted as leopard fur.

The style of representation is abstract. Except for the three oranges, which are

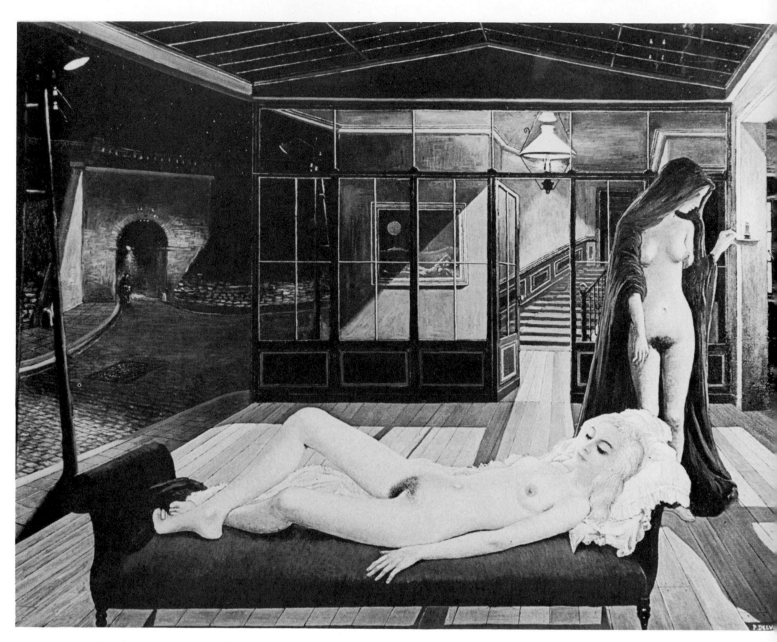

PAUL DELVAUX. *The Blue Sofa*. 1967. Private
Collection, Brussels. © SPADEM, Paris / VAGA,
New York, 1985.

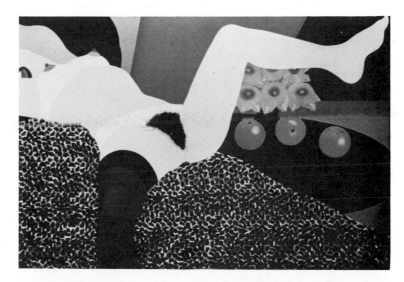

TOM WESSELMANN. *Great American Nude No. 92.*
1967. Private collection, New York. © Wesselmann /
VAGA, New York, 1985.

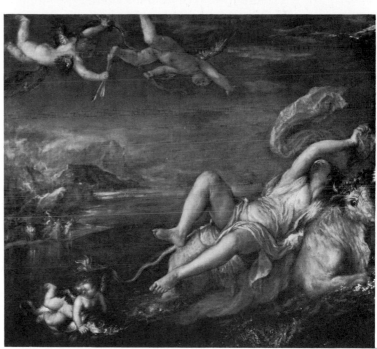

TITIAN. *The Rape of Europa.* c. 1560. Isabella Stewart
Gardner Museum, Boston.

shaded, there is no pictorial suggestion of volume: body, curtains, and tabletop are
rendered by colored fields of uniform value and intensity. It is also a style of simplification.
Only the erogenous parts, associated with sexual ecstasy, are represented. Ecstasy is
another classical theme. "In the nude of ecstasy, the will has been surrendered, and
the body is possessed by some irrational power . . . and flings itself backward."[4] The
Wesselmann *No. 92* displays an unexpected resemblance—even in the movement of the
raised leg—to the *Rape of Europa* (c. 1560) painted by Titian. The meaning of the Wessel-
mann picture is erotic. It is a joyful celebration of the fulfillment of desire.

In discussing this series of figurative pictures presenting the female figure in the nude as central motif, we analyzed each of them as conveying two sets of meanings, the formal and the representational. The representational meanings were derived from the depicted subjects as existing independently from their presence on the framed surface. If we had met Modigliani's model, we would have found her dreamy and passive; Ramos's model, on the contrary, would be lively and articulate. A painting is a window through which we look at actual persons—or so we think.

In fact, we do not *see* the Modigliani or Ramos women anywhere other than on the "flat surface covered by colors arranged in a certain order." The calm and serenity of *The Source* are not read on the face of a person but in some pictorial forms. The subject matter independent of the forms on the canvas cannot be visually attained. We may daydream about her, or him, or it, and let our imagination go; or we may build an abstract concept of the subject matter (the female figure in the nude, or the apples). But the meanings of visual objects do not lie in imaginary beings, nor in abstract concepts, they lie only in the visible.

From the point of view of the meanings of the visual, the form—subject matter distinction is of no use. There is no subject matter independent of lines and shapes, colors and textures, brightness and darkness. Figurative works are not different from nonfigurative works in this respect. Their meanings lie exclusively in their forms.

CHAPTER NINE

Visual Forms as Signs

IN MY AESTHETIC VISION, MONDRIAN'S COMPOSITION OF VERTICALS AND HORIZONTALS stood for order, Tobey's light cloud stood for spiritual illumination, and Delvaux's scene in blue stood for the continuity of the external and oneiric worlds. In these and in the other cases discussed, "meaning something" was equivalent to "standing for something." However, the switch from "meaning" to "standing for" suggests another avenue of analysis.

In common language—our constant guide because it expresses the collective reality built by our society—something that stands for something else is called a *sign*. This directs us to the field of signification.

The relationship of signification may be formalized, on the basis of everyday language and the implications of its practice, in the following paradigm: *In context M, sign A stands for signified B to subject X.*

Sign and *signifier* are generic terms for any item that stands for something other than itself. Such items include the stars and stripes; the Rolls Royce; the color red; and the *liṅga*, the stylized phallus honored in some Hindu cults. Each of these respectively stands for the United States of America; having great wealth; danger; and Śiva, the god of destruction and creation. The concept antithetical to sign denotes that an item stands for itself. Let us refer to this concept using the word *entity*. A tree, a house, and a rock are entities.

But a Rolls Royce and a stone carved in phallic form are also entities, are they not? The sign—entity opposition is exclusively conceptual: any material item can be classified as an entity (it exists here and now) and as a sign (we may make it stand for something else). However, some items are primarily recognized as signs (for example, flags and traffic lights), while others are recognized as entities (for example, tools, animals, and people). If the question What does this item mean? is appropriate, we may conclude that the item is primarily regarded as a sign.

Reviewing examples illustrating the paradigm of signification, one soon realizes that there are different ways a sign stands for a signified, and that there are words denoting these various types of signification.

In English the word *sun* stands for the star that is the basis of the solar system and the source of light and heat; the word *moon* stands for a satellite of the planet Earth. The relationship between *sun* and its signified is arbitrary, as is the link between *moon* and its signified: other English sounds could have been used to signify the star of light and the night satellite. Because the word-signified connection is arbitrary, it is conventional; past and present generations of English speakers have implicitly agreed, and still agree, that what is written *sun* and what is spoken as *sun* stands for the day star. The implicit collective agreement is revealed by the transmission of English vocabulary from parents to their children, who must learn which word stands for what thing. Non-native English speakers must learn the conventional connections between words and things later in life. The lexicon of any language is an arbitrary and conventional code that has to be learned.

There are two partial exceptions to this generalization. Some spoken words of onomatopoeic formation imitate natural sounds (for instance, *buzz*, *crack*, and *cuckoo*); and some written words of pictographic formation imitate the visual appearance of the things for which they stand (for instance, the Chinese characters for tree, root, and rice paddy evoke the visible forms of their signifieds). These are only partial exceptions as their natural connections with sounds and forms have been formalized to such an extent that they too have become conventional.

Thus, words can be said to be signs that stand for their signifieds by conventional reference. Signs by reference may be called *referents*. Referents constitute a first subclass of signs.

A bicycle is an instrument for transportation. During the 1960s and 1970s in affluent industrial nations, it became a sign of ecological concern. The bicycle was and is perceived as an exemplary vehicle. It does not use energy from fossil fuels—nonrenewable sources—and it is not air-polluting. The bicycle makes it possible for one to apply in one's life the mottos "Small is Beautiful" and *vivere parvo*. The bicycle stands as a sign of ecological orientation by being associated with the reduction of wasted energy. It is an *indicator* of its signified by a usual and stable association with it.

Yet the association is incidental. In Europe during the 1920s and 1930s, the bicycle was an indicator of working-class status. In colonial Africa during the 1950s, it was associated with African white-collar employees. The connection this indicator has to each of the three signifieds is not arbitrary: ecology-minded people, working-class Europeans, and African clerks actually used bicycles. Nevertheless, indicator–signified associations, though lasting for some time, were not necessary. Bicycle as vehicle is not intrinsic to any of these three groups.

Indicators, defined as signs by association, constitute a second subclass of signs.

A third subclass of signs consists of *images*. The *Portrait of a Cardinal* by El Greco stands for a particular individual—presumably Cardinal Don Fernando Niño de Guevara—by a similarity of visual appearance. Looking at the portrait, we see Guevara pretty much as a visitor calling on him would have seen him during the year 1600, in his Inquisitor-General office in Madrid. Images are visual duplicates of persons, things, landscapes, and any other visual entity that can be seen in the external world.

Images thus stand for the visible entities they signify by resembling them.

Symbols constitute a fourth subclass of signs. Undulating lines engraved on a slab of stone symbolize flowing water as wavelike patterns appear both in streams and on the stone. In Sri Lanka, banners and other festive trimmings of a yellow-orange color

EL GRECO. *Portrait of a Cardinal*, probably Cardinal Don Fernando Niño de Guevara. c. 1600. The Metropolitan Museum of Art, New York. Bequest of Mrs. H. O. Havemeyer. The H. O. Havemeyer Collection.

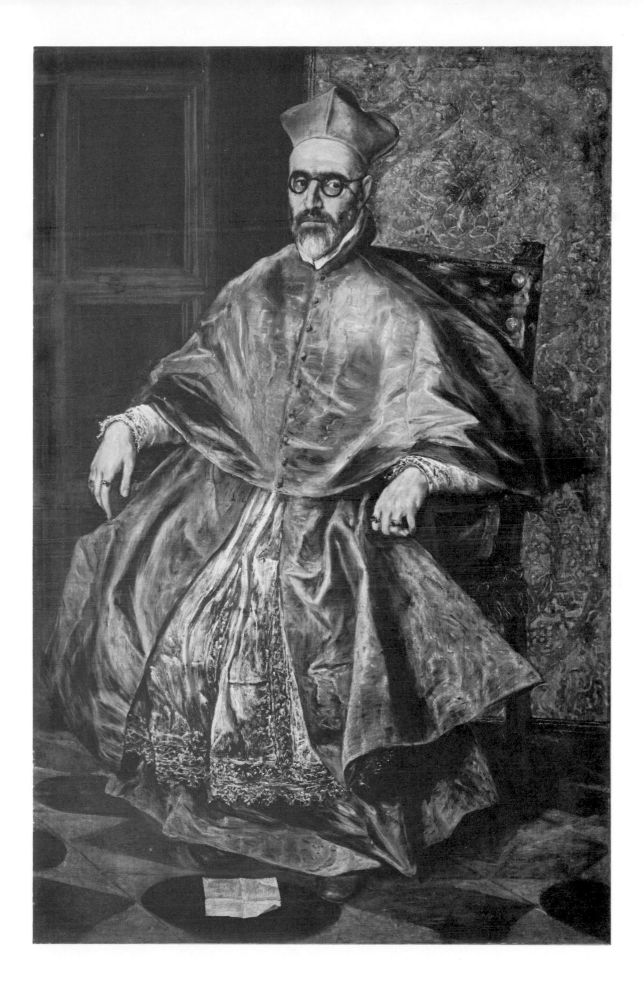

symbolize the monastic order, as these banners and monks' robes have that color in common. The connection between a symbol and its signified is by partial identity or analogy: undulating lines and the yellow-orange color are identical in the signifiers (engraved slab and banners) and in the signifieds (flowing water and robes). Because of this connaturality, the relationship between symbols and what they symbolize is close and free from artificiality.

Symbols are defined as signs standing for their signifieds by participation.*

Referents, indicators, images, and symbols stand for what they signify in a *context*. The context is an essential part of the description of a signification relationship. Without the context of a sentence, the word *star* may, according to my dictionary, refer to ten signifieds.[1] A sentence is necessary and sufficient for clarifying to which of the ten possible signifieds the word *star* refers. For example: "The sky is clear tonight, there are many stars"; "This party is a success, there are many stars"; "There are many stars on the flag"; and "My horse is the one with the star."

The context may be a historical situation. The bicycle, as an indicator, is different in each of the three historical periods mentioned above. The context may be cultural. The swastika is a referent standing for a different signified in ancient India, among the Navaho, and in Nazi Germany.

Signs should not be separated from context. This is generally recognized. Yet contexts are often insufficiently described or are even forgotten altogether. Some studies purporting to interpret signs seem to ignore the importance of placing a sign in its historical and cultural environment.[2]

It is less generally recognized that the relationship of signification includes a *subject* as an essential element. To signify is a mental act: for the signification to exist it has to be posited as part of the construction of reality and be perceived as such.

The subject is the individual stating the relationship between signifier and signified and recognizing it—where else but in individual minds could this be done? Here, the subject is not the individual as unique and different from any other individual, it is the individual-in-collectivity as expressing the actual or potential consensus of a group. The group, or the collectivity, may be a society in its totality, a well-delimited segment of a society (as the members of a profession, for instance), or a nonorganized aggregation (as, for instance, a concert audience or the visitors to an art exhibit). It is the collectivity made of those who posit a signification and those who perceive it.

The consensus of a community of minds, a condition of any signification, should not be understood as the learning of a code, a condition of the signification by reference. A code, as previously stated, is conventional: it is based on an explicit or an implicit agreement. On the contrary, the association between an indicator and what it indicates, the resemblance between an image and what it represents, and the analogy between a symbol and what it is connatural with do not require the learning of a code. Nevertheless, it has to be stated and recognized in a certain context by a subject. In order to perceive the symbolism of natural similarity in the color of festive banners and monks' robes, one must achieve some familiarity with the Sinhalese culture. But there is no code to be learned.

*This terminology differs from the one used in my *Introduction to Aesthetic Anthropology* with respect to three concepts: what stands for something else (here, "sign" or "signifier") was called signifier, and never sign, in the *Introduction*; what the signifier stands for (here, the "signified") was called referent in the *Introduction*; and what stands for something else by convention (here, "referent") was called sign in the *Introduction* (Maquet 1979: 86, 89, 90).

We notice that a certain sign is distant from its signified whereas another sign is close to its own signified. In fact, the four subclasses of signs, when listed in the order of their presentation—referent, indicator, image, and symbol—reveal an increasing closeness between signs and what they stand for.

Referents (that is, mainly words) and their signifieds (things or ideas) belong to different logical categories. They are linked only by a convention validated by the continuous usage of those who speak a certain language at a certain time.

Indicators can be described as temporary metonyms. Like a metonym, an indicator is part of the configuration defining its signified. For example, the crown, an attribute of the royal government, designates the royal government as a whole. The indicator, however, is firmly associated to its signified only for a certain time and in a certain area. For a few decades, riding bicycles was one of the identifying features of working-class men. Indicators are closer to their signifieds than referents are: they are part of what they refer to, but not a necessary and intrinsic part, only an incidental one.

The connection between an image and what it stands for is not incidental; it is isomorphic. The image has a visual structure similar in appearance to the external object for which it stands. Of course, the visual structure is as similar to its object as the medium allows it to be. Sometimes the three dimensions of a volume are transposed into two on the surface of a canvas, or colors are transformed into shades of black and white in a drawing or photograph, or the rough texture of a stone may be represented on a slick and glossy paper. So the image is something other than the external visible entity it represents, but it could not have been made without it. The image stands on its own only after the external entity ceases to exist. There is no Cardinal Guevara any more, but there is still his portrait by El Greco.

Signification by participation establishes the closest relation between sign and signified. A symbol and what it symbolizes have something in common; they are partly identical. The yellow-orange color visible on banners and robes is the same. Banners symbolize robes by sharing the same color. We can go a step further and say that the sign–signifier duality is not entirely maintained in the symbolic relationship. It tends to become blurred.

The terms and definitions proposed here are consonant with common language and our humanistic tradition. They are not entirely congruent with the terminologies used by some contemporary social scientists interested in symbolism. Several of them, such as Milton Singer and Melford Spiro, have chosen to derive their semiotic terms from the conceptual framework designed during the last century by the famous Harvard logician and mathematician Charles Sanders Peirce (1839–1914). It is useful to indicate the main points of divergence.

One of Peirce's definitions of sign is "anything which is related to a Second thing, its Object, in respect to a Quality, in such a way as to bring a Third thing, its *Interpretant*, into relation to the same Object, and that in such a way as to bring a fourth into relation to that Object in the same form, *ad infinitum*."[3] In this triadic model Peirce relates sign to its object as something that refers to something else. Part of our paradigm, "sign stands for signified," is in accordance with the Peircian definition. *Object*, as used by Peirce, is a common and convenient term for *signified*. We use the latter in order to stay clear of any confusion with *object* denoting artifact.

The third term of Peirce's triad, interpretant, is more difficult to define. I have briefly discussed this matter elsewhere.[4] Suffice it to say that most social scientists who derive

their terminology from Peirce seem to ignore interpretants. We may do the same if interpretant is understood as the whole semiotic context which is a cultural constant.

Peirce's *icons* include *images, maps,* and *diagrams.* Our notion of image agrees with his acceptation of this term. For him, in "maps" and "diagrams" the similarity of sign and signified derives from internal organization and not from visual appearance.[5]

Peirce's *symbol* is a conventional sign. In our use, *referent* corresponds to what he calls symbol. We part company with Peirce and his followers in the social sciences on this important matter. Signification by participation is an essential type of relationship in the aesthetic field, and the word *symbol* was and still is used to denote it in the tradition of the humanities. This tradition is expressed in many important works. For instance, the use of symbols as nonconventional signs is constant in Jung. In the dictionary compiled by the members of the Société française de Philosophie, the symbolic relationship is described as natural, and symbol, as a sign "opposed to artificial sign in that it possesses an internal power of representation; for example, the serpent biting its tail as symbol of eternity."[6]

Peirce's *index* "which refers to the Object that it denotes by virtue of being really affected by that Object" is a concept between indicator and symbol in our terminology.[7] Like our indicator, the index is firmly associated to its signified, but like our symbol, it is connatural to it. For Peirce, the height of a mercury column in a thermometer is an index of temperature, and the symptoms of a disease are indices of that disease.

An excellent example of the three Peircian types of signs as used in cultural anthropology is provided by Spiro in a recent essay. He writes that, by Peirce's definitions, "a relic of the Buddha is (or is believed to be) an index of him; a sculpture of the Buddha is (or is believed to be) an icon of him; and the word 'Buddha' is a symbol of him."[8]

This brief discussion of the paradigm of signification provides us with a set of conceptual tools—the category "sign" and its four subclasses, the individual-in-collectivity, and the context—as essential parts of the relation of signification. Let us pursue our elucidation of the aesthetic experience by analyzing aesthetic objects as signs.

Many aesthetic objects are figurative, and thus they are images standing for an external signifier by visual resemblance. This iconic meaning, as far as it leads the viewer away from the representation and to an imaginary external thing or scene, has a negative impact on the aesthetic experience. It should be stressed that when beholders wander from the painted mountain or the Aphrodite carved in marble, they have no access to the great outdoors or a living goddess, but only to mental images of them. That there is no subject matter independent from the forms on the canvas was a conclusion of the last chapter. To approach paintings and sculptures as images distracts the viewer's attention from the visual object.

It also stimulates discursive thinking. On a plaque from Sarnath, we see the images of a sleeping woman, of other human figures, and of an elephant. If we mentally move from the low relief to the scene, we have to know the Buddhist story of the conception of Śākyamuni: his mother, Queen Māyā, dreamt that her unborn child was entering her womb in the form of a white elephant. It has been said that the carved reliefs inserted in the walls and around the doors of many Gothic cathedrals were a "Bible in stone" for the benefit of the illiterate Christians of the Middle Ages. They were images of the Old and New Testament narratives. Believers were expected to interpret cathedral representations using their previous knowledge of the biblical stories. Thus they had to analyze the carvings as images, remember the episodes they had heard while listening to their village

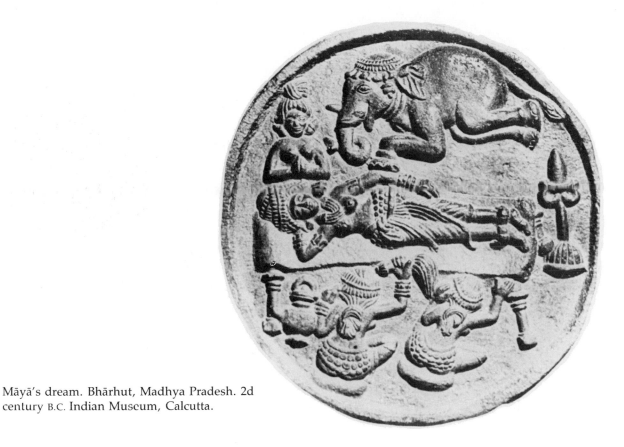

Māyā's dream. Bhārhut, Madhya Pradesh. 2d
century B.C. Indian Museum, Calcutta.

priests, and find the anecdote appropriate to a particular image. This kind of mental
activity is considered to be an obstacle to the contemplative absorption in the visible.

Some formal features in paintings and sculptures can be interpreted as referents,
signs which stand for their signifieds by a convention explicitly or implicitly agreed upon
by a group of people. The good shepherd carrying a lamb on his shoulders, the wheel of
the law, the cross, and the trident are like words that one has to know in order to "read"
the visual forms. In order to fully appreciate a visual object as a sign standing for
something else by convention, one has to learn the code. For instance, that the halo
surrounding the head of some human figures, or even of some animals, refers to the
holiness of the figure represented in the Christian code of signs is a bit of knowledge that
must be acquired by the viewer. That the knot of hair and the long fingers seen on many
statues of the Buddha are two of the thirty-two marks of a superman in the Buddhist
"vocabulary" of forms must be learned in the same manner. When learning these codes
of forms and deciphering the signification of the referents, we are in the cognitive mode
of consciousness, not in the contemplative one.

Indicators, signs that stand for their signifieds through incidental association, are
numerous in the works exhibited in our museums of fine art. In London's National
Gallery, *The Agony in the Garden of Gethsemane* (c. 1580) is one of El Greco's most powerful
paintings. Contrasting with the dominant warm and dark browns, yellows, and reds,
there is in the lower center a dark blue triangular area. Figuratively, it is a sort of cape
upon which Jesus, the central figure of the painting, is kneeling.

I perceived this blue area as an indicator standing for Saint Mary; this blue spot
suggested that Jesus, during his crisis of solitary agony when he so strongly expressed his
feeling of being abandoned by God, was somehow aware of his mother's support. My

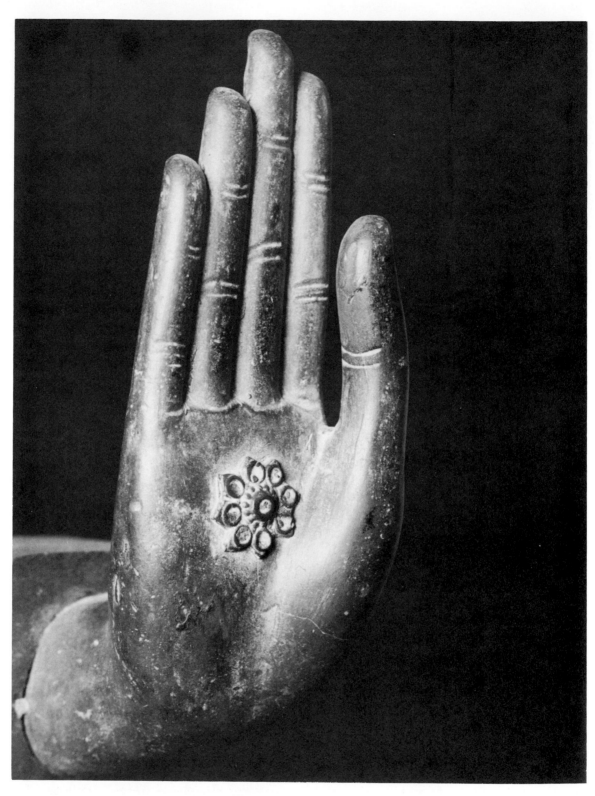

A Buddha's hand with the long fingers mark, in the gesture of bestowing fearlessness *(abhaya mudrā)*. Thai. 20th century. Private collection, Los Angeles. Photo by Jacques Maquet.

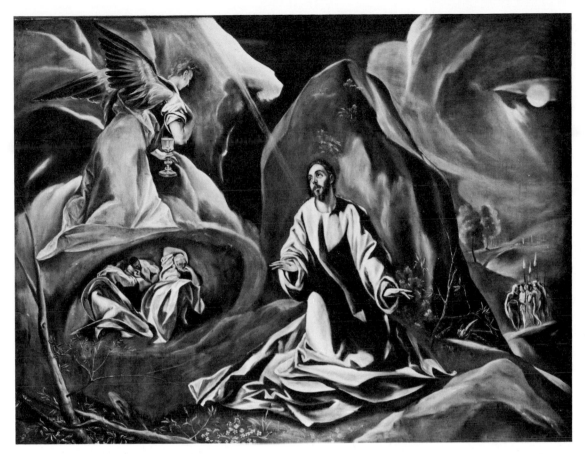

EL GRECO. *The Agony in the Garden of Gethsemane*. c.
1580. National Gallery, London.

interpretation was based on the association of blue with Saint Mary in Christian icon-
ography. Later, I saw that El Greco had painted Saint Mary wrapped in a cape of the same
blue in the *Assumption of the Virgin* (1577), made a few years before *The Agony*. I felt the
probability of my interpretation heightened. Recognizing indicators and determining the
signified with which they are associated require a cognitive familiarity with the specific
subcultures in which the visual objects were made. Again, it is more an intellectual than
a contemplative operation.

El Greco's *Agony in the Garden of Gethsemane* is the image of a scene that can be
recognized by those who are conversant with the New Testament. It includes referents,
such as the angel and the chalice, that can be read by those who know the Christian iconic
code, and at least one indicator that can be interpreted as an allusion to Saint Mary by
those who are familiar with incidental associations common in the Christian tradition.

Similar comments can be made about most of the art works displayed in our
museums: they are signs by resemblance, convention, and association. But these signi-
fications are not rooted in the aesthetic quality of the El Greco. In fact, many paintings
devoid of any aesthetic quality are also images, referents, and indicators. In our earlier
discussion of the form and substance dichotomy, we reached a similar conclusion: a

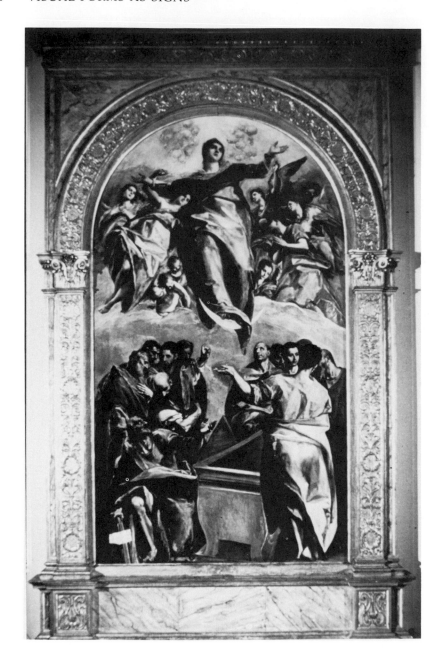

EL GRECO. *Assumption of the Virgin*. 1577. Courtesy
of The Art Institute of Chicago.

picture is not "beautiful" because it represents a beautiful person or a beautiful landscape.
Now we more clearly understand one reason for this: recognizing and imagining,
analyzing and interpreting are discursive mental activities bound to distract from contem-
plative attention to visible objects.

It is not as images, referents, and indicators that aesthetic objects convey meanings
specific to their aesthetic quality: it is as symbols.

Visual Forms as Symbols

SYMBOLS ARE SIGNS WHICH STAND FOR THEIR SIGNIFIEDS BY HAVING SOMETHING IMPOR-
tant in common with the latter. *Nature, essence,* and *identity*—if we take these terms rather
loosely and not in their technical sense in philosophy—express, at least partly, though
imperfectly, what symbolic signifiers and signifieds have in common. Connaturality,
partial identity, and mutual participation convey the sense of the relationship between
symbols and what they stand for.

None of these words is entirely satisfactory because they belong to the discourse
regulated by the principles of identity, contradiction, and the excluded third; the relation-
ship described here, on the contrary, states that the symbol is both identical and not
identical to its signified. This book, of course, belongs to the discourse of rational logic
and plans to remain as such. In order to characterize this relationship in rationally
acceptable terms, we have chosen *participation* as perhaps the best descriptive word: the
symbol participates in the nature of what it stands for.

Mondrian's *Broadway Boogie Woogie* is not only a visible thing which stands for an
invisible idea, order. It participates in what order is. Order is not outside the painting.
The painting makes order visible because it is order. In fact, there is no duality between
this Mondrian and order.

Participation sets symbols apart from other kinds of signs. Signs that stand for
something by conventional reference are clearly separated from their signifieds. The
word *dog* does not participate in the canine nature, nor in the individuality of any animal
designated by that word. We are in the realm of the principle of identity where the sign
"dog" is the sign "dog" and only that; it is not the concept of *Canis familiaris* nor any
particular dog. As already noted, signs by incidental association and by visual resem-
blance are closer to their signifieds than referents are, yet they certainly belong to the field
of duality: the indicator "bicycle" is not a class of people, and a snapshot of a friend, her
image, does not participate in her being.

It was raining in Paris one winter day. I entered the church of Saint-Louis, at the
Invalides, where the monumental tomb of Napoleon has a commanding presence. The

103

space under the dome was suffused with a sunny light which, for a while, looked strange, as the outside weather was dull, damp, and cold. The majestic tomb was bathed in subdued but warm colors. As it happened, there were no tourists that day. The silence was dense, and the immobility complete. Nobody was moving around. I could stand still for some time, just looking at the massive porphyry memorial visible in the open crypt below.

Accustomed to the golden light, imbued with the general stillness, I was, after a few minutes, under the visual influence of the somber tones of the tomb, the straight lines of its base, and the curved contour of its top. At the same time, I was aware of the quality of the space enclosed in the stately architecture of the church.

While I was in this receptive mode of contemplation, a meaning seemed to impose itself in an increasingly pressing manner. It was life as an overwhelming force, as a strong but slow and silent energy that moves on and cannot be stopped by any obstacle.

I left the memorial church still pervaded by these haunting and imposing significations. In the outside mist, I wondered how a visit to the tomb of that great adventurer had produced such powerful intimations on the nature of life. I realized that the glorification of the self-made emperor, who dominated France and Europe for a short time, had escaped me. I was puzzled. My visual perception of the forms had not triggered a recognition of the immortal glory of the emperor. Looking at Napoleon's tomb, I had forgotten Napoleon.

In a retrospective analysis of this aesthetic vision, the golden light and the mausoleum appeared to have been the focal points of the experience. The golden light under the dome, generated by the external light of an overcast sky passing through the stained glass, was perceived as a sign. It was an image of the sunlight when it shines outside, on Paris and elsewhere; it was a replica of the summer sun during a drab winter day. Visually, it was similar to an exhilarating sunny day. I did not perceive it as a referent, although I could have: a shining sun has been conventionally chosen to refer to Pharaoh Akhenaton, Saint Thomas Aquinas, imperial Japan, King Louis XIV, and other famous persons and collectivities. In fact, it would have been appropriate to be reminded of Louis XIV: he had the Invalides built during his reign, he took a sunburst as a personal emblem, and he liked to be called the Sun King. "Sunburst stands for Louis XIV" is a signification I had learned, but it remained buried in my inactive memory when I visited the church of Saint-Louis. On that day, the sunny light was not, for me, a referent. Neither was it an indicator, because I did not perceive it as incidentally associated to a signified.

It was a symbol of life. And indeed, the sunlight is what makes plants grow, what makes the Earth a warm and bright place. The sun is the source of life; it epitomizes life. Of course, I did not analyze in this way when I was under the dome surrounded by the sunny light; it was later that I tried to discover the basis of my immediate perception of the light in the church as a symbol of life.

The mausoleum, designed by architect Ludovico Visconti and completed in 1861, is another powerful symbol. Made in the shape of an oversized sarcophagus, its mass and the red porphyry in which it was carved, stand for everlasting indestructibility; it has the perennial stability of a natural rock with the polish and sharpness of contour of a man-made work intended to stand any impact. The large volutes on the top are spirals reproducing the natural growth of shells and other living organisms. These forms, as in

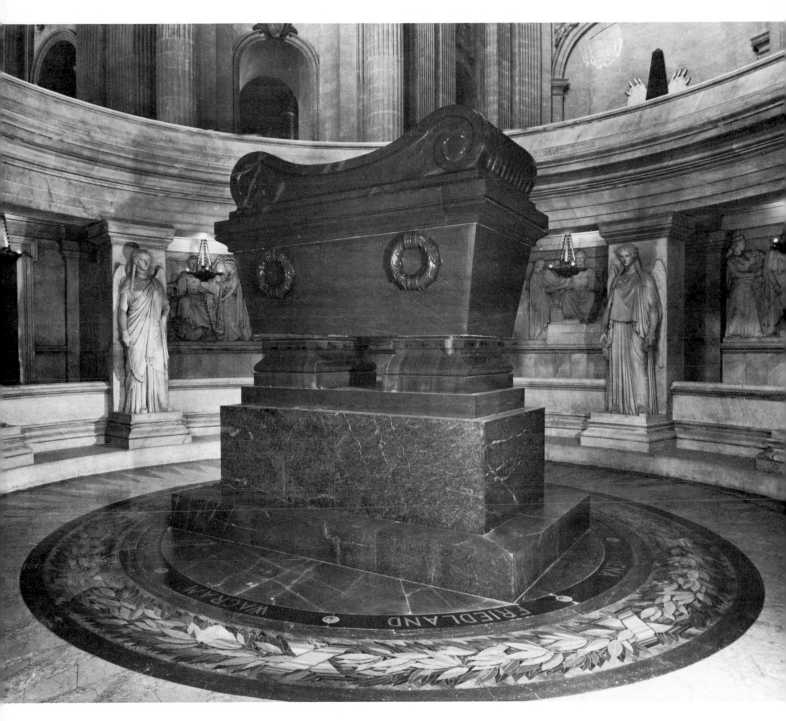

LUDOVICO VISCONTI. Napoleon's tomb. 1861. Photo:
by J. Feuillie, © Caisse Nationale des Monuments
Historiques et des Sites / SPADEM.

African traditional sculptures, where they appear so often, symbolize a law of growth, evoked by the exponential curves.[1] The synthesis of organic growth-forms with those of eternal durability constitute a powerful symbol of perennial life. Another allusion to life is the vegetal green of the granite base.

The ambient golden light and the formal composition of the monument reinforce each other as symbols of a constantly renewed energy, which, impersonally and irresistibly, will continue forever. No wonder I had forgotten Napoleon, a man limited in place and time: his memory could not emerge when confronted by such powerful symbols.

The warm light of the sun stands for life, is life-giving, is life. Marble stands for eternity, is stable and everlasting, is eternity. Spiral stands for growth, is the form of unfolding life, is growth.

This is what is meant by connaturality of signifier and signified, by participation of the symbol in the nature of what it stands for. These statements seem paradoxical, even contradictory. How can symbols, material things existing in the external world—slabs of marble, light diffused in air, and volutes deeply carved in heavy porphyry—have the same nature as the ideas for which they stand, such as eternity, life, and growth?

Let us consider the symbols more closely. Certainly, there are physical things in the external world that act as stimuli for our sensory organs, and to which the latter respond by creating mental contents which are deemed equivalents of the external things. The external things remain inaccessible. More precisely, a continual flow of stimulations is organized by our senses in discrete objects differentiated through the variations we can perceive by those senses. What we call "physical" or "external" things in ordinary language are elaborate mental transpositions of stimuli originating from aggregates we have isolated in the flux that surrounds us. As these transpositions have been constructed collectively, and have met the consensus of those who live in a similar environment and speak the same language, they constitute a coherent system. Consequently, for all practical purposes, we can forget the distance between the external aggregates, ultimately unknown 'in themselves' (what we call "things"), and their mental equivalents, the only items we know. We can speak and act as if there were stones out there exactly as we perceive them. Only in some circumstances, like the present discussion, we have to remember that the stones we look at and speak of are mental equivalents of external aggregates.

In this perspective, the usual statement that "the symbol, a material thing, stands for its signified, a nonmaterial item, such as an idea or an affect" should be phrased: "the symbol, a mental equivalent of an external aggregate, stands for another mental content, such as an idea or an affect." There is a different level of abstraction between the class of symbols and the class of symbolic signifieds—the latter being more abstract than the former—but the members of the two classes are mental objects or constructs or, if we dare use a word coined during the nineteenth century but still uncommon, mentations.

"Marble" is as mental as "eternity"; and so too are "golden light" and "carved spiral." The connaturality of marble and eternity is made possible because each of them is in the mind. Thus it is not contradictory to posit a continuity between symbols and their signifieds. The two terms, as well as the relationship between them, belong to the same realm.

The common nature shared by symbols and their signifieds is the basis for meanings

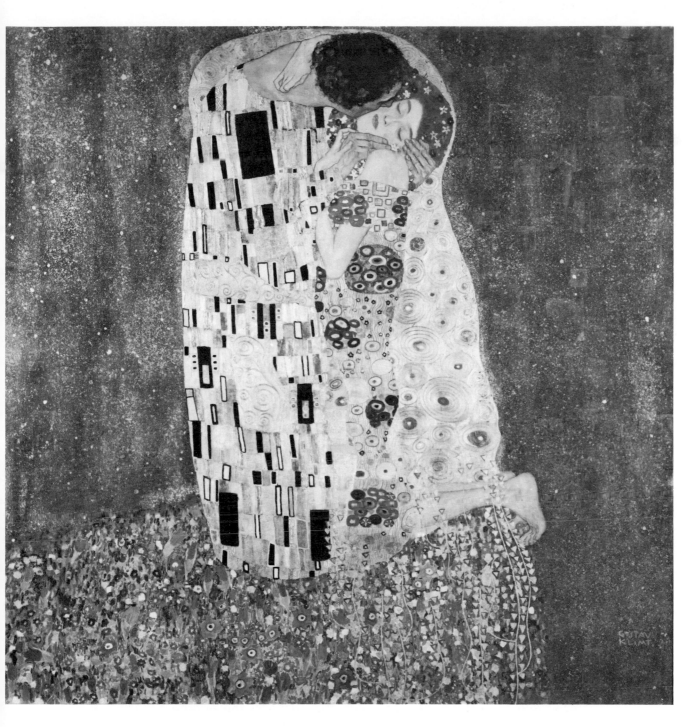

GUSTAV KLIMT. *The Kiss*. 1908. Österreichische
Galerie, Vienna. Photo: Fotostudio Otto.

apprehended by beholders. Symbols "suggest" or "cause" a sliding from themselves to their signifieds. Marble suggests eternity, marble means eternity because its solidity and durability are prolonged, as it were, into the idea of eternity. Lines and shapes, colors and textures, brightness and darkness are the material things which point to some ideas that are in continuity with one another.

I say "with one another" as there may be, and usually is, more than a single relation of signification. Sign A stands for signified B, which as signifier stands for signified C, which as signifier stands for signified D, and so on. Golden light means sun; sun means energy; energy means life. So far, in our analyses, we have considered only single significations; it will also be necessary to include chains of significations in our analyses. The starting point of such chains is a material object, its first signified may be an image, the second a referent, and a subsequent one a symbol. A stone sculpture of a *liṅga* is an image of an erected phallus, which is a referent to Śiva, who in the Hindu tradition is a symbol of the divine as creator and destroyer.

As indicated earlier, the material supports for aesthetic meanings are to be found in the forms of the objects. The overall composition of the work is an important formal feature. As Rudolf Arnheim has convincingly demonstrated, for the Western pictorial tradition, in his *Art and Visual Perception*, the rectangular surface of a painting is a dynamic field of forces, forces that are visually perceived.[2] For instance, the two diagonals—top right to bottom left and top left to bottom right—are apprehended as forces moving in different directions: the first one in an ascending movement, and the second one in a descending movement. Another example is that the part of the picture which is visually heavier (by being darker, for instance) gives imbalance to the composition if it is placed on top (as is the case in Lichtenstein's *Blonde Waiting*).

The color composition is also meaningful. Large areas of green and red in the same painting produce a strong contrast which is perceived as expressing violence and terror.[3] When "combined in many small doses," complementary colors generate an achromatic grey or white and are visually perceived as meaning peace and harmony.[4]

Separate formal elements within the surface of the painting or drawing also carry visual meanings. Straight and angular lines connote masculinity, strength, and swords; curved lines connote femininity, softness, and flowing rivers. In Gustav Klimt's *The Kiss* (1908), the man's cloak is covered with rectangular ornamentations suggesting phallic forms whereas the woman's clothing is decorated with oblong rings evoking vaginal shapes.

Triangular shapes pointing upward suggest the male sex, and when pointing downward, the female one. Red hues hint at fire, life, and blood; blue ones at coldness, ocean, and rationality; green ones at grass, trees, and nature. A circle evokes world, breast, and completeness.

In this brief enumeration of examples, we refrained from using the word *symbol*. Yet a moment of reflection is sufficient to realize that, indeed, the signifiers (such as heavy forms on top, straight lines, triangles, and green) stand for their signifieds (such as imbalance, phallus, sex, and trees) by participation in important common characteristics (such as disequilibrium, rigidity, shapes of the triangle and pubis, and the green color of the foliage).

In the holistic approach of the contemplative vision, symbolic meanings are intuitively perceived. Their recognition is not the result of an analysis. Reasoning and

analyzing may occur later, when and if the beholder wants to verbalize and explain his experience-as-recalled. In this reflection on the original intuitions, viewers may not be able to discover the explanation of their symbolic perceptions. They may have had the intuition of static order when looking at a Mondrian but they may be unaware that in a controversy about Mondrian's strict commitment to vertical and horizontal lines, it has been argued that obliques are spontaneously perceived as dynamic and creating depth.[5] Even if viewers have had an intuitive apprehension of masculinity when looking at Klimt's couple, they may disagree with the generalization about the phallic meaning of any straight line.

This suggests that the perception of symbols may even remain subliminal. The Freudian theoretical construct of the unconscious has proved to be useful in therapy and also as a principle of explanation, and it is nowadays generally accepted. Some psychological studies have demonstrated that children, when submitted to tests on the sexual meanings of abstract shapes, responded to them without being aware of their signification at a conscious level.[6] Symbolic meanings can be apprehended and recorded at a subliminal level.

To many of us, *unconscious* evokes an image of depth. It is like the ocean's depth in which there is a continuum from the surface to an inaccessible bottom. Subliminal is just below the surface and can often be made conscious by an effort of attention, recollection, or interpretation. It may be sufficient to be told that curve is related to softness to precipitate a process of recognition. Then there may be an intellectual reflection on the subliminal made conscious. It is another mental operation, and it is not essential to the aesthetic experience.

Our contention that a symbol and what it symbolizes are in continuity, that they are identical in some important respects, and that they participate in the same nature has a far-reaching consequence: when beholders have an experience of the symbol, they also have an experience of what is symbolized.

In our common language to be "experiencing something" or "going through an experience" is to be deeply and totally involved in some process. Here is an example of what we would refer to as an experience. "One day, I fell into the river and I was drowning. Then somebody saw me and I was saved. I experienced drowning." Experience is opposed to intellectual knowledge. The anthropologist who has read all the books on polygyny, its social functions, its economic consequences, its psychological impact, and its worldwide distribution has a purely intellectual knowledge of polygyny. On the other hand, the man who has lived as husband to several wives in a traditional household of a remote village in the African savanna has experienced polygyny, though he knows very little of it as a general social phenomenon. Learning from books and learning from experience are sharply distinguished in our culture. The latter is considered richer, deeper, and more intimate, as it includes affects and nuances that the purely intellectual knowledge does not convey. On the other hand, book learning is regarded as broader, more precise, and easier to communicate. *Understanding* and *knowing*, when opposed, express the distinction between what is apprehended by experience and what is acquired by an intellectual approach.

Experiencing is a conscious process. Suppose you lose consciousness in a car accident in which your leg has been broken: you do not have the experience of breaking a leg. After regaining consciousness, you experience the mental state of having had a leg

broken and the associated affects such as pain, regret, anger, or dependence. Or suppose you are in the arrival lounge of an airport after having safely landed. You are then told that the landing gear had been blocked until the last second; as it was too late for the aircraft to take off again, you had been in great danger of crashing onto the runway. Because you were unaware of the danger, you had no experience of it, nor of its associated emotions of fear or panic. If one is unaware of a situation in which one is, one has no experience of it.

Conversely, if we think we are in a situation in which, in fact, we are not, we may have an actual experience of a nonexisting situation. For instance, during my first airplane flight, there were turbulences and, at about the same time, a change in the running speed of the engines. It was night and we were above the ocean. I thought we were falling. In fact, the flight was proceeding normally; the turbulences and the change in engine humming did not signal a danger. Nevertheless, my experience of an imminent crash was genuine and terrifying.

Experiencing is always a mental process, whether it is triggered by an external stimulus or by an idea. More precisely, what we experience is a mental content (what we called a mentation), say "danger," which may or may not correspond to an external situation. The emotion hatred arises because the mentation "betrayal by my friend" is present in my consciousness. My experience of that emotion is the same whether my friend actually has betrayed me or not.

What we experience is mental. This conclusion is of crucial importance in our analysis of symbols. When looking at a physical object—Mondrian's grid, the golden light, or the porphyry sarcophagus—which is an external stimulus, we have a mental experience of what it symbolizes—order, life, or eternity.

Symbols are different from other signs in that they are partly what they stand for. Thus, when mentally apprehending symbols, the beholder is connected with the signified. Beyond intellectual knowledge, the beholder achieves understanding as a result of participating in an experience.

Painting 1946, by Francis Bacon, symbolizes, for me, ritual torture. The composition is symmetric and heavy. Diagonals are oriented to the middle of the picture, below the center; this area is weighted by its dark tones. In the lower part, two oval lines are centered around the vertical axis.

The imagery contributes to an impression of somber solemnity. A large hanging carcass suggests a butcher's shop. Garlands, high windows covered with shades, and the hint of considerable interior volume evoke the sacredness of a temple more than the ordinariness of a slaughterhouse or meat shop. The hanging carcass of a large animal has the shape of a headless crucifix; two smaller carcasses are exposed on the superior oval surface as on a sacrificial altar. In the focal area, but a little off center, a bulky figure—the butcher perhaps—in dark and apparently formal attire, stands motionless, as a powerful and ominous presence. His face is only half visible; from the mouth up, it is under the dark shade of an incongruous umbrella, a frequent motif in the Bacon pictures of the mid-forties. A heavy chin and a row of teeth between thick lips are the only visible features of the butcher's face.

Like any of our contemporaries, I know about torture. Humiliating for the victim, degrading for the torturer, ineffective for the government, it is, however, extensively used as an instrument of power. Sometimes, as in the Bacon picture, it is associated with

FRANCIS BACON. *Painting 1946*. 1946. Collection, The Museum of Modern Art, New York.

a ghastly ritual which seems to confer the impersonal inevitability of a ceremony. Also, I know that killing cattle in order to eat its flesh has some disturbing correspondence with execution and torture. This intellectual knowledge has not been increased by my contemplation of the Bacon painting, but my understanding of the experience of torture has deepened. The three headless carcasses, bled and gutted, prepared for retail sale, suggest the denial of identity suffered by torture victims: they experience the loss of their individuality. By looking at the massive and stable figure, one can even somewhat understand from inside the rigid and passionless cruelty of the torturer. The churchlike and altarlike features of the painting indicate that some executioners may see themselves as sacrificial performers.

This is a later verbalization of a visual contemplation of the Bacon picture as I recalled it at the time of my reflection. When I was looking at it, my vision remained holistic and nonanalytic. Also, it remained disinterested: I felt compassion for victims and torturers, and I felt an urge to support organizations like Amnesty International, but my mode of consciousness did not become emotional. Anger and indignation are ego-oriented. They express judgment, condemnation, and self-righteousness more than a concern for others' sufferings. These affective mental states are obstacles to the aesthetic commerce with a work of art.

Torture, as an experience for the victim, is in the victim's mind. If consciousness is lost, the victim does not experience suffering and humiliation until consciousness is regained. Torture is also an experience in the torturer's mind. If drunk or insane, the torturer has no experience of being a torturer. A symbolic picture, such as Bacon's *Painting 1946*, creates mental experiences which are in continuity with the actual torture experiences. Of course, they are not identical. Compared with experiences generated by physical pain and humiliation in the external world, symbolic experiences are of minimal intensity, but they are in continuity with those based on actual torture.

Among the ruins of Anurādhapura, which was the capital of Sri Lanka for thirteen centuries, there is an impressive statue of the Buddha; it was carved in stone in the third or fourth century A.D. Known as the "Buddha in *samādhi*" (mental concentration), it is one of the most ancient images of the Buddha.

I remember sitting in front of the statue, under the trees in what now looks like a quiet park. I was looking at it with visual attention, trying not to be analytical and not to let myself be invaded by the usual worries of daily life. When I first approached it, it was, for me, another piece of classical sculpture of South Asia.

After a few minutes of aesthetic contemplation, I was struck by the inner vitality conveyed by the forms. It was as if a force radiated from the statue. My body assumed a position analogous to the one of the statue, my breathing became slower, deeper, and more regular. My eyes focused on the visual center, the lower abdomen, chosen by many meditators as the place where they perceive each inhalation and exhalation. I had the visual perception of mental concentration. The statue was a symbol of mental concentration, and the statue made it visible. The statue was mental concentration itself. And this gave me an experience of mental concentration.

At the time of this experience, the perception of concentrated force was not even verbalized, and still less, analyzed. Described above is the experience-as-recalled; during the experience-as-experienced, I did not use words. The perception was pure intuition.

Buddha in *samādhi*. Anurādhapura, Sri Lanka.
3d or 4th century. Photo: Archaeological Survey.

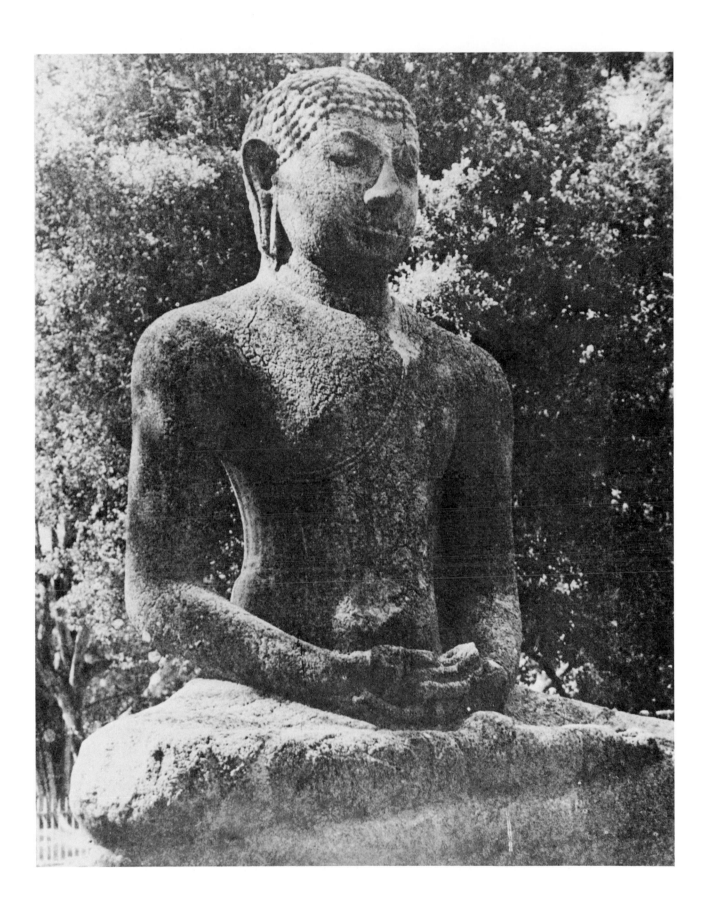

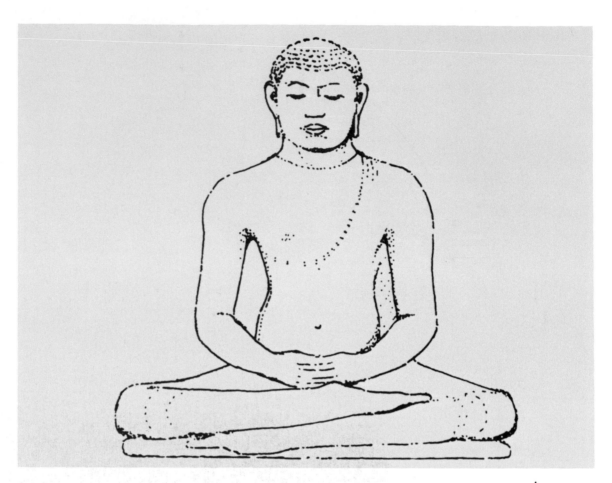

Schema of the Anurādhapura Buddha. Drawings by
Bernard Maquet.

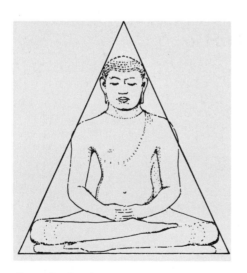

Frontal triangle.

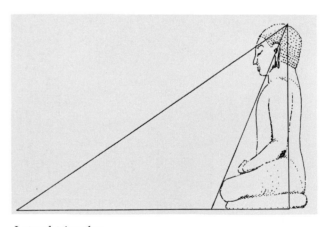

Lateral triangles.

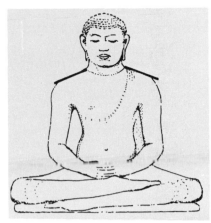

Frontal obliques.

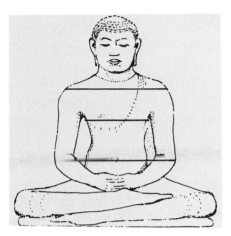

Frontal horizontals.

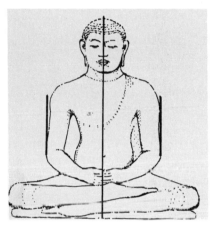

Frontal verticals.

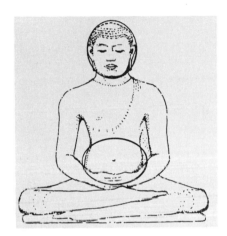

Frontal ovals.

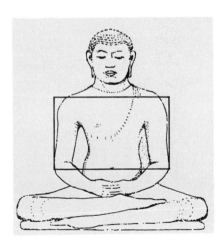

Frontal rectangle.

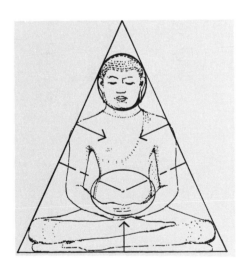

Balance of forces.

Later, wondering what precisely had given me this intuition, I went back to the statue, and looked at it again, this time from an analytical perspective.

I saw that the triangle is the dominant structural form. Frontally seen, the contour can be inscribed in an equilateral triangle. Laterally seen, the back is the vertical line of two rectangular triangles: the baseline of one extends to the knee, and the other to the point where the glance of the Buddha would fall, about six feet in front of the statue. I realized too that the spine and the knees touch the ground at three points which also delimit a triangle. Within the frontal triangle, several other obliques were to be seen: the right leg resting on the left one in the half-lotus position, the thighs, the forearms, the shoulders, and the upper sides of the chest. Besides all these obliques, there were horizontals (particularly the strong baselines of the triangles), verticals (arms, spine), ovals (abdomen, head), and a squarelike four-sided form (arms, forearms, and shoulders).

These forms combine a firm stability with a strong dynamism. The stability is expressed by these forms: an equilateral triangle with one side at the horizontal, the visual weight of the legs, and the symmetry of the left and right sides. Dynamism may be perceived in another set of forms: the obliques which tend to "move" to the horizontal and vertical rather than "staying" where they are. Also, in the equilateral triangle standing on one side, there is an upward motion conflicting with the downward pull of the weighted base, and this creates a tension of forces. The oval tends to roundness, as the squarelike area tends to perfect squareness.

The visual center, where the lines of thighs, forearms, and hands converge, is the oval area located a little, but not significantly, below the geometric center of the frontal triangle. This gives a unity of concentration to the statue.

This analysis is a discursive explanation of a symbolic experience. It suggests how a mental experience of concentration may be triggered by, and lived in, the aesthetic vision of a statue.

Of course, the Anurādhapura statue is also the image of a man, Siddhārtha of the Gautama family and the Śākya clan, the historical Buddha. He lived in the sixth and fifth centuries B.C. (probably from c. 566 to c. 486) in Magadha and other neighboring kingdoms in the Ganges valley of northern India. The resemblance of the Anurādhapura statue to Siddhārtha cannot be assessed, as there is no portrait or description of his physical appearance. Yet some beholders may perceive this statue as standing for the historical Buddha, as an image of him.

For many Sinhalese villagers this statue, as well as the many other representations of the Buddha seen in temples, homes, and public squares, stands for a superhuman being, nonmaterial but existing independently from any idea of him, a being with whom they can communicate through offerings and ritual ceremonies. For them, the Anurādhapura statue is a referent that stands for the living presence of a nonmaterial person.

For the spiritually advanced Buddhists, however—be they monks or lay men and women—this statue is a symbol standing for the enlightened state they hope to attain.[7]

This discussion of the Buddha statue, as symbolic sign and as referential sign, additionally affords a distinction between religion and spirituality. Both religious and spiritual systems are traditions of thought and practice concerned with the human predicament in the world (transitoriness and its dissatisfactions, action and responsibility, life crises and death) and the means to improve it, or at least to make it bearable. The most

significant element included in a religious system is the belief in the existence of, and the interaction with, one or several gods. They are perceived as more powerful than human beings, sometimes omnipotent, as having an essential role in human destiny, and as being free from the limitations of a material body. This view of religion is expressed in common-language dictionary entries and in the vocabulary of many scholars.[8] For instance, anthropologist Melford Spiro states that "the differentiating characteristic of religion is the belief in superhuman beings."[9]

As they are not material, the gods do not belong to the sensory experience of the believers. They are denoted by verbal and visual signs. Verbal signs are proper nouns such as Śiva, Jesus, the Buddha, or God. Visual signs are statues and pictures representing human forms, such as a graceful dancer with multiple arms, a tortured victim nailed to a cross, a meditator sitting in a cross-legged position, or an impressive elderly man with a white beard. And there are emblems, such as the *liṅga*, the Greek word *ikhthus*, an empty seat, or an eye inside of a triangle.[10] These names, human forms, and emblems are referents standing for the invisible and intangible beings they point to. The word *Śiva*, the dancing man, and the *liṅga* refer to the same nonmaterial signified. So do *Jesus*, the victim on the cross, and *ikhthus*; *the Buddha*, the representation of a man sitting in meditation, and the empty seat; and *God*, the noble old man, and the eye.

For religious believers, these nonmaterial signifieds actually exist outside the mind. They are prayed to and revered, solicited and expected to respond to requests, and when offended, they punish or forgive. As they do not have bodily supports, it is difficult to figure out "where" they are. Yet they are treated as living persons who are present where they act, or even omnipresent.

In spiritual systems, gods are irrelevant. Either these systems do not include superhuman beings (this is the case with spiritual systems expressed in philosophical terms, such as Stoicism), or they comprise words, pictures, emblems, and other signs that could refer to nonmaterial beings outside the mind, but which are interpreted as symbols. The man on the cross stands for the ultimate sacrifice of love; and Kṛṣṇa, the handsome flute player, for devotional self-surrender. The serene meditator symbolizes the archetype of man perfected by enlightenment, and the name God stands for the idea of the unconditioned.

Traditions of thought and practice are religious if proper names, human representations, and other personal signs are interpreted as referents. They are spiritual if personal signs are interpreted as symbols. Some traditions, like Buddhism and Hinduism, accept either interpretation. In fact, they hold the symbolic interpretation to be superior to the referential, which is considered too literal and "fundamentalistic." Other traditions, like the ones stemming from the Judeo-Christian-Islamic root, do not allow that freedom of interpretation and usually consider the symbolic interpretation as nonorthodox.[11]

This brief digression in the fields of religion and spirituality provides another example of the explanatory potential of the paradigm of signification. The concepts of symbol and referent have proved to be powerful tools of analysis.

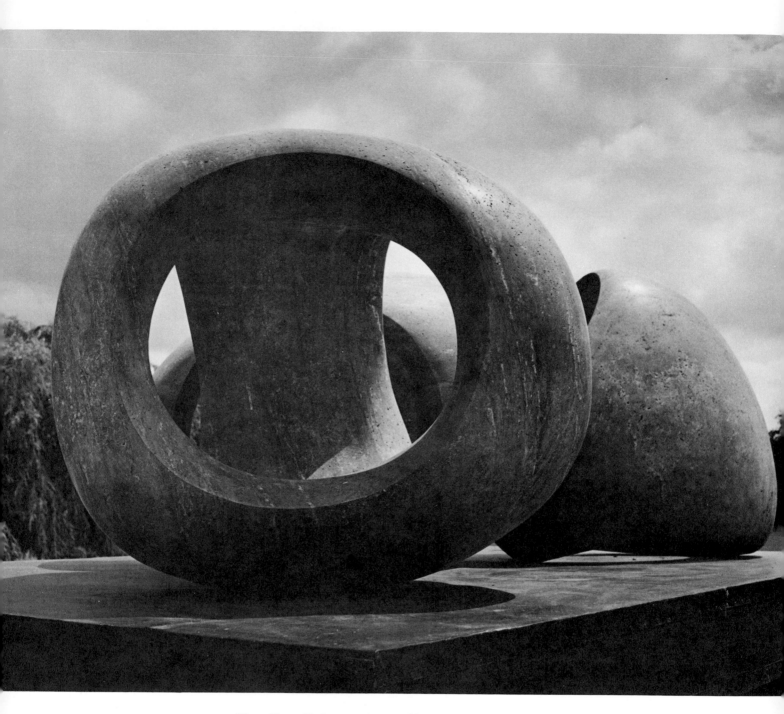

HENRY MOORE. *Three Rings.* Red travertine marble.
1966. Collection of Mr. and Mrs. Robert Levi,
Maryland. Photo by Errol Jackson, by kind
permission of The Henry Moore Foundation,
England.

CHAPTER ELEVEN

The Aesthetic Quality

AMONG THE NUMBERLESS ARTIFACTS SURROUNDING US, SOME WERE MADE, OR SELECTED, to be looked at. They are called art objects. Others, though made and used in contexts other than art, have an equally strong visual appeal. The latter together with the former are what we have termed aesthetic objects. Their forms can stimulate and sustain visual contemplation. This sets them apart from other tangible objects, the visual forms of which are minimally, or not at all, endowed with such potential.

At this point, a question that must be addressed is, What is this mysterious aesthetic quality that some forms display and others do not?

Visual contemplation is holistic. The beholder does not analyze the object in its visual parts, but perceives it as a whole. This gives a clue: the aesthetic quality of the forms should be an attribute of the whole configuration of forms, and not of any form in particular.

It is composition, the congruence of the forms with one another. Composition, from the Latin *compōnere* 'to put together' results from a process of integration. The different visual forms are related in such a way as to constitute an organized whole. Another word for composition is *design*. In sixteenth-century Florence, Giorgio Vasari—painter, architect, and art historian—called the classical fine arts (drawing, painting, sculpture, and architecture) the "arts of design." He believed the unity of the fine arts was founded on design, the disposition of elements according to a plan. The fine arts academy he established in 1562 was called the Accademia del Disegno.[1]

Composition seems to be a modest basis for assessing aesthetic quality. Any artifact not made from a visually uniform matter has parts which are organized in some way, and thus has composition. Certainly, there is some design in almost any man-made object. Nevertheless, excellence in the integration of forms is the ultimate support of the aesthetic quality of the artifact. It is not very common.

There are several principles of design organization. One of them is geometry. Forms are simple geometric shapes, or close to them, and are related to one another as parts of a system of squares and circles, cubes and cylinders, angles and parallels. In art history

Mask. Tikar, Cameroon. Museum Rietberg,
Zurich. Photo: Wettstein and Kauf.

textbooks, an array of straight lines and curves superimposed over a photograph of an art
work makes the composition visible. This reveals the underlying structure of a painting
or a sculpture, not always immediately evident to students. The reducibility of visible
forms to the regular shapes of basic figures is a criterion of excellence in composition.
Some traditional woodcarvings of West Africa, such as the blue Grebo mask of the Musée
de l'Homme and the famous Tikar mask of the Rietberg Museum, and some Cubist
paintings, such as the landscape of *La Roche-Guyon* (1909) by Braque, can be reduced to
fundamental geometric volumes or planes almost without residue. This is extreme
geometrization. The ability to geometrize exists, however, to a lesser degree or in a less
evident manner, in many other art works.

Another principle of composition is based on the ways biological forms develop; it
can be called organic. The different forms in a picture are linked as parts of a living
organism. They are connected as tree trunks are rooted in the soil, as branches expand
from the trunks, as leaves burgeon on the branches. Or, as a flexible neck connects head
and shoulders, as muscles are attached to the bones and move them, and as soft breasts
bloom on the chest. Henry Moore's *Three Rings* (1966) displays the organic composition of
eggshells. Richard Hunt's *Why?* (1974) is a bronze sculpture composed of a rising hand
growing out of the soil as a plant. Aldo Casanova's *Artemis of Ephesus* (1966) has a
composition unified by female sexual forms. Jean Arp's *Ptolemy III* (1961) has a bonelike
structure. These sculptures illustrate the principle of organic composition. They reveal
how strong the integration of biological forms is.

Still another principle of composition is based on movement; it can be called
dynamic. The surface of the canvas or the volume of the sculpture is field or space where
formal elements seem to be animated and to move in an organized manner, as in a ballet.
Movements have direction and force. Composition balances these dynamic variables in a

unified configuration. Antoine Pevsner's *Developable Column* (1942) seems to be still in the process of ascending. Barbara Hepworth's *Pelagos* (1946) is in the process of unfolding its spiral. Bruce Beasley's *Dione* (1964) is visually made of three components and each one seems to be involved in the movement of the whole—horizontal and swift. Kasimir Malevich's painting of a peasant carrying two buckets is entitled *Woman with Water Pails: Dynamic Arrangement* (1912).

Geometric, organic, and dynamic shapes are the main bases of composition. More specific shapes can also be bases of composition. Styles, in fact, are organized around certain fundamental forms. In architecture, the Romanesque style favors round arches, semicircular tunnel vaults, heavy walls, and strong towers. The round arch, structurally as well as visually, was the geometric form that dictated the overall composition of a Romanesque monastery. Cloister, chapter hall, library, and living quarters, together with the church, the most important building, constituted a complex monastic institution.

The privileged form of Gothic style, the pointed arch, is visually a schematization of tall trees, such as beeches, aligned along an avenue. Their branches crossing at acute angles describe an arch. Thus, rib vaults are visually related to organic forms. Of course, they were primarily a technical advance on Romanesque semicircular vaults: combined with flying buttresses, they made the high naves of cathedrals possible. Here again, one form, the ogive, was the principle of composition at the center of the complex configuration that is called the Gothic style.

Composition makes it possible to grasp a visually complex object as a unified whole.

ALDO CASANOVA. *Artemis of Ephesus.* 1966. Franklin D. Murphy Sculpture Garden, University of California, Los Angeles. Photo by Jacques Maquet.

CASANOVA. *Artemis of Ephesus*, detail.

JEAN ARP. *Ptolemy III.* 1961. Franklin D. Murphy Sculpture Garden, University of California, Los Angeles. Photo by Jacques Maquet.

RICHARD HUNT. *Why?* 1974. Franklin D. Murphy Sculpture Garden, University of California, Los Angeles. Photo by Jacques Maquet.

Facing page. ARP. *Ptolemy III*, another view.

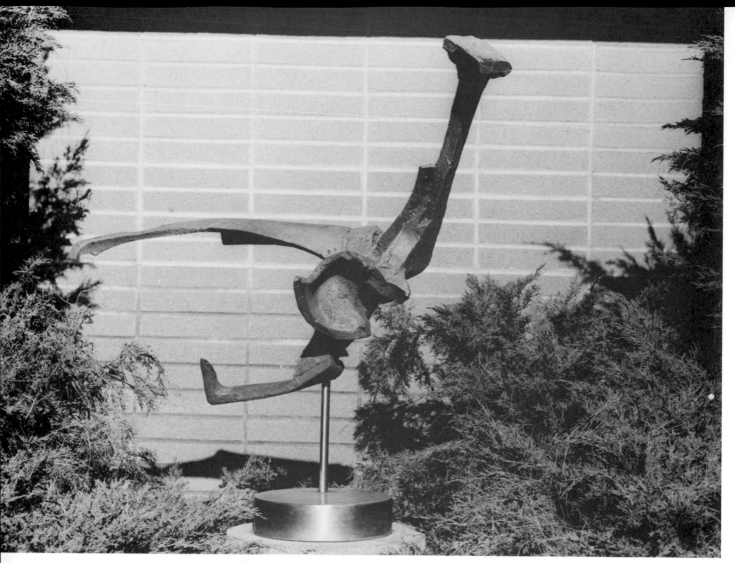

BRUCE BEASLEY. *Dione.* 1964. Franklin D. Murphy Sculpture Garden, University of California, Los Angeles. Photo by Jacques Maquet.

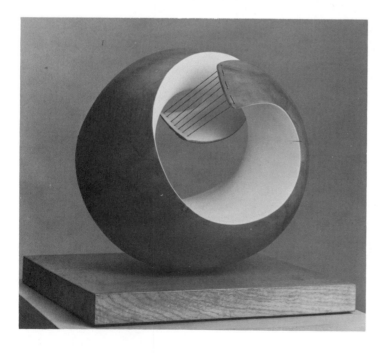

DAME BARBARA HEPWORTH. *Pelagos.* 1946. The Tate Gallery, London.

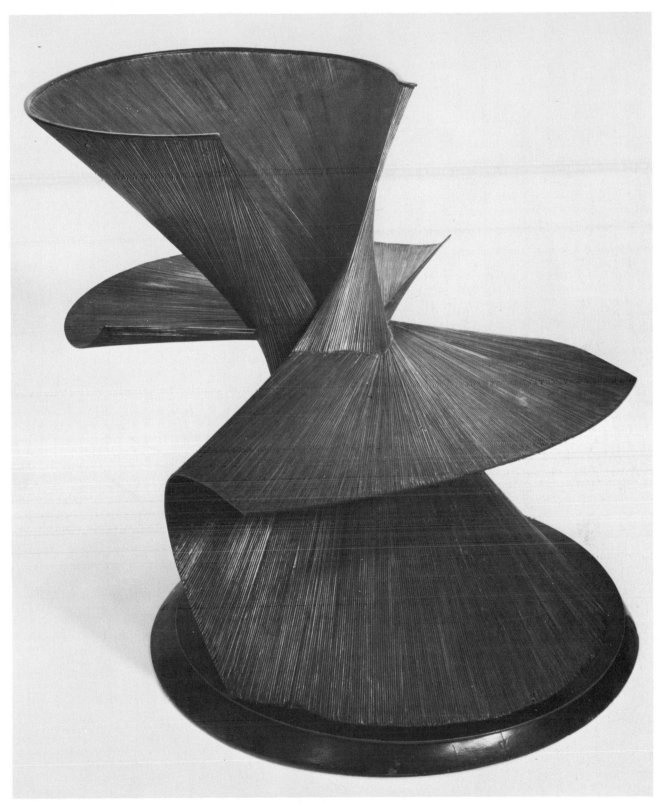

ANTOINE PEVSNER. *Developable Column*. 1942.
Collection, The Museum of Modern Art, New
York.

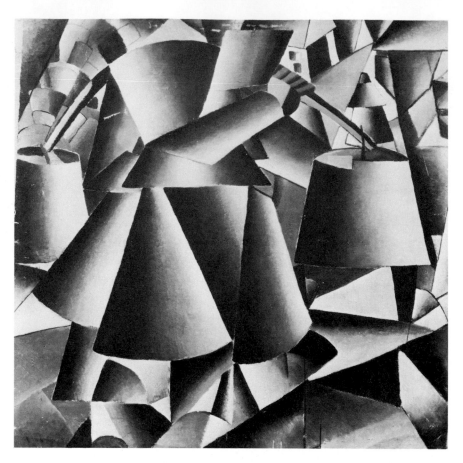

KASIMIR MALEVICH. *Woman with Water Pails: Dynamic Arrangement.* 1912. Collection, The Museum of Modern Art, New York.

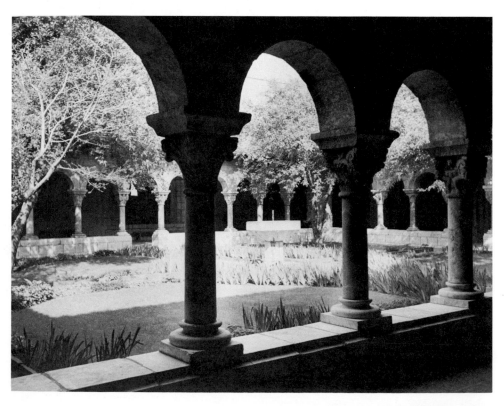

Cloister of the Saint-Michel-du-Cuxa monastery. France. 12th century. The Metropolitan Museum of Art, The Cloisters, New York. Photo by Jacques Maquet.

Abbey of Sénanque. Provence. 12th century.
Photo by J. Feuillie, © Caisse Nationale des
Monuments Historiques et des
Sites / SPADEM.

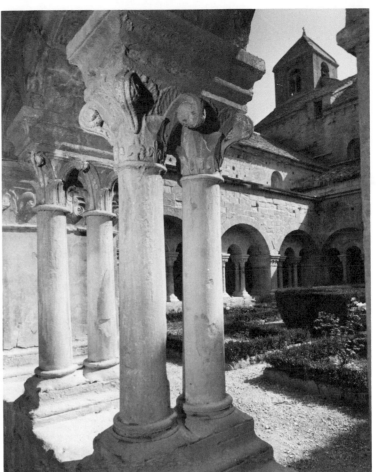

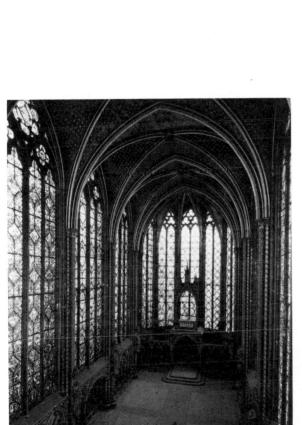

Gothic windows of Sainte Chapelle. Paris.
13th century. Photo by J. Feuillie, © Caisse
Nationale des Monuments Historiques et des
Sites / SPADEM.

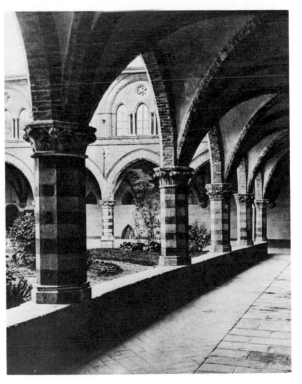

Cloister of Santa Giuliana. Perugia. 13th century.
Photo: Parthenon Publications.

In the aesthetic object, it corresponds to—and facilitates—the holistic perception of beholders.

Well-designed forms express, with compelling force, meanings and values perceived and ascertained by beholders. Composition generates in beholders' minds what is necessary to keep their full attention by clearly and strongly stating what the object stands for.

The configuration of forms in Picasso's *Guernica* (1937) has such expressivity. Angular contours, grey monochromatism, three-part composition centered in an upward triangle, and lighter shapes on the darker area of the ground forcefully convey the meaning perceived by this beholder: war is cruel and absurd. Likewise, the visual structure of the Anurādhapura Buddha, made of triangles and obliques, convincingly expresses meditative concentration.

The word *composition* refers to the congruence of the visual forms with one another. The word *expressivity* refers to the congruence between the configuration of forms and the symbolic meaning of the object. The forms included in the overall design have their own meanings, as discussed above. For example, an equilateral triangle resting on one side conveys the meaning of stability; straight lines, maleness; and a spiral, growth. Do these meaningful forms, organized in a visible configuration, convey the symbolic meaning of the whole work? If, with strength and economy, they do, then they give the object a high level of expressivity. This expressivity is a consequence, or an aspect, of the composition.

Reading contemporary criticism in art magazines and in the general press suggests that this criterion of expressive potential is widely used. Critics readily write that a particular art work is "a strong statement," and then they translate into words the visual symbolism of the piece.

Another consequence of an excellent composition is to set the object apart from its visual environment. The latter rarely displays a well-integrated array of visual forms. On the contrary, in the ordinary visual context of our lives the aesthetic object stands out through its design.

For most of us, everyday life is ego's arena. In that arena, actions and emotions, feelings and desires, analyses and judgments constitute an endless flow. This ceaseless flux has to be interrupted so that the contemplative attention, in which the aesthetic vision develops, may emerge. Usually, our first glance at an art object is part of the flow. In order to perceive an artifact aesthetically, we have to set it apart, as it were. Composition, by contributing to the separation of the object from its visual context, favors the emergence of the contemplative mode of consciousness.

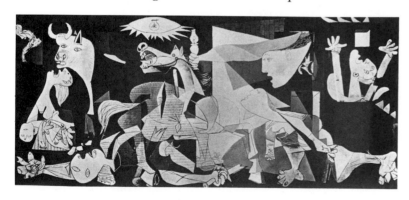

PABLO PICASSO. *Guernica*. 1937. Museo del Prado, Madrid. © SPADEM, Paris / VAGA, New York, 1985.

The single element of composition that most contributes to our shifting to contemplative attention is the frame. By clearly setting the border line between the aesthetic object and its visual environment, the frame implicitly states that what is within its contour is different from the rest and should be approached differently. From ordinary space we move to aesthetic space.

In some cases, the frame seems almost to create the art work. Imagine an unframed Pollock in continuity with the visual surroundings of a parking structure or a shopping center. Would we notice it as a work of art, and look at it with the appropriate kind of mental approach? This should not be overstated. A heap of dirt thrown on the floor of an art gallery is "framed" by its presentation in an exhibition room with the proper labeling (such as "Joseph Beuys: *Fat Corner*, 1974").[2] Its incongruity may be amusing, or arresting, or suggesting some worthwhile reflections, but the object's only composition is its frame. It is not sufficient to bestow on it an aesthetic quality.

In the 1950s and 1960s, happenings and "environments" emerged and were categorized as visual art. The beholder was in the event, was surrounded by it, and became an active participant. There was no composition (everything happened spontaneously) and no frame (one crossed the border line between life and "stage" without noticing it; in fact, it was claimed that there was no stage). Such experiences may have been of value for those involved in them, but it is conceptually confusing to call them aesthetic.

In addition to favoring an initial contemplative attention, composition helps to maintain a disinterested stance. Distancing the self from what is represented—ego distanciation—is made possible by the high quality of visual integration. Let us consider two scenes of violence in which we see a man photographed at the moment he is shot and dies.

During the Spanish civil war (1936–39), *Life* photographer Robert Capa took many dramatic pictures: civilians expecting an announced air raid anxiously looking into the sky, soldiers on their way to the battlefield, refugees crossing the French border, and front-line combat troops in action. One of Capa's combat action photographs was published in newspapers all over the world a few days after it was taken. It made him

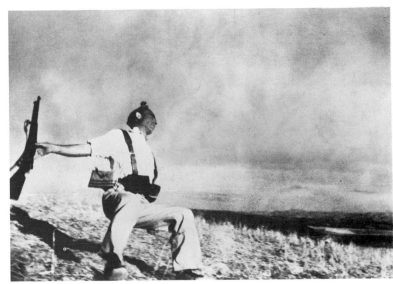

ROBERT CAPA. Death of a Republican volunteer, Spain. 1938. Photo: Magnum, New York, courtesy of *Life* magazine.

famous. It was a close-up of a Republican volunteer falling dead, hit charging toward a Fascist machine gun.

On the backdrop of a vast expanse of sky, the man's movement has been suddenly stopped by a bullet, one assumes, as it has left no visible trace. He has lost his balance and is falling backward, but his torso, for a split second, still holds a straight stance. The rectangular print looks as if it had been carefully centered and organized (though in point of fact, it was not).* The figure, slightly left of center, with an extended arm divides the picture in half; the fugitive shadow suggests depth; and the black rifle strangely balances the black shoulder straps of the belt bags.

This photograph has a high aesthetic quality. The gamut of greys, the coarse grain of the enlargement, the horizontal lines of the ground, and the vertical lines of the figure are formal features that keep the beholder's eye on the rectangular plane of the glossy print. A contemplative engrossment in the picture develops.

Some insights emerge: standing up and facing the ultimate threat; no futile gesture of self-protection; the serenity of a face with eyes and mouth closed. A meaning imposes itself in this beholder's mind. The photograph symbolizes man's dignity when confronting death. In this contemplative apprehension of the symbolic meaning of the picture, the beholder is without self-interest and ego-involvement; he does not feel any sorrow because he too will eventually die. While mentally moving from the picture to the unknown man who happened to die in front of the camera in an Andalusian field, during a sunny day in August 1938, the beholder is not self-centered, but compassionate.

Contrasting the Capa picture with another news photograph of a violent death reveals the importance of composition as a condition of the absence of self-involvement. It is the street murder of a Vietcong suspect by the Saigon police chief, in 1968, during the Vietnam War. The onlooker's visual attention cannot be held by the forms and shapes visible in the plane of the print. Because this picture lacks aesthetic excellence, it elicits no contemplative response. Our attention immediately moves from the image to the repulsive event it represents. We cannot maintain disinterestedness; feeling shame and anger, we are emotionally involved.

The aesthetic quality found in the forms of visual objects is not so mysterious after all. It is composition. Composition closely corresponds to, and stimulates, the aesthetic vision in its dimensions of attention, holism, and disinterestedness.

Visual composition also stands for something else. Like the other formal features of the object, it is a material symbol standing for a nonmaterial signified. Composition symbolizes order. Order is the arrangement of diverse elements into a configuration; it makes them operational or intelligible. It is the core value of the aesthetic quality because it is so basic to our mental life.

At the neurophysiological level, in our perceptual system "objects, figures, and patches are segregated from their environment as circumscribed entities."[3] Wertheimer termed these entities "perceived wholes." Experiments conducted by Gestalt psychologists in the early twentieth century led them to formulate laws of organization of

*Under combat circumstances, Capa "timidly raised his camera to the top of the parapet and, without looking, but at the instant of the first machine gun burst, pressed the button" (Capa and Karia 1974:18). That this composition was achieved by chance does not matter for our argument.

perceptions, such as the Law of Prägnanz, the tendency toward simple forms.[4] Submitted to a constant bombardment of visual stimuli from the external environment, we impose form as a matter of survival. In a work of art, the creator carries this ordering a step further by unifying the formal elements according to a geometric, organic, or dynamic composition, or according to a particular style.

At a subliminal or unconscious level, chaos is an ever-threatening condition. Death is the dissolution of an organization of elements which constituted a well-composed biological unit. Our individual and collective security is constantly imperiled by entropy. At a deep level of the mind, we fear chaos and strive to control it by maintaining or establishing order.

This abhorrence of disorder is transposed, at a philosophical level, into systems of thought which attempt to comprehend the external world—comprehend in the sense of intellectually understand, as well as in the sense of comprise and embrace. There, too, we seek order.

Any artifact with aesthetic quality is a tangible symbol standing for the idea of order. This surprising conclusion from our previous analyses is inescapable. If the configuration of forms in any aesthetic object displays an excellent composition, it necessarily symbolizes order as an idea. Any work revealing a concern for and achieving visual quality is a statement for order and against chaos. Order, of course, is only one of the signifieds of an object: it does not preclude other significations. Nevertheless, it will always be present as a primary symbol. If disorder is to be aesthetically expressed—as, for me, it is expressed in Pollock's action paintings—it will be in a composition that also symbolizes order. Or, if only disorder is expressed—as it is, for me, in Beuys's heap of dirt—it will be something outside the aesthetic realm.[5]

The search for visual order finds its source in the metacultural layer of the human psyche: neurophysiology and the unconscious are not culture-specific. The question so often asked, Are aesthetic criteria culturally determined? can be considered from the perspective presented here.

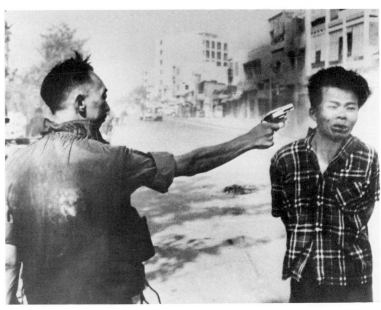

EDDIE ADAMS. Murder of a Vietcong by Saigon police chief. 1968. Photo: Associated Press / Wide World, New York.

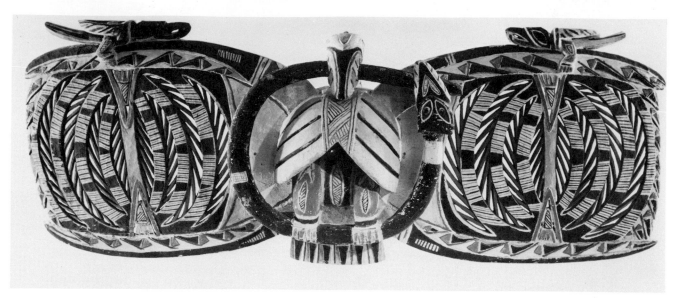

Malanggan open work. New Ireland, Micronesia.
Museum für Völkerkunde, Basel. Photo by P.
Horner.

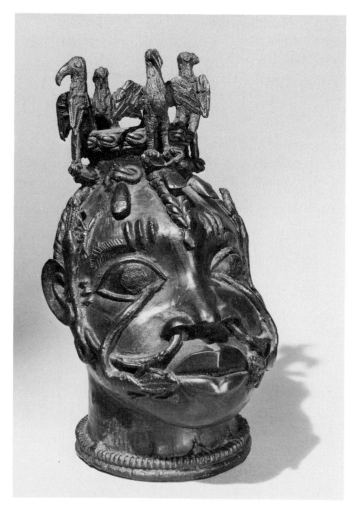

Cast bronze head surmounted by vultures. Benin,
Nigeria. 18th century. British Museum, London.

Stone carving of Quetzalcóatl. Aztec. Photo by G. Jani (Civilisations 1966).

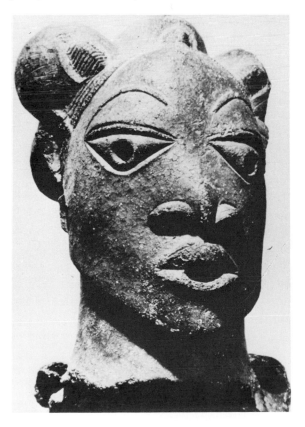

Sculpted head on top of a *nimba* mask. Baga, Guinea. Musée des Arts Africains et Océaniens, Paris. Photo by Jacques Maquet.

Head. Nok, Nigeria. c. 250 B.C. The Nigerian Museum, Lagos.

Trophy head. Costa Rica. c. 1000–1300. Private
collection, Alfonso Jimenez Alvardo. Photo: Detroit
Institute of Art.

The wood carvers of New Ireland in Micronesia, the bronze casters of Benin, the
Aztec stone carvers, and the Art Nouveau painters and sculptors visually organized their
works in organic compositions of vegetal forms. Nok and Ife terra-cottas, some Teoti-
huacan stone carvings, the *nimba* masks of the Baga fertility dances, and French and
Russian Cubist paintings from the beginning of the twentieth century are geometrically
composed. Rayonist painters, Calder in his mobiles, and African carvers using forms of
the exponential curve type chose a dynamic composition.

These different manners of visually ordering forms were predominant in certain
societies during certain periods. But there were variations in time within the same
cultural tradition; the three principles of composition interpreted in several different
styles have existed successively, and sometimes simultaneously, in the societies of the
Western tradition. And as the few examples cited above demonstrate, the same principle
of order has been used in culturally dissimilar societies. We can conclude that the types of
composition are not culture-specific.

Aesthetic quality through visual order has been, and still is, achieved in most, if not
all, societies. It is achieved by similar means. Thus it may be cross-culturally appreciated;

it does not require familiarity with cultural codes. Neither composition nor the symbolization of order are based on cultural specificities.

At this point arises the objection How can geometric order be realized by carvers and painters whose culture does not include grids, rulers, and measurements? The answer is that it is not necessary to know geometry in order to organize forms geometrically. Makers of forms, as well as beholders, perceive that elements are, or are not, at the right place. Some artists confirm their visual evaluation by tracing schemata on squared paper. But most painters, carvers, and engravers—Western as well as non-Western—rely only on their visual intuition. Diagrams revealing the structure of art works are primarily used by teachers who want to explain *how* forms were designed, and *why* they are balanced.

Aesthetic quality is not limited to representations. Some actual views of external scenes—landscapes and cityscapes, mountains and gardens, animals and people—may display the formal features that make a painting or a sculpture aesthetic: they may have composition. The setup of these features is unintentional, the chance result of circumstances; thus such aesthetic encounters are exceptional and fleeting. But they tell us something about the aesthetic quality. Let us compare our mental responses to some pictorial representations of scenes with our responses to similar actual scenes.

I look at a Song (Sung) dynasty hanging scroll attributed to Li Ch'eng, a gentleman-painter of the tenth century. It is entitled *A Solitary Temple amid Clearing Peaks*. The rectangular surface, vertically oriented, is clearly divided into halves. In the upper half, vertical lines dominate, and the weight of the darker areas is at the top where attention is attracted. The lower half is graphically confused: short lines extend in all directions, and there are many irregular shapes. However, horizontal lines establish some order in the visual confusion: a large area at the bottom of the picture is irregularly horizontal; strictly straight lines are concentrated in the middle of the lower half of the picture, and at the top of the lower half. In the middle of the picture, a very stable triangular shape affords a strong point of focus for the entire scroll.

This triangle is the elevated rooftop of the temple, located on a rocky hill; it is sharply drawn on a misty background. A valley separates the temple hill from two towering, almost vertically steep, mountains. The summits are rather flat and covered with trees, but they appear inaccessible. Visually going down from the temple, we find entry buildings at the foot of the hill, on the riverbank. They seem to welcome travelers: there is no fence. In the galleries, around open pavilions built on river piles, two gentlemen leisurely converse, and another, resting on the rail, looks at the scenery.

In the confusion of worldly life, the temple brings peace, balance, and security. It is the focus of social life. Beyond the mainstream, on the other shore, there is the world of illumination, in the mountains. Perhaps a few hermits live in the forest at the top, if they have been able to climb the pathless clifflike slopes of the mountains. This quest is above and beyond the temple. The temple cannot be of much help, except as the last social shelter on this shore, before crossing.

Sitting on the porch of a cabin in the Colorado Rocky Mountains, I look at an actual landscape. Above the timberline, the summit of Longs Peak is bare and impressive. The view reminds me of the Li Ch'eng scroll; I cannot avoid the comparison. The foreground is also horizontal, but not because of a built environment, as on the scroll. Although there are a few cabins, the horizontal dimension is mainly provided by a meadow. Verticals are

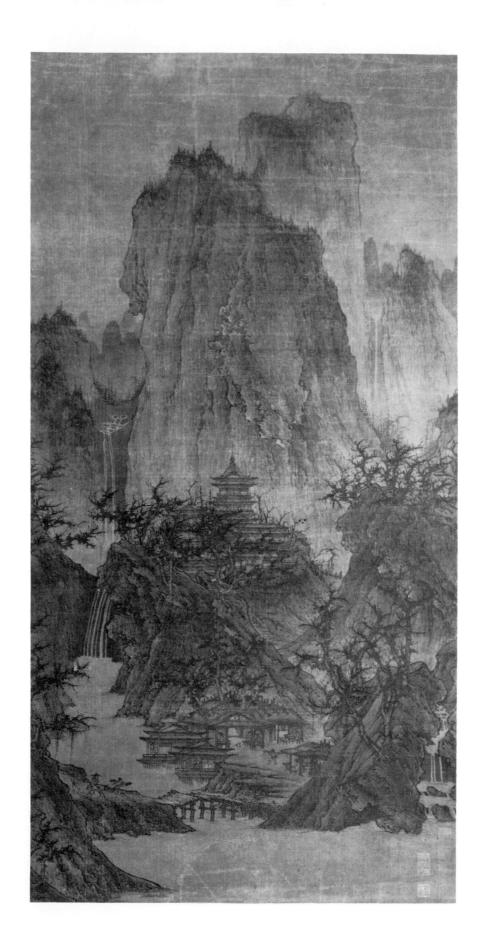

limited to pines and aspens. The visual structure of the landscape is dominated by obliques. Between the place where I sit and the top of the mountain, there is a gradual continuity, not a sharp distinction, as on the scroll. The meaning conveyed to me is that reaching the summit of Longs Peak—as well as of human life—would not be an extraordinary feat, but would require endurance and perseverance.

As I reflect upon this experience-as-recalled, I can identify the components of the aesthetic quality of this actual landscape. A frame was visually provided by two of the posts supporting the porch roof and by the edges of the roof and the platform; they were in the foreground, at the periphery of my vision. This "frame," and still more the memory of the Li Ch'eng scroll, led me to see the mountain view as a painting; it established a discontinuity with my usual way of looking at an environment in which I am physically present. The configuration of forms dominated by obliques was "well organized" by chance, and highly visible. Clearly, there was a "composition" arresting enough to stop discursive thinking and replace it by contemplative vision. The symbolic meaning that emerged—gradual ascension to the peak of life—was perfectly expressed by the visible forms.

On a secluded California beach, a few friends are sea- and sunbathing. A young woman is resting, leaning on her right side. She is seen in the unlimited visual context of the ocean and the beach. Perhaps subliminally remembering Modigliani's *Reclining Female Nude*, I mentally "frame" her. In spite of the slight oblique of her left side, from shoulder to ankle, the dominant lines of her contour perfectly blend with the dominant horizontal lines of the natural setting. The brownish tan of her skin, the beige color of the beach towel on which she is lying, and the greyish yellow of the sand are matching. The lines and colors of her body and the landscape are in perfect accord. She symbolizes the harmony of woman with nature.

A few days later, looking at slides of Modigliani's *Reclining Female Nude*, and Ramos's interpretation of this Modigliani, I remember the view of my sunbathing friend. It is as if I were comparing three very similar paintings of women in the nude, each symbolizing a different idea: earthiness in the Modigliani, openness to communicating in the Ramos, and harmony with nature in the actual scene. The aesthetic quality of the actual scene and the aesthetic experience it triggered in my mind are the same as what resulted from my encounter with the paintings.

As described earlier, I perceived Tobey's *Edge of August* as symbolizing a soft clarity of mind. Later, while visiting Kyoto, I had the opportunity to quietly look at the rock garden of the Ryoan-ji temple. Visual contemplation of this carefully raked gravel rectangle in which fifteen rocks are irregularly placed resulted in a similar perception of mental clarity. Later, another meaning emerged, that of nonduality. The dark and asymmetrical shapes of the stones and the contrasting uniform white ground hid a deep unity under their obvious but superficial opposition. Here again, an actual garden and a painting have similar aesthetic impacts on a beholder. The aesthetic quality is, in either case, made of a well-integrated design supporting a strong symbolic potential.

During World War II, upon leaving an underground shelter after a night air-raid over a small European town, I was stunned by the view of the street. It looked like a stage, theatrically lit to dramatize the space where actors will perform a play. This strange effect was the result of bomb explosions somewhere in the vicinity: the blast had broken and scattered windowpanes. Blacked out window glass had fallen into the street, and lit-up

Attributed to Li Ch'eng. *A Solitary Temple amid Clearing Peaks*. Song (Sung) dynasty, 10th century. The Nelson-Atkins Museum of Art, Kansas City.

rooms shed patches of light. This lighting which, by accident, was visually organized, gave the impression of having been set up by a stage engineer. This view, so different from the ordinary appearance of the street after dark, had interrupted my usual flow of emotions and ideas. In that mode of consciousness, I saw the street littered with broken glass. An electric bulb was hanging from the ceiling in a room suddenly made visible by the absence of darkened glass and curtains. A woman and a child were lying motionless, having been hit by flying debris. Everything I saw meant the absurdity and cruelty of war. This perception did not last very long, perhaps only a few seconds; indeed, some action was required to help the victims.

The absurdity and cruelty of war were the meanings I perceived in *Guernica* when, a few years later, I saw this Picasso for the first time at the Museum of Modern Art, in New York. Two very different "aesthetic objects," the most usual one, a painting in a museum, and the most improbable one, a street devastated by an air raid, had stimulated similar attention and had symbolized the same idea.

These few cases illustrate our point that scenes and objects of the external world may have an aesthetic quality. When they have it, it is not different from the aesthetic quality of museum pieces: it generates the same kind of aesthetic perception

Of course we may discover differences when comparing a particular aesthetic perception triggered by, say, the Li Ch'eng scroll or a Modigliani painting, and the Rocky Mountain view or the actual nude on the beach. But such differences cannot be generalized and attributed to the category of 'actuality' or of 'representation'. For instance, we may expect the formal composition of a natural view, like the one from the cabin, to be weak. As any photographer knows, the "composition" of a landscape must often be improved by manipulating angles and frames before shooting. On the contrary, the painter Li Ch'eng could organize his landscape and give it the composition he wanted within the frame he selected. As it happens, the natural composition may, by accident, be better than the painter's intended composition.

Also, it could be expected that visual stimuli existing in the external world make it more difficult to keep one's mind disinterested. Indeed, when looking at the Rocky Mountain view, I could not help intermittently pondering an offer to sell me that view (as an appendage to the cabin). And while looking at my friend on the beach, I saw her not only as a symbol of harmony with nature, but as a lovely woman. But the ego's possessiveness may be as involved or even more involved, in art objects. The desire to acquire a Sung dynasty scroll or a Modigliani may be as distracting as the desire to own a mountain cabin or to dally with an attractive person.

Beauty, the common-language equivalent of our aesthetic quality, is not only in the eye of the beholder. Beauty is also in the object. In order to offer enough support for the beholder's aesthetic response, the object must have integrity of composition.

It is the overall design that integrates lines and shapes, colors and textures in a complex yet unified whole. This visual integration is achieved according to several principles of order, and several styles. Particular applications of one of these principles may be culture-specific, but the principles are not. Beauty as composition is accessible, even in unfamiliar cultures, as it is entirely comprehensible through vision. There is no need to know the cultural premises for grasping a visual order, or even for assessing the comparative excellence of design in a series of units, the forms of which are organized

Lovers (*mithuna*). Madhya Pradesh, India. 11th century. The Cleveland Museum of Art. Purchase, Leonard C. Hanna, Jr., Bequest.

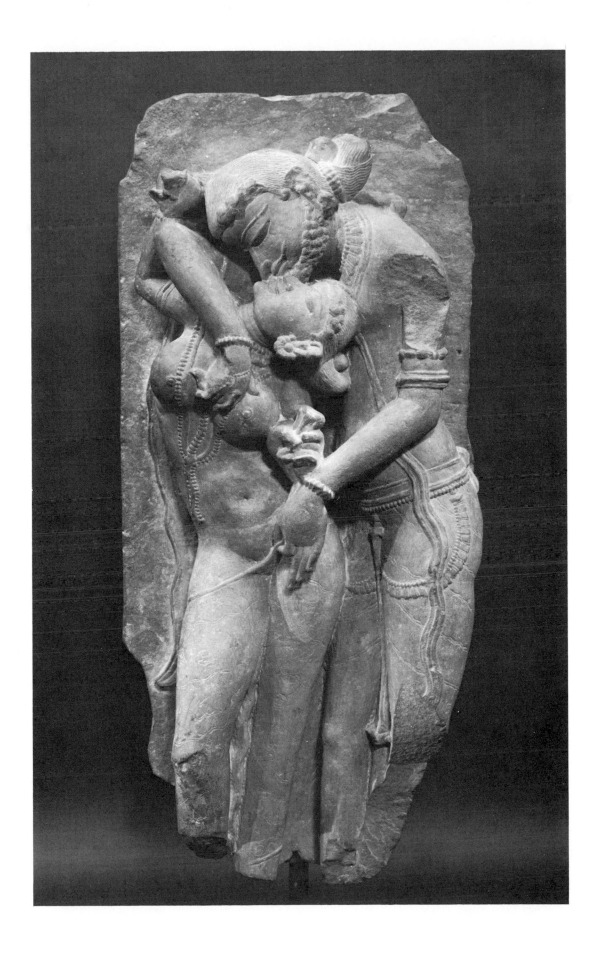

according to the same principle. An example of such a series is afforded by the ten, or more, Gothic cathedrals built in northern France between 1150 and 1250.

The expressive power of an object, its capacity to be a strong symbol, results from its excellence in design. Usually a beholder perceives only one symbolic meaning of an object which may support several meanings. Even so, the beholder perceives the expressive strength of the visual support. For symbolic meanings there is no code to be learned. An African carving may be a potent symbol for Westerners, even when its meanings, referential and symbolic, in its original culture are ignored. So it was with turn-of-the-century European painters as they discovered the beauty of African figurines.

Another result of a sound composition is the establishing of a discontinuity in the usual stream of consciousness of the beholders. This break brings beholders into the mental mode of contemplation, a mode devoid of self-indulgence. A well-composed eleventh-century Indian statue of two lovers, the man gently and voluptuously disrobing his partner, distanciates this amorous representation from the ordinary erotic daydreams of beholders in their everyday life. A painting of a Napoleonic battle does not involve the beholder's ego in the passions of violence and hatred if its composition is outstanding.

CHAPTER TWELVE

Preferences in Art

EVERYBODY HAS PREFERENCES IN ART. HOW PREFERENCES ARE JUSTIFIED HAS BEEN A MUCH-discussed question in the Western tradition, particularly during the last two centuries. Annual salons and awards formally introduced competition, thus assessments and judgments in the visual arts. Wherever similar societal developments have focused the general attention on the bases of evaluation for aesthetic objects, the same question has been raised.

These discussions have, in fact, generated much skepticism about the possibility of making aesthetic judgments. In this regard, an often-stated opinion is that preferences are a matter of taste. The implication is that the reasons for our preferences are based on idiosyncratic factors, not clear to ourselves, thus difficult to verbalize. Usually, when "taste" is put forward, the suggestion is that any further argumentation is futile.

Disillusionment with attempts at aesthetic evaluation stems, at least in part, from two incorrect assumptions. One is that aesthetic quality is expected to be the only legitimate basis for our preferences. This assumption is unrealistic: aesthetic objects are potent symbols. Their symbolic meanings, which emerge during the aesthetic encounter, cannot be ignored in our preferences.

Another incorrect assumption is that preferences should result from individual judgments made afresh by each beholder. Value assessments in religious, ethical, scientific, or political matters are part of the culture transmitted to us. For ordinary participants in a culture—and we are all ordinary participants except, perhaps, in the limited domain of the special expertise of each of us—value judgments are included in the tradition in which we have been enculturated. Even when we accept cultural values and their social legitimations with qualifications and reservations, we do not perceive them as "imposed" upon us: we share them with sincere conviction. Why should it be otherwise in aesthetic matters?

Though not an exclusive basis for preferences in art, aesthetic excellence is certainly relevant to them. How is it determined?

In the preceding chapter, I proposed that the excellence of composition together with its resultants, expressivity and visual discontinuity, form the bases for assessing aesthetic quality. We think this formulation reflects the practice of many art critics and art historians, even if they use a different vocabulary. In one way or another, assessments of aesthetic excellence are concerned with the internal congruence of forms, with the strength and clarity of expression, and with the presence of the object which compels attention and sets it apart.

Artifacts considered to achieve aesthetic distinction are included in art histories devoted to the visual production of a culture or a civilization during a certain period. Or they are the object of detailed monographic studies. Usually, these publications establish broad categories, like "masterpieces of outstanding aesthetic quality," "good pieces," and "minor pieces"; they do not attempt to rank the items competitively. There would be no point in doing so, of course. Nevertheless, comparisons of more or less successful solutions to the problems of integration of forms, of expressiveness, and of compelling presence in the same style do help us to understand better a certain style. The builders of the cathedrals of Rheims, Amiens, and Beauvais have organized Gothic forms differently. Detailed studies of these organizations give us a better grasp of the Gothic principles, and, as a by-product, afford the possibility of ranking these solutions.

In evaluating aesthetic quality, experts can differ, and do differ, but surprisingly very little. There is as much agreement among them as among specialists in such fields of the humanities as philosophy, literature, or the history of science. A cursory survey of the major art history books convincingly demonstrates the extent of agreement among art critics and historians on the inventory of masterpieces, good pieces, and second-rate pieces, and on the conclusions of detailed comparisons and rankings. The consensus is impressive. This reveals that aesthetic appreciation is not as subjective as it is said to be. In fact, it is no more subjective than, say, moral judgments made within the same ethical system (analogous to a stylistic system in the aesthetic realm). Within the system of Catholic theology, the consensus on the morality of a particular action is very high, and thus the judgment is not idiosyncratic. So it is within the system of the Gothic style.

Now we may address the question How is aesthetic excellence relevant to the beholder's preferences? Within an aesthetically ranked series of items belonging to the same stylistic system, the ranking will probably have an influence on the preferences of those who have studied the set of compared works. And the ranking will probably correspond to the intuitive preferences of other beholders who have not made a previous analytical study.

When objects from different stylistic systems belong to the same broad category of masterpieces or good pieces, the aesthetic quality cannot be a basis for preferences, as it is equivalent. The Parthenon, Notre Dame of Paris, and the Taj Mahal are recognized masterpieces; few art historians would consider ranking them in aesthetic quality. Yet many of them—and many common beholders—have definite preferences. On what are these preferences founded?

They are founded on the symbolic meanings of the masterpieces. For many beholders, the Parthenon (5th century B.C.), through its small size, its clarity of plan, and its Doric simplicity, stands for an austere equilibrium of rationality and an organized life free from intimations of a realm beyond the human world. This meaning is perceived when

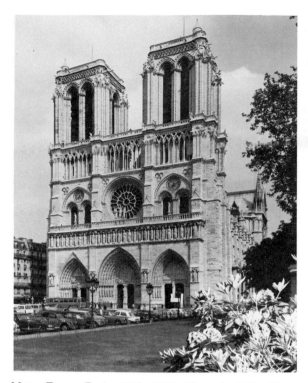

Notre Dame. Paris. 1163–1250. Photo by J. Feuillie, © Caisse Nationale des Monuments Historiques et des Sites / SPADEM.

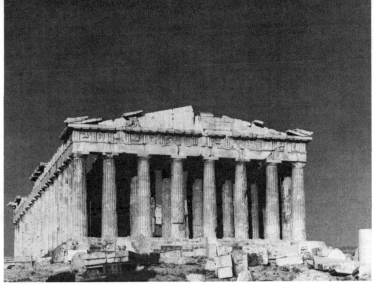

Parthenon. Athens 447–432 B.C. Photo by Jacques Maquet.

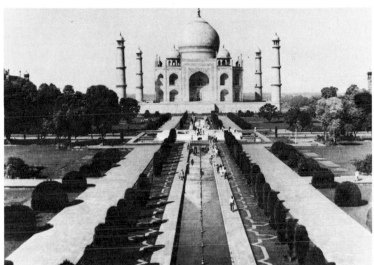

Taj Mahal. Agra. 1634. Photo by Nino Cirani (Civilisations 1966).

one contemplates the visual forms of what remains of the Parthenon; it is not separate, nor separable, from the vision. As these signifieds are in continuity with the Parthenon as it now stands among the ruins on the Acropolis, they are deeply experienced by the beholders. Balance, rationality, and the limitations of human life are more than cognitions, they are mental experiences.

Notre Dame of Paris (13th century) is a vision of luminous windows, a lofty nave, a forest of pointed arches and flying buttresses. It symbolizes the belief in the heavenly dimensions of life and the idea of a responsive suprahuman power; it makes the beholders experience transcendence. Beholders in the cathedral symbolically experience all this, even if they do not know it intellectually.

The Taj Mahal (17th century) is the grandiose mausoleum that houses the tombs of Shah Jihan and his favorite wife, whom he so passionately loved. The light and bulbous dome, the four elegant minarets, the white marble walls inlaid with semiprecious stones, the surrounding gardens remind beholders that life, even as incredibly sweet and

pleasurable as it may be tasted by those quietly sitting in the gardens and looking at the Taj, always ends in the sadness of death.

Each of these three buildings is recognized as one of the few highest achievements of world architecture. Each has what is needed to interrupt the ordinary mental flow and command the full attention of beholders. Each displays a perfect integration of the forms characteristic of its style. Each is effectively expressive of what it means. All this makes each of these buildings outstanding in aesthetic quality. But it does not give any basis for preferring one over the others. Aesthetically, they belong to the same category of highest achievements. Preferences cannot be founded on differences in aesthetic quality.

Preferences are founded on a consonance of the values symbolically expressed by the aesthetic object with the beholder's own values. A work of art stands for some intangible entity, is in continuity with it, and generates an experience of it. It is therefore preferred by beholders attuned to some values rather than to other ones. I prefer to undergo symbolically some experiences rather than other ones. For instance, I look forward to having an experience in continuity with the Anurādhapura Buddha's quiet and energetic concentration and not with the Bacon painting's passive and active torture. An abstract cognition is neither pleasant nor unpleasant, whereas an experience, even if symbolic, is either positive or negative.

In a less extreme illustration, contemporary beholders who believe that living is an endeavor that could and should be rationally controlled are attuned to the Parthenon's values. Notre Dame, on the contrary, is preferred by those who see in life a transcendental dimension of a dependence upon some power higher than man. Those who believe transitoriness and fleetingness are the most moving attributes of human life are likely to feel more in harmony with the Taj Mahal's symbolic significance.

That preferences are based on a consonance of values should not be rigidly construed. Because being a victim and being a torturer are aspects of the human condition, I sometimes welcome having a symbolic experience of torture. I do not wish to repeat such an experience frequently; I would like to experience concentration more often.

All of us are open to new values, although of course each of us has a different degree of openness. Experiencing them symbolically is always an enrichment, and sometimes produces a change in our previous system of values. Rivera, Orozco, and Siqueiros have introduced many non-Mexicans to some understanding of the values of the Mexican revolution. African carvings exhibited in France, Germany, Great Britain, and the United States during the first decades of this century have made some of the basic values of traditional Black Africa appreciated and respected in the industrialized West.

It can be said, then, that artifacts without aesthetic quality cannot convincingly support symbolic meanings. Thus they cannot be preferred, because preferences are based on the consonance of symbolically expressed values in the objects with the values of the beholder. Aesthetic excellence is not directly relevant to art preferences. It is the condition, but not the criterion, of preferences in art.

When young members of a contemporary industrial society slowly assume the common culture that existed before they were born, they are given an inventory of art works along with aesthetic judgments of them and preferences for some of them.

As mentioned above, aesthetic judgments primarily consist of very brief evaluations, such as "masterpiece," "good piece," and sometimes "inferior piece but valuable in this

or that regard." Finer judgments are not usually included in the common heritage of a society; they are transmitted in some subcultures, such as those of visual artists or of wealthy amateurs.

"The whole society" that makes collective judgments in aesthetic matters is not the whole society, of course, but "the art establishment." Those who have an impact on collective aesthetic judgments and art preferences belong to many categories: art practitioners, such as painters, designers, sculptors, and graphic artists; theorists, including art school teachers, critics, aestheticians, and art historians; museum curators and gallery dealers; art magazine and journal writers; art foundation executives and art school administrators; collectors of original works and buyers of prints and other reproductions of originals. In this heterogeneous group, the decisive influence belongs to the celebrities of the art and art-related professions and to those members of the privileged minority who are interested in the arts.

Preferences for a style, a genre, or an artist are also transmitted. Our present acquaintance with many different styles, genres, and artists gives us more scope for individual choices than ever before. For several generations of Renaissance Italians, the preference for the architectural styles of classical antiquity was culturally transmitted together with contempt for the other styles. The style of medieval churches was considered so ugly that it was called Gothic after the Goths, the barbarian invaders who sacked Rome in the fifth century. Such a preference, restricted to one style only, is very alien to the prevailing ecumenical approach. In fact, preferences transmitted in contemporary industrial societies reflect an openness to everything that has aesthetic quality, whatever the style, the origin, or period. Preferences are still strong, but they are not exclusive. Tolerance of other preferences is valued and even socially expected.

The art establishment—its leaders and followers—seems to reach a consensus on quality and preferences in the aesthetic field, past and present. The distinction between aesthetic quality (based on composition, expressivity, and discontinuity) and preferences (based on a correspondence between the meanings of the object and the beholders' values) is blurred in the prevailing opinions and convictions, views and sentiments which emanate from the art establishment. Our distinction is a useful conceptual tool for the analysis of the establishment's views and assessments, but it is rarely made explicit in the everyday aesthetic discourse of our culture.

In fact, views and opinions that express a consensus are rarely formulated as such. After reading a few favorable articles on an artist, seeing an artist's work frequently exhibited, noticing the high price of an artist's works and how often photographs of them appear in the media, we conclude that this artist is recognized as very good and is liked. We can summarize the many clues and marks of appreciation by concise, trivial statements like "Picasso is great," "Dali remains surprising," or "We all like Senufo masks." These terse statements summarize many analyses and evaluations, many judgments and intuitions; in their simplicity they encapsulate the art establishment's consensus. It is a fluid process which includes revisions and, rarely, revolutions.

The biography of a twentieth-century artist gives a glimpse of how the mechanisms of aesthetic recognition operate in our society.

Jackson Pollock was born in Wyoming in 1912. His artistic career began when, at thirteen, he entered an art school in Los Angeles. Four years later he moved to New York

and pursued his training under Thomas Benton, at the Art Students' League. When Pollock was twenty-six, he worked on the art programs of the Work Projects Administration, as did many young artists of his generation.

To be an art school graduate is, in our society, the first identification of professionalism in art. Attending a well-known school, having a renowned teacher, and living and working in one of the few international art centers—New York City was already one in the thirties—are additional assets.

In the early 1940s he joined the New York surrealist group. With them, he participated in the 1942 International Surrealist Exhibition in New York; it was Pollock's first breakthrough into fame. For a thirty-year-old painter, it was an achievement to be associated with surrealism at a time when this important trend was being passionately discussed in the art community. It was an opportunity to be represented in an exhibition that widely extended the visibility of surrealism to the large intellectual, literary, and artistic audience of the metropolitan area.

The following year, in 1943, he had a one-man exhibition at Peggy Guggenheim's gallery, Art of This Century, which became by contract his agent. From that time on, he had the benefit of the powerful support of Peggy Guggenheim, perhaps the most discriminating and committed art patron of the time, and the prestige of being associated with a historical name among the American elite, Guggenheim.

In the fifties, influential art critic Clement Greenberg devoted several supportive articles to Pollock; he made him known to, and appreciated by, the intellectual elite readership of *Partisan Review, The Nation,* and *Commentary.* No work by Pollock would go unnoticed. Indeed, his paintings, sometimes criticized, more often praised, were always discussed. As a celebrity could do, and should do, Pollock innovated. He transposed the surrealist "method" of automatic writing into painting. In order to be liberated from rational control, one should write fast, "let it go," and try not to impose a logical development on one's text. A similar liberation from rational planning was achieved by *action painting:* the new technique of painting Pollock made famous. A canvas was stretched on the floor; briskly walking around it, Pollock dripped fluid paint and spread a thick impasto. This technique, in addition to its effectiveness in freeing the mind from learned routines, had the necessary ingredients to make it newsworthy: it was outrageous, easy to understand, and associated with the glittering high society.

I do not mean to suggest that Pollock's success was due simply to a clever manipulation of public relations. His work was liked because of its consonance with the spirit of the time. The beholders of his action paintings belonged to an intellectual minority who had been made aware, through surrealism and psychoanalytic theories, of the repressive impact of rational structures. The symbolic meaning of action paintings—liberation from logical and social constraints—corresponded to the values of the New York art establishment.

In 1948 Pollock's work was exhibited in Europe with the Peggy Guggenheim collection. The following year, when Pollock was thirty-seven, *Life* magazine devoted an article to him entitled "Jackson Pollock: Is He the Greatest Living Artist in the United States?" What happened during the remaining seven years of Pollock's life was an answer to that question. To many, Pollock was indeed the greatest living artist in the United States. From 1949 to 1956, the year he was killed in a car accident, Pollock had more than a dozen one-man exhibitions in important galleries in Europe and America,

including one at the Museum of Modern Art in 1956. Since his death, his reputation has been further enhanced by recognition from critics, curators, and buyers.

Preferences are necessarily verbalized by individual voices. But the consensus of these voices in a certain society at a certain time indicates that the values and meanings symbolized in art are consonant with collective values, hopes, dreams, and fears. Individual preferences are secondary: they select from within the collective selection. If consensual preferences were not primary, what would be the explanation for the dominance of certain symbolic values and themes in a society at a certain period?

Symbolic meanings are strong in environments, happenings, and performance art events. A brief formal analysis of 116 photographs of such "art processes," which illustrate three chapters (covering the years 1955 to 1970) of Adrian Henri's *Total Art*, reveals that 88 pictures—representing 76 percent of the 116—symbolize chaos, deterioration, or destruction.[1] In some, shapes not visually reducible to Cézanne's spheres, cylinders, and cones are dominant and stand for chaos and messiness. In others, fluid but viscid forms evoke decay and disintegration. In still others, exploding forms evoke violent destruction. We know that environments, happenings, and performances constituted marginal categories on the art scene of the fifties and sixties. Nevertheless, the fact that three-quarters of their productions (as reflected in this apparently unbiased series of paintings) were so oriented at least indicates that the theme of destruction was haunting the collective psyche.

Using the same approach—brief, quick, but educated evaluations of the symbolic meanings of a set of book photographs—I glanced through the seventy or so pictures in Camilla Gray's book illustrating what the Russian avant-garde painted during the years 1912 to 1914.[2] Destruction was certainly not a meaning symbolized by the forms.

In the Rayonist compositions of Larionov and Goncharova, in Malevich's cylindrical

MIKHAIL LARIONOV. *Glass*. 1912. Solomon R. Guggenheim Museum, New York. Photo by Robert E. Mates.

NATALIA GONCHAROVA. *Cats*. 1913. Solomon R. Guggenheim Museum, New York. Photo by Robert E. Mates.

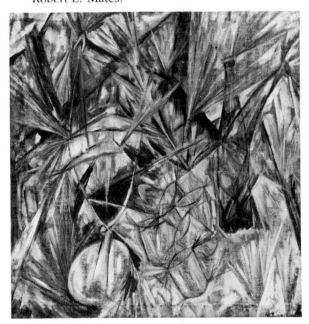

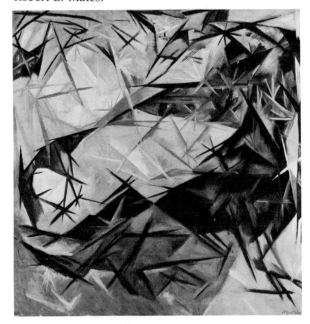

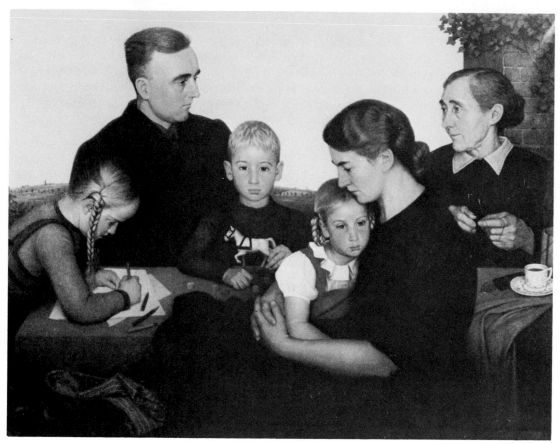

ADOLF WISSEL. *Kahlenberg Farm Family.* c. 1939.
Photo: Carl Hanser Verlag.

forms as well as in his Suprematist compositions, in Tatlin's oval shapes, curves, and pointed intersections of lines in his stage backcloths, and in Goncharova's machines, forms symbolize a vibrant and dynamic vitality. What these very different pictures have in common is the dominance of an oblique composition. In the early years of the second decade of this century, the intellectual and progressive audiences of Moscow and Saint Petersburg liked these artists' works because the symbols in their paintings corresponded to the values collectively held by the intelligentsia.

In these analyses, the concept *value* should be broadly understood. Here, we do not refer only to the values explicitly regarded as positive in a certain society, at a certain time—such as, in the Third Reich, work and family, war and sacrifice for Germany. We refer also to values not overtly recognized, such as eroticism, a hidden indulgence in many societies; to obsessions, such as death anxiety; and to fears, such as the contemporary horror of atomic doom. In fact, in the present context, the word *value* connotes the dominant themes and constant concerns that pervade the collective imagination of a society.

The art establishment consists of persons who belong to their time and society. They share the values, concerns, and themes of their cultures, and they perceive the corresponding visual symbols. Their positive responses to works of art are certainly influenced

by the symbolic meanings of the objects. It is not easy to determine the relative importance of the aesthetic quality and the symbolic meaning in the collective response of the art establishment. We should not forget that quality and meaning are simultaneously perceived in the aesthetic experience, and distinguished only in the experience-as-recalled by those inclined to discursive reflection.

Moreover, most art establishment people want their aesthetic judgments and art preferences to meet with public approval. Art dealers want to sell, curators want to attract visitors, publishers of art magazines and books want subscribers and readers, art schools want students. Certainly, they are leaders and pacesetters in aesthetic matters, but they have to be followed. The concern not to outdistance the general public cannot fail to orient, consciously or not, their selection to works that will have large appeal because of their consonance with dominant themes and values.

The components of aesthetic quality—clarity, simplicity, and integration of composition; expressive power; and discontinuity with the everyday environment—are not culture-specific, and consequently, aesthetic excellence may be intuitively perceived and discursively analyzed cross-culturally. Furthermore, certain aesthetic objects are preferred on the basis of the consonance of their symbolic meanings with the beholders' values and not on the basis of their aesthetic excellence, at least, not primarily, in most cases.

Are preferences, then, culture-specific? If preferences result from a correspondence between the symbolic meaning of the object and a cultural value, can we perceive the value symbolized by an object made in another culture? Can we like and prefer a visual object symbolizing an "alien" cultural theme?

Between Creators and Beholders

SO FAR, THE PARADIGM OF SIGNIFICATION HAS BEEN THE ONLY FRAMEWORK FOR THE DIS-cussions: *in context M, sign A stands for signified B to subject X.* There was an object, and there was the beholder looking at it. Nobody else or nothing else was involved in this visual and mental relationship. Often the creator of the visual forms was mentioned, but mainly in order to identify the object. No attempt was made to include the painter or engraver, the sculptor or designer in the aesthetic commerce between the beholder and the work. Should artists be included in the aesthetic experience?

It seems they should. Listen to conversations about paintings and sculptures, read newspaper reviews of exhibitions, and pay attention to arguments used when opinions about art objects are debated: to a large extent, discussions are about what the painter wanted to say, what the sculptor intended to state, and what the artist wished to convey to the audience. In fact, the search for the meaning of a particular art object is almost always expressed in terms of the artist's intentions. Our everyday discourse about visual arts implies that art works convey messages from artists to beholders, and that a main concern of the latter—if not the main concern—is to decipher the message hidden in the object.

How do visual forms convey messages? Are they vehicles for meanings in the process of communication?

Not all uses of terms concerning communication imply a commitment to the assumption that art is communication. Occasionally terms belonging to the communication vocabulary have been loosely used in sentences like "Picasso *tells us* in *Guernica* that war is absurd and cruel" and "The anonymous carver of the Anurādhapura *Buddha wanted to convey to Sinhalese people* that there was invulnerability in serene concentration." Despite this wording, we were primarily concerned with the meanings of the works, and not with the intentions and messages of the creators. In the following discussions, we shall strictly use the precise terminology defined by the paradigm of communication.

The relationship of communication includes two actors, the sender and the receiver,

151

CONSTANTIN BRANCUSI. *Adam and Eve.* 1916–21.
Solomon R. Guggenheim Museum, New York.
Photo by Carmelo Guadagno and David Heald.

and what is sent and received, the message. The sender translates a nonmaterial message into a physical medium (or vehicle) which is transmitted to the receiver. The receiver reconverts the medium into the message intended by the sender.

Adapted to the visual arts, the paradigm of communication may be so formulated: *in context M, sender Y embodies message B into form A; in context L, receiver X interprets form A as standing for message B.* Sender Y, the artist, transmutes idea B into a visual configuration of forms, aesthetic object A. Then object A is looked at by receiver X, the beholder, who apprehends in it idea B.

The second part of the formula—*in context L, receiver X interprets form A as standing for message B*—is similar to the signification paradigm—*in context M, sign A stands for signified B to subject X.* Do we conclude that the subject's meaning and the receiver's message are identical? Or do "message" and "meaning" stand differently for their respective signifieds?

A few years ago, in a retrospective exhibition of the works of Constantin Brancusi (1876–1957), I saw a striking carving in the beautiful space of the Guggenheim Museum. It was a complex wood structure, about eight feet high. It looked like a pillar, but strangely, it was made of two statues, each on its own pedestal, and one on top of the other. On the label were only two dates, 1916–1921, and the title, *Adam and Eve*.

This caption put me on the analytical track. Where was Adam? Where was Eve? And what was Brancusi's message about them? Because of the title, I assumed that each statue was a human figure, and I tried to identify Adam and Eve. Rendition was at the limit of the figurative. The style was Cubist in the sense that the two figures were represented by a few geometric-like forms selected from the human body repertory. Each figure seemed to have been carved out of a beam; symmetry and verticality dominated.

The top figure had, at its center, a bisected horizontal cylinder which I perceived as everted lips, a "mouth." Above it, the volumes appeared to be sections of a "face" and a "forehead." This reading might have come simply because these forms were above the mouth. At any rate, mouth, face, and forehead together constituted a "head." Under the central cylinder, and perpendicular to it, there were a long and narrow cylinder, the "neck," and two spheric forms, the "breasts." Eve was the figure on top.

Looking at the other figure, which was supporting Eve's pedestal, I did not see it as clearly masculine. Rather, to me, the general shape suggested a squatting woman, perhaps because it reminded me of a Luba chief's stool supported by a caryatid. The horizontal half-cylinder supporting the capital (which was at the same time Eve's pedestal), the capital itself, and the forms behind the caryatid's "neck" evoked to me a woman's face under a hat (the capital), and locks behind the neck. Without the *Adam and Eve* caption, I would have read Brancusi's message as stating that an older woman, represented as sexually neuter, supported a younger one, beautiful (the elegant long neck) and sexually attractive. The message could have been "mother superseded by daughter."

But this was not the message. The title clearly indicated that the figures were not two women. Adam was to be found. Perplexed and searching for clues of interpretation, I looked around. Among the other Brancusi works, I noticed a glittering *Male Torso*, made in polished brass and dated 1917. There was a striking similarity of forms between the three cylinders of the *Torso* and the neck and breasts of *Eve*. In the former, the vertical cylinder was the "trunk," and the two inferior cylinders at right angles were the sepa-

Chief's stool, village of Buli. Luba, Zaire.
British Museum, London.

CONSTANTIN BRANCUSI. *Male Torso*. 1917. The
Cleveland Museum of Art. Hinman B. Hurlbut
Collection.

rated "legs." Also, the *Torso* had very explicit phallic connotations: it evoked penis and
testicles.

Returning to *Adam and Eve*, I noticed that the top figure could as well be interpreted
as including the masculine motive of the *Torso*. The trifurcated form was as much penis
and testicles as neck and breasts. In that perspective, maybe Adam was the top figure,
supported by Eve as caryatid. However, the mouth above the trifurcated form definitely
was not masculine. If it was a mouth, it was a woman's mouth; its proximity to the phallic
form also suggested the meaning of vulva.

Still perplexed, I saw another Brancusi: a columnlike carved wood piece, dated 1915
and called *Caryatid II*. The head and the capital it supported were different from the
corresponding forms in the lower figure of *Adam and Eve*, but revealed some similarities
too. The word *caryatid*, used in the title by Brancusi himself, referring to a supporting
pillar in the form of a *woman*, not a man—which, as a sustaining column, was called a
telamon. *Caryatid II*, with the protuberant abdomen of an African ancestress figurine, was
distinctly feminine. How strange, I thought, to represent Adam by a figure without any
sexual attribute (whereas Eve's sexuality was ostensively displayed) and formally so
close to a female caryatid. Perhaps Brancusi wanted to say that a dominant Eve had
castrated a dominated Adam.

Finally, I read the notes in the exhibition catalogue. I learned that the two statues had

been brought together long after they had been independently carved. The upper one was called *Eve* when created in 1916, and the lower one, "now figure, now base," probably did not acquire its appellation *Adam* before its association with *Eve*, in 1921. Art critic Sidney Geist concluded: "The work surely reflects Brancusi's current attitude on the social relations of the sexes: beautiful woman is now the crushing burden of responsible man."[1]

Disappointed, I left the museum. If Brancusi wanted to say what Geist assumed he wanted to say—that "beautiful woman is now the crushing burden of responsible man"—he had produced a poor vehicle for his message. In this work, he proved to be the unskilled sender of a message embodied in confusing forms.

A few days later, I had another opportunity to see the same piece. This time, I did not think about deciphering Brancusi's message. I looked at it with attention and receptivity. I had a deep and positive aesthetic rapport with the sculpture.

It was indeed a work of high aesthetic quality. Bisected cylinders, full and truncated spheres, and half-cubes are expertly arranged. The triangular indentations of the base provide a discrete rhythm. Oak, chestnut, and limestone give a varied texture. The whole sculpture is boldly vertical. Together, these formal characteristics build a well-balanced composition that has strength and lightness, stability and upward dynamism. The composition harmoniously blends the dominant geometric order with a less pervasive, but still strong, organic order.

When heedfully contemplated, these forms also offer meanings. To this beholder, the overall meaning of the work is a statement about the dominance of sexuality in an individual's life. This is intuitively perceived prior to any analysis. However, this holistic perception may be discursively explicated.

CONSTANTIN BRANCUSI. *Caryatid II*. 1915. Collection Musée National d'Art Moderne, Paris. Brancusi Bequest, 1957. Photo by Robert E. Mates.

The composition, divided by a central wooden block, presents an evident duality. I do not perceive the upper part as a human figure in which forehead and mouth, neck and breasts, or penis and testicles are parts of a body. I see it as a composite emblem of sexuality, feminine *and* masculine, rather than feminine *or* masculine. Let me make a comparison with optical perception tests designed to demonstrate space illusions. When we look at the outline of a cube drawn in perspective, the same square sometimes appears as the front surface of the cube, and sometimes as the rear surface. Analogously, in *Adam and Eve* the upper configuration of forms successively appears as a visual arrangement of female attributes, then of male attributes, or as the union of both. This dramatically suggests the fusion of the two sexualities. The placement of this emblem on the top pedestal, the symmetry and frontality of its two forms, and its relatively large size confer on this symbol solidity, eminence, and assertiveness.

The lower part, which I perceive as a human shape, is an asexual figure. Its sexuality—the neuter gender seems appropriate here—is separated from the human figure and dominates it. The squatting or sitting figure represents the self, the self of a woman or a man. Dominated by its sex impulses, the self supports the burden of the triumphant desire. The stooped, but enduring and sustaining, figure suggests that the struggle, if there was any, is over. The victory of sexuality has been secured and the self has accepted, or is resigned to being servant and provider of desire.

This is how this beholder verbalized and explained his second encounter with the Brancusi sculpture when he reflected upon his experience-as-recalled. For him, it symbolized the domination of self by sex impulses. To this beholder it was the signified for which the sculpture stood. This was its meaning, but certainly it was not Brancusi's message, as the latter must be somewhat related to the title, *Adam and Eve*.

If Geist's deciphering of Brancusi's message ("beautiful woman is now the crushing burden of responsible man") is correct—that is, conforms to the idea Brancusi wanted to convey—it is clear that meaning and message, at least in this case, are completely different. It is also clear that they are of unequal value. *Adam and Eve*'s meaning is strong and compelling; its message is unclear and uncertain.

That meaning and message of the same aesthetic object can be so dissimilar in content and value is a strange and paradoxical conclusion. But the paradox is of our own making. A symbol is a polysemic signifier: it stands for several signifieds. As the essential quality of a vehicle of communication is to stand for one signified only, that is to be monosemic, a symbol cannot be a good means for embodying messages. To try to transmit messages through symbols is to use the wrong kind of vehicle.

Approaching *Adam and Eve* in the contemplative mode of consciousness, I perceive it as a symbol of self and sexuality. Another beholder, also contemplatively approaching the same work, may perceive another meaning in it. Mondrian's *Broadway Boogie Woogie* may stand for Manhattan to one beholder, for joyful jazz to another, and for the underlying order of life to still another. Each beholder, while aesthetically looking at a configuration of forms, has an intuitive grasp of a symbolic meaning.

Subjects have the sense of perceiving a meaning in the forms. In fact, they endow the forms with a symbolic meaning. They create it, in the full acceptation of the word *create* 'cause to exist'. Such a creation occurred when I posited that Tobey's *Edge of August* stood for quiet illumination.

That several meanings may be attributed to the same aesthetic object is mainly

explained by the impact the beholders' past experiences have on the symbolic under-standing. For instance, a beholder without any experience of meditation is unlikely to endow the Tobey with the meaning of quiet illumination.

Though beholders endow and attribute meanings, they do not simply project mean-ings onto aesthetic objects as if those objects were Rorschach plates. Meanings are not arbitrary, they are clearly in the forms. What a symbol stands for arises from the symbol itself: it compels recognition.

In relationships of communication, on the contrary, receivers do not create messages on the basis of their life experiences. The receiver proceeds by applying to the vehicle the appropriate code of interpretation, the one used by the sender for translating a message into its embodiment. In the decoding of messages, the sender's function obviously has priority. Senders select the messages and codes they use. Vehicles are referents which stand for their signifieds by convention.

When mistaking symbols for referents, viewers use the wrong model of interpreta-tion. Acting as receivers, they try to ascertain the artist's message. As visual forms are not limited to one meaning, they look for clues external to the object such as preparatory sketches, dates of beginning and completion of the work, and its title. Further apart from the object, clues are looked for in the personal life of the artist as it is known through letters, diaries, opinions of contemporaries, and recollections of friends. These sources, usual for a biographer, and possibly for an art historian, are relied upon for deciphering a message. For instance, they make it likely, or not, that Brancusi would express a strong opinion on the exploitation of man by woman in a couple. In the search for Brancusi's message, the decisive argument was external to what can be seen in the actual work: the objection that a neuter figure could not represent Adam was removed by Geist's informa-tion that *Eve* was placed on a base five years after being carved, and that base, a caryatid, was called *Adam*. As in this case, the search for a message often leads to a discursive investigation of circumstantial evidence and the message is reached as a conclusion of elaborate reasonings.[2]

If art objects were media of communication, they would be very poor carriers of messages. As they are symbols, each stands for several ''messages,'' thus obliging the receiver wanting to escape ambiguity to conduct a circumstantial research which is unlikely to attain a definitive conclusion.

The paradigm of communication was evolved from language as a vehicle for information. Language is the best instrument of communication we have. Words are contextually monosemic referents: in everyday verbal communication, words have only one meaning in the context of a sentence (unless they are puns). Admittedly, dictionary entries list several acceptations for almost any word, but in the classroom, the office, the shopping center, and at home, we do not use isolated words. We use them in sentences, the natural units of oral or written language. If a word in an isolated sentence still remains ambiguous, the broader linguistic context (the preceding and following sentences) or the situational context (the circumstances in which the sentence is uttered) clarifies it. Each sentence, in a text, has only one meaning, and so does the text as a whole. Any person having learned the code, that is the vocabulary and grammar of the language, will apprehend the single meaning. This makes the language an ideal channel for transmitting messages without distorting the meaning intended by the sender.

In the last decades the linguistic metaphor has been popular in the social sciences. Kinship systems and marriage rules have been likened to communication systems, and so too have been works of art.[3] Using language as a *metaphor* for art, or for other cultural phenomena, suggests stimulating comparisons, but taking language as a *model* for aesthetic commerce is misleading.

Receivers of linguistic messages—the readers of this page, for instance—apprehend meanings embodied in the words, sentences, and texts by the sender—the writer of this book, for instance—ideally without adding anything to them. Encoding and decoding are tasks for the intellect. Feelings and emotions are not allowed to interfere. Whatever the variety of their past experiences, receivers should retrieve the same message from the same text: the one that the author has committed to the words.

Beholders, on the contrary, invest the visual object with meanings related, in part, to their past experiences. Because of this rooting in individual experiences, symbolic meanings attributed to the same object by different beholders are bound to be different. However, this symbolic variety is limited. The commonalities in our experiences are many: the human predicament provides a broad basis for a consensus of interpretation. Wasted energy, anxiety, gravity and sincerity, fulfillment of sexual desire—symbolic meanings we have posited in the Pollock, Lichtenstein, Ingres, and Wesselmann paintings we contemplated—are experiences familiar to everybody. Symbolic meanings attributed to the same work by several beholders are not idiosyncratic. Neither are they identical, as they should be—and as the linguistic messages perceived by different readers of the same book frequently are (if they are not identical, it is because of some inadequacies in writing or reading).

A receiver's interpretation of a text is valid if it does not distort the sender's message. A beholder's interpretation of a visual work is valid for the beholder if it has the quality of compelling evidence. In the perception of what a work stands for, there is an immediacy that makes arguments irrelevant. It is analogous to the conviction arising in ordinary vision from the vision itself. I am convinced that I see the green of a leaf through my sensation of it. In a similar manner, I am convinced that the Tobey is a symbol of quiet illumination because I perceive quiet illumination when looking at *Edge of August*. But, again, the validity of a symbolic interpretation is not restricted to a single subject. By sharing a verbal account of my insight with others, I may stimulate them to perceive the same symbolic meaning. In this sense, a consensus may arise. Whether a symbolic meaning remains unshared or becomes consensual, it is not validated by conformity to a sender's intention.

Language is an apt medium for conveying complex messages. Languages perfected by countless generations of speakers and writers, grammarians and lexicologists, ordinary users and expert "wordcrafters" are marvelous vehicles for messages. The analytical and combinative characteristics of linguistic elements make it possible to translate long, complex, and qualified messages into textual vehicles. Dictionaries and grammars provide precise linguistic codes for the translation of ideas into texts by senders, and the reversion from texts to ideas by receivers. By contrast, beholders approach composed works as totalities; meanings are intuitively perceived and not deciphered with the help of standardized codes. After the visual contemplation, if the beholders try to verbalize the symbolic meaning it is usually done in very few words: a noun referring to the symbolized entity (such as *joy* or *war* or *anxiety*), one or two adjectives or qualifiers (such

as *sensual* or *absurd* or *of death*), and maybe some value assessments (such as *good* or *fearful* or *degrading*). These few words have a poor analytical content. If it were a message, the message would be very crude: it would not include internal complexity, causal explanation, nor the unfolding of consequences. The informational content would be very limited or even trivial: everybody knows that "war is cruel," and "sensual fulfillment is a joy," and that "sun is life."

Being intuitive and holistic, symbolic interpretation proceeds from the whole mind, and not only from its intellectual function. Being discursive and analytical, linguistic communication is able to transmit accurately extended and intricate messages.

Language is the main tool for human cooperation. For collective survival, information on the environment, its dangers and its opportunities, must be transmitted quickly and precisely; warnings and orders have to be given and received. Linguistic messages are essential for producing commodities and transacting their sale, for acting one's roles in social organizations and institutions, for everyday living in the workplace and at home. The tower of Babel myth has reminded us for centuries that no common endeavor is possible in the confusion of messages.

Communication, of which language is the exemplary vehicle, belongs to cognition and action. Symbolic signification, of which aesthetic vision is one support, belongs to contemplation. The hypothesis that aesthetic forms, like a language, communicate messages from artists to beholders, has produced little more than confusion. It should be discarded.[4]

Yet creator and beholder are not isolated from one another, with nothing in common. Between them is a communion, a participation in corresponding experiences. The creator, when shaping forms, and the beholder, when looking at them, have corresponding experiences.

Sensual ecstasy perceived in the Wesselmann painting expresses the painter's experience of it and is in continuity with the beholder's experience of it. This experiential common ground, this shared understanding, establishes a close bond between creator and beholder: a communion. For my part, there is recognition of something I lived through. Because of this, it is evident to me that the painter has lived through something similar.

Communion is a deeper and more complete type of relationship between two persons than that resulting from the communication of messages. Communication only involves the cognitive function of the mind, whereas communion is more comprehensive. It is a sharing that gives rise to a broadened identity: beholder and creator constitute a 'we'. The 'we' is extended to other beholders who respond to the same work. They too have been through corresponding experiences. A nonorganized set of kindred minds is generated on the basis of experiences consonant with each other and with the creator's own experiences.

As we concluded in an earlier discussion, experiences are always mental, whether triggered by external events and processes or by inner stimuli. Recall the Bacon painting considered in chapter 10. I have never been tortured, but like almost everybody, I have been submitted to minor pains and humiliations. These external circumstances have produced some mental experience of inflicted distress which has been extended to a certain understanding of torture. This experience helped me to "recognize" the meaning of torture in the Bacon picture and to become aware of something common to Bacon and

me. I do not know if Bacon's experience of torture was based on an encounter with torture itself or with minor humiliations. But I do know that a shared understanding of torture establishes a bond between the painter and the beholders of this work.

Sharing a mental experience with an absent painter and an absent audience cannot be expressed in words. Like a silent gesture—my hand gently pressing your arm—a common experience is better left unqualified by words if its depth and concreteness are to be preserved.

Communion is not communication. The corresponding experiences are deep but undefined, important to self but inchoate—to use James Fernandez's telling word.[5] I perceive *Adam and Eve* as rooted in Brancusi's experience of the tensions of sexuality, and this corresponds to my own experience of those tensions. But if I want to go further and express in words what *Adam and Eve* means to me, I do not know if Brancusi would have focused the verbalization of his experience in the same way that I did, or if he would have even wanted to particularize his experience with words. At any rate, he did not do so. Instead, he has provided us, the beholders of *Adam and Eve*, with a work emanating from and reflecting a profound experience, but not limited to an aspect of that experience. His sculpture remains an "open work"—if we may use the formulation chosen by Umberto Eco as the title of one of his books.[6] Because they are open works, aesthetic objects are susceptible to accommodating several meanings, each validly posited by a different beholder. The polysemic character of symbols finds its source in the nonverbalized experience of the creator.

Different beholders may validly attribute different meanings to the open work, but not *any* meaning. The original experience reflected by the work must be respected. And it will necessarily be respected by the beholders who recognize this original experience of the artist as corresponding to an experience of their own.

Between those who design and shape aesthetic objects and those who contemplate these works, there is no communication through message. There is communion through experiences. What does the artist intend to say? is not the right question. The right question is, What experience does the artist want to express and share?

Aesthetic Vision, a Selfless Experience

EXPERIENCES ARTISTS WANT TO EXPRESS AND SHARE ARE EMBODIED IN AESTHETIC FORMS which suscitate and uphold perceptions of a specific kind. They are neither cognitions nor emotions. Early in this book (chapter 5), we noticed striking similarities in descriptions of aesthetic perceptions and meditative experiences. This convergence led to the conclusion that these two kinds of experiences were rooted in and revealed an original mode of consciousness, contemplation.

These observations were reinforced and became more intelligible when analysis of the visual forms as meanings allowed us to state that aesthetic objects are symbols, and that there exist important differences between symbolic signification, a contemplative mental process, and communication, a cognitive and action-oriented process.

Symbolic forms also establish a distance between the beholder's affectivity and the symbolized meanings or values. Remember the Capa photograph of the Spanish volunteer's violent death. Suppose an observer had been in the place of the camera and had seen, for the split second the event lasted, the man fall exactly as it had been framed and frozen on the film. The observer, immersed in this war action, caught in cross fire, would have had an experience of the death scene different from the one we have when looking at the photographic print. The observer's self-involvement would have normally generated an emotional experience different from the experience devoid of self-interest stimulated by the aesthetic excellence of Capa's photograph.

This question of emotional distance in aesthetic perceptions must be more clearly elucidated. In order to place it in context, we will begin by describing the contemplative process and its obstacles.

In the waking state of everyday life, we are, for a good part of the time, in what can be called a digressive frame of mind. Thoughts and emotions, sensations, and impressions, feelings and other mental contents follow each other at a rapid pace in what seems to be a constant process of digression: straying from one to another according to inner or external incitements. By contrast, when we perform a certain task, be it reading a book or

161

MARK ROTHKO. *Black on Grey.* 1970. The Mark Rothko Foundation, New York.

listening to a lecture, fencing in the arms room or driving on a congested and slippery freeway, mental digressions stop. One's mind becomes concentrated on the task at hand.

Apart from putting an end to the wanderings of the mind, which is the common result of all focused mental attitudes, concentration is specific to the task to be performed. It is analytical when the task is solving a problem in science or technology or in everyday life decisions. It is comprehensive when the task is responding to a complex and changing situation which may include unexpected elements. The driver has a comprehensive attention to everything that happens on the road, the fencer to every move of the adversary.

These two types of mental concentration are familiar mental processes: analytical concentration is learned, and comprehensive concentration is spontaneously achieved.

Beginning in elementary school, we are trained to analytically concentrate our attention on intellectual matters such as reading, memorizing, and solving arithmetic problems. Later, we are encouraged to analyze our moral life through introspection by discriminating between good and bad actions, examining our intentions, setting goals, and planning ways to attain them. We are trained to focus our attention on an object for the sole purpose of dissecting it into elements as a preparation for action—such as repeating to a teacher what we have read, convincingly arguing in a discussion, and improving our chances of success.

Comprehensive concentration is not learned. Yet it is often experienced, at least for brief periods of time, as it naturally arises under the pressure of strong stimuli. Without effort, our attention focuses on the whole situation when we are confronted with a danger, engaged in competitive games, or submitted to other intense stimulations. The latter may be internal, such as acute pains, or external, such as large and shining images in motion on the screen of a darkened theater, or the commanding sounds of a Wagner overture.

Looking at an aesthetic object is another task that requires mental concentration. This concentration is an attention focused on the visible forms of an object, and limited to them, centered on and circumscribing the seen as seen, without any addition. Because of this focalization on the bare sensory, this type of concentration may be called bare attention.

This name comes from the Theravāda meditational tradition. "Bare attention is the clear and single-minded awareness of what actually happens to us and in us, at the successive moments of perception. It is called 'bare', because it attends just to the bare facts of the perception as presented . . . through the five physical senses. . . ."[1] Beholders' as well as meditators' minds should not roam beyond the perceptible forms, attempting to associate them to mental contents of other known or experienced things. One's past experience is very important, as we have seen, but there is no effort to conjure it. It remains buried, as it were, under the conscious level, and if it appears as a reminiscence, it is not entertained by the beholder. There is no attempt at analyzing, comparing, and theorizing.

The effect produced in beholders by "just seeing" is similar to the one achieved in meditators by "just breathing" or "just sitting." It is a mental deconditioning. It is the suppression or the bypassing of the intellectual and emotional outgrowth which stands between beholder and object of vision, meditator and intended object of attention. In this

state of bare attention, things are perceived 'as they are'. This does not mean, as remarked earlier, that we reach things as they are 'in themselves'—that is, independently from anybody's perception—but that we apprehend them directly through our sense organs and not through conventional conceptualizations. For instance, it is to see the Brancusi sculpture as a configuration of visual forms and not through the title, *Adam and Eve*, which suggests that a male and a female figure should be identified.

Bare attention is not an easy type of concentration to achieve. In the seen, perceiving only the seen is a mental stance generally ignored in contemporary Western societies. In societies where meditation is recognized as an important spiritual exercise, a few individuals regularly practice contemplative attention, many occasionally have a taste of it, and everybody knows about it.

This ancient Buddhist practice, the bare attention to the sensed as sensed, is echoed, across centuries and continents, by Maurice Denis's notion of a picture as being essentially "a flat surface covered by colors arranged in a certain order." Here, too, forms should be devoid of their conventional accretions and individual associations. This concentration on the forms as seen makes it possible to take a first step in affective distanciation from the object. Both formulations epitomize the same attitude of exclusive attention to the visible, an attitude that decreases the possibility of ego-involvement in what is represented by the picture.* If we see first an arrangement of forms and colors rather than a bloody piece of meat or a sumptuous and voluptuous body, then distasteful or pleasing associations, frightening or erotic daydreams triggering anew a digressive state of mind will not develop. Bare attention necessarily generates an emotional distance, or it disappears.

Most easel paintings, drawings, and figurines do not impose their presence upon us. They discreetly call our attention. We have to make an effort in order to maintain concentration on them and to resist mental digressions. Nevertheless, mental digressions keep coming, and sheer willpower does not seem sufficient to push them away.

A few years ago, an exhaustive retrospective of Mark Rothko's works was presented at the Los Angeles County Museum of Art. To survey in one visit the creation of a major twentieth-century artist is a demanding experience. At the end of the exhibition, looking at a painting entitled *Black on Grey*, and dated 1970, I tried to pay attention, "bare attention," to its visual forms. But what I knew and felt kept interfering.

I knew that this particular painting belonged to Rothko's last period: black or brown on grey. The large acrylic works of this period are horizontally divided into two rectangles, the darker on top, the grey at the bottom. The two areas are separated by a thin white band which evokes —for me, at least—the horizon separating an icy surface, lake or snow, from a dark sky. After his previous periods, characterized by light rectangles floating on colored grounds and by glowing colors (red on orange, yellow on yellow), this picture was ominous. Its darker hues and rectangles, stabilized on the canvas plane, made *Black on Grey* the end of a stylistic development and of a life trajectory. Rothko could not have gone any further in darkness and simplicity of shapes and colors. A few weeks after finishing this painting, he committed suicide in his New York studio.

*Following common usage in everyday language, we call 'ego' or 'self' "the conscious subject, as designated by the first person singular pronoun." (American Heritage Dictionary 1982: s.v. "ego.")

I tried to look, just to look, at *Black on Grey*, in bare attention. Questions and comments, feelings and comparisons kept bubbling into my mind: Suicide as the perfect manner to bring a successful career to an end . . . "He had reached the farther shore of art," a comment read in the exhibition catalogue[2] . . . Marcus Rothkowitz's immigration to the States from czarist Russia, in 1913, when he was ten years old . . . The liberal and radical New York celebrity, so rich and famous in the fifties that he could refuse to sell his paintings to museums of which he disapproved[3] . . . The depressed man, who, in the sixties, feared that his work had reached a dead end . . . Picasso, who never reached a dead end, though he died at age ninety-two . . . I feel overwhelmed by this painting, but why? . . . The dark sky is not a sky, and this is not a landscape.

Through willpower, I could not stop these diversions which irrupted in my attempt at visual contemplation. Frustrated, I tried another tactic. Instead of struggling in vain to prevent them from reaching my consciousness, I stepped back, as it were, and let thoughts and feelings come and go. I noticed their appearance and also noticed that, left alone, they disappeared too. My previous attempts at getting rid of them had had the effect of reactivating them. I was still overwhelmed by the painting, but I was now aware that I was overwhelmed, and this, somehow, seemed to establish a distance between this emotion and me. After some time, diversions became less intense and less frequent, and I could more successfully develop a contemplative attention to the forms of *Black on Grey*.

Switching tactics—from forcibly repelling digressions to noticing them come and go—amounts to extending bare attention to any mental content appearing in our consciousness. Instead of focusing our attention only on the visually perceptible forms of the aesthetic object, we open our attention to encompass anything that happens in our mind. In so doing, beholders rediscover a mental approach which has been used for centuries in Theravāda meditation, *mindfulness*.[4] To be mindful is to be aware of what occurs in our minds from moment to moment. I hear a sound, and I am aware that I hear a sound. I am angry, and I notice that I am angry. I think of Rothko's immigration and I take note that I think of Rothko's immigration. This awareness function is similar to what, in contemporary psychology, is called by Charles Tart, the "Observer," and by Arthur Deikman, the "Witnesser."[5]

Being mindful of mental digressions as soon as they occur, instead of trying to bar them or to expel them, in fact has the effect of speeding up their disappearance. Noticing interfering thoughts and affects somehow weakens them. They fade away on their own more quickly than under the pressure of our will. When they are disappearing, the meditator gently directs the attention back to the object or process, such as the breathing, that was selected.

Mindfulness has effects other than causing thoughts, feelings, and emotions to dissipate. One of them, particularly relevant to aesthetic perception, is the distanciation between beholder and mentations. Most of the time, ego is deeply involved in its emotions and thoughts. When mindful of unwanted mental contents, of their emergence and disappearance, I perceive them as distinct from me, and alien to me. As I wish they would not be present in my mind at this time when I want to concentrate my attention on visual forms, I do not identify with them, and I do not feel responsible for them. I notice the emergence of an emotion of hatred against somebody who is close to me. As it arises against my volition, I do not assume responsibility for it. In an affective mode of consciousness, I would feel guilt and shame, regret and embarrassment for hating somebody I usually love. Being mindful of the genesis and transience of this sentiment of hatred, I

see it separate from me, at a distance. When I look at a painting, my imagination moves from the surface of lines, shapes, and colors to the amorous encounter represented, and pleasant erotic daydreams arise. As soon as I notice their unintended emergence, I perceive them as distant, and I can return my attention to the seen as seen.

This nonidentification of ego with its feelings and emotions allows the meditators' and beholders' minds to remain calm and quiet. They are fully alert to everything that occurs, but their egos are not involved.

Another effect of mindfulness is to give us an experience of ego's limitations. Ego is not the lord of the inner realm of consciousness: it cannot steadily fix its attention on a painted surface for more than a few moments, or on breathing for more than a few inhalations and exhalations, without the irruption of distracting thoughts and affects. In the digressive state of mind, prevailing most of the time, we have intimations of the limits of ego's power. But it is the sustained mindfulness which gives an insight into the extent of these limits.

In meditation, mindfulness of what happens in the body—breathing, back pain, hurting legs—makes one experience another borderline of ego's power. Processes essential for life are not related to the individual and unique ego; they operate impersonally and usually they are even beyond the reach of awareness.

During a meditation retreat in a Sri Lanka monastery, I wrote the following entry in my diary on the twenty-second day: "Impermanence of ego is experienced here as a vivid evidence. Ego amounts to the present body in constant entropy, a few memories that come and go, and a few limited projects for a dubious future. . . . Images and ideas, feelings and emotions enter and leave my field of consciousness, one linked to the other by trivial or bizarre associations. I do not perceive them as 'mine' any longer."[6]

Even as "Observer" or "Witnesser," ego is not experienced as a permanent and substantial entity. The observing function is another mental content which appears and disappears too. Like other mental states and processes, the mindful ego emerges into consciousness and fades away. Our socially constructed concept of a self—an individual core, resistant to essential change, and supporting the modifications occurring in the course of a lifetime—is not experienced in meditation.

Aesthetic contemplation is not a spiritual path. It is not practiced with as much method and sustained intensity as meditation. Yet mental concentration on a visual object and awareness of hindering digressions produce, to a lesser extent, some results analogous to those just described. In the aesthetic encounter of object and beholder, the object is given priority over ego, as it were. Aesthetician Harold Osborne, who describes aesthetic contemplation as a form of absorption, writes that "absorption is never complete to the point where ego-consciousness disappears," but that it includes a "loss of subjective time-sense, a loss of the sense of place, and a loss of bodily consciousness."[8]

This weakening of ego in the aesthetic absorption is the result of a process parallel to the process just described for meditation; but it is not as radical. The beholder's ego is not the conquering ego of action, the assertive ego of cognition, the introspective ego of affectivity. It is the disappearing ego of contemplation.

Disinterestedness is an essential quality of aesthetic contemplation. Contemplation has even been defined by it. "The word 'contemplation', " Osborne writes, "has been used to express this kind of disinterested engrossment which is central to aesthetic commerce with this environment." According to Osborne, the original meaning of this concept's use in aesthetic discourse is to be found in the philosophical and theological

controversies of seventeenth-century England and France. Against Thomas Hobbes's "intelligent egoism," Lord Shaftesbury and the other Cambridge Platonists maintained that virtue and goodness must be pursued for their own sake and not from "enlightened self-interest." In the controversies between Jansenists and Jesuits, the notion of "disinterested" love of God emerged: to love God for his own sake, and not from hope of heaven or fear of hell.[8] Clearly, for these seventeenth-century philosophers and theologians, to be disinterested meant to be devoid of self-interest.

The same idea is expressed in the tradition of insight meditation by the term *nonattachment*. Contrary to the usual view, there is nothing altruistic in "being attached to." This is obviously so in the case of attachment to things. If I am attached to my Picasso or to my summer house in the Rockies, it is not for their sake but for my sake: for the pleasure, the sense of security, and the prestige these material possessions afford me. Even if I am attached to something I do not own—the Golden Gate Bridge or Botticelli's *Birth of Venus*—it is because these famous works have special significance for me. Attachment to persons is also a gratifying emotion to the subject. When our affectivity toward another is purified from attachment, what remains is a concern for the other's well-being, called 'loving kindness' (the usual translation of the Pāli word *mettā*) and 'compassion' (*karunā*) in the Buddhist tradition.

In the Western philosophical tradition of aesthetics, as well as in the Buddhist tradition of meditation, ego is considered an obstacle to contemplation. The beholder should be disinterested, that is, not self-interested, and the meditator should be nonattached, that is, not self-attached. In the dialectic of contemplation, selflessness is a condition of the contemplative mode of consciousness and at the same time a consequence of it. Selflessness makes contemplation possible and thus is reinforced by contemplation.

In meditation, "one gradually shifts to detachment. Clinging to ego, things, and others begins to be experienced as childish" is what I wrote on the thirtieth day of the Sri Lanka retreat mentioned earlier. And two days later: "Detachment is not indifference. The concern for others (*mettā*) remains, but it is no longer possessive, as are all the worldly loves, even the mother and child one. Once again, love without possessiveness is possible only for those who have experienced the ego as an illusion."[9]

In the aesthetic vision, the reduction of self-interest is, again, parallel to what happens in meditation, but not as radical. It is the experience of ego's noninvolvement in the object's symbolic meaning.

From aesthetic vision and meditation, we inferred a specific mode of consciousness, contemplation; it is also manifested in other insight-oriented processes. The contemplative mode of consciousness cannot be reduced to cognition; neither can it be reduced to affectivity. In the preceding chapter, the differences between contemplation and cognition were analyzed; in the present chapter, contemplation was shown to be deeply different from affectivity.

In order to grasp the originality of aesthetic phenomena, it was necessary to bring to light their rooting in contemplation. Rarely, if ever, do phenomena studied by anthropologists require such an extended clarification. This is due, partly at least, because the distinctive character of the contemplative mental mode is not clearly recognized in the common Western construction of the human psyche. Intellectuality and affectivity, volition and action are easily distinguishable concepts in our ordinary communication. Contemplation is not. Yet contemplation is what confers on aesthetic objects their unique function, and fascination, in our lives.

The Aesthetic Object as Cultural

The Cultural Component in Aesthetic Objects

IT IS AN "OBSERVED FACT," WROTE ANTHROPOLOGIST CLYDE KLUCKHOHN AND PSYCHOLO-gist Henry Murray, "that everyman is like all other men, like some other men, like no other man."[1] In this succinct sentence, they intended to establish a framework in which to categorize personality determinants. We may use the same framework for distinguishing in any behavior and in any artifact a human, a cultural, and a singular component. This distinction is, of course, purely intellectual. One cannot sensorially apprehend the components as different aspects, nor physically separate them. Yet this distinction is a useful tool of analysis.

Having recognized the components, exclusive attention can be paid to one of them, granting it priority over the others. Thus far we have related aesthetic experience and aesthetic quality to the human component. The contemplative mode of consciousness was indeed interpreted as a function of the neurophysiological system common to all human organisms; the symbolic meanings of aesthetic objects were perceived as grounded in the common experience of the human predicament; and the ultimate value of order was considered to be rooted in an unconscious layer of our psyche.

The cultural component is also important in the analysis of the aesthetic experience. Yet two positions that practically ignore the relevance of culture in aesthetic creations have been important in Western thought.

In the Western tradition since Greek antiquity, an enduring intellectual trend has stated in various ways, that great art arises from a world different from the visible and tangible one in which we live, and that it reveals this ideal world or at least gives a glimpse of it. This trend is usually referred to as Platonism, though many of its variations are different from Plato's original doctrine. *Metaphysical idealism* is a better designation, as the artist is said to find inspiration in ideas rather than in visual forms, and because ideas are construed as ontological rather than as purely mental.[2]

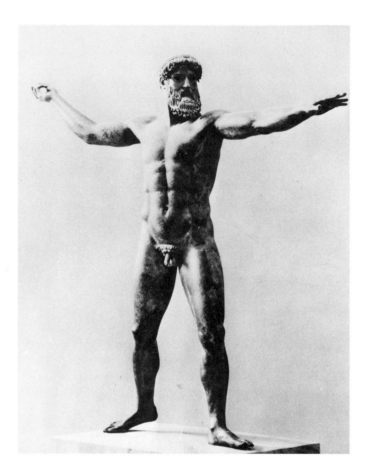

Attributed to Calamis. *Zeus of Artemision*.
c. 460 B.C. National Museum, Athens. Photo by
Boissonas.

Let us start this brief discussion of the metaphysical idealist trend by alluding to Plato's famous myth of the cave. Prisoners are chained in a cave facing the back wall. Behind them is a fire; between them and the fire, people walk in procession. The prisoners, who cannot move or look behind them, just see moving shadows cast on the wall in front of them. As they never see the procession, they take the shadows to be actual people.

What is known through our senses—the multiplicity of people, animals, and things around us—is also a procession of shadows projected by eternal and unchanging Ideas. An Idea is like an independently existing essence—we would say a prototype—of which we see only imperfect replicas in nature. There is the Idea of Tree, and numberless trees. It should be added that, for Plato, Ideas can be apprehended only by reason, thus they could hardly serve as visual models for a painter or a sculptor. However, for the Neoplatonist Plotinus, who lived eight centuries after Plato, great artists have some intuitive perception of Ideas that they can render in their works. For instance, beholders of the *Zeus* by Calamis are made better aware of the Idea of Man at the peak of his maturity through this sculpture than by looking at actual handsome men.

The conception that art reveals some ideal realm beyond the appearances of the phenomenal world has persisted through some medieval and Renaissance philosophical trends to the works of Schopenhauer in the nineteenth century and the essays of Wassily Kandinsky in the twentieth century. At the popular level, metaphysical idealism has

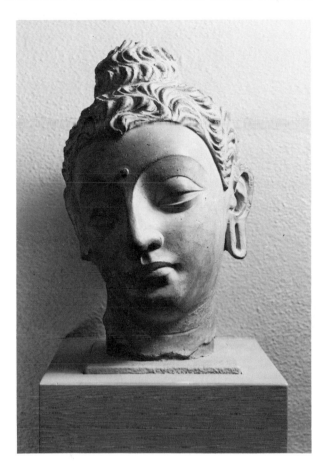

Head of the Buddha. Gandhāra, Pakistan. 4th
century. Victoria and Albert Museum, London.

been translated in the vague and widespread belief that artists have some uncanny
understanding of mind and nature. Not unlike seers, they have access to what is behind
the ordinary and the tangible, and through their art, they have the power to share with us
some of their insights.

Eternal Ideas and ultimate reality, the noumenal beyond what senses can perceive,
are conceived of as transcendental and absolute. Thus they are not dependent upon a
particular culture. Because Ideas are metaphysical, self-sufficient, and immutable, they
are not submitted to cultural variability. And because great art is a partial reflection of the
ideal world, it is also free from cultural limitations. It is to be assessed relative to that
world, not to ephemeral cultural values. Thus it does not include a cultural component.

Art's freedom from cultural determinants is an illusion. Examples of art works
manifesting eternal Ideas are usually looked for in the classical Greek statuary of the fifth
century B.C. and in the sculptures of the neoclassicism of the seventeenth and eighteenth
centuries in Europe. It is about these human representations that the words *beauty,
sublimity, nobility, and idealization* are profusely repeated. Even if we take into considera-
tion all the aesthetic objects distantly inspired by the classical Greek model—for instance,
the Buddha statues of the Indian style of Gandhāra from the second to the fourth century
of the Christian era—this classical production is manifestly culture-bound. It is not closer
to the eternal Idea of the human figure than are the "conceptual" representations of men

and women by, for example, the Egyptian or the Dogon, the Cubists or the pop artists, and Moore or Giacometti. If there was an archetype or an eternal Idea of the human body somewhere in the collective unconscious or the conscious mind, there would be at least some convergence in its visual figurations. Obviously, this is not the case.

Metaphysical idealism also denies the relevance of the singular and the human components. The model's singularity and the artist's idiosyncrasies should not influence the aesthetic object, as its value only depends upon being an undistorted reflection of the Idea. For the same reason, the human component—the common neurophysiology and the common existential experience—is irrelevant in the perspective of metaphysical idealism. It is believed that Ideas, as objects, entirely dominate the subject; that artists and, through artists, beholders are passive spectators of the epiphanies of another world; and that this other world would manifest itself even without spectators.

Such transcendentalism, implicit in the idealistic approach to art objects, is alien to the intellectual reality built in this century. Yet sometimes it still lingers in our minds in the attenuated form of a belief that creation, appreciation, and experience of aesthetic objects would mysteriously escape any cultural influence. Or, as in a recurrent dream, we fantasize a world of shining and self-existing entities to which art would be bridge and gate. But, when sobered, we recognize that the cultural component is as present in art as in any other human activity and production.

Romanticism is the other intellectual trend that minimizes the cultural component in art. It does so by emphasizing the singular component.

During the dominance of romanticism on the intellectual and artistic scene—in the second half of the eighteenth century and the first half of the nineteenth century—a main tenet of this reaction against classicism and its universal rationality was that art expressed the uniqueness of an exceptional individual, a genius. A genius was not learning and slowly progressing; he was inspired, even compelled to create out of an inner necessity stemming from his own singularity. The social milieu, recognized as the main determinant in the ordinary lives of ordinary people, was a hindrance against which artists should rebel if they wanted to be great. Their genuineness and spontaneity should not be inhibited by social constraints. Artists were not thought to be inspired by a god, a daemon, or a muse (though these were commonly used metaphors) but by a force unique to each of them. How romantics conceived of the nature of this uniqueness does not matter for our present discussion; what is of interest to us is that this inner voice was considered as independent from society. It was, as we would say, culture-free.

Today these romantic conceptions are no longer held by art historians and aestheticians. Yet they still influence the aesthetic discourse. In critical assessments originality and self-expression are given high marks. They also influence the popular stereotypes; for instance, artists are expected to be "different," "marginal," or "bohemian."

Certainly, every individual is unique as a creator and as a beholder in the aesthetic field, just as every person is unique in other fields of human endeavor. This singularity is rooted in the particular genetic heritage of each individual. As life unfolds, singularity extends, because cumulative experience slowly shapes each of us differently—indeed, no two life histories are alike. But the singular component is as limited in the aesthetic field as it is in other fields.

The phenomenon of style in the visual arts makes this clear. Style is a constant configuration of forms which can be visually perceived in a set of objects. There is a

Abbey of Saint-Martin-du-Canigou. Pyrénées Orientales, France. 11th century. Photo by J. Dieuzaide, from Zodiaque, France.

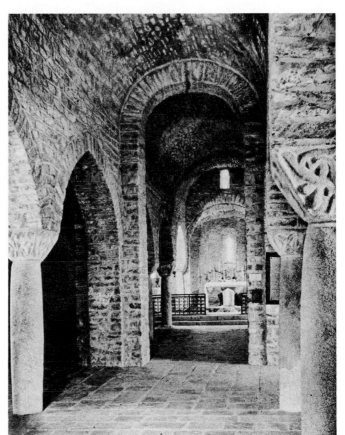

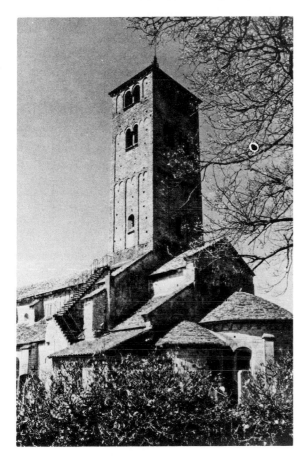

Church of Chapaize. Saône-et-Loire, France. Photo: Zodiaque, France.

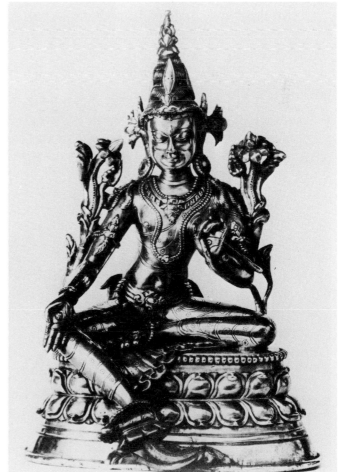

Bodisattva Avalokiteśvara. East India. 12th century. British Museum, London.

collective style made of patterns common to the artifacts of a school of painters, a group of wood-carvers in the same tribal society at the same period, or a guild of stonecutters and masons building churches in a vast regional area. And there is an individual style when a constant configuration of forms may be discovered in all, or most, of the art works created during one person's career.

When visiting the ancient towns of Western Europe, one can readily perceive collective styles in architecture. Beholders, at first sight, discern the characteristics of the Romanesque style—semicircular arches, barrel vaults, thick walls, and massive towers—in several churches. In other ones, they easily spot the Gothic configuration—pointed arches, rib vaults, flying buttresses, high naves, and tall towers. Recognizing the styles was a game I played with my parents when, as a child, I traveled with them. In a museum, it is not necessary to identify a particular painting by its title, author, and date before classifying it as Impressionist or Cubist. Nor do we have to read labels to state that a mask is Baule or Senufo, or that a statue of Avalokiteśvara is Indian or Japanese.

If a hitherto unknown visual object is discovered, where and when it was made can usually be determined by its style alone. Style is the first criterion used by archaeologists and art historians when they have to solve a question of origin. Suppose the Braque *Portuguese* was discovered today without any identification, say, in a New York City basement. Art historians and connoisseurs would have no difficulty attributing it to the Cubist school and determining that it was painted in Paris between 1905 and 1915. This attribution, based exclusively on stylistic evidence, would be unquestionable. Only the matter of authenticity—Is it a fake?—would remain open; it would be investigated by means other than a stylistic study, for example by chemical and radiographic analyses. If the object reflected only, or even mainly, the originality of an unknown genius, it would be impossible to situate it in the culture of a group, a trend, or a period. A collective style embodies the cultural component of an aesthetic object.

Individual styles also exist. The individual style of a painter may be so evident that another skillful painter may imitate it and create "originals" in the style of the first painter. In 1937, a hitherto unknown painting was offered to the Boymans Museum in Rotterdam. Experts attributed it to Jan Vermeer (1632–75), and one of them stated that it was the Vermeer masterpiece. The museum bought it. In 1945, after two other recently discovered Vermeers had been bought, one by the Royal Museum of Amsterdam and the other by Field Marshal Göring, an obscure painter named Van Meegeren was arrested for having sold a national treasure, a Vermeer, to the enemy during wartime. As a defense, Van Meegeren claimed to have sold only a fake Vermeer he had painted himself, like the other ones bought by the Dutch museums. To convince the court, he had to paint, under controlled conditions, still another Vermeer.

This story proves that individual styles indeed exist. If new paintings can be successfully made in the style of Vermeer and even sold as original Vermeers, then they certainly embody the Vermeer configuration of forms. But even in such an extreme case, the individual style is based on a more extended collective style, the seventeenth-century Dutch genre painting of scenes from daily life. More precisely, the Vermeer genre pictures are painted in the collective style of the Utrecht Caravaggisti, "painters who went to Rome in the first decade of the seventeenth century and were influenced by the technical methods of Caravaggio."[3] The indoor scenes were situated in a space of shallow depth and were rendered in warm hues with highlights on some items such as rich pieces of cloth. The Vermeer style is a particular approach to the broader collective

JAN VERMEER. *Woman Reading a Letter.* c. 1662–64.
Rijksmuseum, Amsterdam.

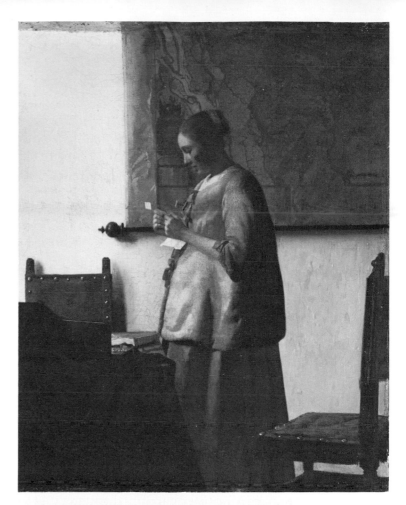

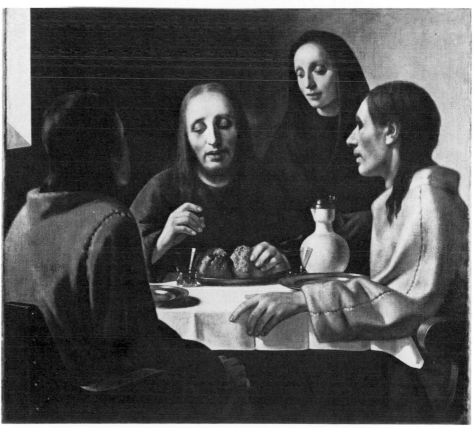

HAN VAN MEEGEREN. *Disciples at Emmaüs.* c. 1936.
Archives Centrales Iconographiques. © A.C.L.,
Brussels.

style of a school of seventeenth-century Dutch genre painting. An individual style belongs to the collective style just as a musical variation belongs to the theme: it is a modification and limitation of the theme.

By granting paramount importance to the artist's singularity in the creative process, romanticism denies, or at least ignores, the significance of culture in aesthetic objects. This is misleading. Style, as a collective configuration of forms, provides the framework in which artists develop their own individual approaches. The singular component of an aesthetic object is, as it were, encompassed in the cultural component.

Unlike metaphysical idealism and romanticism, the anthropological view expressed by Kluckhohn and Murray is comprehensive and balanced. The paradigm of the three components can be usefully applied to aesthetic phenomena.

"Like all other men," every human goes through a birth-to-death cycle. All of us need to eat and sleep every day. We are male or female and reproduce sexually. The long period of maturation our offspring require necessitates some sort of a social organization. This human component is metacultural, based on commonalities among all men and women: specific neurophysiological organisms, similar societal requirements, identical active sets of cognitive, affective, and contemplative responses to the earth environment. The aspects of behavior and production that can be logically related to these commonalities are not culture-bound. For that reason, they make a direct understanding across cultural boundaries possible. A traditional African carving symbolizing sex or death, joy or fear, friendship or hierarchy may be directly apprehended by non-African beholders as standing for these ideas.

"Like some other men"—men who belong to the same society, the same class, or the same group—we eat only the foods that the other members of our society, class, or group eat. We speak the language they speak, we marry according to the same rules, we believe in the same gods and worship them in the same temples. The cultural component refers to that part of our behavior that is similar in all the members of the society in which we have been born or in which we live and to that part of the artifacts that is similar in the artifacts made in the same society. Aesthetic styles are rooted in the cultural component, which may be a societal culture—associated with a nation (the Japanese style) or a traditional kingdom (the Benin style)—or a class culture (the proletarian style), or an institutional culture (the Jesuit or Bauhaus style).

Compared to the whole range of possibilities defined by the human component, the cultural range is limited. It may be understood as the result of a process of exclusion. Among all the foods that we could physiologically assimilate, among all the languages that we could speak, among all the world views that make sense, among all the configurations of forms that may be used to represent the human figure, only a few— sometimes only a single one—are offered by a culture to its bearers. In the year 1875, French people certainly had a large culinary selection from which to choose but it did not include borscht, chop suey, or tempura; they could speak only French as the language of everyday communication; they could adhere to a Christian, a rationalist, or, for some, a Judaic world view, but not to an Islamic, a Hindu, or a Taoist one; and French painters could be academic or Impressionist. In this perspective, the cultural component may be construed as obtained by excluding some of the possibilities in the human spectrum.

"Like no other man" in our culture, each of us speaks the common cultural language. Each of us plies the trade learned with other apprentices and creates forms by using the

repertory of a culturally accepted style in a unique manner. Some aspects of our actions, procedures, and results receive our singular marks better than others. The individual accent of a speaker is easily noticed and immediately recognized whereas the singular manner in which each of us writes is not as perceptible. The more complex the result of an endeavor, the clearer are the clues of the actor's uniqueness. Singularity may be more in the relationships between the elements than in the elements themselves. It is analogous to the uniqueness of each human face: each feature may be found identical in another face, but not the total configuration of all of them.

As the cultural is included in the human, so the singular is included in the cultural. Human, cultural, and singular are related to each other as Russian dolls, by inclusion. This also entails, in most cases, a process of restriction. Regarding the foods available in my society, I express my uniqueness by preferring some and abstaining from others and rarely by inventing a new recipe. Similarly, I dress in a unique manner by choosing a few items among those considered appropriate in our society at a certain time and rarely by designing an original outfit or by having one designed for my exclusive use.

During the nineteenth and twentieth centuries, international communication networks of ideas, artifacts, and people have considerably increased the range of what each industrial society makes available to its members. The result is that there is more from which to choose. But the individual difference is still achieved by decreasing the range of what is available. In the field of visual forms, our information has become encyclopedic and the range of acceptable styles has increased considerably. In the past, even in the great traditions, a single style was usually dominant in one or several societies during a certain period. Creators of forms, and their audiences, were limited to variations within the framework of a dominant style.

Among the three components are also relations of logical priority. Logically, the human component is first: one can posit a concept of human being as such, without cultural and idiosyncratic determinations, and reason about this abstract human being. This is what philosophers usually do. One cannot posit a purely cultural being who would not also be human. The same is true for the unique configuration of particularities: they have to be predicated upon a being who is both human and cultural. The singular styles of Picasso and Braque in the years around 1910 can only be contrasted as variations of Cubism, the cultural style they both used.

Perhaps anthropologists have not "discovered" culture, but they have certainly put it at the center of their constructions of reality. This focus on culture is expressed in their approach to any phenomenon they study: they consider it as cultural and focus their analyses on its cultural component. As in concrete personalities, behaviors, and things, anthropologists cannot disentangle one component from the remaining two and consider each separately. For them, emphasis on the cultural means awareness of it, and not exclusive attention to it.

This awareness of the cultural provides, in fact, the best perspective for elucidating, as much as possible, the interplay among the three components. The cultural dimension is, as it were, more extended and more significant than the singular one. The way female and male students are dressed on campus differs from the way women and men of the same age are dressed in business offices, and within each population individual differences are noticeable. But the latter, the intragroup differences, are less striking than the intergroup ones. If this impressionistic observation is correct, the cultural factor is in this

case more significant than the singular dimension. Similar observations can be made in the aesthetic field. There are more architectural similarities among the Romanesque churches built in central France during the twelfth century than there are between those Romanesque churches and the Gothic cathedrals of northern France erected at about the same time. Andy Warhol's work is certainly idiosyncratic, yet it forcefully reflects—and is explained by—the artistic and literary milieu of New York City in the sixties.

The human component is more fundamental than the cultural component. Yet universal needs are collectively met by a variety of cultural objects. Through their well-integrated forms, the Parthenon, the Taj Mahal, and Notre Dame induce aesthetic contemplation. But this conclusion is only a first step. We also want to know how the different styles of these three masterpieces affect and color visual experiences. The cultural is the domain of variety and multiplicity, the domain of the visible, whereas the human is its uniform foundation. It is with the cultural that visual commerce is established.

Encounters between cultural objects and singular beholders generate aesthetic experience rooted in a mode of consciousness common to all humans. Focusing our attention on the cultural component, in the anthropological manner, is the most promising approach at this stage of our study.

The Aesthetic Segment of a Culture

FOCUSING OUR ATTENTION ON THE CULTURAL COMPONENT OF AN AESTHETIC OBJECT IS not easy. Though conceptually the three components are clearly distinguished, in concrete objects they cannot be separated. So, instead of taking the arduous path of artifact analysis, we shall consider aesthetic objects in their cultural context. The best way to apprehend the cultural component in an object is to replace it in the concrete culture in which it is a living presence.

The cultural context is where the artifact is functioning as an item having an aesthetic relevance. Most often, it is the culture of the society where the object was made, but it may also be where the object has been assimilated as "good to look at."

The cultural contexts in which we locate aesthetic objects are, in the contemporary period, national cultures. In today's world, a nation is the broadest and most meaningful society for each of us. A national state gives its citizens their essential identity through a passport; it sanctions the use of an official language; and it regulates schools and courts of law, marriage and inheritance, professions and business. It is within the national framework that we find the essentials needed during our life cycle. For that reason, it may be called a total society. At other times, a cluster of hunters' bands, a tribe, a traditional kingdom, or a city-state constituted a total society for its members.

A total society is perceived, by those who live in it, as extending beyond the individual lives of its members. It was there before I was born, and it will be there after I die. And indeed, it generally encompasses many generations. To be born in a total society is to become heir to a collective property, moral and material. The societal culture is this vast heritage that every member of the society will slowly appropriate during an entire lifetime.

Aesthetic objects, and art objects where they are recognized as such, are included in these societal heritages. But what niche should observers assign to them when they analyze such a complex and diversified heritage? This is not an easy task, as a culture encompasses houses, castles, and roads built by preceding generations; philosophical doctrines, codes of ethics, and sciences elaborated or adopted by the members of the society; as well as specific forms of government, kinship, production of commodities, and economic transaction.

179

To bring some order to anthropological analyses of these congeries of cultural elements, several anthropologists divide societal cultures into three levels. Cornelius Osgood was among the first anthropologists who did so. In his studies of the Ingalik culture, Osgood treated in three separate volumes their material culture, social culture, and mental culture.[1] Independently, but less explicitly, I have used a similar ordering in my fieldwork in Rwanda and in my studies on the networks of power and the types of civilizations of sub-Saharan Africa.[2] There are other ways to arrange cultural items for descriptive and analytical purposes. But, as the three-layer model has proved to be satisfactory in other studies, we shall use it in the aesthetic field. The three levels are, in my formulation, the productive, the societal, and the ideational.[3]

Forms organized in a visual order are what make an artifact aesthetic. Formal organizations belong to the ideational level. Like a language, a science,a philosophy, a system of beliefs, or a body of laws, a style constitutes an ideational configuration. The word *configuration* suggests the integration of elements in a system, and the word *ideational* indicates that the elements of these systems are ideas, not relations between people and not material resources. A visual aesthetic object is a focus around which different sorts of human relations are woven, and it is, of course, a material thing. But what makes it aesthetic is its ability to sustain aesthetic contemplation, and that depends upon the configuration of visual forms.

The other ideational configurations also have productive and societal dimensions, but what is specific to them is that they are systems of ideas. What matters in a language are the meanings, not the sounds or the printed words—though they are indispensable supports for meanings. What matters in a book of philosophy or science is not the materiality of the book but its stimulation of a cognitive response in a prepared mind—though without the book, there would be no cognition. Analogously, though the material artifact is the necessary support, what matters is the form that stimulates an aesthetic response.

Aesthetic configurations primarily belong to the ideational level, but not exclusively. They are also significantly present on the other two levels.

Like other artifacts, aesthetic objects must be materially produced. Thus they also belong to the productive level of a culture. The system of production of a society is concerned with the raw materials and the potential energy contained in the societal environment, and with the productive processes. The latter should be applied to the transformation of the environmental resources into commodities necessary for the survival and development of the total society. The systems of production of a society are on the border line between nature (the environment) and culture (the techniques). Aesthetic objects, and art works where they exist, are submitted to the same production process as other items produced in the society. The stuff from which they are made comes from the same environmental resources, and the techniques used to make them are similar to those employed for other artifacts. The traditional masks of Africa were made out of the soft wood found in the forests around the villages; the same timber was used for carving bowls, plates, spoons, and sticks, and the same tools were handled by the same craftsmen. Calder's metal sculptures were welded according to usual shipyard techniques. Gods and goddesses of Greece were carved in marble extracted from the quarries that provided the slabs used for building temples and marketplaces.

Around aesthetic objects, networks of relationships involving members of the total

society have developed, and some have been formalized in institutions as impressive as the Metropolitan Museum of Art, in New York City; the Musée du Louvre, in Paris; the British Museum, in London; and the Hermitage, in Leningrad. Earlier in this book we discussed how, in contemporary capitalist societies, art galleries channel transactions from artist to customer, be the customer a corporation, museum, or private individual. Art magazines communicate information throughout the art constituency and the society at large, comment on recent works, review and criticize current exhibits, build and debunk reputations, and by doing so increase or diminish the market value of some artists' works. In socialist countries, analogous mechanisms seem to operate under the impulse of political patronage, the equivalent of our profit incentive. And in each society of the industrial world, be it capitalist or collectivist, art schools and university art departments teach the skills necessary for painting and drawing, designing and making graphics, carving and engraving. Art supply stores sell brushes and chisels, paints and easels, paper and crayons.

Aesthetic objects are present in each of the three large horizontal divisions of a culture: systems of production, societal networks, and ideational configurations. The word *horizontal* may surprise: the model we discuss is not in space but in the mind, where there are no verticals and horizontals. This is certainly true, but the term *layers* as previously used suggests horizontal and superposed divisions. The cake metaphor helps us to visualize the productive layer as the basis of a societal culture. A total society—a permanent group of people whose individual and collective needs are met within the group—must first provide its members with food and shelter if the group is to survive. This is why the systems of production are first and basic and thus are visualized at the bottom. Immediately above are the societal networks. Possessing techniques appropriate to extract food from the environment and to provide shelter is not sufficient: the group must organize the way decisions are made, conflicts are settled, and commodities are distributed. Ideational configurations are appropriately the top layer of the construct.

In locating aesthetic phenomena in a culture, we must start at the top layer. A material object is aesthetic because of its configuration of visual forms; the aesthetic specificity is ideational. It is at this level that we should assign, say, "Gothic style," "Tyiwara headdress," and "Rothko's rectangles." Under these configurations, in the middle layer of societal networks, we should note "guilds of master builders," "Bambara initiation association," and "New York School abstracts"—of course these brief notations do not represent an analysis.

Under the societal institutions associated with a certain configuration of forms, one should note, on the lower level, how the object is produced. For example, the techniques used to insure solidity to slender Gothic vaults and to large rose windows; the tools used by Bambara carvers when making antelope headdresses; the technique of applying acrylic to paper or canvas and the resulting floating quality of Rothko's rectangles.

Suppose we distribute the items of twelfth-century French culture on a three-layer diagram. If we enclose "Gothic style," "guilds of master builders," and "architectural techniques for building cathedrals" by drawing a vertical line cutting across the three horizontal divisions of the diagram, we circumscribe the aesthetic segment of the French culture of that time.

The aesthetic segment of a culture gathers in a single conceptual unit all the elements related to designing, financing, making, distributing, changing, and improving aesthetic objects. A diagrammatic presentation makes visually clear that the aesthetic encounter between a receptive beholder and an art object is deeply rooted in the culture of a particular society. Considering configurations of forms apart from the rest of the aesthetic segment of a culture has been a point of view often adopted in the past by art historians. Such an approach certainly concentrates on the essential, but it neglects important explanations of the essential. For instance, change in style or conservatism in forms may be due to fluctuations in production techniques or in the power structure of the professional establishment. Such change should not be explained by purely aesthetic considerations.

The somewhat elusive cultural component discussed in the preceding chapter is made more concrete and perceptible when it is related to the aesthetic segment. The cultural component of an art work is its internal reflection of the cultural context. The aesthetic segment is that part of the context which is closest to the object. The whole context—and not only the aesthetic segment—impinges upon the object. But, by its proximity, the aesthetic segment has the strongest influence on the configuration of forms.

In chapter 7, the concept of *aesthetic locus* was introduced. Does *aesthetic segment* add anything to it? It does. Aesthetic locus remains at the ideational level of the configurations of forms, whereas aesthetic segment encompasses everything that is related to the societal and technical determinants of the object.

But a conceptual distinction, however neat it may be, is not a sufficient reason for introducing a new intellectual tool. It must be useful for analysis. Aesthetic segment and aesthetic locus are, in fact, complementary. They are both needed for identifying aesthetic artifacts. This is true even in societies which, like our own, possess the category of "art" in their language.

In contemporary industrial societies, art objects—exclusively made or selected to be looked at—provide observers with sets of artifacts considered by the members of the group as displaying a high aesthetic quality. In the nineteenth century, the fine arts of drawing and painting, sculpture and architecture clearly indicated where aesthetic forms were to be found. Because pictures, statues, and edifices were made by specialists, it was easy to discern the limits of the aesthetic segment in social organizations and in production systems on the basis of the social category of "art objects." However, the aesthetic locus included more than art objects in the nineteenth century; it includes much more in the twentieth century.

The concept of aesthetic locus—which, as defined earlier, denotes the categories of objects in which aesthetic expectations and performances are concentrated—may help us to identify these classes of objects which are not "fine arts" but for which aesthetic expectations are high, for instance, the field of industrial design applied to household appliances, to office furniture, and to automobiles.

In cultures that have not evolved the concept of art there is, however, an aesthetic locus. And it is essential to determine it in order to delineate the aesthetic segment. It is as if the members of such a society had agreed to localize their concern for visual composition and expressive power in the forms of certain classes of objects. We mentioned earlier

the masks in several traditional societies of Africa, the paraphernalia of Christian ritual in the European Middle Ages, and the facial makeup of some nomads of West Africa.

Aesthetic loci may not be immediately identifiable to outside observers. A certain familiarity with the culture is necessary. One should listen to what people say about objects they make or acquire. One should look for noninstrumental forms as they may point to an aesthetic locus. When the members of the group pay attention to non-instrumental forms in certain objects, when these forms dominate the design or the surface of artifacts, when "designers" or "decorators" have a higher status than ordinary craftsmen, then an aesthetic locus is suggested.

Aesthetic diffusion would be the alternative to aesthetic locus. In that case, the aesthetic quality would be diffused more or less equally in all artifacts of a society. This is a logical possibility, but it does not seem that it exists or has ever existed. Even in a society permeated by a vigorous aesthetic concern, like traditional Japan, there were areas in which aesthetic creativity and appreciation were centered. Thus there were aesthetic loci and aesthetic segments.

The next three chapters will illustrate some of the relationships among the items located within the aesthetic segment as well as relationships between the aesthetic segment—more precisely, some parts of it—and the rest of the culture. It is important to consider how material, societal, and ideational elements of a culture both condition the configurations of forms and are conditioned by those configurations. We should also consider whether there are relationships of consistency between visual forms and other phenomena.

General statements such as "art is the mirror of society" or "art is part of the superstructure" do not help much in explaining the complex interplay of influences and equivalences, causes and effects, antecedents and consequents. Each relationship should be concretely observed and described in its particularity. Later, patterns will perhaps emerge. Even in aesthetic and symbolic matters, anthropology is an empirical discipline in the sense that it primarily relies on observation.

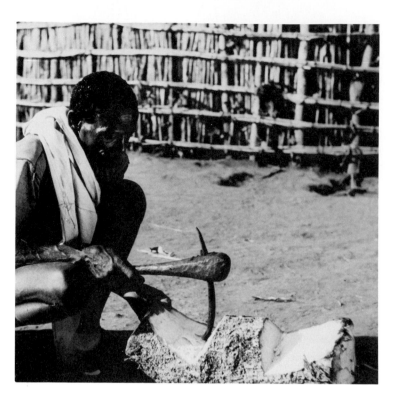

Above left, carving a shield from a tree trunk. *Above right*, carving almost completed. Rwanda. 1955. Photos by Jacques Maquet.

Below left, woman pounding in a mortar; figurine carved in one piece of wood. Lwena, Zaire. Royal Museum of Central Africa, Section of Ethnography, Tervuren, Belgium. Photo by Jacques Maquet. *Below center*, lineage ancestor figurine. Bembe, Zaire.

Royal Museum of Central Africa, Section of Ethnography, Tervuren, Belgium.
Below right, Kongo figurine carved in soft stone *(mintadi)*. Angola. Royal Museum of Central Africa, Section of Ethnography, Tervuren, Belgium.

CHAPTER SEVENTEEN

Techniques of Production and Aesthetic Forms

HANDCRAFTED OR MANUFACTURED ITEMS ARE PRODUCED IN A PARTICULAR SOCIETY FROM raw materials available to the members of that society. Materials found in the physical environment of a society, on its territory, are preferred to imported ones, particularly when and where means of transportation are not developed. Imported raw materials are also used, and sometimes extensively—as, for instance, in the European countries that had colonial empires during the nineteenth and twentieth centuries. Few societies have ever been limited to working and transforming only what was available on their territories. Yet regional availability is an important factor. Societies inhabiting an environment lacking in trees usually do not produce wood artifacts.

On the other hand, the mere presence of certain kinds of raw materials does not insure their utilization. The techniques necessary to extract them from the ground and to transform them into commodities may not be offered in the cultural heritage of the group living there. Mineral oil has been in the subsoil of western Asia for thousands and thousands of years but was irrelevant to the societies of the region: they did not have the mechanical equipment to extract it, nor the large sources of energy necessary to operate it, nor the engines to consume that fuel.

It would not be worthwhile to state these truisms if we were fully aware of their consequences within the aesthetic segment. Materials, tools, and techniques of production influence aesthetic forms. Let us see how.

The human figures which were traditionally carved in West and Central Africa are less than life-size. Most of them are ancestors' statues not taller than two or three feet. Yet they convey an impression of importance and monumentality. Formally, they are characterized by frontality and verticality, upward orientation and symmetry of left and right sides.

These forms are well suited to the materials, tools, and carving technique used. The material is a section of a tree trunk or a branch. The tools are adzes, gouges, and knives appropriate for cutting out parts of the original piece of wood. The technique can be called a technique of subtraction: starting from a cylinder of timber, a sculptor removes parts of it and does not add anything to it. The figurine is carved in one piece out of the original cylinder. This suitability of forms to medium, tools, and technique can be better expressed by saying that the tree trunk and the removing procedure "suggest to" or "direct" the carver to make a columnlike shape: straight body, head on the axis, symmetrical arms close to the body.

This influence of the medium on the forms is also illustrated by the contrasting case of the *mintadi*, soft-stone funerary figurines of kingdom of Kongo chiefs. The material used, steatite, can be cut with the same knife used for wood carving. The block of stone from which the figurine is sculpted makes it possible to create a large repertory of shapes. Carvers have taken advantage of this potentiality: many *mintadi* are not symmetrical; for instance, the head may be tilted to one side.[1]

Sections of trunks and branches do not impose certain forms, but they orient carvers toward forms appropriate to their own cylindrical shapes. They do more. They direct carvers toward a certain principle of geometric composition: the contour acts as a rectangular frame standing on its narrow side and suggests vertical carving. This dominance of vertical lines provides the whole composition with a strong integration; and this makes it possible to achieve a high aesthetic quality. Expressivity is also sustained by the composition and suggests a meaning perceived by many beholders: several vertical lines standing on a narrow basis have a towering effect. It is not surprising that the African statues selected to be displayed in our museums stand for monumentality and nobility despite their modest dimensions.

Another stylistic consequence of the medium should be noted. Wood as material is short-lived under African conditions: the extreme climate and the vigorous action of termites cause rapid deterioration. Because of these environmental circumstances, "the average life of a wooden sculpture is between twenty and twenty-five years," according to Denise Paulme's estimate. As a consequence, "no style could ever be fixed by the presence of authoritative models. . . . Thus, every sculptor could give free rein to his inspiration within the limits of fixed canons."[2]

The quantity of available material has affected visual forms. Until the seventeenth century, the copper imported by the kingdom of Benin from the Mediterranean coast of Africa was carried by caravans across the Sahara Desert. Then it came by sea, in larger quantities. This resulted in a change of style in the bronze heads and plaques. As more copper was available to the casters, reliefs and figurines became heavily ornate: "the idealization of faces was replaced by stylization, and ornaments, especially the huge collars, took on a very great importance."[3]

New techniques open new formal possibilities. In the nineteenth century, prefabricated cast-iron beams constituted an important advance in engineering. Some imaginative architects used them to replace wooden and stone supports, the only ones ever used before in building. A new "glass-and-metal" style was born. Huge volumes were enclosed in very light walls. For the Great Exhibition of 1851, Sir Joseph Paxton erected, in Hyde Park, the largest building ever constructed until that time. Dubbed Crystal Palace

Bronze plaque showing an official holding a box.
Benin, Nigeria. Early 17th century. British
Museum, London.

Bronze plaque showing two officials, one carrying
an ivory gong. Benin, Nigeria. Late 17th century.
British Museum, London.

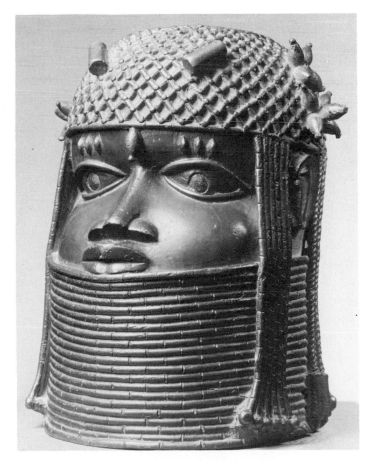

Bronze head. Benin, Nigeria. Late 17th century.
The Nelson-Atkins Museum of Art, Kansas City.
Nelson Fund.

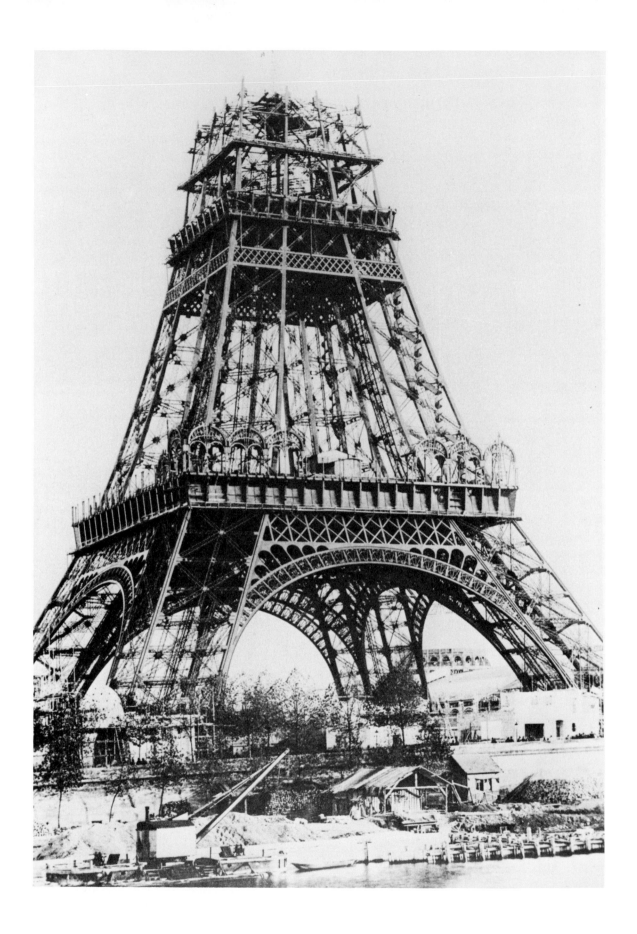

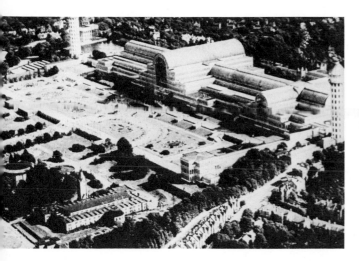

JOSEPH PAXTON. Aerial view of the Crystal Palace. Hyde Park, London. 1851. Photo: Fox.

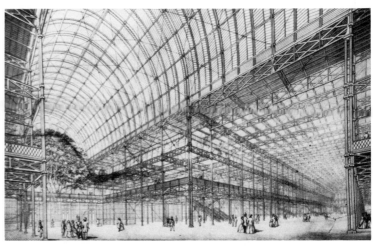

PAXTON. Interior of the Crystal Palace. Photo: Library of the Royal Institute of British Architects.

EERO SAARINEN. TWA terminal. 1956–62. JFK International Airport, New York. Photo: USIS.

in *Punch*, it was a "completely prefabricated structure based on standard units which were mainly multiples of twenty-four."[4]

Very high open structures were possible for the first time. For another industrial exhibition held in 1889, Gustave Eiffel built a thousand-foot tower in Paris. It was also prefabricated, and was assembled by only 150 men. In 1876 Eiffel had built for the Bon Marché a structure consisting of galleries surrounding a glass-roofed central space that rose the full height of the building. The Bon Marché building became a model on which other department store structures were drawn.[5] By the end of the nineteenth century, the glass-and-metal style was well established and widely spread. The Bradbury Building, designed by George Wyman and erected in Los Angeles in 1893, is an example of this style. The configuration of forms that characterizes it—visible skeleton, slender sup-

GUSTAVE EIFFEL. Eiffel Tower under construction in 1889. Paris. Photo: Delpire.

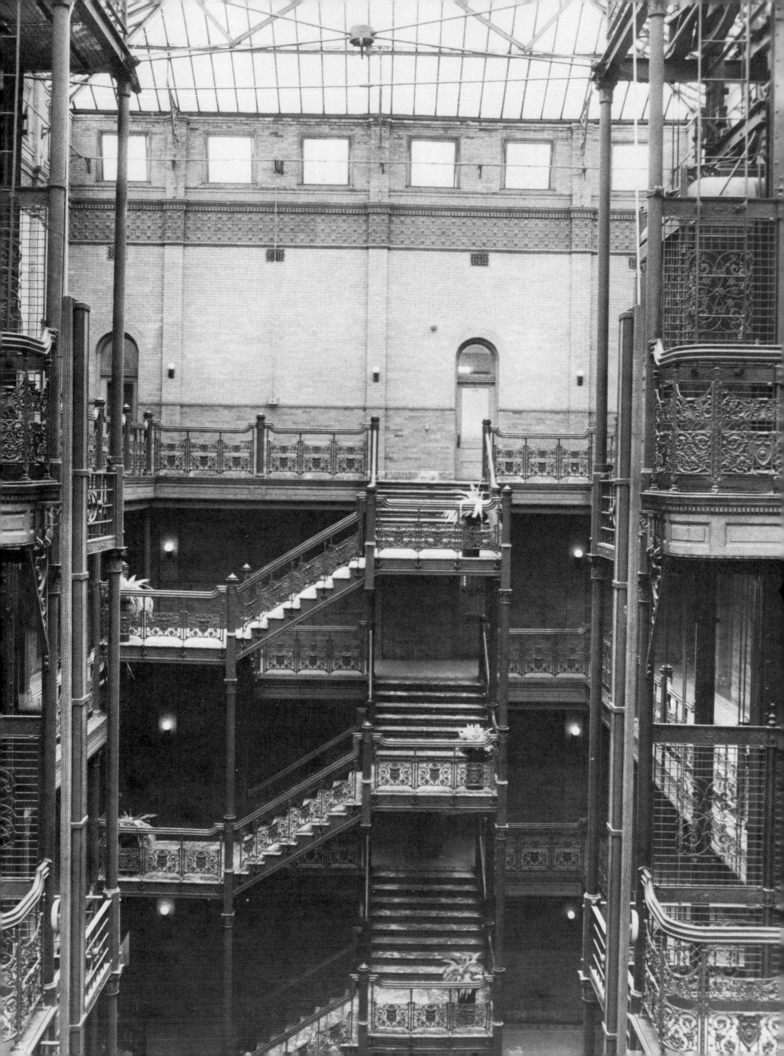

MORRIS LOUIS. *Alpha-Pi*. 1960. The Metropolitan Museum of Art, New York. Arthur H. Hearn Fund.

KENNETH NOLAND. *Song*. 1958. Collection of the Whitney Museum of American Art, New York.

ports, glass walls, and high-rise structures—has been made possible and has been suggested by a new technique in engineering.

Forms more revolutionary than those realized through glass and iron are achieved by ferroconcrete and prestressed concrete. With these new materials, the architect's freedom of design seems to have become illimited. The light, thin, and resistant slab can be shaped in curved and cantilevered forms that no building ever displayed before. Striking examples of the new forms made possible by prestressed concrete are the Exhibition Hall at La Défense, near Paris, the shelter above the marketplace at Royan, and the TWA terminal at JFK International Airport, New York.

Cast iron and steel in the nineteenth century and reinforced concrete in the twentieth century are dramatic illustrations of the impact of materials and techniques on forms. A less spectacular instance of the same phenomenon is the effect achieved by some painters' use of acrylic coatings. Art historian and critic Edward Lucie-Smith labeled them "post painterly abstractionists." Writing about Morris Louis, one of these abstractionists, Lucie-Smith mentions that "Louis achieved his originality partly through the exploitation of a new material, acrylic paint," and of a new technique, staining the canvas rather than painting on it. "The staining process meant a revulsion against shape, against light and dark, in favor of color."[6] A new chemical, acrylic, and a new technique, staining, made it possible for Morris Louis, Kenneth Noland, Mark Rothko, and others to dye canvas rather than apply pigments on it. This "directed" artists, "suggested" to them giving a paramount importance to color over the other visual forms—line, shape, brightness, or texture. As a consequence, no evocation of space was present. One should remember that space is perceived by beholders in many nonfigurative paintings where oblique lines are found. (See, for instance, Richard Diebenkorn's *Ocean Park* series—which are oils on canvas.)

GEORGE WYMAN. The Bradbury Building. Los Angeles. 1893. Photo by Jacques Maquet.

RICHARD DIEBENKORN. *Ocean Park No. 94*. 1976.
Artist's collection.

In these illustrations, some features of the productive process of aesthetic objects in a particular society have influenced the forms of those objects. The processes fall into two categories.

First, the absence of some materials or techniques has prevented the emergence of some forms. The organic shapes of the shells in prestressed concrete, which enclose the inner volumes of many contemporary buildings, could not have been realized with the building materials previously used in architecture: wood, stone, bricks, and adhesives like clay or cement. The absence of stonecutting techniques for hard stone has prevented the development of large-scale three-dimensional forms in the savannas and forests of sub-Saharan Africa. This type of negative influence may be called a process of exclusion: the system of production excludes some aesthetic forms.

This process, it should be noted, does not imply its reverse. From the absence of a configuration of forms, one should not conclude that the necessary medium was unavailable. Free-flowing forms were absent from the sculptural repertory of most societies of traditional Africa. We know that, in fact, some forms could develop only in the soft-stone medium. Soft stone was widely found in most natural environments of sub-Saharan Africa, and all the societies of the traditional era—from prehistory to the industrial age—had wood-carving tools, also appropriate for soft stone. Yet soft-stone carving remained exceptional in Africa; it does not seem to have been practiced except among the Kissi, the Kongo, and the inhabitants of Esie, a Yoruba village.

A second type of influence could be called a process of conduction: when materials and techniques are conducive to certain forms. To indicate the process, we have used the terms *to suggest, to direct, to orient, to be appropriate,* and *to be suitable.* The cylindrical section of a tree trunk suggests that it should be carved vertically and that straight lines will dominate. Heavy columns and walls are architectural forms particularly suitable to stone. Acrylic directs to give priority to color over other forms. Prestressed concrete is conducive to light shells covering large areas with very few points of support.

The process of conduction is not a relationship of necessity. A large quantity of copper made available to craftsmen will not necessarily result in overornate forms. But it is conducive to them; it makes them probable, not certain. Other influences or obstacles may restrain or destroy the expected consequence. Some carver who has traveled and has seen a technique of sculpturing by addition may adopt it and make disciples; for them, the cylindrical timber will no longer be conducive to elongated vertical shapes.

The process of conduction is what I have called elsewhere a partial conditioning.[7] The conditioned event cannot appear without the conditioning event, but the latter does not necessarily cause the conditioned one to occur. Architectural shells cannot appear without prestressed concrete, but prestressed concrete does not cause architectural shells to occur. In other terms, the building technique is the necessary condition for some form, but is not its sufficient condition.

In cultural matters, we are most often in the soft logic of partial conditioning—'if A, then probably B'. Unfortunately, we cannot often use the hard logic of causality—'if A, then B'.

So far, we have considered the part of production that is within the aesthetic segment; that is the raw materials, tools, and techniques of transformation used to make aesthetic objects. The rest, and the most significant part of the production system of the whole society, also has an impact on the forms.

Funerary figures. Ekoi, Nigeria. Photo: Nigerian Museums.

Particularly important is the relationship between the amount of commodities produced by a unit (be it the whole society or parts of it, such as the extended families) and the amount of commodities that unit consumes. When consumption is equivalent to production, the unit is at a level of subsistence; if the unit consumes more than it produces, the unit is below the subsistence level; and if it consumes less than it produces, it is above the subsistence level. The unit to be considered here is the total society, which may be as small as a tribe comprising a few villages or as large as an industrial state.

In societies with a subsistence production, the process of exclusion can be frequently observed. When there is no surplus, the society cannot afford to have professional craftsmen: persons obtaining an income from selling or exchanging what they make in their specialized occupation. In subsistence societies, there is no purchasing power. This was the situation among the tillers living in the clearings of the equatorial forest of Africa. Carvers were ordinary cultivators, simply more skillful than their neighbors; they did not undergo any training and used simple tools and easy-to-work timber.

These carvers were what we would call amateurs in our society. And this had an impact on the objects they made: the finishing was rough, the work sometimes revealed clumsiness of execution; lines and colors were often bold and vigorous, rarely intricate and shaded; and there were many, apparently unintended, irregularities. These features define what can broadly be called a folk style. In the civilization of the clearings—as we have called the dominant cultural model of the rain forest tillers of Africa—the subsistence level of production excluded the professional expertise needed for creating sophisticated forms and was conducive to a folk style.[8]

When production exceeds consumption, the society is above the subsistence level. Consequently, the range of aesthetic forms is less limited and certain stylistic characteristics are likely to be present. In the savanna state of the Kuba (in today's Zaire), and in the kingdom of Benin (in the south of today's Nigeria), the surplus was concentrated and controlled by the rulers. With it, they could support a retinue of courtiers and servants, advisors and craftsmen. The Kuba sculptors, being kept by the high chiefs, could devote time and energy to the exercise of their vocation. From hard wood, they carved cups

Tusk on head. Benin, Nigeria. Late 17th or 18th century. British Museum, London.

reproducing the features of a human head and made stools, boxes for cosmetics, and headrests. These artifacts were covered with carefully executed geometric or anthropomorphic engravings. A similar intricate ornamentation was woven in, or embroidered on, fabrics of raffia. The above-subsistence standard of the Kuba society resulted in forms characteristic of elite art: abundance, even overabundance, of decorative motifs; professional execution expressed in regularity and finishing; and media requiring specialized techniques.

Benin also was a prosperous state until 1897, the year of the famous British punitive expedition which brought back to London a huge quantity of works in bronze and ivory. These works were plaques representing government and military topics, memorial heads supporting carved tusks, and other objects in brass and ivory. The metal artifacts had been made by casters using the complex lost wax technique on imported copper. Equipment, material, and know-how were beyond the reach of amateurs. Forms, particularly in the flamboyant decadence beginning in the eighteenth century, revealed a concern for realistic representation. Decoration covered the whole surface, and a high standard of execution was evident. There was a predilection for precious materials: ivory and metals. These features were made possible through the rulers' concentration of the society's

resources. As with the Kuba, the probable occurred: forms revealing an elite configuration were created in a society producing a surplus of commodities.

When production does not meet the consumption requirements, the whole social fabric disintegrates. Colin M. Turnbull's dramatic study of the Ik of Uganda suggests that ideational systems are the first to fall apart.[9] Belief systems, ethical codes, and world views are lost in one generation even if the group survives longer. Getting food for oneself becomes the only motivation. Cognitive, affective, and contemplative modes of consciousness seem to be turned off. In societies living at a below-subsistence standard, the process of exclusion is at its maximum. It precludes the creation or appreciation of aesthetic forms.

These few cases, taken from traditional African cultures, illustrate how forms are conditioned by the ratio of consumption to production of the society as a whole. Other processes of production—also outside the aesthetic segment—have an impact on the system of forms. Let us consider the industrial techniques of production. Though not meant to be used for manufacturing aesthetic objects, some nevertheless were adopted for making them, and this had consequences on their forms.

Before the manufacture of series of identical objects by machines, all the artifacts of everyday life—from kitchen utensils to pieces of furniture—were crafted by hand. Each was made independently from the others, was different from the others, was unique. During the preindustrial era, the Western fine arts emerged as a specialized field of activities devoted to making aesthetic objects. Engravers and painters, sculptors and architects naturally used the only known method of making objects, handwork.

After the nineteenth-century switch from craft to industry for the production of everyday artifacts, artists continued to use manual techniques. This persistence was in tune with the romantic ethos dominant at that time. The uniqueness of the object corresponded to the uniqueness of its inspired creator.

In the last few decades, some industrial techniques have been used, still with timidity, in what is recognized in our society as the field of art. Victor Vasarely, the principal originator of the op art school, designed prototypes from which identical "multiples" were reproduced. Prototypes, more similar to architect's plans than to finished paintings, were not originals. Each multiple was an original.[10]

Vasarely designed the prototype; so does an industrial designer. As mentioned in Chapter 11, the concept of design is not new in the arts. In sixteenth-century Florence, Giorgio Vasari considered design to be the common and essential element of the fine arts. Designing is making a plan according to which the elements of the work will be put together when the object is fabricated. During Vasari's time and in the following centuries, artists were designing and handcrafting their works. In industrial production, the two tasks and the two roles are separated: the visual composition is drawn in plan by the artist as designer, and the object is manufactured by the machine according to the plan. This separation does not deprive the finished object of its art quality and originality—after all, architects themselves have never been expected to build the edifices they have designed.

Industrial fabrication does not affect the aesthetic potentialities of objects; they are not disqualified from having an aesthetic value because they are mass-produced. But the technique of production—hand or machine—affects their forms. Handmade objects

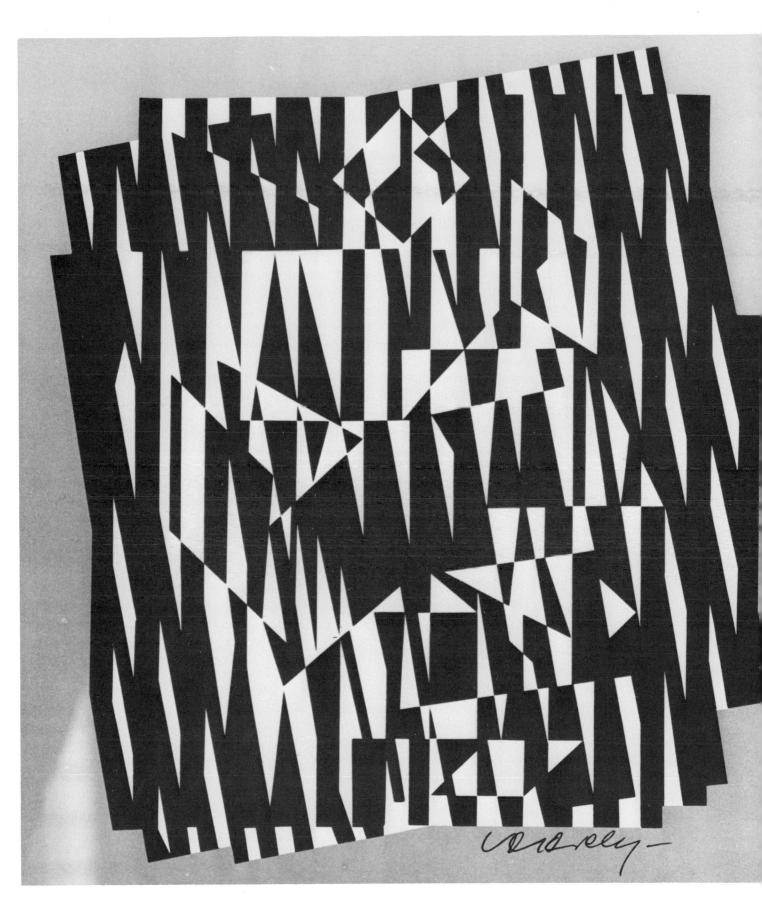

usually fail to achieve sharpness in lines, symmetry in shapes, regularity in textures, and uniformity in hues and brightness to the same degree that machine-processed objects do. This kind of formal perfection conveys meanings to the beholder other than what handmade forms convey.

This is the sense in which it can be said that new techniques of production introduced outside the aesthetic segment may influence the configuration of forms—in the case just discussed, by making them sharper and perfectly regular.

The influence of several aspects of material production on aesthetic forms concretely illustrates what is meant by cultural integration. Changes in the quality or quantity of raw materials or in the type of fabrication techniques have repercussions beyond the context of production in which they occurred. As these repercussions are indirect and distant, they are often unintended or even unexpected. It is only through analysis that these chains of conditions and consequences are brought to light. What has been uncovered suggests that this network of conditioning relationships is all-pervasive: a total culture operates as a system in which all the parts are indirectly interconnected. As an empirical discipline, anthropology attempts to make a detailed analysis of these interrelationships.

Although we have not gone far in this analysis, we have gone far enough to understand that an aesthetic configuration—a style, for instance—is interconnected with the rest of the cultural system; it is not autonomous from it and does not transcend it. This needs to be stated again, because the autonomy of what art historian Henri Focillon has called ''the life of the forms'' is still lurking in our minds as a half-accepted legacy of the Platonic world of Ideas.[11]

In these analyses, I take cultural materialism as a guiding principle. It is not a philosophic position concerning the ultimate nature of the world; it is simply a useful theory in research and in the construction of reality. The materialist principle in anthropology can be plainly formulated: in a cultural system, production is the primary condition. Why? A culture has an adaptive function; it makes possible the survival and development of a group and its individual members in a certain environment. The first requirement of collective and individual life is to obtain food and materials for shelter from the environment. This is achieved by the process of production implemented by the group, or by the processes of acquisition of hunters and gatherers who do not grow crops or breed cattle.

Post-Darwinian biology integrated evolution into its construction of reality, and post-Freudian psychology included unconscious processes in the commonly accepted models of the human psyche. Similarly, after Marx, considering production as the most significant force in the shaping of society became a part of the common reality of the social sciences. This theoretical assumption, essentially Marxian in origin, has been widely used in anthropology where it is usually known as cultural materialism.[12]

The materialist assumption is evidently appropriate to societies struggling against an adverse environment with rudimentary techniques, and to imaginary groups organizing for survival on an uninhabited island after a shipwreck—groups that social scientists used to posit for the sake of speculation. But, it may be objected, the materialist assumption is not fitting to the contemporary and industrialized world: our productive systems provide food and other commodities in abundance, and our urgent problems are of distribution and repartition, not of production.

This objection should be answered, first, by pointing out that our contemporary world is still a world of scarcity. Many developing nations do not produce enough food and other necessities for their people, and the so-called first world nations compete for natural resources to be transformed into energy. Thus production remains a constraint. A second answer is that the priority of production is not only manifested by the evident necessity of food and shelter; it is also expressed by the more subtle processes of exclusion and conduction analyzed above. The elucidation of these processes, deduced from the cultural materialist premise, contributes to our understanding of how aesthetic forms are integrated in the contemporary industrial societies.

Cultural materialism does not mean more than the concrete processes of influence we can discover in cultural interactions. Exclusion and conduction do not represent a rigid and necessary determinism. The systems of production limit the ideational potentialities that can develop in a culture, and they favor some potentialities which are particularly compatible with them.

CHAPTER EIGHTEEN

Societal Networks and Aesthetic Forms

SOCIETAL NETWORK IS, ADMITTEDLY, SOCIOLOGICAL JARGON. THIS CONCEPT HAS ABOUT THE same connotation as *institution* or *social organization*, but it is more precise. *Societal* is the adjective corresponding to the construct *total society*. In *societal networks*, the adjective reminds us that the networks we are considering are located within national states in the contemporary world, and, in the past, within tribes, kingdoms, city-states, or other groups in which members' activities were complementary in meeting everyone's total range of life concerns.

In everyday life, each of us is involved in many societal relations. We perceive them immediately as subsumed under different categories, as belonging to different networks. I visit with my father, it is a familial relationship; I buy a typewriter, it is a commercial relationship; I discuss a decision with the dean, it is a professional relationship. These interactions result from a continuous participation in different networks. The visit to my father expresses our belonging to the same kinship network, my purchase of the type-writer concretizes the cooperation between the dealer and me in the same economic network, and the discussion with the dean manifests our partnership in the same occupational network.

Networks are few. In a comparative study of some traditional and modern African societies, I distinguished seven of them: kinship, alliance, government, hierarchy, dependence, association, and exchange of goods.[1] Networks are stable and permanent. We perceive them as based on such fundamental interactions between members of the same society that they have been, and will be, there for countless generations. Before my father and me, descent from the same ancestor was recognized and a kinship network was built on it; and so it will be after me and my offspring. Similarly, a long-lasting government network developed from the basic relation of coercion between rulers and subjects; and a durable network of inequality grew from, and amplified, the fundamental relationship of

201

LUDWIG MIES VAN DER ROHE. Toronto-Dominion Center. Toronto, Canada. 1969. Photo by Bernard Maquet.

social superiority and inferiority. They constitute the commonly accepted grid that makes our relations with others relatively safe and predictable.

In the cultural model I have used, societal networks constitute the second level, above production, and below ideational systems. In this chapter we shall examine the conditioning of aesthetic forms by networks and take heed of any intimation of an influence in the opposite direction, from aesthetic forms to networks.

Within the aesthetic segment of a culture, specialized networks group together the makers of objects that belong to the aesthetic locus of the society. During the European Middle Ages, master builders and craftsmen, stonecutters and masons, cabinetmakers and goldsmiths were organized in guilds and corporations. In their heyday, guilds and corporations were powerful networks. Each was practically in charge of a specialized sector of the economy. Inside, they strictly regulated the work of their members. The number of new admissions was limited, promotion was through seniority and tests, and the established hierarchy could effectively pressure apprentices, companions, and masters. The conservatism built into the structure of guilds and corporations conditioned the formal configurations of the works. In order to succeed within that network, one had to imitate the authoritative models rather than be innovative. The senior masters, who, at the end of their creative careers, judged and assessed the works of the younger craftsmen, were not likely to reward departures from the traditional styles.

When makers of objects relevant to the aesthetic locus ceased to be regarded as craftsmen and became artists, the network situation changed. Artists were those who made artifacts intended for visual use only; they had learned the skills of their discipline, and they practiced it according to the doctrine of a certain group or movement. Like craftsmen, artists had to be technically proficient; in addition, they were expected to adhere to sets of convictions around which loosely organized associations were constituted. Such were the Wanderers and the Nabis, the Fauvists and the Cubists, the painters of Die Brücke and the Neue Sezession.

Though these groups are fluid and short-lived, say, the Abstract Expressionists and the Minimalists, they constitute networks important for esprit de corps and self-identification. And, of course, they influence the aesthetic forms of what is designed or painted, made by collage or assemblage, as the purpose of these movements is to promote some approach or style in aesthetic creations. In fact, this is often so successfully achieved that it is not easy to recognize one Rayonist from another, Goncharova from Larionov, or one Cubist from another, Braque from Picasso.

The training that makers of aesthetic objects must undergo was first provided by the guilds through apprenticeship in the masters' workshops and later by fine arts academies and art schools. These educational networks, confined to the aesthetic segment, went beyond teaching the skills: they promoted certain formal configurations, certain styles. This is still true today. The International Style in architecture, a dominant influence throughout the world from the 1940s to the 1960s, was also known as the Bauhaus style. It had, indeed, its origin in the Bauhaus, a school of architecture and the applied arts, which operated in Germany for only fourteen years, from 1919 to 1933. The style was geometrical, austere, and refined in lines and shapes; it extended, beyond architecture, to industrial design of furniture and mechanical equipment; it became synonymous with *modern*. This is an extreme example of an educational institution's impact on aesthetic

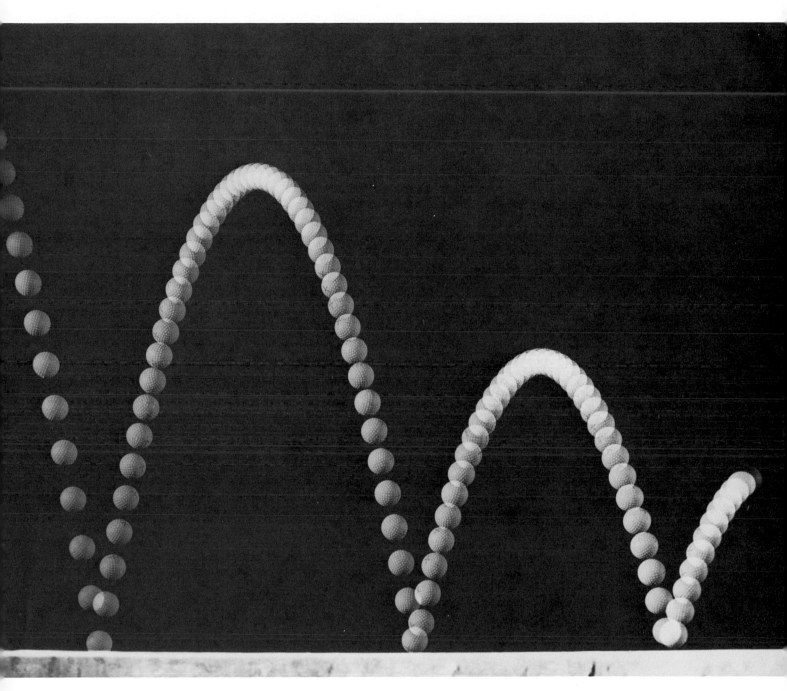

HAROLD E. EDGERTON. Stroboscopic photo of a
bouncing golf ball. 1959. Photo: Dr. Harold E.
Edgerton. Massachusetts Institute of Technology,
Cambridge, Massachusetts.

forms; to a lesser degree, all important art schools influence what their former students design during their careers.

Aesthetic objects are not always produced by professionals. In certain societies, or in certain disciplines, the contribution of amateurs is significant. Are they also organized in networks which condition some formal aspects of their works?

We use the term *amateur* to denote those makers of aesthetic objects whose production does not significantly contribute to their livelihood. The term itself does not suggest a proficiency inferior to professional expertise. Yet professionals often make better works because they have been through a longer training, use more costly and complex equipment, and are frequently in a competitive situation. This is the case in contemporary industrial societies where amateurs and professionals are often engaged in the same pursuits, such as drawing, painting, and photography. There are also societies where aesthetic objects are exclusively produced by amateurs. Societies with a subsistence production cannot afford the luxury of professional craftsmen, and this circumstance is conducive to a folk style.

In affluent societies of the industrial age, photography is predominantly a leisure activity, in terms of the proportion of pictures shot by amateurs. And, though many photographs by amateurs and professionals do not have an aesthetic quality, photography certainly belongs to the aesthetic focus of our time.

Amateur photographers are not grouped together in networks. Some join an association, but such associations rarely constitute strong networks with a clearly defined set of rights and duties supported by positive and negative sanctions. A pastime that does not require long and arduous training and may be taken up and dropped at will does not seem to offer a sufficient basis for a solid network. Yet the loose network constituted by the readership of magazines for amateur photographers has an impact on the forms. Photographs printed in these magazines tend to be imitated. When a new accessory permits achievement of some special effects, these magazines offer models to amateurs. In the mid-fifties, electronic strobes became widely available on the market; they made it possible to freeze high-speed movements. Magazines intended for amateurs published, at the same time, many sharp pictures of falling drops of water, bouncing golf balls, bullets striking targets, and seemingly exploding bottles of milk breaking on a hard floor. A loose network of amateurs was sufficient to add the sharpness of frozen movements to the repertory of aesthetic forms in photography.

The most influential network within the aesthetic segment of contemporary societies is probably the art market. As it is a part of the commercial market of the whole society, art works are thus also regarded as commodities.

They are bought by persons who want to look at them or to make a wise investment in inflationary times or to realize a quick profit from a lucky speculation. Ancient art has a constantly increasing value. Paintings, sculptures, and other artifacts made by established names of the past reach extremely high prices, and a drop in their monetary value is unheard of; the only risk for investors is to buy a forgery.

The value of current art is lower and considerably less stable. It fluctuates according to a combination of elusive factors such as the reputation of the artist, current trends, and relative rareness. Reputation depends on different factors such as participation in collective exhibitions and one-man shows; the purchase of pieces by celebrities, known collectors, and museums; representation by a prestigious gallery; and recognition by critics. When exercised with the vigor and clarity, the perceptiveness and convincing

power of a Clement Greenberg, art criticism may become the most significant factor in making the reputation of an artist. Greenberg is generally considered to have almost single-handedly gained recognition for such New York painters as Jackson Pollock, Barnett Newman, and Mark Rothko, through his essays published in the forties and the fifties.[2]

In the aesthetic segment, current trends express the fashion phenomenon that is so essential to our profit oriented economic system. Every few years —say, every five years or so—a new aesthetic trend should emerge in order to stimulate sales. Demand for the trendy raises the prices for works belonging to the current movement, whereas prices for out-of-trend art objects remain stationary or even decline. There was less demand for Abstract Expressionist paintings when pop art was in favor.

Also, degree of rareness relates art works as commodities to the laws of supply and demand. When a commodity is scarce, its price goes up. When Picasso died in 1973, the number of Picassos in his estate was so large that if they had been put on the market at the same time, the value of other Picassos would have dropped. Instead, the mass of estate works was kept off the market and the works were slowly released one by one.

Some art galleries in Paris and New York are known to have made huge profits as sole agents for famous painters discovered when the yet-unrecognized artists were still at the beginning of their careers. No wonder gallery owners act as coaches of the painters in their stables and try to make their fame happen. The management of a career for profit is bound to affect the content and form of the works. Gallery owners are likely to advise their artists to produce objects that are salable at profitable prices and thus are in tune with recent trends and other market conditions—like the preference of the majority of buyers for a certain size of canvas or a certain price range.

Market requirements are many and varied. Yet one is predominant, innovation. Change is built into the system as a stimulant for purchasing; thus change for the sake of change is a rational guide for action. The commercial network of art objects favors innovation in aesthetic forms. I do not suggest that the rapid pace of innovation in current art is determined only by market necessities. Yet the latter makes innovation highly desirable.

The medieval guild organization and the current art market illustrate how societal networks, developed within the aesthetic segment, may influence the ideational system of forms. In each case, influence is achieved through pressure exerted on the makers of forms: craftsmen were encouraged to follow traditional models and to avoid being innovative, and contemporary artists are encouraged to change and to find newness. The mechanism of pressure is simple and universal: the stick and the carrot. Innovative craftsmen and conservative artists are punished in material losses and failure to achieve prestige and reputation; conservative craftsmen and innovative artists are rewarded in material gains and reputation.

This conditioning of forms by networks is not of necessity but of conduction. A network characterized by seniority and tradition is not a sufficient condition of conservatism in visual forms—some medieval companions resisted the pressures to conform. Neither is it a necessary condition—stylistic conservatism sometimes has been maintained where there was no rigid network of seniority. But a socially conservative structure is conducive to continuity in forms, and thus makes it probable. Anthropologists, and other social scientists, should not disregard the probable, although the probable is less satisfactory for the mind than the necessary.

MARCEL BREUER. Cesca side chair, manufactured by Thonet Brothers. 1928. Collection, The Museum of Modern Art, New York.

Outside the aesthetic segment, two societal networks are particularly relevant to aesthetic forms, government and hierarchy—also designated as social stratification. Through each of these networks, distinctions are established among the members of a total society. Rulers are separated from subjects through government institutions. Superiors like aristocrats, nobles, or upper-class members are distinguished from inferiors like traders, farmers, or middle- and lower-class members through a hierarchical network.

The two networks are conceptually different, but in concrete societies they partly overlap. Usually, most rulers belong to the superior stratum, only a few to the inferior strata, and many members of the superior stratum are not rulers.[3] Before the revolution of 1789, most of the members of the royal government of France, the rulers, were nobles (the superior layer). Some belonged to the bourgeoisie or third estate (the highest inferior layer); clergy, manual workers, and peasants were the other inferior layers. As the nobility was a relatively large stratum, and the royal government a rather small group, most of the nobles were thus outside the ruling group.

Those at the top of government and social hierarchy networks constitute a minority which has privileged access to the material, technical, and intellectual resources of the whole society. Privileged minorities are more closely associated with the makers of aesthetic objects than are ordinary farmers or middle-class citizens.

Art objects, and artifacts belonging to the aesthetic locus of a society, are always more expensive than purely instrumental objects. Aesthetic forms require superior skills and often better materials and tools; it takes more time to make them. The Cesca side chair designed by Marcel Breuer in 1928, and produced by Knoll International, was

The Abramtsevo church, designed and built on
the Mamontov estate. 1882. Photo from Gray
1971.

considerably more expensive than any ordinary chair; yet most ordinary chairs were just
as good for sitting on. To go beyond instrumentality and to design a chair that is also
good to look at is bound to be more expensive. Drawing an image that is good to look at,
be it a still life or a landscape, a nude or a portrait, necessitates long training and some
talent; the time of a highly skilled person is costly.

The expensive objects are also superfluous. There is certainly an aesthetic need
rooted in the contemplative mode of consciousness. The aesthetic experience is an
essential encounter with the world. But the satisfaction of the aesthetic need may be more
easily postponed, diverted, or counterbalanced than the need for most of the instru-
mental artifacts. For most of us, the need to have a chair to sit on is more urgent
than the need to have a chair to look at.

Only those who are privately affluent or are in a position to spend public or corporate
funds can afford works of art. In traditional Benin, only the *oba* and his courtiers and
officers—that is to say, the rulers—could devote large quantities of expensive imported
copper to the casting of high-relief ornamental plaques. In seventeenth-century France,
only King Louis XIV could assemble the best architects, landscape designers, painters,
sculptors, cabinetmakers, and engineers to build Versailles. In twentieth-century New
York City, only large corporations, public institutions, or the wealthy can commission the
painting of murals such as the ones by Diego Rivera in the Rockefeller Center.

For a long time, privileged minorities were also the leisure classes. They, and particularly their women, were the only groups who had the opportunity to frequently enter into visual commerce with aesthetic quality, to learn the appreciation of forms, to be influenced by artists, and to offer them an understanding and responsive audience.

In the second half of the nineteenth century, the most vital group of Russian artists was the Wanderers. They wanted to bring art to the village people and to revive traditional folk forms. When they were not on country roads, they were living as a colony of artists at Abramtsevo, the estate of Savva Mamontov, a capitalist entrepreneur and railroad builder. Mamontov, a trained singer and a sculptor, and his wife participated in the activities of the Wanderers. Through their financial and moral support, the Mamontovs made it possible for the Wanderers—also known as "Mamontov's circle"—to design, to paint, to carve, and to propagate the revival of traditional Russian folk art.[4]

During the late thirties, art collector Peggy Guggenheim was the discriminating Maecenas of the Surrealists; she financed and directed a London gallery, Guggenheim Jeune, committed to the promotion of this movement. Later, in the forties, she opened the Art of This Century gallery in New York City, where she organized one-man shows for Pollock, Motherwell, Hoffman, Rothko, and others. When she moved to Venice, in the early fifties, her collection was exhibited in several European cities.

The Mamontovs and Peggy Guggenheim were exceptional patrons of the arts, and their action on the aesthetic scene of their times was significant. Patrons less committed and of lesser means also interact with the creators of aesthetic forms. From artists they receive a practical visual education; and to them they make their preferences felt. By selecting the art works they buy, by expressing interest and appreciation for certain kinds of objects, for certain trends, or for certain styles, they determine what will become the aesthetic locus of their cultures.

In thirteenth-century Europe, the high dignitaries of the Christian church—the popes and their Roman court, the bishops of capital dioceses, the abbots of famous monasteries—belonged to the privileged minorities of England, France, Germany, Italy, Spain and other Christian countries. They made religious ritual one center of that century's rich aesthetic locus. In sixteenth-century Japan, the tea ceremony was developed in Zen monasteries and then adopted by the aristocracy. Around it many features developed, and together they constituted an aesthetic locus of the Japanese culture of that time. Again, this was a consequence of the Japanese establishment's influence on aesthetic creation.

Granted, the makers of aesthetic objects were dependent upon the establishment's patronage in medieval Christianity, in the Japan of the Ashikaga period, and in royal France. Are they as much in need of the support of the privileged minorities in the contemporary industrial world? After all, many aesthetic objects are produced or reproduced in large quantities. They are not that expensive.

Thanks to industrial design the aesthetic quality of many mass-produced objects has considerably improved. Certainly, posters and excellent photographic reproductions of paintings are available. Designers and artists who participate in these industrial processes may, indeed, become more independent from the wealthy few. However, just as haute couture sets the trend for the ready-to-wear in fashionable clothes, the original, unique, handmade pieces still dominate the art scene and the art market. Such pieces are expensive and are for those who have reached the top of the power and superiority networks.

NATALIA GONCHAROVA. *Haycutting.* 1910. Artist's collection.

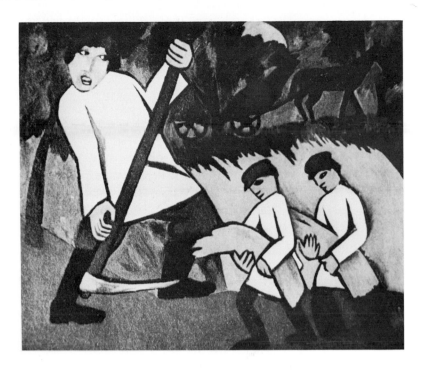

Socialist realism in the Soviet Union offers an exemplary though intriguing illustration of the influence of a societal network, the governmental structure of the U.S.S.R., on the styles of representation in the visual arts. The case is exemplary because political decisions were explicitly and officially stated; it is intriguing because it seems to have developed in a manner that runs counter to Marxian doctrine.

During the first two decades of this century, the Moscow artistic scene was extraordinarily lively, innovative, creative, and aesthetically revolutionary. In 1906, the Blue Rose Group was constituted and the magazine *Golden Fleece* was founded. In close association, the group and the magazine organized four exhibitions, from 1907 to 1909, presenting French post-Impressionists and Fauvists as well as Russian painters, particularly Mikhail Larionov (1882–1964) and Natalia Goncharova (1881–1962). From then on, the Russian artistic life offered developments parallel to—not imitations of—what was happening during the same decades in Paris, Rome, Munich, and other avant-garde centers.

In that stimulating atmosphere, several movements, loudly announced by manifestos, were born, briefly came into bloom, and rapidly disappeared. Such were, in 1911, Larionov's and Goncharova's Rayonism (inspired by Italian futurism); in 1912, the Cubo-Futurism launched by Kasimir Malevich (1878–1935); in 1915, Suprematism promoted by Malevich again; and the rival movement, Productivism, whose leader was Vladimir Tatlin (1885–1953). To these names, one should add Aleksandr Rodchenko (1881–1956), Liubov Popova (1889–1924), Ivan Puni (1894–1956), better known by his French name, Jean Pougny, and Natan Altman (1889–1970) to have an idea of the variety of talents to be found in the Russian avant-garde during the years immediately preceding the Revolution of October 1917.[5]

Rather than deeply opposed schools, these movements were stages in the development of what could be considered one generation of artists. Fundamentally, despite

discussions and manifestos, they passed through these different stages together. Even Malevich and Tatlin—whose competition for the leadership of the avant-garde went to the point of physically fighting each other before the 1915 opening of 0.10. The Last Futurist Exhibition of Paintings—were on parallel paths. One basic characteristic common to the early twentieth-century Russian artists, therefore, should be emphasized: the repudiation of the naturalistic style of representation. This style was dominant in nineteenth-century academies everywhere; in Russia, it was particularly stressed at the Petersburg Academy of Art.

A representation is naturalistic when the painter attempts to convey a visual perception similar to what the retina records when looking at the object—person or thing—in the outside world. The naturalistic painter is concerned with imitating visible appearances, including an illusory rendition of three-dimensional space through linear perspective, through flat planes varying in luminosity, or through different colors suggesting different depths.

Antithetical to naturalistic, or perceptual, representation is conceptual representation. The sculptor, painter, or engraver wants to convey some characteristic of the represented entity which the artist thinks to be its essence or concept and which is not visible. For instance, I make a drawing of an adolescent's body as I see it, as everybody sees it, and as it would appear in a photograph: it is a naturalistic image. Suppose I want to show that this youthful body is transitory; transitoriness is its essence, it is an element of its concept, but it is unseen. In order to convey the idea of transitoriness, I may draw the skeleton under the skin and flesh, thus suggesting that death is already present in this adolescent: it is a conceptual representation.

Painters of the early modern period, in France, Germany, and Italy as well as in Russia, did not want to imitate the visual appearances of objects seen in the outside world. They wanted to convey what they perceived behind the appearances. German Expressionists depicted a scene *and* their personal reaction to the scene by simplifying and "distorting" lines. Fauvists transposed emotions and feelings into colors, bold and arbitrary. Cubists revealed the underlying geometrical forms by analyzing and unfolding volumes into interlocking planes. Rayonists represented light, as reflected on the angles of represented objects, by rays of color in all directions.

Through these different movements, paintings become more and more entities of their own, and less and less representations. Some Rayonist paintings by Larionov or Goncharova are on the borderline between representation and nonfiguration; one needs the title to recognize what is depicted. With Suprematism, the border is crossed, and one is in the nonfigural, more commonly called the abstract.

The repudiation of naturalistic representation, which had been dominant in the Western tradition since the Renaissance, was an aesthetic revolution. Another revolution, social and political, was in the making at the same time. They were somehow converging.

Though not directly involved in the preparation of the Revolution of October 1917, the Russian avant-garde was radically opposed to the czarist establishment, to its norms and values. Artists expressed their social alienation and marginality by outrageous costumes, nonsense plays, and "absurd poetry" recitals in bohemian coffeehouses such as Café Pittoresque, the interior of which was designed and decorated in 1917 by Tatlin, Rodchenko, and Georgii Yaculov (1882–1928). They dreamt of the Middle Ages when, they thought, art was integrated into life and artists were recognized as contributing

ANDRÉ DERAIN. *The Old Tree*. 1905. © ADAGP,
Paris / VAGA, New York, 1985.

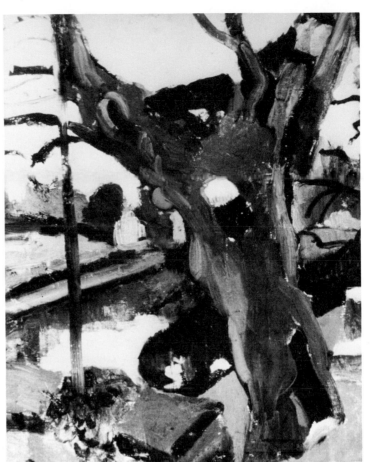

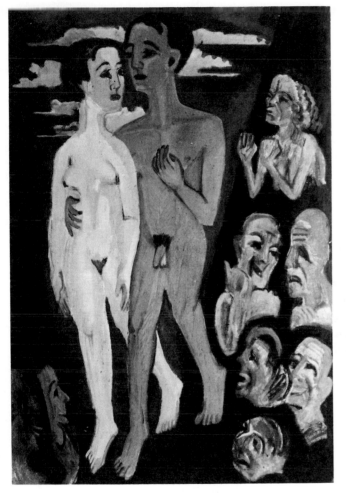

ERNST KIRCHNER. *Two Against the World*. 1924.
Kunsthalle, Hamburg. Photo by Ralph
Kleinhempel.

WASSILY KANDINSKY. *Black Lines*. 1913. Solomon R.
Guggenheim Museum, New York. © ADAGP,
Paris / VAGA, New York, 1985.

members of society. So the October Revolution was welcomed. "Cubism and Futurism were the revolutionary forms in art foreshadowing the revolution in political and economic life of 1917," said Malevich.[6] "The events of 1917 in the social field were already brought about in our art in 1914 when material, volume, and construction were laid as its basis," said Tatlin.[7]

Artists were indeed given responsibilities in the new regime. In the Department of Fine Arts, created in 1918 under the People's Commissariat of Enlightenment, decision-making positions were occupied by Tatlin, Malevich, Rodchenko, and Altman. Wassily Kandinsky (1866–1944), who had returned to Russia from Germany where he had been involved in the Blaue Reiter movement, was also employed in the Department of Fine Arts. And Marc Chagall (1887–1985), also back from Berlin, was made Commissar for Fine Arts at Vitebsk, where he was born. Within four years, these artists-turned-commissars organized thirty-six museums throughout the country, and bought modern works of art with a budget of two million rubles.

They were not only administrators; they continued to design and produce works. In 1919 Tatlin was commissioned to design a *Monument to the Third International* to be erected in the center of Moscow. Described by Tatlin as "a union of purely plastic forms (painting, sculpture, and architecture) for an utilitarian purpose," the monument, according to Osborne, "was to be in glass and iron, twice the height of the Empire State Building, and the central glass cylinder was to revolve."[8] Models were made, but it was never built. In 1920, in an exhibition called Non-Objective Creation and Suprematism, new works by Malevich (including his famous *White on White*), Rodchenko, Popova, Kandinsky, and Antoine Pevsner (1886–1962) were shown.

In 1921, Tatlin and the former Productivists developed a new movement under the name of Constructivism. This movement was a continuation of Productivism, which promoted constructions in space made of "actual" materials—as opposed to two-dimensional paintings creating an illusory space. Consequently, the Constructivists considered easel painting obsolete and held the artists' participation in the industrial process more relevant to a new type of society whose techniques of production were industrial. Hence, the development of industrial design. Tatlin and Rodchenko designed furniture and clothing for workers; Malevich designed plates for the State porcelain factory; Popova designed textile patterns; and Altman designed stamps. Rodchenko and El Lissitzky (1890–1947) created new typographical systems and new graphic techniques such as photomontage.

Artists were also involved in education and propaganda. They designed stage sets for theaters and large public celebrations like the First of May and the anniversary of the October Revolution. They also drew posters and magazine covers.

During these effervescent and chaotic years, there were many internal tensions and struggles among the artist-commissars. Yet at the ideational level of the systems of forms, there was no confusion. During the first five years of the new regime, the forms were clearly modernist and in the line of the prerevolutionary trends that had been developed by the same artists. The aesthetic revolution against naturalistic representation had been won. The two trends that dominated the artistic scene were, for different reasons, opposed to naturalistic representation. Constructivism, the construction in actual space of utilitarian objects, condemned representations as such; and Suprematism had reached an extreme in nonfiguration with the 1919 Malevich monochrome paintings,

VLADIMIR TATLIN. Model for the *Monument to the Third International*. 1920. State Russian Museum, Leningrad.

KASIMIR MALEVICH. Cup and teapot. c. 1920.
Designed for the State Pottery, Leningrad.

ALEKSANDR RODCHENKO. *Hanging Construction.* 1920.
Museum of Modern Art, Oxford.

where the shape of a square was indicated only by a difference in texture obtained by the brushwork. The new forms, created during the last years of the old social order and in opposition to it, were still in the process of evolving. They provided the new ideational systems that corresponded to the new social order. What happened also conformed to Marxian doctrine: new relations of production generate a new superstructure. Thus the new economic basis of society was expected to be reflected by a new art.

Then socialist realism appeared. Its configuration of forms was in complete opposition to modernism. In painting and sculpture, it was a return to nineteenth-century academic naturalism, and in architecture, to a sort of neoclassicism. Instead of Suprematist painting built up from squares and circles, crosses and triangles, back were heroes and rulers, portraits and landscapes; instead of Constructivist dynamic forms in iron and glass, back were columns and Corinthian capitals, cornices and pillars, ballroom-size halls and monumental staircases. From a Marxian viewpoint, the return to naturalistic figuration and neoclassical styles introduced the incongruity of reestablishing a superstructure that had been generated by the exploitative capitalistic system. The subject matter was new—workers and Red Army soldiers, dams and industrial plants, Lenin and later Stalin—but the style of representation, idealized naturalism, was the same.

The first manifestations of socialist realism were, at the level of societal networks, closely associated with the state and party power structures. In May 1922, the Association of Artists of Revolutionary Russia was founded. It rejected the "abstract concoctions

ALEXANDROVICH DEYNEKA. *The Defense of Sebastopol.*
1942. Photo from Zimenko 1976.

ALEXANDROVICH DEYNEKA. *The Tractor Driver*. 1956.
Photo from Zimenko 1976.

M. SAVITSKY. *Partisan Madonna.* 1967. Photo from
Zimenko 1976.

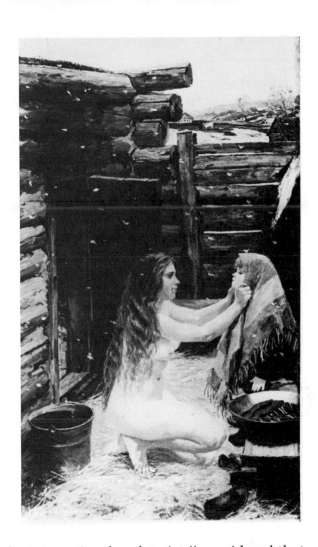

ARKADY ALEXANDROVICH PLASTOV. *Spring. At the Bathhouse.* 1954. Photo from Zimenko 1976.

discrediting our Revolution in the face of the international proletariat," considered that "our civic duty before mankind is to set down, artistically and documentarily, this great moment of history in its revolutionary impulse," and advocated "the monumental forms of Heroic Realism."[9] The name *socialist realism* was not used in 1922; it was introduced in 1934, at the first congress of the Union of Soviet Writers—Stalin is credited with having coined the term. But, since 1922, a doctrine stating that art should be a tool of social transformation, and that its style should be naturalistic, has been the explicit, and enforced, policy of the Soviet government.

The first aspect of the doctrine—that art should be a tool of social transformation—is consistent with those principles of Marxism that give priority to action over contemplation. It also fits the situation of a government that has to achieve societal stability and economic survival in an international environment of hostility—which was the situation of the Soviet Union during the twenties and thirties. What is puzzling is the second aspect of socialist realism. Why did the Soviet government and the party impose an idealized naturalism as the style of representation?

A clue to answering this question may be found in the seemingly surprising similarity between this Soviet policy and the "cultural policy" of the National Socialist regime in Germany. After Adolf Hitler became chancellor in 1933, as a consequence of the presidential elections of 1932, the artistic scene in Berlin and Munich, Dresden and Düsseldorf changed completely.

The scene had been modernist. The Bauhaus, founded in 1919 by Walter Gropius (1883–1969) was, first in Weimar and later in Dessau, the main center of diffusion for industrial design and nonfigurative art in the twenties and early thirties. Russian Constructivism had spread to Germany. In 1922, at a congress of artists held in Düsseldorf, an international association of Constructivists was formed. Later, several European groups of Constructivists—De Stijl of Piet Mondrian (1872–1944) in Holland, the Cercle et Carré of Michel Seuphor (b. 1901) in France—collaborated with the Bauhaus. Wassily Kandinsky, who had left the U.S.S.R. in 1921, held a teaching position at the Bauhaus.

From 1933, the National Socialist party mounted a campaign against "degenerate" art and artists. It culminated, in 1937, with an exhibition of "degenerate art" held in Munich. Among the nine categories listed in the guide to the exhibition, one was devoted to abstract and Constructivist paintings characterized as expressing "total madness" and the "height of degeneracy."[10] In another building, the newly built House of German Art, not far away from the "alien and cosmopolitan, Jewish and Bolshevist" art exhibit, the first Great German Art Exhibition was held during the same summer of 1937.

This German art exhibit, and the following seven which took place until 1944, gave a fair idea of what the government and party leadership meant by what they called "the art in the Third Reich." It was a representational art, depicting in idealized naturalistic style, interiors and family scenes, nudes and landscapes, portraits and subjects from classical antiquity. All of these paintings were in continuity with the art production of many second- and third-rate German painters of the nineteenth century. New subjects were treated in the same naturalistic style: war scenes of bombardments of London, tank battles, conquering troops entering Poland. There were also allegories pertaining to the National Socialist mythological world: German knights of the Middle Ages, young and

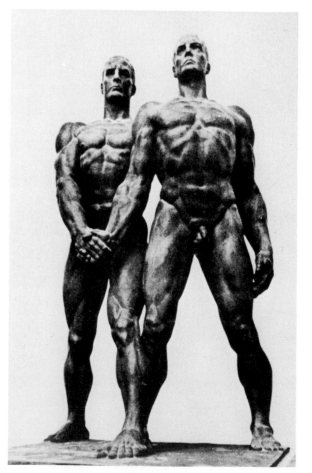

JOSEF THORAK. *Comradeship*. 1937. Photo from Frankfurter Kunsverein 1975.

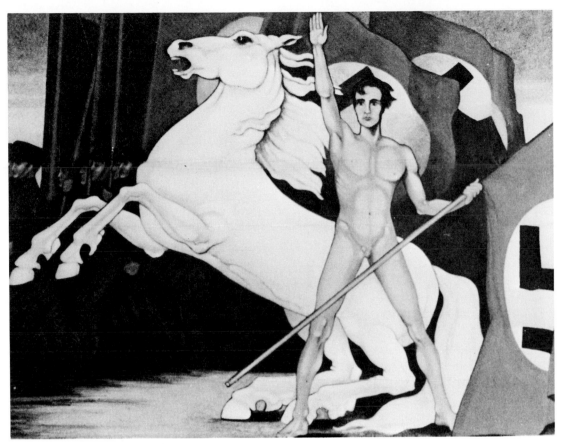

WALTER HOECK. *Young Germany* (adapted by Beatrice Fassell). Photo: Carl Hanser Verlag.

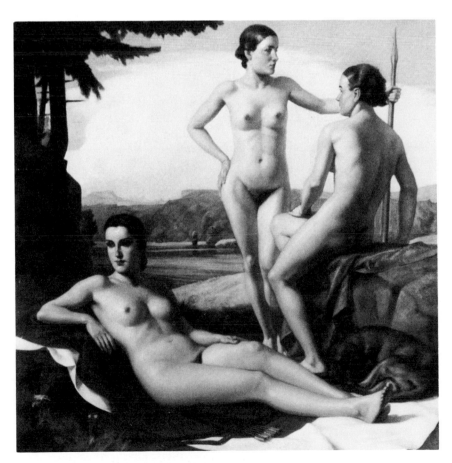

IVO SALIGER. *Diana at Rest.* Photo: Carl Hanser Verlag.

naked men defending the flag, and Olympic athletes in Greek nudity. And, of course, there were portraits of the Führer and other personalities of the regime.

The idealized images of Hitler and his associates, of the blond and healthy-looking young men and women of Germany, and of the sunny wheatfields of the German homeland were naturalistically rendered. It is ironic that Stalin and his associates, the workers, soldiers, mothers, and partisans of the Revolution, and the dams, railroads, steel plants, and electric works of the Soviet homeland were represented in exactly the same style.

We may rephrase the question on the Soviet imposition of naturalism. Why did the one-party governments of the U.S.S.R. and National Socialist Germany perceive visual modernism as a potential threat to their regimes?

Each of these countries was in the process of mobilizing its people's energies in an effort of economic and military development. Each had evolved a totalitarian system of government: a system in which as complete a control as possible is achieved through individual commitments to collective goals. The latter may be any national priority such as "industrialization, racial mastery, or proletarian unity."[11]

In this perspective, a naturalistic representation is more amenable to control than a conceptual one. Being a visual imitation of the appearance of an outside entity, a naturalistic representation immediately directs the beholder's attention to the outside entity. When I look at a realistic image of a Red Army soldier, my interest moves immediately beyond the canvas. The painting is a window through which I see the "real" soldier. In my thought, there is the soldier, not his picture. My comments are about him, not about his image: he looks strong and happy, his stance is impressive. A naturalistic representation, particularly if its aesthetic quality is mediocre, acts as a relay to what is represented; it does not retain the beholder's attention to the "flat surface covered by colors arranged in a certain order."

Picasso's *Guernica* is representational too. I recognize each element: bull, mother and child, horse, lamp, bulb, and the like. But it is not a window through which I can see the German bombers attacking the town of Guernica in 1937. Each element is represented according to what Picasso thinks, not according to what he sees. The figure I call the mother is a visual transposition of a certain idea of a suffering and despairing mother. It does not resemble the perceptual image produced by the view of any actual woman I have ever seen or will ever see. The whole picture does not look like an actual scene of destruction that one could photograph in a street after it had been hit by an air raid. The whole picture is a conceptual representation of it.

Because it does not open a window on the world out-there, *Guernica* has several possible meanings; it is polysemic. It is also polysemic because its aesthetic excellence makes it a powerful symbol. Polysemy bothers some beholders. When *Guernica* was shown in Paris three months after the bombing of Guernica, many friends of the legal government of Spain criticized Picasso for being obscure.[12]

Polysemy does not bother only some beholders. It makes the rulers' control of their subjects' thinking more difficult. How can rulers be sure that beholders will apprehend the "correct" meaning, that is, the one the rulers deem to be correct?

A sign's polysemy is derived from two possible sources. One, discussed earlier, is the aesthetic quality of a work. Aesthetic excellence makes a work a powerful symbol, and a symbol is polysemic. Even naturalistic images are symbolic if they have aesthetic quality—though some people see Botticellis and Raphaels only as images.

Conceptualism in representation is the second source from which polysemy is derived. When a painting visually represents what is thought rather than what is seen, it certainly suggests different meanings to different beholders; it also suggests different meanings to the same beholder in other circumstances. When a human face is drawn in profile, only one eye will be depicted if the work is treated in naturalistic style; the second eye is known to be on the other side of the face but is not seen. If the second eye is depicted on the face in profile, as Picasso sometimes did, it is a conceptual representation. As this feature is bound to be interpreted differently by different beholders, it is a multivocal sign.

Achieving a totalitarian control of meanings through conceptual representations is impossible. A case from the field of music makes this clear. In 1948, Soviet composers were invited by the central committee of the party to write operas, and other pieces with songs, instead of the symphonies and other forms of instrumental music they had usually produced. To operas and songs, words give an unambiguous content, whereas instrumental music allows a greater freedom of interpretation.

For totalitarian rulers, modernism in the visual arts presented a more threatening danger than the dissemination of some particular ideas which were prohibited: it trained minds to look beyond the surface of things. Cubism, Suprematism, surrealism, and other isms of modernity had in common the establishment of a distinction between what is seen and what is unseen but essential.

A modernist rendering of a partisan may suggest, even state, that under the appearance of an armed militant committed to a noble cause, there is a trained killer in a system of organized violence, or a naive victim who will be sacrificed for the defense of a privileged minority to which he does not even belong, or a killer and a victim at the same time.

Non-naturalistic images and nonfigurative compositions build into beholders' minds the habit of perceiving everywhere, even in rulers' statements, a dichotomy between what appears and what is hidden. Interestingly, the distinction between the face value of a position and the class interests it covers, and the disclosure of those interests, were weapons used by Marxists against their opponents. Such ideological analysis is at the origin of the sociology of knowledge.

If this interpretation is valid, it may be expected that totalitarian regimes, afraid of the freedom of thought stimulated by the polysemic character of visual symbols, will try to dry up the two sources of these symbols—aesthetic excellence and conceptualism. This is, in fact, what happened in Stalin's Russia and Hitler's Germany.

The condemnation and suppression of conceptualism and nonfiguration by socialist realism indeed offer a privileged case for studying how a societal network outside the aesthetic segment of the Russian society—the Soviet leadership of the government and the party—had, during more than half a century, a decisive and even brutal impact on what appears to be a purely aesthetic matter: the choice of a style of representation.

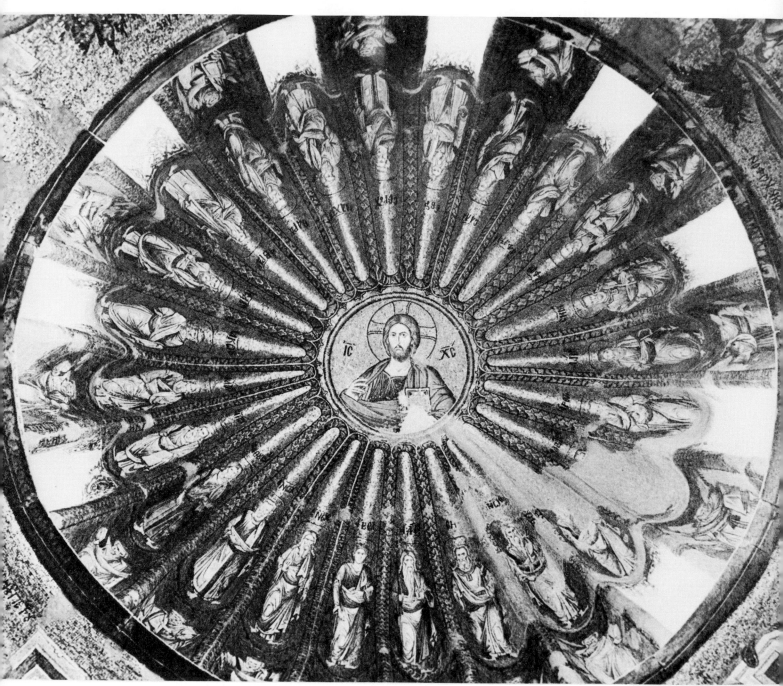

Dome of the Church at Chora. Constantinople.
13th—15th century. Photo by Guler (Civilisations
1966).

CHAPTER NINETEEN

Aesthetic Forms and Other Ideational Configurations

IN THE THREE-LEVEL MODEL OF A CULTURE USED IN THIS BOOK, THE THIRD LEVEL IS DEVOTED to systems of ideas. Idea is broadly understood as any product of mental activity such as perceptions and conceptions, inductions and deductions, cognitions and significations. These mental products are expressed or supported by material items such as written or spoken words; sounds produced by instruments; contours, volumes, and colors. These material items are not considered in their physical dimensions—words as printed characters, sounds as vibratory disturbances, and colors as electromagnetic radiations. They are considered in their mental dimensions—words assembled in a book as constituting a novel, sounds organized as a concerto, and colors disposed on a canvas as a still life. As these examples indicate, the units are, on the ideational level, configurations or systems of ideas. Such are the Navaho world view, nuclear physics, the Bantu languages, Greek mythology, electronic technology, Christian theology, and Islamic law.

To make these numerous systems of ideas more manageable for study, we may categorize them according to different criteria. Dominant function, for example, may be chosen as the principle of classification. From this point of view, one may distinguish cognition-oriented, action-oriented, affectivity-oriented, and contemplation-oriented configurations. The dominant function of sciences and philosophies, world views and cosmologies, models of the human psyche and physiology is to explain man and the world; these ideational systems are cognition-oriented. Technology, language (particularly in its rhetorical use), ethics, and ritual are examples of action-oriented systems of ideas; they provide mental means for changing the world and for acting upon men and gods. Affectivity-oriented systems generate and direct feelings, strivings, and impulses. Such are, for instance, language in its emotional uses, devotional ceremonies, and the visual eroticism of some pictorial traditions. Styles of composition, aesthetic systems,

223

methods of meditation, and spiritual paths are contemplation-oriented configurations; they provide the mental underpinnings favoring establishment and maintenance of the contemplative mode of consciousness.

Ideational configurations may be classified on the basis of principles other than the dominant function. One could use the mental process that predominates in each system and distinguish between empirical or deductive configurations, rational or nondiscursive methods, historical or scientific approaches. Still another principle of classification could be the subject matter on which each system is focused: universe or earth, inanimate world or biosphere, humankind or its environment, and many other categories.

Aesthetic configurations belong to the ideational level. They are systems of visual forms displaying an aesthetic quality because of their integrated design. It is in the ideational systems—not in the societal networks nor in the processes of production—that aesthetic specificity is to be found. It is because they embody an aesthetic system of forms that some artifacts have an aesthetic value—not because they are in a fine arts museum, have been made by professional artists, or display techniques taught in art schools. In this chapter, we shall explore how systems of forms are related to ideational configurations like theological doctrines, world views, conceptions of time, and kinship theories.

Byzantine Christianity conceived of God as transcendent. He was above, and independent of, the material universe of sun, moon, and stars he had created. He had caused the earth, living nature, and humankind to exist, but he did not need them to exist. Despite God's incarnation in the human form of Christ, the divinity was thought of as completely distinct and separated from man. Absolute and unrelated, God transcended everything that was not his own being.

Byzantine religious imagery has had a long tradition of eleven centuries, if we consider it as coextensive with the Byzantine Empire—which, historians have agreed, lasted from 330, when Emperor Constantine established Byzantium, under the new name of Constantinople, as the capital of the Roman Empire, until 1453, when the Turks conquered Constantinople. Of course, during this long era Byzantine art fluctuated—

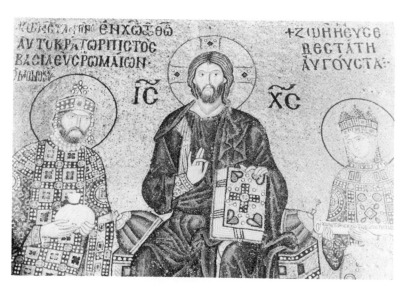

Mosaic of Christ as Pantocrator. Hagia Sophia basilica. Constantinople. 11th century. Photo by Guler (Civilisations 1966).

there were three "Golden Ages" and, between them, periods of artistic depression—but it maintained a significant persistence in forms.

The religious iconography became standardized and thus remained constant in its themes and conventions. Integrated into the interior architecture of churches, religious imagery was set in mosaics or fresco painted on the semidome over the apse or on the dome over the center of the building, high above the heads of the congregation. The divine figures and referents were depicted on a uniform golden or blue background.

A hand pointing downward in the sky was an iconic referent for God the Father, and a dove was for the Holy Ghost. Christ as Pantocrator (universal ruler) was represented majestically standing or sitting on an imperial throne. His image dominated the pictorial field in glorious isolation. Sometimes, as in the church at Chora in Constantinople (dating from the Third Golden Age, 13th–15th century), Christ was at the apex of the dome; the apostles and disciples, much smaller in size, were disposed in a perfectly regular circle at the lower part of the dome. Sometimes, the Virgin Mary and apostles, prophets, and saints were depicted on the walls, also standing in front of a uniform background.

The rendering of Christ and the other heavenly figures is stylized. They are frontally depicted as elongated figures, rigidly motionless, remarkably impersonal, and abstract. The style of representation is definitely conceptual. Suggestions of volume, mainly by shading and overlapping of the folds of the tunics, are so limited that the figures appear flat. As there are no visual clues for the third dimension, there is no pictorial space. The figures seem to be floating in front of the ground.

These features—stylization, impersonality, absence of volume and pictorial space—characterize Byzantine representation. This style does not guarantee that mosaics and frescoes made in accordance with its canons have an aesthetic quality—no style guarantees that. But it certainly offers a framework for strong composition, and many Byzantine images have a compelling unity of design.

The expressivity of Byzantine style is also remarkable. Its features make many mosaics and frescoes the visual equivalents of the theological doctrine of God's transcendence. Represented outside our three-dimensional space, high above us, without human thickness and individual traits, the divine icons and referents are really separated from us, different from us: they transcend us. This, of course, produces a congruence of forms and meanings. Byzantine style, more than others, establishes a visual discontinuity between the heavenly world of the divine and the everyday environment, which is also ego's arena. This break facilitates an initial contemplative attention and helps to maintain it in the beholder's mind.

The close association of mosaics and frescoes with an architectural form, the dome, reinforced their aesthetic and symbolic value. Hagia Sophia (holy wisdom) basilica (532–537), built by architects Anthemios and Isidoros in Constantinople during the First Golden Age, exemplifies Byzantine religious architecture in its most impressive realization. Its dome, placed at the center of an almost square building, dominates the basilica by its massive presence. For ordinary Christian believers entering the sacred space of Hagia Sophia, the monumental dome stood for the heavenly abode of God and his celestial court of angels and saints; for scholars and theologians, it symbolized the transcendence of the divine.

Between two ideational configurations of Byzantine culture, the aesthetic system and the theology of transcendence, there is a relation of symbolism: the aesthetic forms

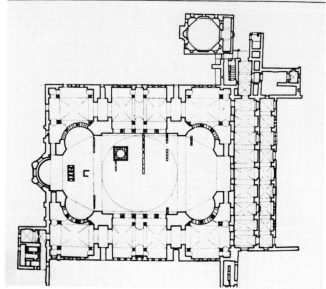

Hagia Sophia basilica, ground plan.

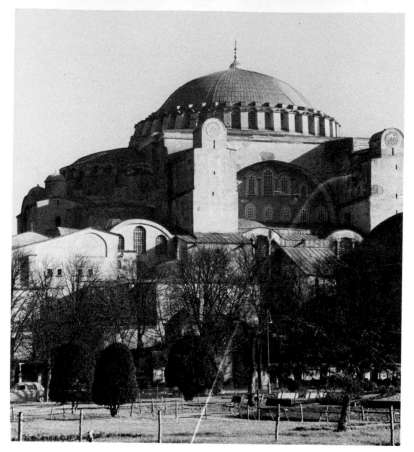

ANTHEMIOS AND ISIDOROS. Hagia Sophia basilica. Constantinople. 532–537. Photo by Jacques Maquet.

stand for transcendence by participation. Material signifiers—mosaics and dome—display forms different and separate from, and superior to, the usual forms in our environment. They transcend the material world and they convey the idea of transcendence by participating in the divine world. By experiencing transcendence through aesthetic forms we have a taste of the idea of the transcendence of the divine.

The relationship between Byzantine forms and Byzantine theology may also be expressed in terms of correspondence. Each of the two configurations corresponds to the other, each one is equivalent to the other. The words of theological treatises and, on the other hand, the representational and architectural forms express in different idioms the idea of divine transcendence. Accustomed as we are to look for causal relationships, we wonder which is first, theology or visual forms. A detailed historical study could perhaps solve this problem, but that is not certain. It is certain that the visual and intellectual processes reinforced each other over the centuries of Byzantine civilization. The visual environment of the church and the theological doctrine reflected each other. They presented two highly consistent and parallel ideational systems to new members of the society, who were in the process of enculturation.

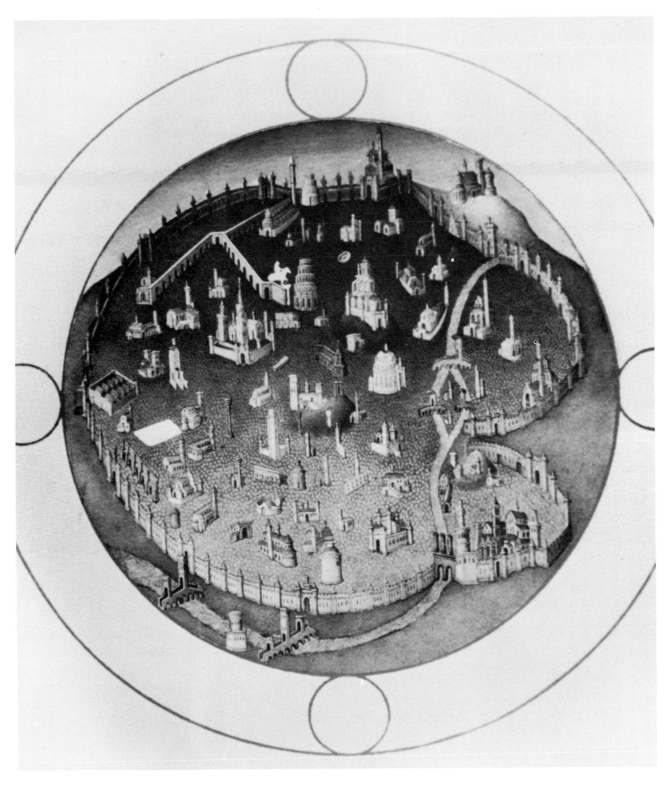

POL DE LIMBOURG. A plan of Rome from the illumi-
nated *Très Riches Heures du Duc de Berry*. c.
1414. Musée Condé, Chantilly. Photo: Draeger
Frères.

In the Latin Christianity of the Middle Ages, the world was viewed as God-oriented. The world was conceived of as created by God and thus entirely dependent upon him. In fact, God's action was understood as continuous and permanent: it maintained the world in existence. What mattered was God's point of view, if we may say so.

Like their colleagues of Constantinople, Latin theologians such as Thomas Aquinas wrote about divine transcendence. But it seems that the dependence of the created, another facet of God's absoluteness in theological discourse, was more appealing to Latin Christianity. In the world view of ordinary Christians, God was mainly imagined as a good king upon whom his subjects were dependent. He was not too far from his creatures, he was concerned and he watched them.

Many towns, ports, villages, and castles were depicted in illuminated manuscripts made during the Middle Ages. In the famous masterpiece by Pol de Limbourg (active c. 1399–c. 1416), the *Très Riches Heures du Duc de Berry* (1408–16), there is an illumination of Rome. As in many other medieval images of towns, Rome is seen from above, enclosed within her walls. Inside the walls, we see only important monuments, each carefully drawn, each situated in relation to the others on an empty surface; no streets appear.

Limbourg, like many illuminators, used a perspective from above when representing a town. In the fifteenth century, this was an exercise of imagination. Nobody had yet seen Rome from above, at such a distance that the whole city could be embraced in one view. It was also an exercise in conceptualization, as Rome was reduced to her essential monuments. The picture was inscribed in an astronomic circle which makes it a separate whole. All this suggests that the quasi-aerial perspective is not simply a bird's-eye view.

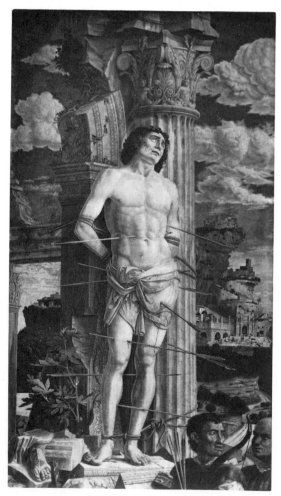

ANDREA MANTEGNA. *Saint Sebastian.* c. 1472. Musée du Louvre, Paris. Photo: Vizzavona, Paris.

Facing page. MANTEGNA. *Saint Sebastian,* detail: a view of Rome in the background.

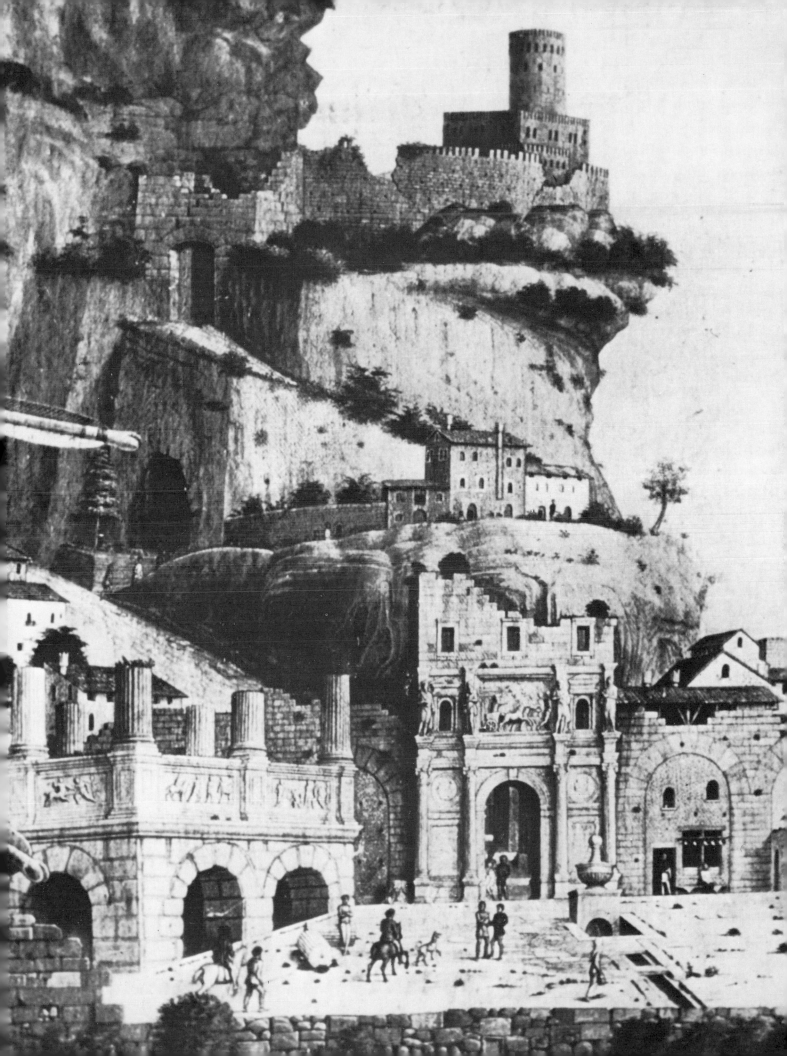

It could well be a God's-eye view. Rome is represented with, and only with, the buildings that make her identity and magnificence. It is the city in her own self, it is Rome in her own being: in her dependence upon God and her autonomy from human viewers. Rome is represented from what can be called an ontological point of view. This is "God's point of view" in the sense that he "sees" and creates persons and things as they are in their own being. This theological idea is expressed by an all-embracing view of the essentials. It is not an aerial perspective, but an ontological perspective: it visually apprehends entities as they are.

If this interpretation is valid, then there is a correspondence between two ideational configurations of Western medieval civilization: the God-oriented world view and the ontological perspective.

About sixty years after Limbourg made the illumination in the *Très Riches Heures*, another view of Rome was painted by Andrea Mantegna (1431–1506). In the background of a *Saint Sebastian* (c. 1472) is a "composed landscape" made from representations of actual sceneries—a medieval castle, a farmhouse, a church facade, and excavated ruins. Mantegna organized these sceneries as an imaginary landscape of the most improbable mountains.

The perspective is entirely different from that of the Limbourg. The pictorial space is achieved through the vanishing-point perspective, a Renaissance discovery. Lines start from the picture plane and converge to a vanishing point: the point where the lines intersect, beyond the background of the pictorial space. The illusion of the third dimension is thus obtained. In the Mantegna, the perspective is solidly established on the rectangular floor in the foreground. The lines also continue from the picture plane toward the viewer: invisibly, the pictorial space extends from the vanishing point beyond the picture plane; the diverging lines generate a space that includes the beholders.

Art historian Pierre Francastel discusses the Limbourg and the Mantegna in his book *Peinture et Société*; he writes that their comparison permits us "to apprehend one of the most striking jumps in figuration that can be imagined."[1] This jump from what I have called an ontological perspective to a vanishing-point perspective is equivalent to another striking jump, from a God-oriented world view to a man-oriented world view.

At the Renaissance, there was indeed a shift in orientation of the dominant conception regarding relations among God, man, and the world. With the retrieval of Greek and Roman thought, man again became the focus of ideational systems. Man's significance appeared more crucial than God's transcendence over the creation or the creation's dependence upon the creator. It is difficult not to interpret as corresponding phenomena the shift from one rendition of the third dimension to another rendition, and the shift from one world-view orientation to another.

A comparison between two other masterpieces illustrates the same correspondence. The altarpiece *Adoration of the Lamb*, begun by Hubert van Eyck (d. 1426) and completed by his brother Jan (1380–1441) in 1432, sits in splendor in the Saint Bavo Cathedral, in Ghent. It includes over two hundred figures. They are symmetrically disposed in four groups, two on each side of a central vertical axis on which a fountain and the lamb are placed. The whole scene is set in a meadow surrounded by trees; beyond, near the horizon, one can see the towers of a city. Visual depth is created through a diminution in size of the figures at a distance from those in the foreground, through partial concealment of those who are behind other figures, and through differences in hues and brightness.

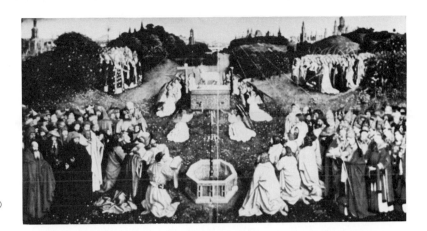

HUBERT AND JAN VAN EYCK. *Adoration of the Lamb.* c. 1432. The Ghent Altarpiece. Saint Bavo, Ghent. © A.C.L., Brussels.

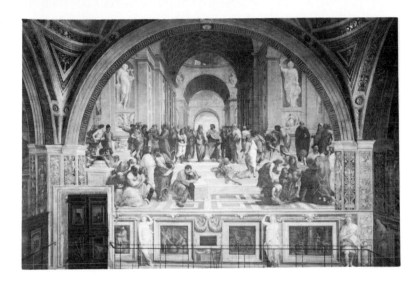

RAPHAEL (RAFFAELLO SANZIO). *The School of Athens* c. 1509. Raphael Stanze; Pontifical Monuments, Galleries, and Museums; Vatican City.

The pictorial space stops at the picture plane; it does not extend toward, or include, the beholder. In fact, the world of the lamb and its worshippers exists there, in itself. Beholders look at the scene from a viewpoint that is neither aerial nor terrestrial; they look from "outside" at a world that is independent from where it is looked at and even independent from the fact that it is looked at or not. This is another example of the ontological perspective.

The School of Athens (c. 1509), the famous fresco by Raphael (1483–1520) painted on a wall of the Vatican Stanza della Segnatura, expresses the new status of philosophy in the Renaissance. Philosophy is no longer *ancilla theologiae*, servant of theology; reason is no longer subordinated to faith. Plato and Aristotle are in the center, and around them are all the Greek philosophers known at the time of Raphael. The meaning of the picture's content is clear, and it is completely different from the meaning of the *Adoration of the Lamb*—after all, the lamb is a referent for Christ, the incarnated son of God.

The composition of *The School* is frequently analyzed because it is a model of stability and movement, of centrality and diversity. Movements of hands and arms, directions of glances, and body postures organize and connect groups and figures so as to constitute a

harmonious and lively unity of fifty or so figures. Although Plato and Aristotle are clearly the most important persons—their figures are centrally placed—there are other discussions going on, and most of the figures do not look at them. This nonradiating composition expresses what philosophy should be. Philosophy progresses through discussion; the authority of even the greatest philosophers does not put an end to questioning; there is no hierarchy among philosophers—most figures are on a plane with Plato and Aristotle.

The perspective with a central vanishing point gives a strong stability to the pictorial space. Raphael has stressed perspective by placing the philosophers in the grandiose architecture of a Renaissance church opened to the sky. The stripes on the marble floor in the foreground, the high walls, and the vaults make the lines of perspective visible. Because of the centrality of the vanishing point, the beholder is placed at the center of the duplicated world the painting presents; it extends from the fresco into the actual space. The pictorial space invades, as it were, the actual space; the beholder is welcomed among the philosophers. This feature of the Italian Renaissance perspective is the visual equivalent of the man-oriented world conceived by Renaissance thinkers.

The Limbourg−Mantegna comparison and the van Eyck−Raphael comparison illustrate a term-to-term correspondence between God-oriented world view and ontological perspective, and between man-oriented world view and vanishing-point perspective. A structural analysis would emphasize the correspondence between the two relations and thus would include the four terms in a single homology.[2] 'God-oriented world view is to man-oriented world view as ontological perspective is to vanishing-point perspective.' This can be presented in the following formulation:

$$\frac{\text{God-oriented world view}}{\text{man-oriented world view}} :: \frac{\text{ontological perspective}}{\text{vanishing-point perspective}}$$

The relation-to-relation correspondence amplifies the term-to-term relation and adds another equivalence between two ideational systems, world view and aesthetic system.

The Dogon, Senufo, and Baule of West Africa traditionally conceived of the past as a time in which different events concerning their origin and human life, their migrations and the introduction of certain crops occurred without a fixed chronological order. Narratives of these events were not recited in the same order, neither were the events considered as having happened in a sequence. The past was construed as an undifferentiated field where *before, after,* and *simultaneously* were not relevant. Tales of what happened in the past could have been introduced by "once upon a time" as in our fairy tales. Anthropologists call this past without sequential structure a mythical time, as the cultural myths are localized in this broad temporal frame.

In the kingdoms of Dahomey and Benin, two other societies of traditional West Africa, the past was constructed as linear and chronological. Like our own past, their past was historical: reigns, battles, droughts, and confrontations with invaders—European and other—were remembered in chronological order.

In his analysis of doors carved in wood, low reliefs in clay, and plaques in bronze made in these societies, art historian Jean Laude has called attention to two different clusters of features characterizing the reliefs carved, molded, or cast.[3]

The cluster of traits observed on the Dogon, Senufo, and Baule wooden doors and shutters include a nonsequential disposition of the figures carved on the surface, and an

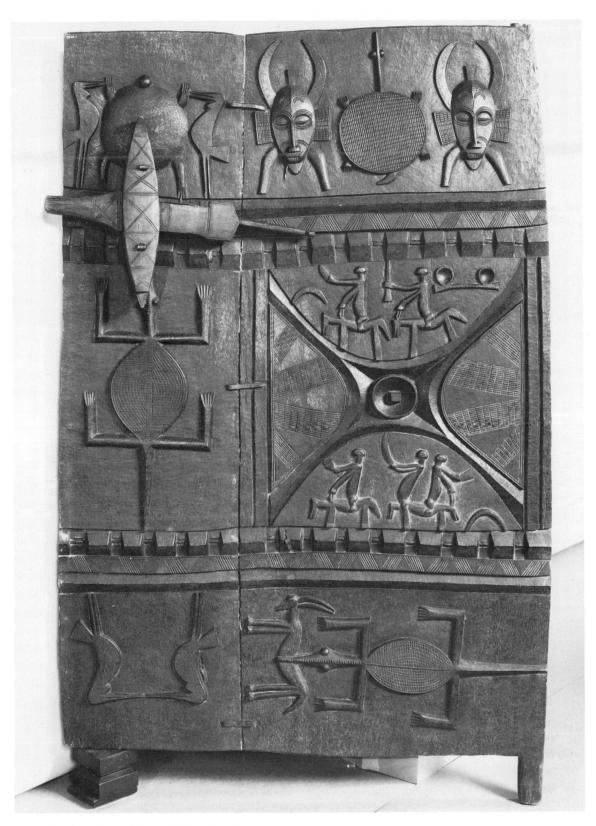

Door. Senufo, Ivory Coast. University Museum,
University of Pennsylvania, Philadelphia.

High relief in clay. Abomey, Dahomey. Musée de l'Homme, Paris. Photo: Hoa-Qui, Paris.

In the royal enclosure of Abomey, building with clay high reliefs. Dahomey. Photo: Hoa-Qui, Paris.

absence of depth. Laude mentions a Dogon shutter summarizing one of the creation myths: the sculptor has juxtaposed figures in a manner that does not suggest the order in which they should be "read."[4] Figures in low relief, lightly hollowed, and similarly disposed are frequent on Senufo doors.

Another cluster of traits characterizes Dahomey clay reliefs and Benin bronze plaques. Each new king of Dahomey had a new palace built; its walls were covered with deeply recessed squares from which emerged figures and motifs modeled in high relief. Each of these concave reliefs related historical events concerning kings, who were identified by emblems. An impression of perspective was achieved by the actual depth of the recessed square. In several Benin bronzes, there was an attempt to render perspective by casting figures in high relief, by placing the more distant at the higher part of the plaque, and sometimes by combining bird's-eye view and frontal view in the same plaque—as, for instance, in the famous sacrifice of a bull.

Here again, there is a term-to-term correspondence between mythical time and shallow relief, and between historical time and deep relief. Again, our conclusions can be formulated in a relation-to-relation correspondence comprising the four terms:

$$\frac{\text{mythical time}}{\text{historical time}} :: \frac{\text{shallow relief}}{\text{deep relief}}$$

'Mythical time is to historical time as shallow relief is to deep relief.'

It should be noted that the two corresponding ideational conceptions, mythical time and shallow relief, are found in the cultures of societies organized in villages under the authority of lineage patriarchs, whereas historical time and deep relief appeared in kingdoms governed by powerful rulers. Obviously, kings based their legitimacy and

Bronze plaque showing the sacrifice of a bull.
Benin, Nigeria. British Museum, London.

prestige on their predecessors, and thus historical past was important to them; by contrast, sacred origins were more relevant for elders of kinship groups.

The two societal networks, kinship founded on descent and government founded on coercion, were, in their turn, reflective of the material bases of the societies. The Dogon, Senufo, and Baule were farmers who produced just above the subsistence level; Dahomey, through her large plantations and slave labor, produced a considerable surplus, and Benin, through long-distance trade directly controlled by her rulers, was economically prosperous.

The processes of exclusion and conduction which we observed between systems of production and societal networks, and between societal networks and ideational configurations, combined with the process of correspondence we have analyzed among the ideational configurations, account for the dynamic and ongoing integration of a culture. A similar interplay of influences across cultural levels and of correspondences among ideational systems is found in traditional Africa regarding descent groups, ancestors' rituals, doctrines of kinship, and figurines of ancestors.

The source of group solidarity without which an individual would have been completely powerless in the crises of everyday life was the lineage comprising the living descendants of a certain ancestor. To be a descendant of ancestor A was an individual's essential identification. The lineage also endowed the descendant of A with a set of rights, for example, to have a plot of land for growing food, to be helped in case of a bad

crop, and, for a man, to have one's wives and children taken care of in case of untimely death. The importance of the societal network of kinship was expressed by the ancestor's ritual, an ideational configuration. It was a private and familial ritual: a simple altar in the family compound, everyday offerings of token foods, and a few words addressed to the ancestor.

Ancestors were often represented by statues. These statues were certainly an important part of the aesthetic locus in the cultures of Atlantic and equatorial forest tillers. Many of these ancestors' figurines—at least those we see in museums and art books—display a remarkable aesthetic quality: their composition is well integrated along vertical lines, and their meanings are expressed with force.

Ancestors' carvings did not portray singular individuals: recognition of somebody as a member of *a lineage* was more important than ascription to *a particular lineage*—indeed, in the subsistence societies of the forest clearings, all lineages were approximately equal in resources.

These figurines were usually represented in the nude, and their sexual organs were openly displayed. This is rather surprising as adult nudity was practically unknown in traditional Africa. Nudity in figurines reinforced the abstract quality of ancestors: their human nature was stripped of the cultural associations of clothes. Penis and vulva were emphasized as organs of generation, not of pleasure. They reminded the descendants that ancestors, male or female, were at the origin of many generations, and that they expected their strength to continue through new generations. The lineage would remain strong because the offspring of the living generation would be numerous.

This doctrine of kinship is not an anthropological inference. Sayings, proverbs, and narratives from Africa's past express it plainly. Men and women of innumerable villages of contemporary Africa still live by these values of kin solidarity and lineage fertility; they explicitly mention them. This kinship doctrine was, and still is, a cognitive configuration. The aesthetic configuration of ancestral figurines corresponds to it.

In this chapter we have reviewed several instances in which relations between an aesthetic system and another ideational configuration could be ascertained. These relations were, in all these cases, relations of correspondence. On the other hand, examples analyzed in the preceding chapters revealed that the relations among cultural phenomena distributed on different levels—production systems, societal organizations, and configurations of ideas—were conditioning relations.

Relations of correspondence are different from relations of conditioning. In the former, one term is equivalent to the other, homologous to the other, or isomorphic to the other: no priority of one term over the other is indicated or even implied. It may be that in a correspondence, one term has some precedence over its correspondent. For instance, the theological concept of transcendence may be anterior in time to the corresponding visual figuration of transcendence. This precedence is of secondary importance; what matters is the correspondence itself.

For a long time it has been recognized that some domains—such as myth, magic, and ritual—were not ruled by the rational logic of conditioning relations. These domains were thought to be exclusively found in non-Western cultures. It has been less readily recognized that some large areas of the Western cultures—such as the symbolic and the aesthetic domains—are also governed by a logic of correspondence.

Ancestors' figures. Dogon, Mali. Museum Rietberg, Zurich.

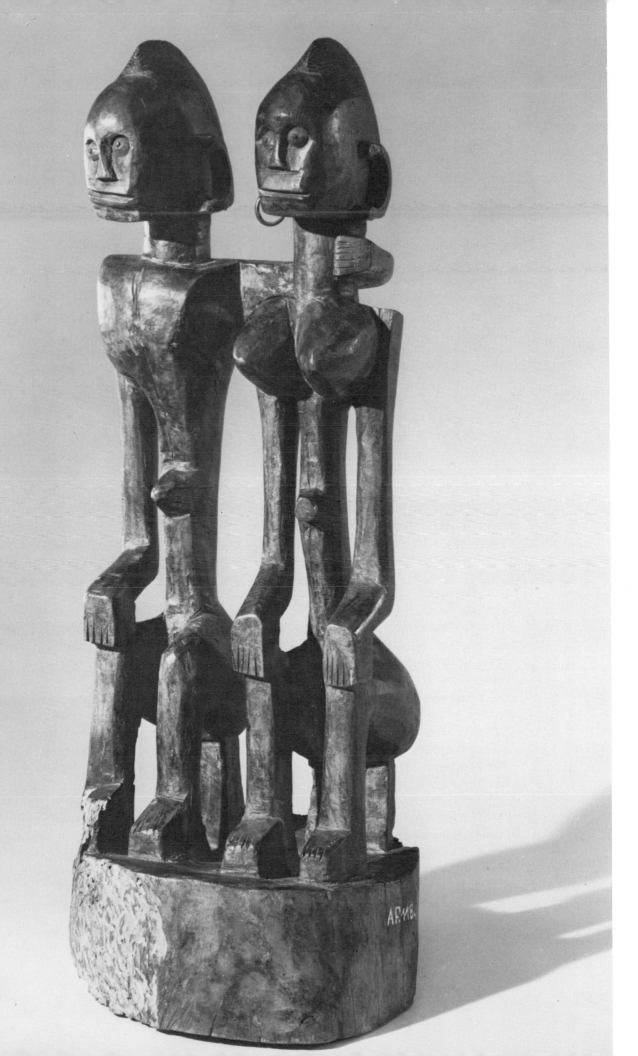

By contrast, in relations of conditioning, one term causes the other to exist; or one term is the antecedent of the other by preceding it; or, as an independent variable, one term determines, through its variations, the variations of the other; or one term excludes the other; or one term is conducive to the other. This logic of conditioning, in fact, does not extend its dominion much beyond everyday life, the techniques of production, and reasoning in scholarly and scientific knowledge.

In our examples, the conditionings were always in the same general direction: from productive systems to societal networks and from societal networks to ideational configurations. Is there ever a conditioning in the opposite direction? Do aesthetic systems ever have an impact on social structures or techniques of production? Or, to put it in Marxian vocabulary, Does the aesthetic part of the superstructure in any way determine social and economic realities?

In his 1942 talks at the Yenan forum on literature and art, Mao Zedong said that "literature and art are subordinate to politics, but in their turn exert a great influence on politics." He stated that "proletarian literature and art are parts of the whole revolutionary cause of the proletariat; they are, as Lenin said, cogs and wheels in the whole revolutionary machine. . . . If we had no literature and art even in the broadest and most ordinary sense, we could not carry on the revolutionary movement and win victory."[5]

In the same Yenan talks, Mao explained why literature and art are needed for revolution. "There is suffering from hunger, cold, and oppression, and also there is exploitation and oppression of man by man. These facts exist everywhere and people look upon them as commonplace. Writers and artists concentrate such every-day phenomena, typify the contradictions and struggles within them and produce works which awaken the masses, fire them with enthusiasm and impel them to unite and struggle to transform their environment. Without such literature and such art, this task could not be fulfilled, or at least not so effectively and speedily."[6] Even in the Marxist-Leninist tradition, the least likely to grant importance to aesthetic configurations, art is conceived of as a powerful force on societal networks through the mediation of its influence on people's minds. It can reveal to them what they do not perceive in their own lives, and move them to action.

In Mao Zedong's perspective, aesthetic configurations do have an impact, first, because art is more convincing than reality; and, second, because this apprehension through art is more conducive to action than the direct apprehension of the outside world.

From the point of view of this study, if a visual or literary representation provides a better understanding of what is represented than its direct consideration, it is because it is symbolic. *Workers Returning Home* (1913) by Edvard Munch (1863–1944) is an image of Norwegian men leaving the factory at the end of their shift. They are many; the dominant blue of their workclothes is like a uniform; the faces of the multitude are just indicated, except for four men in the foreground, who seem to be passing by the beholder. We could recognize them, particularly two of them, if we were to meet them again.

The picture's composition is clear. The vanishing-point perspective includes the viewer. The harmony of dark and muted hues is balanced. There is movement in the crowd, marching as it were, in the same direction. The center is marked by one of the four identifiable faces; it attracts the beholder's attention by its unique tonality—a slightly greenish grey—whereas the other faces are a warm reddish color.

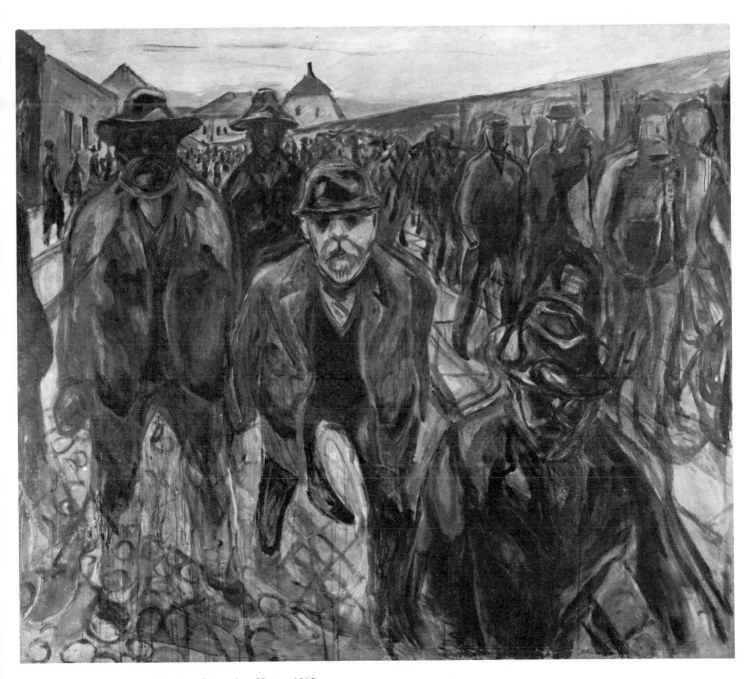

EDVARD MUNCH. *Workers Returning Home.* 1913.
Munch Museum, Oslo.

The painting also reveals a compelling expressivity. It symbolizes the advance of the working class, quiet and irresistible. The strength of this class is in its numbers: it is an impersonal mass when seen at a distance. It is also in the uniqueness of each worker: seen at close quarters, each is a rugged individual.

In the outside world, I have sometimes walked against the flow of a crowd and have seen, like the beholder of the Munch painting, people walking by me on either side. Because of the noise, because I attempted to avoid colliding with anybody, because what I saw had no visual composition, I did not perceive any symbol in these situations. My vision had not been "concentrated" and "typified," as Mao said, and thus I had no understanding of the meaning of what I saw.

Let us now address the second point in our reading of Mao Zedong on art: perceiving a situation through its artistic representation is a stimulant for action. We interpret this to mean that an aesthetic perception is a better stimulant for action than an intellectual one.

According to the popular Western view of the human psyche—conceived of as having three main functions, intellection, affectivity, and will—a work of art generates emotions and feelings, even passions, and these affective states, more than cold intellection, stimulate the will to act. The picture of a starving child generates shame and indignation; and shame and indignation trigger my will to do something about hunger in the world. The picture of a massacre raises my anger, and my anger determines that I join a peace movement. In earlier discussions, we have questioned the validity of the popular construction of the psyche which ignores contemplation, and of the view that art arouses emotions. But some pictures certainly arouse emotions in some viewers, and these emotions incite them to act. Maybe this is what Mao Zedong had in mind when he spoke of the masses fired by writers and artists into changing the conditions in which they live.

In this book's perspective, aesthetic perception belongs to contemplation and not to affectivity. Does contemplation prepare us for action better than intellection and emotion? I think that it does.

An adequate justification of this answer would require more than the few comments appropriate here. Let me just sketch the main lines of the argument that I would develop. I would begin by repeating that in the aesthetic perception—attentive, total, and devoid of self-interest—there is no intention to change what we are looking at. It is only when this visual contemplation of a part of the outside world is over that action becomes a possibility.

Then it should be shown that the symbolic meanings attained in a contemplative perception afford a deeper understanding of the depicted situation than does a purely intellectual knowledge. Thus, if something is to be changed, the advisability or necessity of action is better grasped. In that sense, the contemplative mode of consciousness prepares us for action.

Finally, it should be pointed out that contemplation is better than affectivity because the latter is always ego-oriented. Anger and indignation are indeed strong impulsions for action because of ego-involvement. When another car passes me and makes me angry, the involvement of my pride and my ego gives me the impulse to act, that is to accelerate and overtake the presumptuous car. Affectivity is a good preparation for indiscriminate action. Contemplation is a good preparation for unselfish action.

We would then be able to conclude that, from this perspective, aesthetic responses to literature and art generate wise actions and wise revolutions.

CONCLUSION

The Individual Nexus

WHEN I WAS A CHILD, THE PARISH PRIEST GIVING US RELIGIOUS INSTRUCTION ONCE TACKLED the paradox of bliss in paradise. All those in paradise will be perfectly happy, he said, despite the fact that their rewards will not be equal. Rewards will indeed be commensurate with the degree of virtue each soul had reached when living on earth. The problem was thus: How can those with smaller rewards be perfectly happy? The priest solved the problem by using a metaphor: virtue is a bowl and bliss is what fills the bowl. What matters is to have one's bowl filled up to the brim. One is completely satisfied as one's bowl is full, be it small or large.

I am not sure we were convinced that a small ice cream cone is as satisfactory as a big cone because it is filled to its capacity. Yet the metaphor conveyed an important meaning: even the ultimate one can dream of, the beatific heavenly bliss, must be experienced in the individual. Divine happiness is what is perceived by each person. It is, as it were, localized in an individual nexus.

This emphasis on the individual suggests how the universal and the cultural dimensions of the aesthetic experience can be unified in individual beholders.

In the third part of this book aesthetic objects were shown to be deeply integrated in the particular cultures where they had been made or adopted. Aesthetic forms are among the ideational configurations of the culture of which they are part: they are influenced by the processes of production and are responsive to institutions and other societal networks. In a word, aesthetic objects are deeply cultural.

They are also deeply universal. In the first two parts of this work, I stressed the panhuman dimensions of aesthetic objects. Their aesthetic and symbolic qualities elicit responses across cultural boundaries because they are attuned to the common humanity of the beholders.

Intellectually, these two aspects—the human and the cultural—can be distinguished; that has been done in this book. Concretely, they are indissociable. The universal human can be reached only through the particular cultural. Serene concentration, a universal value, is symbolically experienced through a cultural embodiment, the Anurādhapura Buddha, a product of the Sinhalese culture of the third and fourth

centuries A.D. The geometric order of natural forms is perceived through Braque's *Roche-Guyon*, a product of French Cubism in the first decade of this century. The 'human as such' cannot be expressed or perceived because it cannot exist devoid of cultural determinations. In the visual experience, human and cultural are one.

It was mentioned earlier that any activity, behavior, or artifact includes a singular component. An anonymous craftsman interpreted the Sinhalese tradition of the time and carved in stone the Anurādhapura Buddha. Braque—not Picasso, Gris, or Delaunay—painted *Roche-Guyon*, and it is through his singularity that we perceive the French Cubism of his time. We may go a step further and realize that the oneness of the aesthetic experience is situated in the individual beholder.

There the connection between universal, cultural, and singular is established. The individual as the nexus of the aesthetic experience can actualize, unify, and make manageable some of the infinite potentialities of the object. The same, and other, potentialities of the object will be similarly appropriated by other individuals.

This final localization of aesthetic experiences in the individual beholder helps us to confront towering masterpieces with confidence and restraint. Confidence because masterpieces are not there to remain in their intimidating splendor but to be looked at by you and me, and to be related to our individualities. Restraint because our individual response is commensurate with the aesthetic capacity of each of us, capacity that has been shaped by our previous encounters with the visual arts, our memory of other life experiences, and the contemplative skills we have developed. Though our bowl may not be large, it will be filled.

As the aesthetic experience is enclosed within the purview of the beholder, so is the intellectual journey reported in this book.

The topics dealt with were towering too: What is art and what is the experience of it; what is contemplation and how does it differ from cognition and affectivity; what is signification and what is communication. These problems, and other ones touched on in this book, have dominated the intellectual history of the West for several centuries. They too could be intimidating.

Yet we—the readers and the author—embarked on this journey. The aim was to understand intellectually what is implied in our aesthetic encounters with visual objects and what these encounters reveal about art, symbols, and our psyche. Our inquiry was not set on the general level of philosophy, art history, or even anthropology. Certainly we used these disciplines and other ones, but as mirrored in our individual understandings. The moon was carefully observed in its reflection on the water of our bowls, not in the sky.

In this book, the observer of the visual arts was an anthropologist.

Aesthetic Anthropology as Critical Knowledge

AESTHETIC EXPERIENCE IS CONTEMPLATION. THE ANTHROPOLOGY OF AESTHETIC EXPERIENCE is cognition. And it is anthropological cognition, or knowledge: a reality built on the basis of certain data, through certain research methods and logical procedures, and expressed in a certain discourse. Data, methods, procedures, and discourse are anthropological—and not theological or philosophical, for instance—when recognized as such by anthropologists.

Anthropology is what anthropologists practice, anthropologists are those who practice anthropology—this circle is actually a spiral. Suppose a group of nineteenth-century scholars, say, the founders of the Anthropological Society of London, defined anthropology as some matters they wanted to study in a certain manner. Those who later joined the Society continued the same line of study; yet they abandoned some areas of inquiry and opened others, they modified some research techniques, and they invented new ones. For each new generation of anthropologists, anthropology is what they agree to do; it may be something slightly, or significantly, different from what previous generations agreed to do. Building the anthropological reality is an ongoing process of continuity and innovation. This is what the spiral metaphor suggests.

Aesthetic anthropology, as presented here, is in continuity with anthropology as a social science and as a discipline of the humanities. And, cautiously, it goes a little beyond the usual data, the usual research techniques, and the usual types of reasoning.

Critical knowledge is knowledge built with a constant concern for the cognitive value of each step. Scholars, by definition, have this constant concern. In order to achieve the highest certainty attainable in the different fields of scholarship, they use unambiguous concepts and reliable instruments, they carefully check their observations, they avoid unfounded extrapolations of the research results, and they are rigorous in their logical reasoning.

243

Everyday knowledge is noncritical when, as often happens, we do not check the veracity of gossip, or when we state others' motivations on insufficient grounds. Action-oriented knowledge is noncritical when a careful analysis of a situation matters less than a quick decision. Knowledge based on the authority of gods and scriptures, leaders and party doctrines, elders and tradition is not critical. In all these cases, we do not attempt to evaluate and improve the degree of certainty—the epistemic quality—of what we know.

In the first chapter, we briefly described the paradigm of critical knowledge—theory, hypothesis, and observation. The paradigm is common to the social sciences and humanities. It is mainly at the stage of verifying hypotheses through observation that the social sciences and humanities differ. In the social sciences, verification is principally achieved by correlating quantifiable variations of phenomena; in the humanities, verification is achieved through an interpretive observation of one or more cases.

In aesthetic anthropology, the social sciences' method of correlation of variables may be used and, in fact, has been used. An excellent example of this approach can be found in the article "Art Styles as Cultural Cognitive Maps," by anthropologist John L. Fisher.[1]

Fisher wants to study connections between art styles and sociocultural conditions "in a widely distributed sample of primitive, relatively homogeneous societies."[2] He begins by choosing two sets of variables previously and independently established by psychologist Herbert Barry III, for art styles, and by anthropologist George Peter Murdock, for sociocultural conditions. Barry had selected five stylistic variables (from simple to complex, from empty to crowded, from symmetrical to asymmetrical, from no enclosed figures to enclosed figures, and from straight lines to curved lines) and had rated the graphic arts of thirty societies on each of the five axes. For instance, on the axis from simple to complex design, Andamans is the first society at the "simple" end of the axis, and Marquesas is the first at the "complex" extremity of the same axis.[3]

Three social variables are chosen by Fisher from among those rated by Murdock in his "World Ethnographic Sample."[4] They are egalitarian to hierarchical, male-oriented residence in marriage to female-oriented residence in marriage, and polygyny to monogamy. Fisher's sample is determined by the overlap of Barry's and Murdock's samples; it includes twenty-nine societies.

Fisher's theory is that "a very important determinant of the art form is social fantasy, that is the artist's fantasies about social situations that will give him security or pleasure."[5] From this theory, Fisher deduces hypotheses—sometimes by a rather lengthy chain of deductions—that can be tested by the degree of correlation between some of the stylistic and social variables. One of these hypotheses is the following: "Design with a large amount of empty or irrelevant space should characterize the egalitarian societies; design with little irrelevant (empty) space should characterize the hierarchical societies."[6]

There is thus an expected positive correlation between egalitarian societies and empty forms. The correlation would be perfect if all the egalitarian societies in the sample, and only the egalitarian ones, had graphics with empty forms. In fact, of 19 egalitarian societies, 12 have empty space in design, and 7 have crowded space; and of 9 societies with high stratification, 2 have empty space, and 7 are crowded. The hypothesis is supported at a statistically significant level (p is less than .05).[7]

The correlation method is particularly fruitful in the investigation of limited prob-

lems where two variables may be numerically valued in a manner that does not stretch their usual meaning. Some years ago, Catherine S. Enderton, at that time a graduate student, wanted to test her hypothesis that the important political developments that had occurred in the People's Republic of China during the fifties and the sixties had been reflected in the visual arts.[8]

She took all the color plates published in the Beijing *Chinese Literature* journal from 1952 to 1972, as a nonrepresentative but significant sample of the paintings and drawings of recent China. Enderton rated each of the 523 color plates from 1 to 4 on four axes by answering these questions: Does it contain more contemplative or more active elements? Is it more in the traditional Chinese style or in the Western style? Is it more linear or more painterly? Does it emphasize more the dominance of nature or the dominance of man? "Objective" criteria—in the sense that they could be easily used by raters other than Enderton—were defined in the paper.

The values on the four axes were transformed into annual percentages. For example, in 1956, before the Great Leap Forward, a contemplative maximum of 88 percent was attained on the contemplation–action axis; in 1968, at the peak of the Cultural Revolution, an active maximum of 100 percent was reached.

During the seven years preceding the Cultural Revolution (1959 to 1965), 217 pictures with contemplative dominance were published in *Chinese Literature*, and 119 with active dominance. During the five years of the Cultural Revolution (1966 to 1971), 35 pictures with contemplative dominance and 151 with active dominance were published. At the .01 significance level, the chi-square value was 99.2; thus the correlation between contemplative dominance and pre-Revolution years, and between active dominance and Revolution years can be considered as significant.

The study of aesthetic phenomena by quantitative correlations has also been applied on a large scale. As far back as 1937, Pitirim A. Sorokin published his ambitious *Fluctuation of Forms of Art,* a 750-page book. It was the first volume of a still more ambitious work, the four-volume *Social and Cultural Dynamics.*[9]

The four volumes offer a theoretical explanation of the cultural history of the Western world from the fifth century before Christ to the twentieth century. Sorokin's theory may be summarized in a few statements. The part of a culture which has priority and a determining influence on the other parts is the cultural premise. The cultural premise is a conception of the ultimate reality and of the supreme value. Logically, there can be only three premises. The *sensate* premise states that what we can attain through our senses is the only 'reality'; the *ideational* premise holds that what is beyond our senses is 'real' whereas the world is but an illusory appearance; and the *idealistic* premise affirms the 'reality' of both the world of our senses and the world beyond what they can reach.

The different compartments of a culture are integrated around the dominant premise and reflect it. In the course of history, there has been a cyclical movement among the three premises. During the twenty-five centuries of Western civilization, the cycle has been repeated twice. Before the fifth century B.C., the premise was ideational; during the fifth and the fourth centuries, it became idealistic; and from the third to the first century B.C., the premise was sensate. After a period of transition—first to fourth century A.D.—the cycle was repeated: ideational from fifth to twelfth, idealistic from thirteenth to fourteenth, and sensate from fifteenth to twentieth century.[10]

Sorokin uses two methods of empirical verification: a qualitative analysis carried out by what he calls the logico-meaningful method, and a quantitative analysis achieved by what he calls the causal-functional method. "Such a combination appears to [him] to be the only sound approach in the social sciences. It gives full freedom to logical thought—generalizing and analytical—and, at the same time, it tests its deductions inductively by the relevant empirical facts."[11] In this discussion, we are concerned only with the quantitative procedures.

Paintings and sculptures were classified under different categories according to their content. For instance, they were classed as religious or secular. From the point of view of the "spiritual to sensual atmosphere," art works were classified under five categories: extremely spiritual, moderately spiritual, neutral, moderately sensual, and extremely sensual. Representations of the body, from covered to nude, were distributed under the following headings: body covered, partly covered, uncovered except sex organs, nude with sex organs not depicted, nude with sex organs depicted. Eight types of landscapes were distinguished: urban, rural, mountains, sea, seasons, sunny, gloomy, and with human beings. There were also tables of portrait types according to the social class and the sex of the persons depicted, as well as tables of genre paintings according to such types as everyday life, festivals, and military scenes. The classification according to styles comprised these headings: impressionistic, naturalistic, mixed, expressionistic, and formal.

The span of time to be analyzed was reduced to the twenty centuries of European history. The time distribution was made by century except for the first ten centuries, which were lumped together, and the last two centuries, which were divided into smaller periods.

Two samples of pictures and sculptures made during these two thousand years were independently tabulated. One, including 32,299 items, was analyzed in Prague; and the other, of 16,679 items, was distributed into the same categories in Cambridge, Massachusetts. Here is an example of the results obtained: among the 16,260 seventeenth-century items, 14,722 were classified as naturalistic and impressionistic, 969 as formal, and 569 as mixed.[12] The fluctuations of all these variables were reported on graphs. For Europe, as a whole, the curves of the religious, the spiritual, and the covered body in art revealed a somewhat similar profile. And so did the curves of the secular, the sensual, and the nude.[13]

Sorokin concluded that there was a parallelism between the second cycle of dominant cultural premises (his independent variable) and the fluctuations of several important aspects of art works during the same span of time (his dependent variables). These quantified correlations indeed support Sorokin's contention that at any period of time, the metaphysical part of a culture (its conceptions of ultimate reality and supreme value) and the aesthetic part are integrated.

Sorokin's use of the correlation method in the aesthetic field is open to many criticisms. His categories are often ambiguous and lack clear indicators. He does not say how the two samples were selected nor if they were overlapping. His statistical analysis is crude. Yet it is an attempt that deserves to be studied: it shows the pitfalls of applying the quantitative method to aesthetic data, and it suggests some improvements.

Critical knowledge of aesthetic phenomena may also be achieved through the interpretive observation characteristic of the humanities. In fact, over its short history,

mainstream anthropology has more frequently used interpretive description than quantitative correlation. The latter was confined to a supporting role.

Since the second decade of this century—during which Malinowski spent a long time in the field among the Trobrianders, and Radcliffe-Brown did the same among the Andaman Islanders—typically, anthropological research has been carried out by an anthropologist observing, alone, a small-scale society or a single community for a period of about one to two years. The observer usually went into the field with a theory in mind from which hypotheses were deduced. They were tested through an in-depth observation.

It is obvious that the participant-observer type of research offers more opportunities for interpretive analysis than for statistical correlation. During my first field work, I approached the traditional kingdom of Rwanda from the typical research situation just described. After two years in the field, my book on Rwanda was an interpretation of what the system of government, the social hierarchy, and the feudal institution of the *ubuhake* meant for the Rwanda people. It meant that a premise of inequality pervaded the whole social fabric.[14] Some crucial points of this interpretation were quantitatively verified: I administered a 100-item questionnaire to a sample of 300 individuals belonging to one stratum of the society.[15] The method was primarily interpretive—as in the humanities. Secondarily, it was quantitative in the sense that some of my interpretations were supported by correlated quantified data—as in the social sciences.

In some domains of anthropology, the variables correlation method is particularly appropriate. It is the case with economic anthropology, which deals with surplus and growth, with productivity of techniques and distribution of goods. But in most domains, and aesthetic anthropology is one of them, interpretation remains the primary method.

Remember our discussion about the African equatorial forest environment constituting an obstacle to the development of an elite style in visual objects and being conducive to a folk style. Suppose we want to test this hypothesis deduced from the theory of cultural materialism.

If we chose to test it through the quantitative correlation method, we would first establish a representative sample of the societies of tillers which are known to have existed between the fourth parallel north and the fourth parallel south, and west of the Great Lakes of Africa. Then we would determine whether their system of production was at the subsistence level by consulting a list such as the Human Relations Area Files. Also, we would determine the characteristics of elite art and folk art, find aesthetic objects made in these societies, and have one or several persons rate the objects in terms of the indicators of the characteristics. As a control, we would do the same with a sample of surplus societies of the southern savanna. Finally, we would correlate the numerical values of the "forest variables," stylistic as well as productive, and we would do the same with the "savanna variables." Statistically significant correlations between the production variables and the style variables would confirm the hypothesis.

It could be tested through interpretive observation too. We would select a forest society, for instance the Lega—because they have been studied by an excellent anthropologist, Daniel Biebuyck. We would read his book *Lega Culture*.[16] As readers, we would attempt to understand their farming system, their stateless organization, and their values. We would look at the pictures of their small human figurines and go to museums where some of these figurines could be seen. Then we would proceed in the same manner with, say, the Luba society, a kingdom of the savanna.

This would give us a concrete understanding of a forest subsistence culture and of a savanna surplus culture; and we would have a visual perception of the differences between concrete folk forms and elite forms. We could further expand our study, noticing that some of the elite characteristics of the Luba were analogous to others found in the artifacts of the Kuba, the Cokwe, and the Kongo. Similarly, some of the folk features of Lega objects could be related to some forms produced by the Amba, the Tetela, and the Fang. We might also see differences in styles and try to grasp the meanings of these differences, as well as of the similarities. Finally, we would conclude that there are—or there are not—two cultural models: the subsistence cultures of forest farmers with folk style, and the surplus cultures of savanna kingdoms with elite style.

Anthropologists, usual practitioners of the interpretive approach, sometimes have been intimidated by the dominance of the correlative approach in the natural sciences, such as physics and biology, and in the social sciences, such as economics and sociology. And we have become apologetic about the epistemic value of our enterprise. Should we be so?

As stated above, there is only one paradigm of critical knowledge—theory, hypothesis, and observation. Qualitative interpretation and quantitative correlation are different methods of hypothesis testing. Observations, made and presented either qualitatively or quantitatively, will confirm, or not confirm, the hypothesis. Correct observations are thus of paramount importance in the search for epistemic quality.

Observations are correct when made according to an explicitly described procedure that is always the same. The procedure defines the observation. Cold and warm are what is measured by the variations of the mercury in a thermometer. Light is what is measured by the variations of the indicator of a light meter. Gothic is the architectural configuration characterized by the pointed arch, rib vault, and flying buttress. Aesthetic perception is indicated by concentrated, holistic, and disinterested attention. Temperature, light, style, and a specific type of perception can be correctly observed if the same measuring instrument or the same conceptual tool is applied in each case.

Conceptual constructs, the usual tools of interpretation, and instruments, the usual tools of physical and biological observation, may be crude or elaborate, easy or difficult to apply. When consistently used, they provide observers with comparable and reliable observations.

Defining facts or data by the procedure of observation makes it possible for other researchers to replicate observations. When procedures are fully described, the research may be repeated; idiosyncratic biases, if there were any, can be discovered and eliminated. This is why replicability is essential to critical knowledge.[17]

When observations have been correctly made, they provide a valid basis for testing hypotheses. The method of quantitative correlation is not superior to qualitative interpretation. Each of them permits hypotheses to be confronted with "facts." As anthropologists, we habitually use the interpretive approach; we should not be ashamed of it.

The difference between the approach of the sciences and the approach of the humanities is in the kind of hypotheses to be tested. (I follow here the common usage which limits the term *science* to a discipline of knowledge primarily using the quantitative correlation method.) Scientific hypotheses are more abstract than those of the humanities. The social scientist will formulate only hypotheses that can be verified by correlating numerical values of variables, for example, the number of bodies represented "uncovered

APPENDIX: AESTHETIC ANTHROPOLOGY AS CRITICAL KNOWLEDGE 249

except sex organs" in seventeenth-century pictures. The hypotheses that can be tested by such quantified data have to be pretty abstract—and shallow.

Between forty and fifty thousand art works have been "processed" by Sorokin's Prague and Cambridge evaluators. This has confirmed his hypothesis that there is a positive correlation between the fluctuations of the three metaphysical premises and the fluctuations of art variables. It also demonstrates that during the last twenty centuries of the Western European cultures, there has been a correspondence between world views and aesthetic configurations. This is one of the hypotheses of this book.

A scholar in the humanities would express the Sorokin idea in a similar hypothesis and test it by an in-depth interpretation of a few philosophic and artistic ideational systems within the context of a few concrete cultures of Western Europe. The hypothesis—that there is indeed a correspondence between metaphysical premises and visual forms—would be confirmed by the analysis of only a few cases. A thorough description would reveal the mechanisms of the correspondence, make it understandable, and indicate under what conditions we may expect it in cases not studied.

Like mainstream anthropology, aesthetic anthropology achieves critical knowledge through correlating quantified variables or through interpreting in depth the meanings of cultural phenomena. Because many aspects of the aesthetic experience cannot be translated into numerically valued variables without losing their significance, they will be approached in the perspective of the humanities. Anthropologists specializing in comparative aesthetics will assume the role of scholars more often than the role of scientists.

They also will have to assume the role of trailblazers. The aesthetic experience, as an object of anthropological study, introduces us to the field of inner phenomena. Anthropologists are not trained to deal with purely mental phenomena. Because these phenomena cannot be observed from without, they should be observed from within through the experiential approach; unfortunately, the experiential method seems to negate any possibility of critical knowledge. Finally, relations among ideational configurations are described as correspondences, and relations between symbols and their signifieds are analyzed as participations; a logic of correspondence and participation seems to be out of place in the discourse of critical knowledge that is dominated by a logic of causality.

We can identify art objects by external indicators, such as "being displayed in museums"; we did just that in the first stage of our study. But this identification does not reveal what these objects mean for the people of our culture. Another indicator we used, "objects made or selected for an exclusive visual use," also leaves the cultural meanings of these objects opaque. As a discipline of the humanities, anthropology is concerned with meanings. In this case, the meanings lie in the inner experience of the beholder.

Anthropological observers can certainly become beholders instead of being observers of beholders. This method of inquiry, the experiential method, is an active participation in the inner process to be studied, and an analytical observation of the process in one's own consciousness.[18] Obviously, there are limits to the applicability of this method, and in certain circumstances, the experiential approach may raise questions of deontology or plain personal honesty. I have briefly discussed some of these limits elsewhere.[19] The observer's participation in aesthetic perceptions does not bring up any of these problems, however. Here, we shall consider only the epistemic value of the experiential method: Does this method generate observations that meet the anthropological criteria of critical knowledge?

As in any other discipline of knowledge, the diversity of anthropological criteria

must meet the common requirement of replicability. Observations that cannot be replicated may be correct, but they are outside the scope of disciplines of knowledge. Can inner observations be replicated by other observers and used to test the same hypothesis? Can they confirm or not confirm the same hypothesis?

Inner observations may be replicated as field observations may be replicated. The conditions of conventional field research in anthropology—the anthropologist observing alone a small community for an extended period of time—do not allow the same kind of replication that is made possible by laboratory conditions. But anthropologists are expected to conduct research in such a way that similarly trained persons, using the same conceptual systems and the same techniques, can make comparable observations.

Observers of the inner field can also make their conceptual system clear and operational. After all, it is the aim of the terminology of a discipline. During the last two decades or so, the concern for the "natives' point of view" has become predominant; as a result emic categories, those "regarded as appropriate by the actors themselves," have been given priority over etic categories, those "judged appropriate by the community of scientific observers."[20] A system of etic categories in the fields of aesthetic experience and the contemplative mode of consciousness is still in the making.[21] Through explanation and discussion, examples and comparisons, concepts such as concentration, disinterestedness, and expressivity may be clarified and become unambiguous in the scholarly discourse of anthropological observers. They will retain in everyday discourse—and in literary discourse—some vagueness and uncertainty of meaning, but observers may agree on one meaning and make these concepts monosemic. An agreement is not even necessary: as long as an observer elucidates the meanings of the conceptual tools used in observation, this original observer makes it possible for others to replicate the observations. A clear conceptual system can always be translated into another conceptual system.

Emic categories are also translatable because anthropologists' inner observations allow them to understand what "natives" experience and say about those experiences. In that respect, the anthropologists' experiences are experiential referents that allow them to grasp what people of another culture say about their visual experience. We want to know if they have an emic category corresponding to, say, our etic category of "aesthetic experience."

Understanding conceptual systems that are alien because they were elaborated in another cultural tradition, or in the same cultural tradition but long ago, is not a new problem. Textual scholars, ancient commentators of all great traditions, as well as Western philologists of modern times, have demonstrated that hermeneutics, the methodology of interpretation, can retrieve conceptual systems and make them understandable across cultural barriers. A language, even the spoken language of everyday life, also reveals an emic conceptual system, if studied as a text.

Data provided by careful observation of our inner life should not be banished from the anthropological realm. These observations are replicable and therefore contribute to the building of a body of critical knowledge. They may have an epistemic value of the same order as the data collected in a usual field situation. Irrespective of their internal or external nature, observations will improve in cognitive value whenever their replicability increases through more rigorous and more explicit concepts and techniques.

Aesthetic anthropology demonstrates that our area of research should not be re-

stricted to what is conventionally recognized as "observable": tangible artifacts and visible behaviors. It should not be restricted to the logical field governed by the principles of identity and causality either.

Symbols participate in the nature of what they stand for. They are neither identical nor nonidentical to their signifieds. This is a type of unusual logical relation. It is logical in the sense that it is a pattern in the ordering of ideas; it is unusual in the sense that this symbolic relation does not fit into our rational logic based on the postulates of identity, contradiction, and the excluded third.

Anthropology is governed by rational logic, but the aesthetic and the symbolic studied by anthropologists are not. In descriptions and analyses we should venture into these fields, we should use the appropriate maps, and we should not impose a rational logic on ideas connected through other patterns.

Causality is another relationship belonging to the field of rational logic. We have discovered that it is not appropriate to describe by causality the relationships among configurations of ideas such as visual styles, philosophic doctrines, and world views. These relations are better qualified by the term *correspondences*.

The anthropological study of aesthetic and symbolic phenomena suggests that more scholarly attention should be paid to logics other than the rational, even in the industrial societies of the contemporary world.

As a concluding comment, I would like to say that the phenomenological perspective stated at the beginning of this book, though not mentioned again, was not lost.

Works of art and aesthetic objects, styles and societal networks, contemplation and the aesthetic experience are constructed realities. There are not external entities, material or nonmaterial, to which our cognitive constructs should be compared to assess their "truth." There are only realities built in the mind.

The facts we observe in order to test our hypotheses are previously built realities. Our newly constructed hypotheses must fit what are considered as facts by the consensus of scholars and scientists who have preceded us.

This is how critical knowledge is interpreted from a phenomenological perspective.

Notes

Chapter 1: *The Reality Anthropologists Build*

1. Maquet 1974a.
2. Maquet 1972a.
3. Tylor 1871:1.
4. Goldschmidt 1976:3.
5. Ibid.
6. Maquet 1979.
7. Berger and Luckmann 1966.
8. Kuhn 1962.

Chapter 2: *Art in Everyday Reality*

1. Lima 1971.
2. Maquet 1979.
3. Malraux 1967.
4. For a discussion of "primitive art" definitions proposed by Warren L. d'Azevedo and George Mills, and implied in Robert Farris Thompson's Yoruba studies, see Anderson 1970:13–22.

Chapter 3: *The Aesthetic Vision*

1. Staal 1975:124.
2. Brody 1970:27–31.
3. Osborne 1970b: 27–37.
4. Ibid., 28–29.
5. Ibid., 29.
6. Ibid., 30.
7. Ibid., 31.

Chapter 4: *The Significance of Form*

1. Haftmann 1972, 1:41–42.
2. Maquet 1979:18.
3. Weber 1980:109.
4. Osborne 1970b:31.

Chapter 5: *Aesthetic Vision as Contemplative*

1. On the *Yoga Sūtra,* see Woods 1927, Feuerstein 1979, and Hariharānanda Āraṇya 1981; on the *Visuddhimagga,* see Rhys Davids 1975 and Ñāṇamoli 1975.
2. The Vyāsa and Vāchaspatimiśra commentaries, together with the aphorisms, were translated by Woods (1927); the book is 350 pages.
3. For instance, Vivekananda 1973, Prabhavananda and Isherwood 1969, and Taimni 1972.
4. Woods 1927:8.
5. Ñāṇamoli 1975:85, 178.
6. Woods 1927:19, 24, 26, 31; Feuerstein 1979:30ff.
7. Ñāṇamoli 1975:248.
8. Osborne 1970b:30.
9. Woods 1927:36.
10. Osborne 1970b:35.
11. Ñāṇamoli 1975:144–61.
12. Maquet 1975, 1980.
13. Maquet 1975:183; Maquet 1980:141.
14. Maquet 1976.
15. Bogen 1973:111.
16. Ibid., 107.

Chapter 6: *Aesthetic Experience in Other Cultures*

1. Leiris and Delange 1968:40–45.
2. Munro 1965.
3. De 1963, Pandey 1950 and 1963, and Walimbe 1980. See also Gnoli 1956.
4. Maquet 1979:21.
5. For a discussion of the relationships between leadership and its aesthetic manifestations in traditional Africa, see Fraser and Cole 1972, and my review of it (Maquet 1973a).
6. For a discussion of the Baule whisks, see Himmelheber 1972:185–208; for the Lega ivory figurines, see Biebuyck 1973:149–81; and for the rank sculptures of New Hebrides, see Guiart 1963:35–38, 232.

Chapter 7: *Art in Other Cultures*

1. This was the case among the Dogon (Leiris and Delange 1968:142) and the Bamileke (Balandier and Maquet 1974:44–46).
2. Maquet 1979:36.
3. Leiris and Delange 1968:35.
4. Maquet 1979:36.
5. See Read 1964.
6. Delange 1974:148–50. The Bororo-Fulani are also known as the Wodaabe.
7. Maquet 1973b.
8. Goldwater 1967 and Laude 1971. For a thorough analysis of the African art influence on French painting during the years 1905–14, see Laude 1968.
9. Laude 1971:12.
10. Maquet 1972b:35, 41.
11. Goldwater 1967:5.
12. Morgan 1877.
13. Haddon 1895:317–18.
14. Laude 1968:29–36; Goldwater 1967:104–40; Kahnweiler 1963:222–36.
15. Haftmann 1972, 1:88.
16. Einstein 1961.
17. Quoted in Newton 1981:10.
18. For example, Apollinaire 1917, Guillaume and Munro 1926, and Olbrechts 1959.
19. Goldwater 1967:273ff.

Chapter 8: *Meanings in Aesthetic Objects*

1. Clark 1956:23–25.
2. Arnheim 1974:155.
3. Ramos 1979:5–7.
4. Clark 1956:359.

Chapter 9: *Visual Forms as Signs*

1. American Heritage Dictionary 1982: s.v. "star."
2. Such is the case of Cirlot 1962.
3. Peirce 1931–35, vol. 2, par. 92.
4. Maquet 1982:3.
5. See Peirce 1931–35, vol. 2 par. 92.
6. Lalande 1947:1058 (my translation).
7. Peirce 1931–35, vol. 2, par. 248.
8. Spiro 1982:55.

Chapter 10: *Visual Forms as Symbols*

1. Maquet 1972a:145.
2. Arnheim 1974.
3. Ibid., 359.
4. Ibid., 360.
5. See ibid., 425–26.
6. See McElroy 1954.
7. Maquet 1982:8
8. See American Heritage Dictionary 1982: s.v. "religion."
9. Spiro 1966:95.
10. See Maquet 1982:7.
11. Ibid., 7, 8.

Chapter 11: *The Aesthetic Quality*

1. Munro 1967:31.
2. Henri 1974:148.
3. Kohler, in Henly 1971:116.
4. See Ellis 1967:54; and Arnheim 1949:163.
5. A most illuminating study of visual composition is Arnheim's *The Power of the Center* (1982). On the significance of form, see the first exponent of the "significant form" (Bell 1958:17ff.); Langer 1953:24ff.; and Langer 1976:203ff.

Chapter 12: *Preferences in Art*

1. Henri 1974:27–185.
2. Gray 1971:131–83.

Chapter 13: *Between Creators and Beholders*

1. Geist 1969:104.
2. The dichotomy presented by Alexander Alland, Jr. (1977:69–70), semantic information and aesthetic information, is analogous to the distinction between message and meaning.
3. See Francastel 1965.
4. For a semiotic discussion of signification and communication, see Eco 1976:32–47.

5. Fernandez 1982a, 1982b.
6. Eco 1962.

Chapter 14: *Aesthetic Vision, a Selfless Experience*

1. Nyanaponika Thera 1962:30.
2. Waldman 1978:69.
3. Ibid., 65.
4. See the *Māhā Satipaṭṭāna-Sutta,* translated from the *Dīgha-Nikāya* by T. W. Rhys Davids and C. A. F. Rhys Davids (1971:327–46). A better translation is found in Nyanaponika Thera 1962: 117–35.
5. Zinberg 1977:205, 230.
6. Maquet 1980:149.
7. Osborne 1970b:35.
8. Ibid., 23.
9. Maquet 1980:150.

Chapter 15: *The Cultural Component in Aesthetic Objects*

1. Kluckhohn and Murray 1948:35, 46.
2. For a description of metaphysical idealism, see Osborne 1970a:87–99.
3. Oxford Companion to Art 1970: s.v. "Caravaggisti."

Chapter 16: *The Aesthetic Segment of a Culture*

1. Osgood 1940, 1958, 1959.
2. Maquet 1961, 1971, 1972a, 1972b.
3. See diagram in Maquet 1979:58.

Chapter 17: *Techniques of Production and Aesthetic Forms*

1. See Maquet 1972a:71; and Balandier and Maquet 1974: s.v. "ancestors" and "sculpture, stone."
2. Balandier and Maquet 1974:297.
3. Maquet 1972a:137.
4. Oxford Companion to Art 1970: s.v. "Paxton, Sir Joseph."
5. Ibid., s.v. "Eiffel, Gustave."
6. Lucie-Smith 1969:106.
7. Maquet 1979:70.
8. Maquet 1972a:68–73.
9. Turnbull 1972.
10. Vasarely 1965: 35, 36. See Maquet 1970:56n.
11. Focillon 1955.

12. See the contributions of Sidney Mintz, Maurice Godelier, and Bruce Trigger in *On Marxian Perspectives in Anthropology* (Maquet and Daniels 1984). On the term *cultural materialism,* see Harris 1968 and Harris 1979:x.

Chapter 18: *Societal Networks and Aesthetic Forms*

1. Maquet 1971:21–26.
2. See Greenberg 1961.
3. See a diagram of stratification and government in traditional Rwanda, in Maquet 1971:158.
4. Gray 1971:9–36.
5. See Gray 1971:185–218.
6. Quoted in Gray 1971:219.
7. Quoted in Oxford Companion to Twentieth-Century Art 1981: s.v. "Tatlin."
8. Ibid.
9. Ibid., s.v. "Russia and the U.S.S.R."
10. Hinz 1979:41.
11. Encyclopedia of the Social Sciences 1968: s.v. "Totalitarianism," by Herbert J. Spiro.
12. Berger 1965:164, 165.

Chapter 19: *Aesthetic Forms and Other Ideational Configurations*

1. Francastel 1965:100–01 (my translation).
2. Maquet 1974b:125.
3. Laude 1971:215–39.
4. Ibid., 217, 221.
5. Mao Tse-tung, 1965:25, 26. Mao Tse-tung was the usual romanization of the name of the Communist leader (1893–1976) before the presently accepted *pinyin* form, Mao Zedong.
6. Ibid., 19–20.

Appendix: *Aesthetic Anthropology as Critical Knowledge*

1. Fisher 1971.
2. Fisher 1971:172.
3. Barry 1957.
4. Murdock 1957.
5. Fisher 1971:173.
6. Ibid., 176.
7. Ibid., 180.
8. Catherine S. Enderton, "Mao Tse-tung and the Arts of China." Paper presented as a course requirement in aesthetic anthropology, Department of Anthropology, University of California, Los Angeles, 28 November 1972.

9. Sorokin 1937a, 1937b, 1937c, 1941.
10. Maquet 1974a:132–33.
11. Sorokin 1937a:xi.
12. Ibid., 393.
13. Ibid., 418–19.
14. Maquet 1961.
15. Ibid., 173–85.
16. Biebuyck 1973.
17. On the validity, reliability, and replicability of observations, see Pelto 1970:34, 35, 41, 42.

18. A sustained application of the experiential method was the main research approach of Larry Peters (1981) in his excellent study of Tamang Shamanism in Nepal.
19. Maquet 1981.
20. Harris 1968:571, 575.
21. Such a system of sophisticated categories has been presented in three books by Robert Plant Armstrong (1971, 1975, 1981).

Works Cited

Alland, Alexander, Jr. 1977. *The Artistic Animal. An Inquiry into the Biological Roots of Art*. Garden City, N.Y.: Doubleday, Anchor Books.

American Heritage Dictionary. 1982 [1969]. *The American Heritage Dictionary of the English Language*. Ed. William Morris. Rev. college ed. Boston: Houghton Mifflin.

Anderson, Richard L. 1979. *Art in Primitive Societies*. Englewood Cliffs, N.J.: Prentice-Hall.

Apollinaire, Guillaume. 1917. *Sculptures nègres*. Paris: Paul Guillaume.

Armstrong, Robert Plant. 1971. *The Affecting Presence: An Essay in Humanistic Anthropology*. Urbana: University of Illinois Press.

———. 1975. *Wellspring: On the Myth and Source of Culture*. Berkeley and Los Angeles: University of California Press.

———. 1981. *The Powers of Presence: Consciousness, Myth, and Affecting Presence*. Philadelphia: University of Pennsylvania Press.

Arnheim, Rudolf. 1949. "The Gestalt Theory of Expression." *Psychological Review* (Lancaster, Pa.) 56, no. 3: 156–71.

———. 1974 [1954]. *Art and Visual Perception*. Rev. ed. Berkeley and Los Angeles: University of California Press.

———. 1982. *The Power of the Center: A Study of Composition in the Visual Arts*. Berkeley and Los Angeles: University of California Press.

Balandier, Georges and Jacques Maquet, eds. 1974 [French ed. 1968]. *Dictionary of Black African Civilization*. New York: Leon Amiel.

Barry, Herbert, III. 1957. "Relationships between Child Training and the Pictorial Arts." *Journal of Abnormal and Social Psychology* (Washington, D.C.) 54:380–83.

Bell, Clive. 1958 [1914]. *Art*. New York: Capricorn.

Berger, John. 1965. *Success and Failure of Picasso*. Harmondsworth: Penguin Books.

Berger, Peter L., and Thomas Luckmann. 1966. *The Social Construction of Reality*. Garden City, N.Y.: Doubleday.

Biebuyck, Daniel. 1973. *Lega Culture*. Berkeley and Los Angeles: University of California Press.

Bogen, Joseph E. 1973. "The Other Side of the Brain: An Appositional Mind." In *The Nature of Human Consciousness*, ed. Robert E. Ornstein, 101–25. San Francisco: W. H. Freeman.

Brandt, Henry. 1956. *Nomades du soleil*. Lausanne: La Guilde du Livre et Editions Clairefontaine.

Brody, Grace F. 1970. "The Development of Visual Aesthetic Preferences in Young Children." *Sciences de l'Art / Scientific Aesthetics* (Paris) 7, nos. 1–2: 27–31.

256

Capa, Cornell, and Bhupendra Karia, eds. 1974. *Robert Capa, 1913–1954*. New York: Viking Press.

Chadwick, George F. 1961. *The Works of Sir Joseph Paxton, 1803–1865*. London: The Architectural Press.

Cirlot, J. E. 1962 [Spanish ed. 1958]. *A Dictionary of Symbols*. New York: Philosophical Library.

Civilisations. 1966. *Civilisations, peuples et mondes*. 7 vols. Paris: Editions Lidis.

Clark, Kenneth. 1956. *The Nude: A Study in Ideal Form*. Garden City, N.Y.: Doubleday.

De, S. K. 1963. *Sanskrit Poetics as a Study of Aesthetics*. Berkeley and Los Angeles: University of California Press.

Delange, Jacqueline. 1974 [French ed. 1967]. *The Art and Peoples of Black Africa*. New York: Dutton.

Eco, Umberto. 1962. *Opera Aperta*. Milan: Bompiani.

———. 1976. *A Theory of Semiotics*. Bloomington: Indiana University Press.

Einstein, Carl. 1961 [German ed. 1915]. "La Sculpture nègre." *Médiations* (Paris) 3: 93–114.

Ellis, Willis D., ed. 1967. *A Source Book of Gestalt Psychology*. New York: Humanities Press.

Encyclopedia of the Social Sciences. 1968. *International Encyclopedia of the Social Sciences*. Ed. David L. Sills. New York: Macmillan.

Fernandez, James W. 1982a. "The Dark at the Bottom of the Stairs." In *On Symbols in Anthropology. Essays in Honor of Harry Hoijer, 1980*, ed. Jacques Maquet, 13–43. Malibu, Calif.: Undena Publications.

———. 1982b. *Bwiti. An Ethnography of the Religious Imagination in Africa*. Princeton, N.J.: Princeton University Press.

Feuerstein, Georg. 1979. *The Yoga-Sūtra of Patañjali*. Folkestone, Kent: Dawson.

Fisher, John L. 1971 [1961]. "Art Styles as Cultural Cognitive Maps." In *Art and Aesthetics in Primitive Societies*, ed. Carol F. Jopling, 171–92. New York: E. P. Dutton.

Focillon, Henri, 1955 [1939]. *Vie des Formes*. Paris: Presses universitaires de France.

Fondation Maeght. 1967. *Dix ans d'art vivant, 1955–1965*. Saint-Paul, Alpes Maritimes: Fondation Maeght.

Francastel, Pierre. 1965 [1954]. *Peinture et société*. Paris: Gallimard.

Frankfurter Kunstverein. 1975. *Kunst im 3. Reich. Dokumente der Unterwerfung*. Frankfurt am Main: Frankfurter Kunstverein.

Fraser, Douglas, and Herbert M. Cole, eds. 1972. *African Art and Leadership*. Madison: University of Wisconsin Press.

Geist, Sidney. 1969. *Constantin Brancusi, 1876–1957: A Retrospective Exhibition*. New York: The Solomon R. Guggenheim Foundation.

Gnoli, Raniero. 1956. *The Aesthetic Experience According to Abhinavagupta*. Rome: Istituto Italiano per il Medio ed Estremo Oriente.

Goldschmidt, Walter. 1976. *Culture and Behavior of the Sebei: A Study in Continuity and Adaptation*. Berkeley and Los Angeles: University of California Press.

Goldwater, Robert. 1967. *Primitivism in Modern Art*. Rev. ed. New York: Random House.

Gray, Camilla. 1971 [1962]. *The Russian Experiment in Art, 1863–1922*. New York: Harry N. Abrams.

Greenberg, Clement. 1961. *Art and Culture: Critical Essays*. Boston: Beacon Press.

Guiart, Jean. 1963 [French ed. 1963]. *The Art of the South Pacific*. London: Thames and Hudson.

Guillaume, Paul, and Th. Munro. 1926. *Primitive Negro Sculpture*. New York: Harcourt, Brace.

Haddon, Alfred C. 1895. *Evolution in Art*. London: W. Scott.

Haftmann, Werner. 1972 [German ed. 1965]. *Painting in the Twentieth Century*. 2 vols. New York: Praeger.

Hariharānanda Āraṇya, Swāmi. 1981 [1963]. *Yoga Philosophy of Patañjali*. Calcutta: University of Calcutta.

Harris, Marvin. 1968. *The Rise of Anthropological Theory. A History of Theories of Culture*. New York: Thomas Crowell.

———. 1979. *Cultural Materialism: The Struggle for a Science of Culture.* New York: Random House.

Henly, Mary, ed. 1971. *The Selected Papers of Wolfgang Kohler.* New York: Liveright.

Henri, Adrian. 1974. *Total Art. Environments, Happenings, and Performance.* New York: Oxford University Press.

Himmelheber, Hans. 1972. "Gold-Plated Objects of Baule Notables." In *African Art and Leadership,* ed. Douglas Fraser and Herbert M. Cole, 185–208. Madison: University of Wisconsin Press.

Hinz, Berthold. 1979 [German ed. 1974]. *Art in the Third Reich.* New York: Pantheon Books.

Hoebel, E. Adamson. 1972. *Anthropology. The Study of Man.* 4th ed. New York: McGraw-Hill.

Kahnweiler, Daniel-Henry. 1963. *Confessions esthétiques.* Paris: Gallimard.

Kluckhohn, Clyde, and Henry A. Murray. 1948. "Personality Formation: The Determinants." In *Personality in Nature, Society and Culture,* ed. Clyde Kluckhohn and Henry A. Murray, 35–48. New York: Alfred A. Knopf.

Knoll. 1971. *Knoll au Louvre. Catalog of the Exhibition.* New York: Knoll International.

Kuhn, Thomas. 1962. *The Structure of Scientific Revolutions.* Chicago: University of Chicago Press.

Lalande, André, ed. 1947 [1902–23]. *Vocabulaire technique et critique de la Philosophie.* 5th ed. Paris: Presses universitaires de France (for the Société française de Philosophie).

Langer, Susanne K. 1953. *Feeling and Form. A Theory of Art Developed from "Philosophy in a New Key."* New York: Charles Scribner's Sons.

———. 1976 [1942]. *Philosophy in a New Key. A Study in the Symbolism of Reason, Rite, and Art.* 3d. ed. Cambridge, Mass.: Harvard University Press.

Laude, Jean. 1968. *La Peinture française et "l'Art nègre."* 2 vols. Paris: Klincksieck.

———. 1971 [French ed. 1966]. *The Arts of Black Africa.* Berkeley and Los Angeles: University of California Press.

Leiris, Michel, and Jacqueline Delange. 1968 [French ed. 1967]. *African Art.* New York: Golden Press.

Lima, Mesquitela. 1971. *Fonctions sociologiques des figurines de culte 'hamba' dans la société et dans la culture tshokwé (Angola).* Luanda, Angola: Instituto de Investigação Cientifica de Angola.

Lucie-Smith, Edward. 1969. *Late Modern. The Visual Arts since 1945.* New York: Praeger.

McElroy, W. A. 1954. "A Sex Difference in Preferences for Shapes." *British Journal of Psychology* (London) 45:209–16.

Malraux, André. 1967 [French ed. 1947]. *Museum Without Walls.* New York: Doubleday.

Mao Tse-Tung [Mao Zedong]. 1965 [Chinese ed. 1953]. *Talks at the Yenan Forum on Literature and Art.* Peking: Foreign Languages Press.

Maquet, Jacques. 1961 [French ed. 1954]. *The Premise of Inequality in Ruanda. A Study of Political Relations in a Central African Kingdom.* London: Oxford University Press.

———. 1971. *Power and Society in Africa.* New York: McGraw-Hill.

———. 1972a [French ed. 1962]. *Civilizations of Black Africa.* New York: Oxford University Press.

———. 1972b [French ed. 1967]. *Africanity. The Cultural Unity of Black Africa.* New York: Oxford University Press.

———. 1973a. "Establishment Images and Elite Adornments." In *Arts in Society* (Madison, Wis.) 10, no. 2: 297–301.

———. 1973b. "The Fading Out of Art in Industrially Advanced Societies." *Journal of Symbolic Anthropology* (The Hague) 2: 21–26.

———. 1974a. [French ed. 1951]. *The Sociology of Knowledge.* Westport, Conn.: Greenwood.

———. 1974b. "Isomorphism and symbolism as 'explanations' in the analysis of myths." In *The Unconscious in Culture. The Structuralism of Claude Lévi-Strauss in Perspective,* ed. Ino Rossi, 123–33. New York: E. P. Dutton.

———. 1975. "Expressive Space and Theravāda Values: A Meditation Monastery in Sri Lanka." *Ethos* (Berkeley, Calif.) 3, no. 1: 1–21.

————. 1976. "The World / Nonworld Dichotomy." In *The Realm of the Extra-Human. Ideas and Actions,* ed. Agehananda Bharati, 55–68. The Hague: Mouton.

————. 1979 [1971]. *Introduction to Aesthetic Anthropology.* 2d ed., rev. Malibu, Calif.: Undena Publications.

————. 1980. "Bhavanā in Contemporary Sri Lanka: The Idea and Practice." In *Buddhist Studies in Honour of Walpola Rāhula,* ed. Somaratna Balasooriya and others, 139–53. London: Gordon Fraser.

————. 1981. "Scholar and Shaman." Introduction to *Ecstasy and Healing in Nepal,* by Larry Peters, 1–6. Malibu, Calif.: Undena Publications.

————. 1982. "The Symbolic Realm." In *On Symbols in Anthropology. Essays in Honor of Harry Hoijer, 1980,* ed. Jacques Maquet, 1–11. Malibu, Calif.: Undena Publications.

Maquet, Jacques, and Nancy Daniels, eds. 1984. *On Marxian Perspectives in Anthropology. Essays in Honor of Harry Hoijer, 1981.* By Sidney Mintz, Maurice Godelier, and Bruce Trigger. Malibu, Calif.: Undena Publications.

Morgan, Lewis H. 1877. *Ancient Society.* New York: World Publishing.

Munro, Thomas. 1965. *Oriental Aesthetics.* Cleveland: Press of Western Reserve University.

————. 1967 [1949]. *The Arts and Their Interrelations.* Cleveland: Press of Western Reserve University.

Murdock, George Peter. 1957. "World Ethnographic Sample." *American Anthropologist* (Washington, D.C.) 59: 664–87.

Ñāṇamoli, Bhikkhu, trans. 1975 [1956]. *The Path of Purification (Visuddhimagga) by Bhadantācariya Buddhaghosa.* Kandy, Sri Lanka: Buddhist Publication Society.

Newton, Douglas. 1981. "The Art of Africa, the Pacific Islands, and the Americas. A New Perspective." *The Metropolitan Museum of Art Bulletin* (New York) 39, no. 2.

Norberg-Schulz, Christian. 1975 [Italian ed. 1974]. *Meaning in Western Architecture.* New York: Praeger.

Nyanaponika Thera. 1962. *The Heart of Buddhist Meditation.* London: Rider and Co.

Olbrechts, Frans M. 1959 [Dutch ed. 1946]. *Les Arts Plastiques du Congo belge.* Brussels: Editions Erasme.

Osborne, Harold. 1970a [1968]. *Aesthetics and Art Theory. An Historical Introduction.* New York: Dutton.

————. 1970b. *The Art of Appreciation.* London: Oxford University Press.

Osgood, Cornelius. 1940. *Ingulik Material Culture.* New Haven, Conn.: Yale University Press.

————. 1958. *Ingalik Social Culture.* New Haven, Conn.: Yale University Press.

————. 1959. *Ingalik Mental Culture.* New Haven, Conn.: Yale University Press.

Oxford Companion to Art. 1970. *The Oxford Companion to Art.* Ed. Harold Osborne. Oxford: Oxford University Press.

Oxford Companion to Twentieth-Century Art. 1981. *The Oxford Companion to Twentieth-Century Art.* Ed. Harold Osborne. Oxford: Oxford University Press.

Pandey, Kanti Chandra. 1950. *Comparative Aesthetics.* Vol. 1, *Indian Aesthetics.* Banaras [Varanasi], India: Chowkhamba.

————. 1963 [1936]. *Abhinavagupta: An Historical and Philosophical Study.* 2d ed. Varanasi: Chowkhamba.

Peirce, Charles Sanders. 1931–35. *Collected Papers.* 8 vols. 1–6, ed. Charles Hartshorne and Paul Weiss. Cambridge, Mass.: Harvard University Press.

Pelto, Pertti J. 1970. *Anthropological Research. The Structure of Inquiry.* New York: Harper and Row.

Peters, Larry. 1981. *Ecstasy and Healing in Nepal.* Malibu, Calif.: Undena Publications.

Prabhavananda, Swami, and Christopher Isherwood, trans. 1969 [1953]. *How to Know God. The Yoga Aphorisms of Patanjali.* New York: New American Library, Mentor Books.

Ramos, Mel. 1979. *Mel Ramos. Watercolors.* Berkeley, Calif.: Lancaster-Miller.

Read, Herbert. 1964 [1934]. *Art and Industry. The Principles of Industrial Design.* Bloomington: Indiana University Press.

Rhys Davids, C. A. F., ed. 1975 [1920–21]. *The Visuddhimagga of Buddhaghosa*. London: Pali Text Society.

Rhys Davids, T. W., and C. A. F. Rhys Davids, trans. 1971 [1910]. *Dialogues of the Buddha, Part II*. London: Luzac and Co. (for the Pali Text Society).

Snellgrove, David L., ed. 1978. *The Image of the Buddha*. Tokyo and Paris: Kodansha International / UNESCO.

Sorokin, Pitirim A. 1937a. *Fluctuation of Forms of Art*. Vol. 1, *Social and Cultural Dynamics*. New York: American Book Co.

———. 1937b. *Fluctuation of Systems of Truth, Ethics and Law*. Vol. 2, *Social and Cultural Dynamics*. New York: American Book Co.

———. 1937c. *Fluctuation of Social Relationships, War and Revolution*. Vol. 3, *Social and Cultural Dynamics*. New York: American Book Co.

———. 1941. *Basic Problems, Principles and Methods*. Vol. 4, *Social and Cultural Dynamics*. New York: American Book Co.

Spiro, Melford E. 1966. "Religion: Problems of Definition and Explanation." In *Anthropological Approaches to the Study of Religion*, ed. Michael Banton, 85–126. London: Tavistock Publications.

———. 1982. "Collective Representations and Mental Representations in Religious Symbolic Systems." In *On Symbols in Anthropology. Essays in Honor of Harry Hoijer, 1980*, ed. Jacques Maquet, 45–72. Malibu, Calif.: Undena Publications.

Staal, Frits. 1975. *Exploring Mysticism*. Berkeley and Los Angeles: University of California Press.

Taimni, I. K. 1972 [1961]. *The Science of Yoga. The Yoga-Sūtras of Patañjali in Sanskrit, with Transliteration in Roman, Translation in English, and Commentary*. Wheaton, Ill.: Theosophical Publishing House.

Turnbull, Colin M. 1972. *The Mountain People*. New York: Simon and Schuster.

Tylor, E. B. 1871. *Primitive Culture*. London: J. Murray.

Van Offelen, Marion, and Carol Beckwith. 1983. *Nomads of Niger*. New York: Harry N. Abrams.

Vasarely, Victor. 1965. *Vasarely*. Neuchâtel: Editions du Griffon.

Vivekananda, Swami. 1973. "Patañjali's Yoga Aphorisms." In *Raja-Yoga*, by Swami Vivekananda, 105–267. Calcutta: Advaita Ashrama.

Waldman, Diane. 1978. *Mark Rothko, 1903–1970. A Retrospective*. New York: Harry N. Abrams (in collaboration with the Solomon R. Guggenheim Foundation).

Walimbe, Y. S. 1980. *Abhinavagupta on Indian Aesthetics*. Delhi: Ajanta Publications.

Weber, Ernst A. 1980 [German ed. 1978]. *Vision, Composition, and Photography*. Berlin and New York: de Gruyter.

Woods, James Haughton, trans. 1927 [1914]. *The Yoga-System of Patañjali*. Oriental Series. Cambridge, Mass.: Harvard University Press.

Zimenko, Vladislav. 1976. *The Humanism of Art*. Moscow: Progress Publishers.

Zinberg, Norman E., ed. 1977. *Alternate States of Consciousness*. New York: Macmillan, Free Press.

Analytical Table of Contents

261

Index of Proper Names

(including works of art)

Index of Topics